"I have seen things so beautiful they have brought tears to my eyes. Yet none of them can match the gracefulness and beauty of a horse running free."

— *Anonymous*

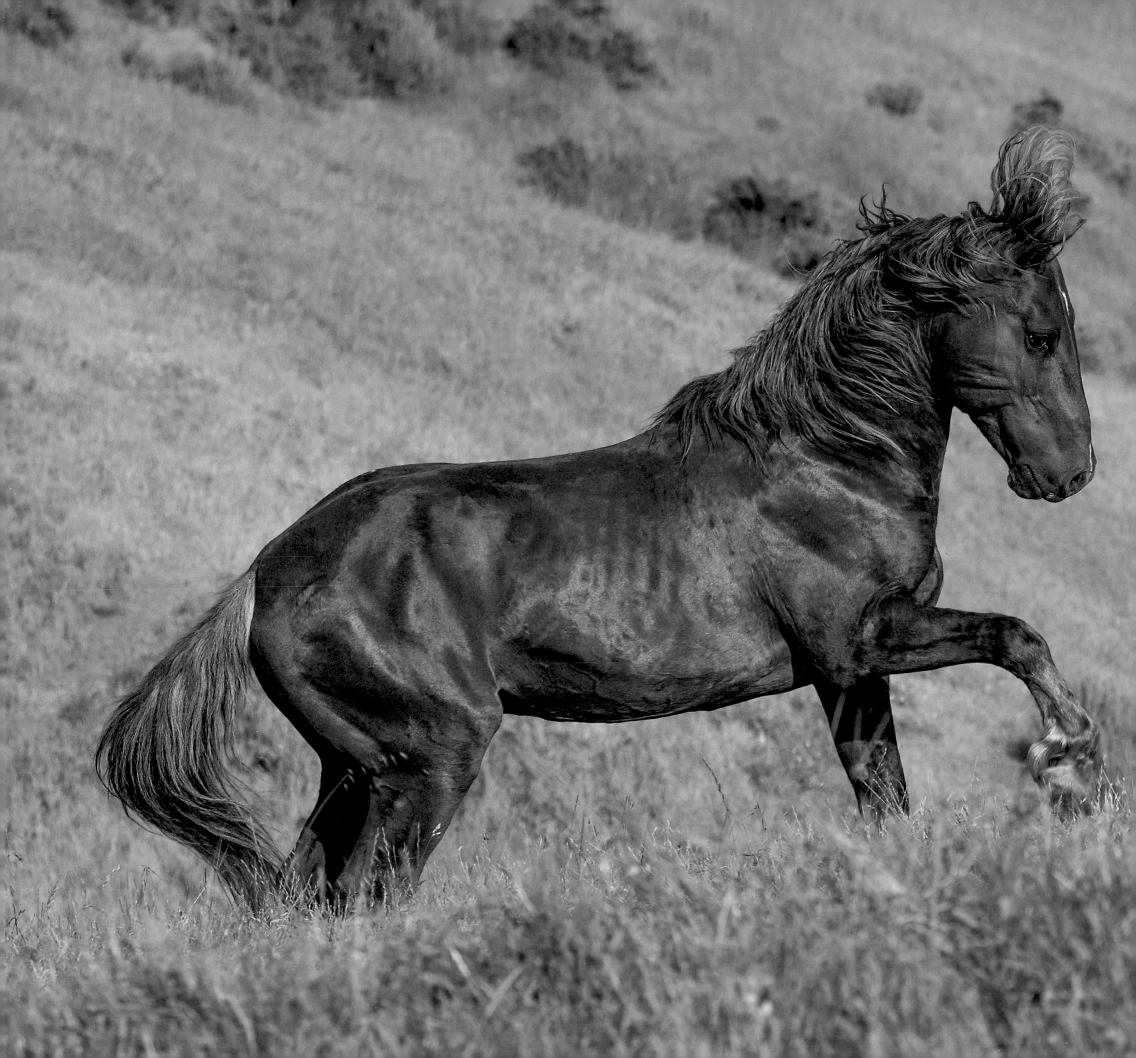

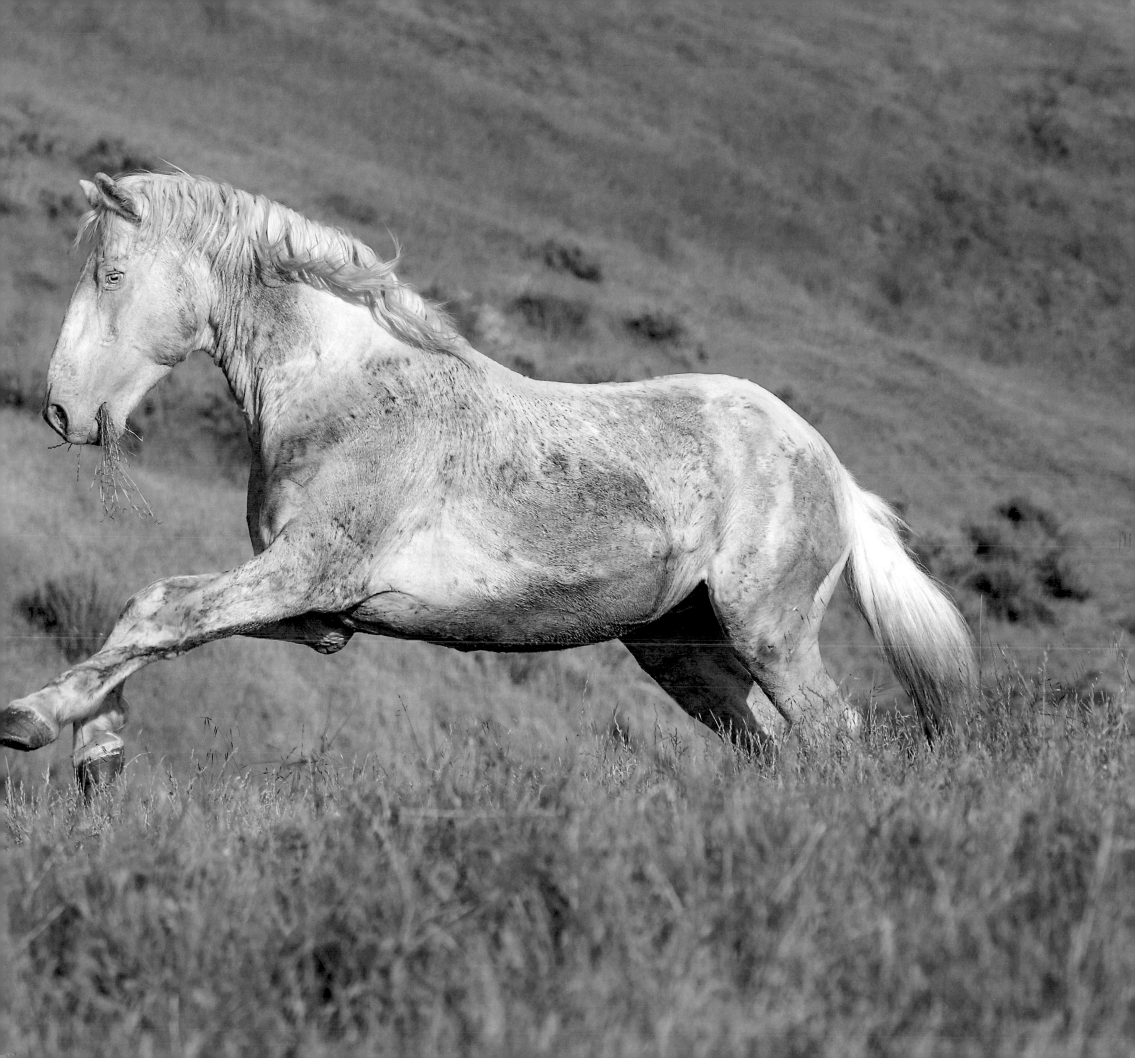

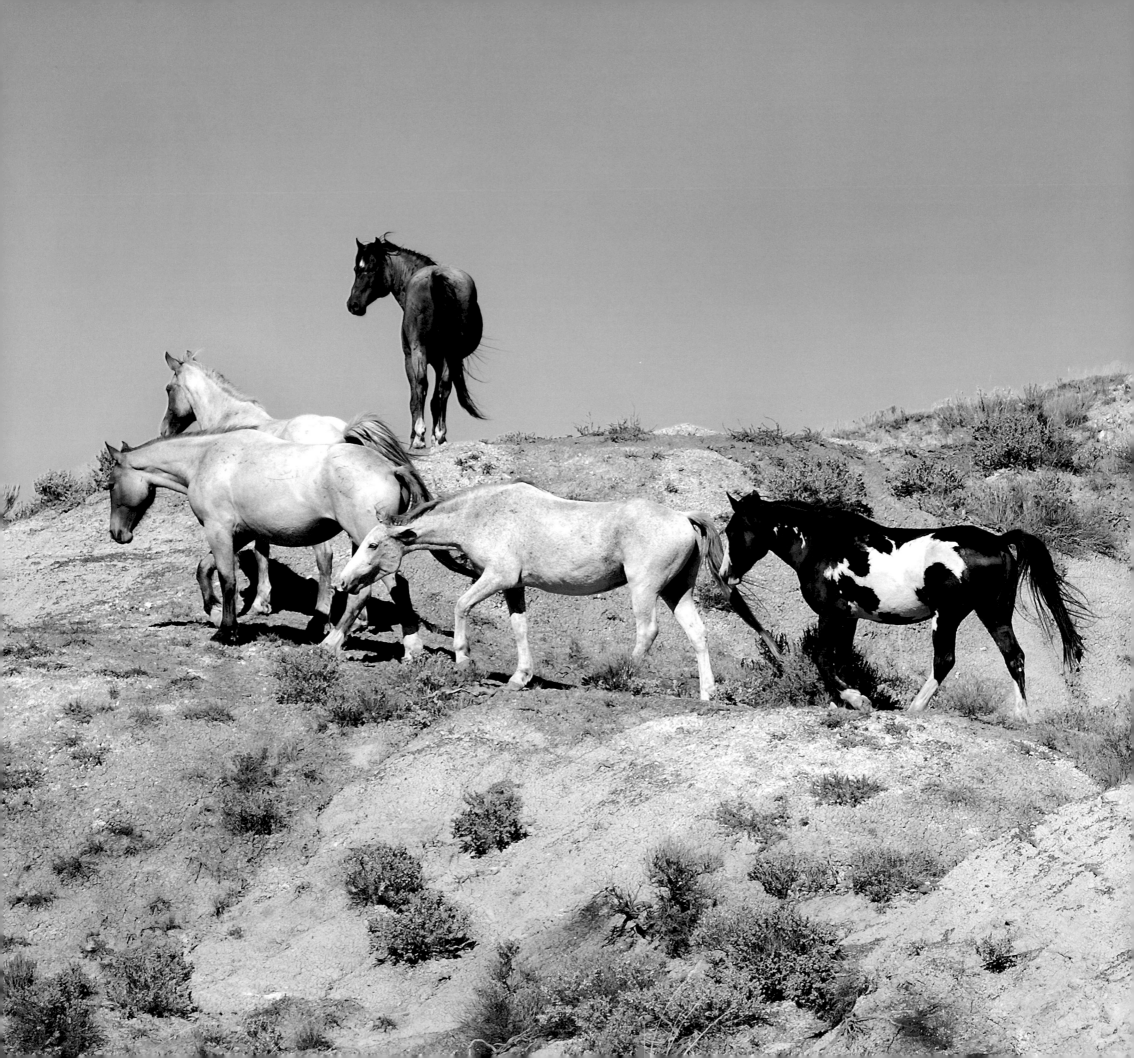

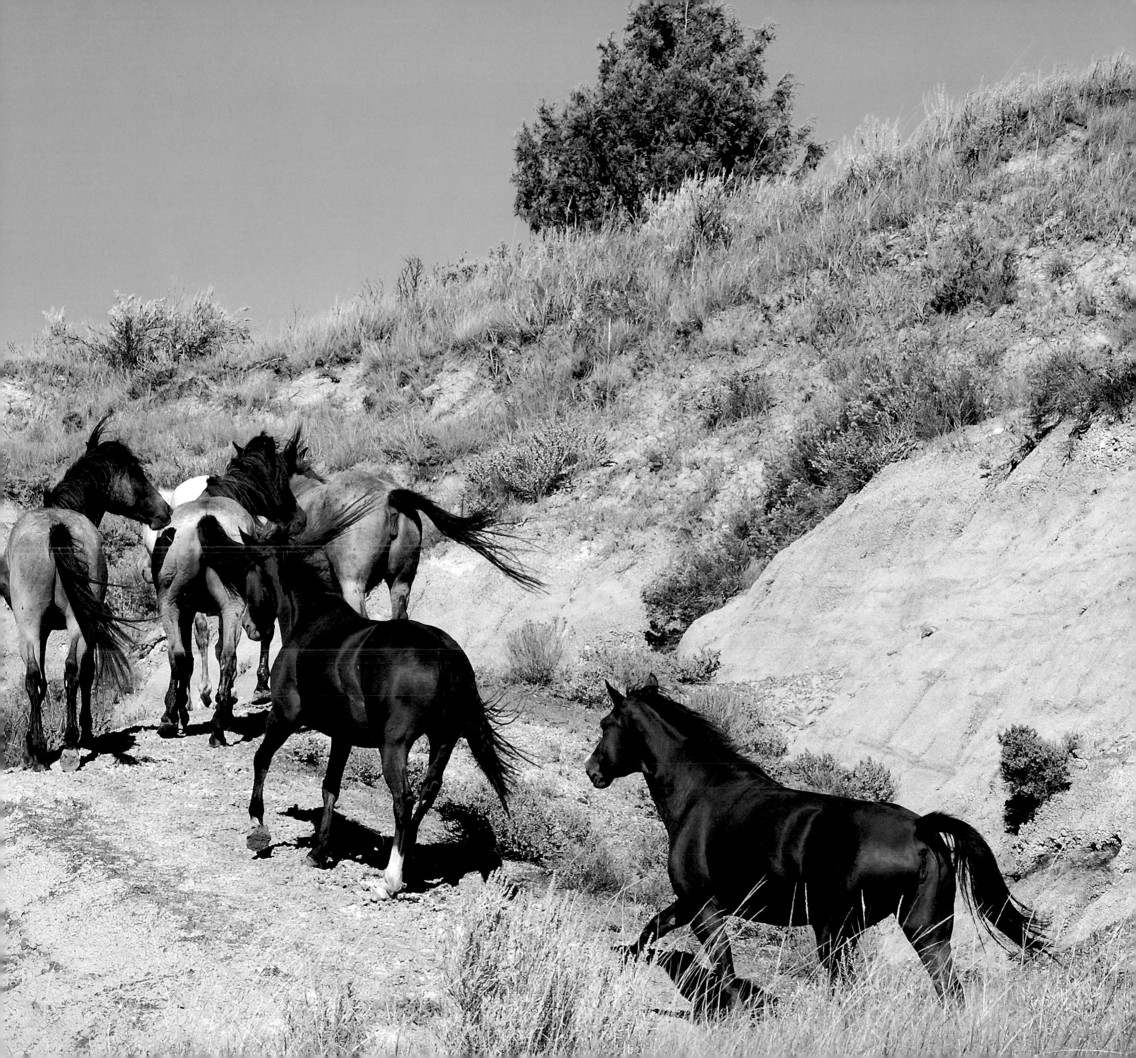

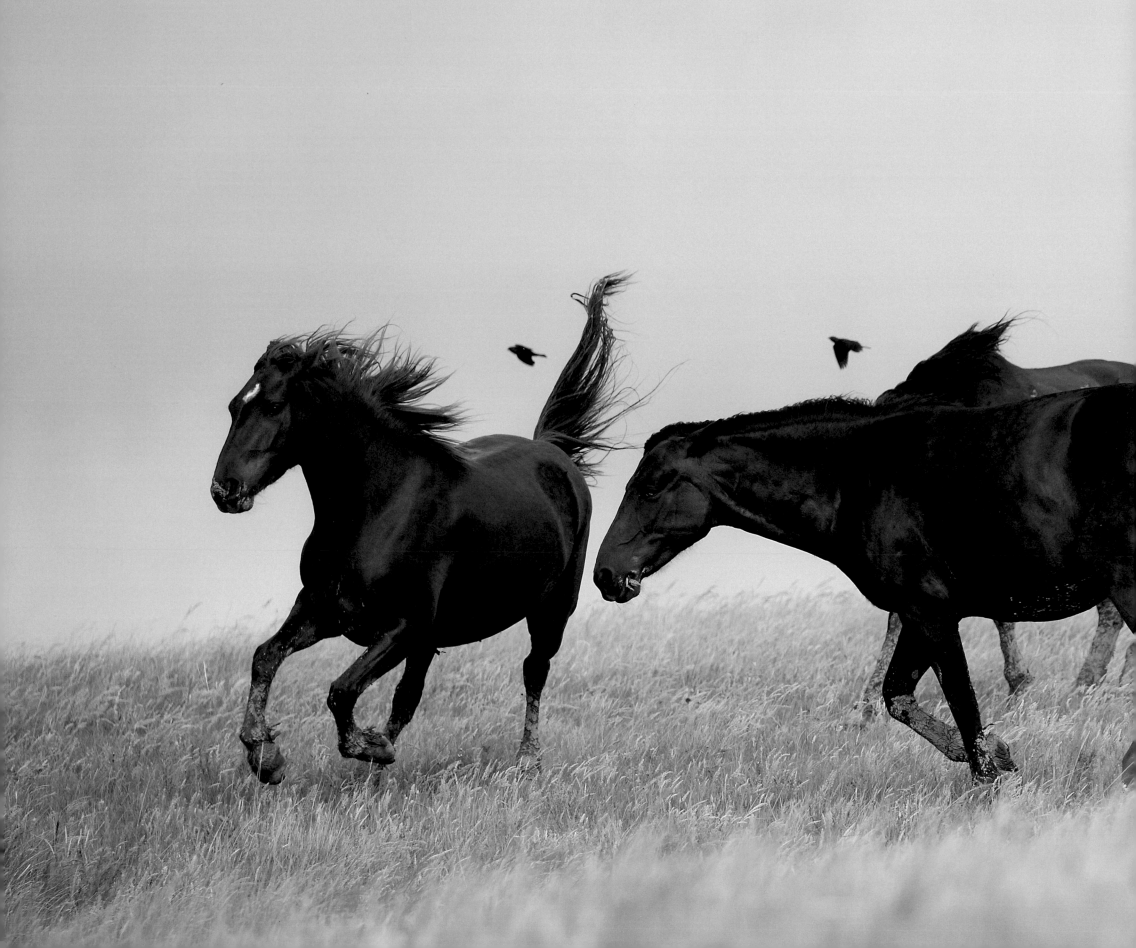

THE WILD HERD

A Vanishing American Treasure

DEBORAH KALAS

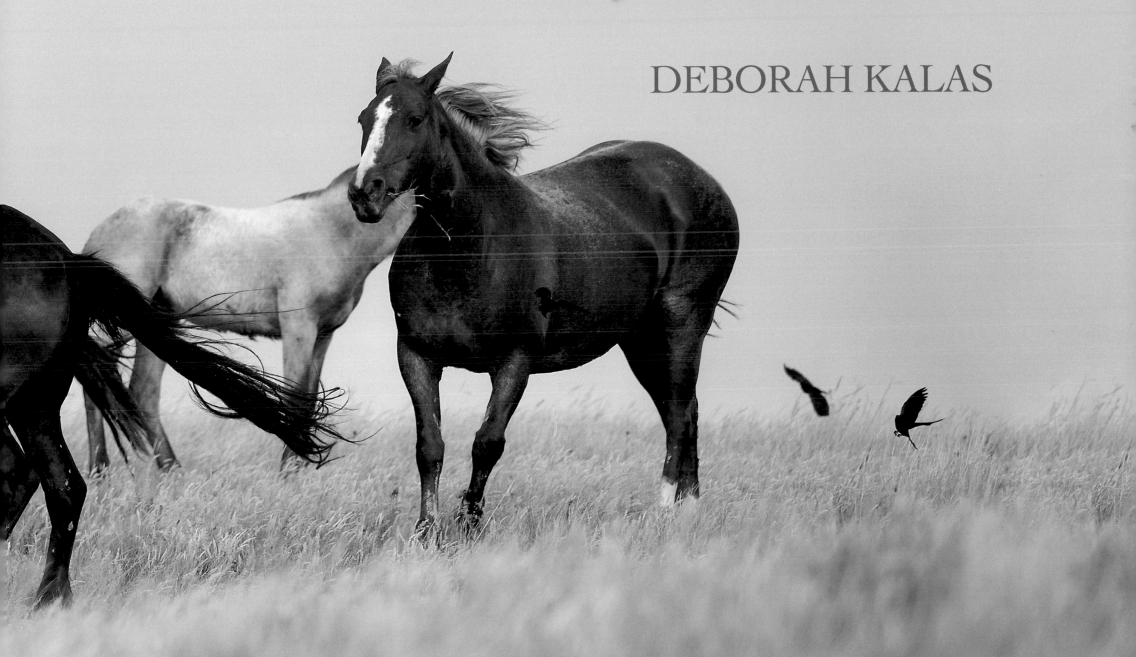

Val de Grâce Books
Napa, California

Websites: TheWildHerd.com, DebKalasHorsePhotographer.com

First Edition

Printed by Crash Paper through Artron Art Printing (HK) Ltd., China.

23 22 21 20 19 1 2 3 4 5

ISBN: 978-0-9976405-9-5

Library of Congress Control Number: 2019943483

Designed and produced by Terri Wright, terriwright.com

Cover artwork hand drawn by C.R. Liles

Horse drawings on vellum pages created by Jenna Bingham

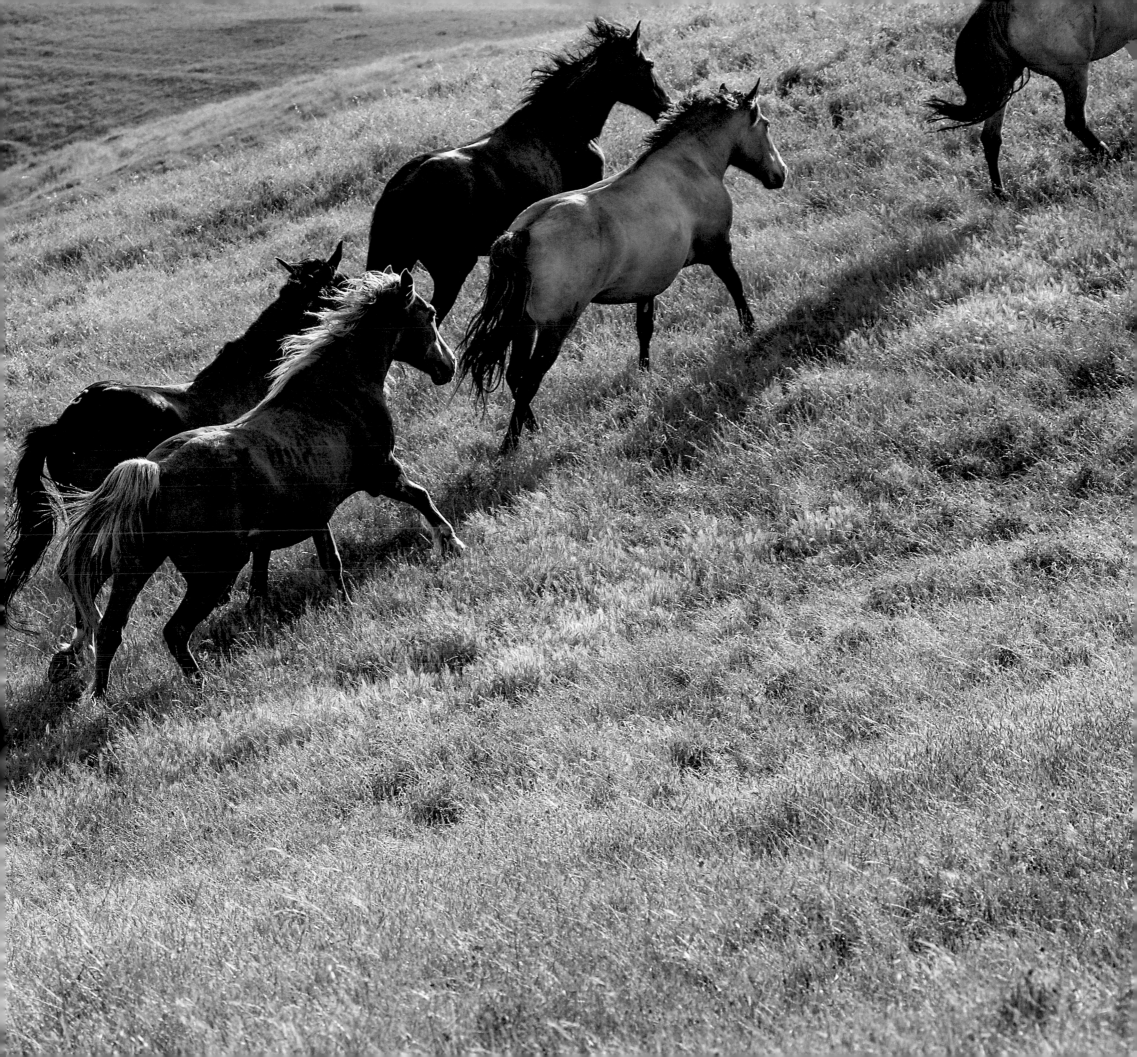

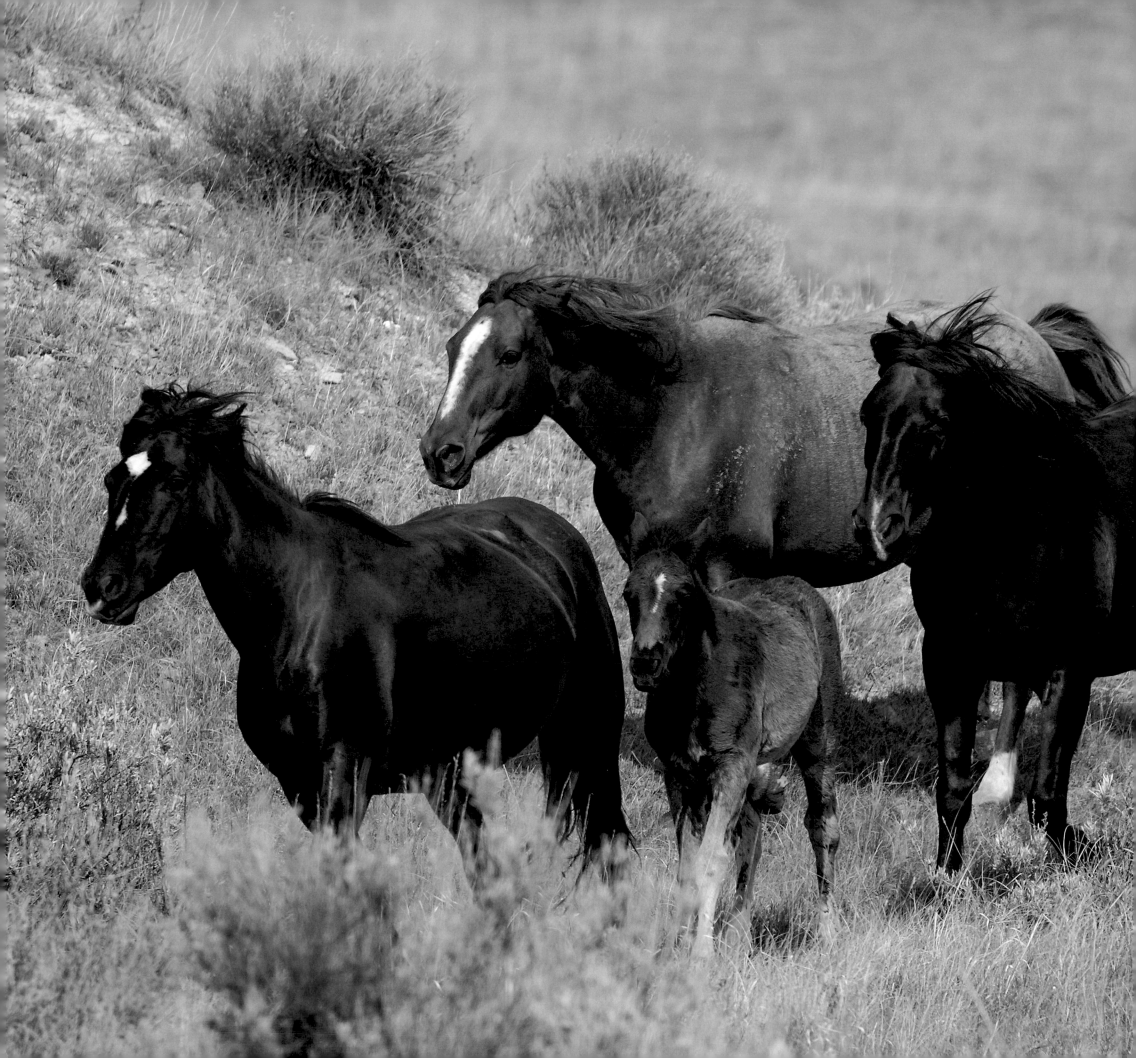

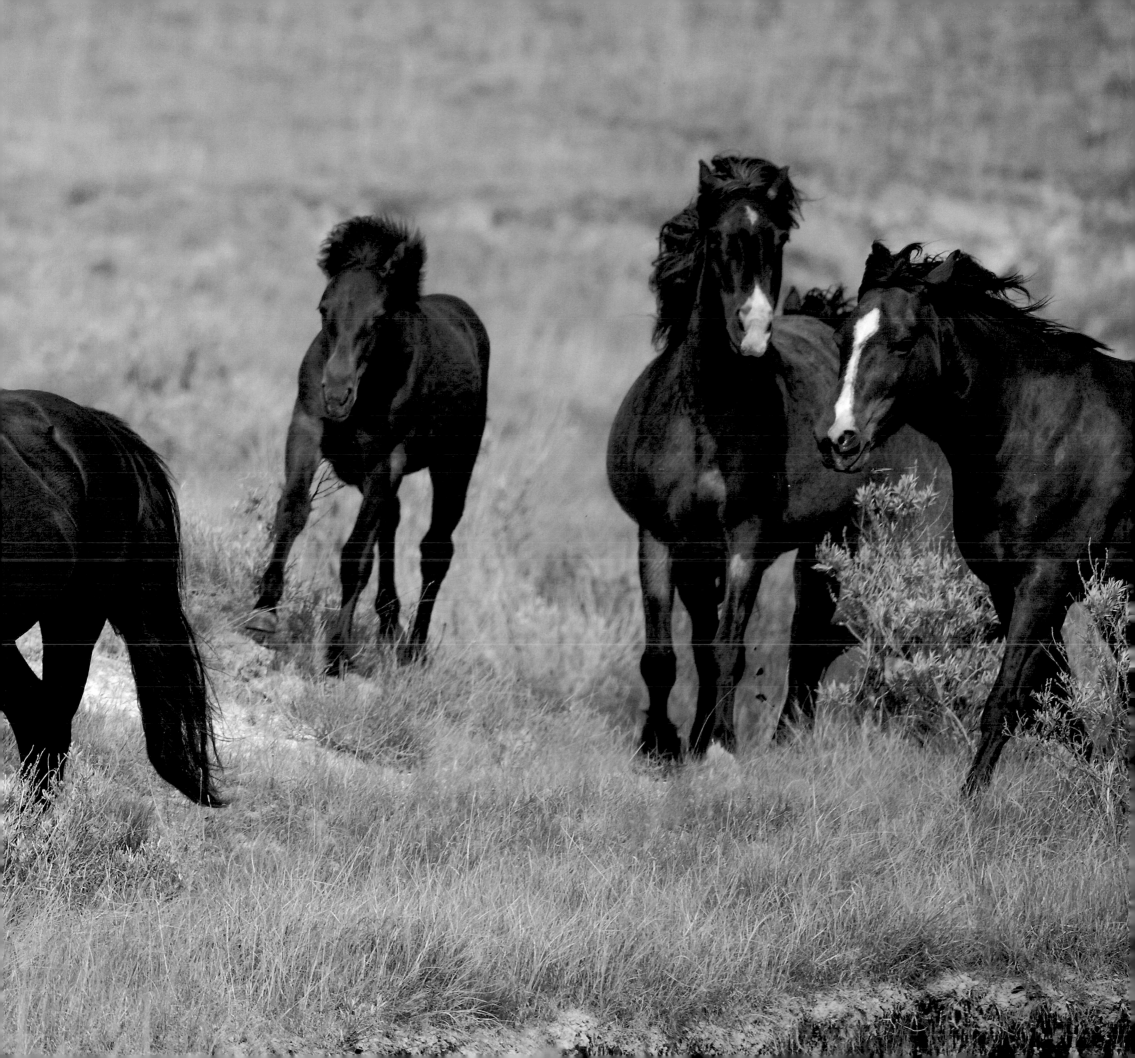

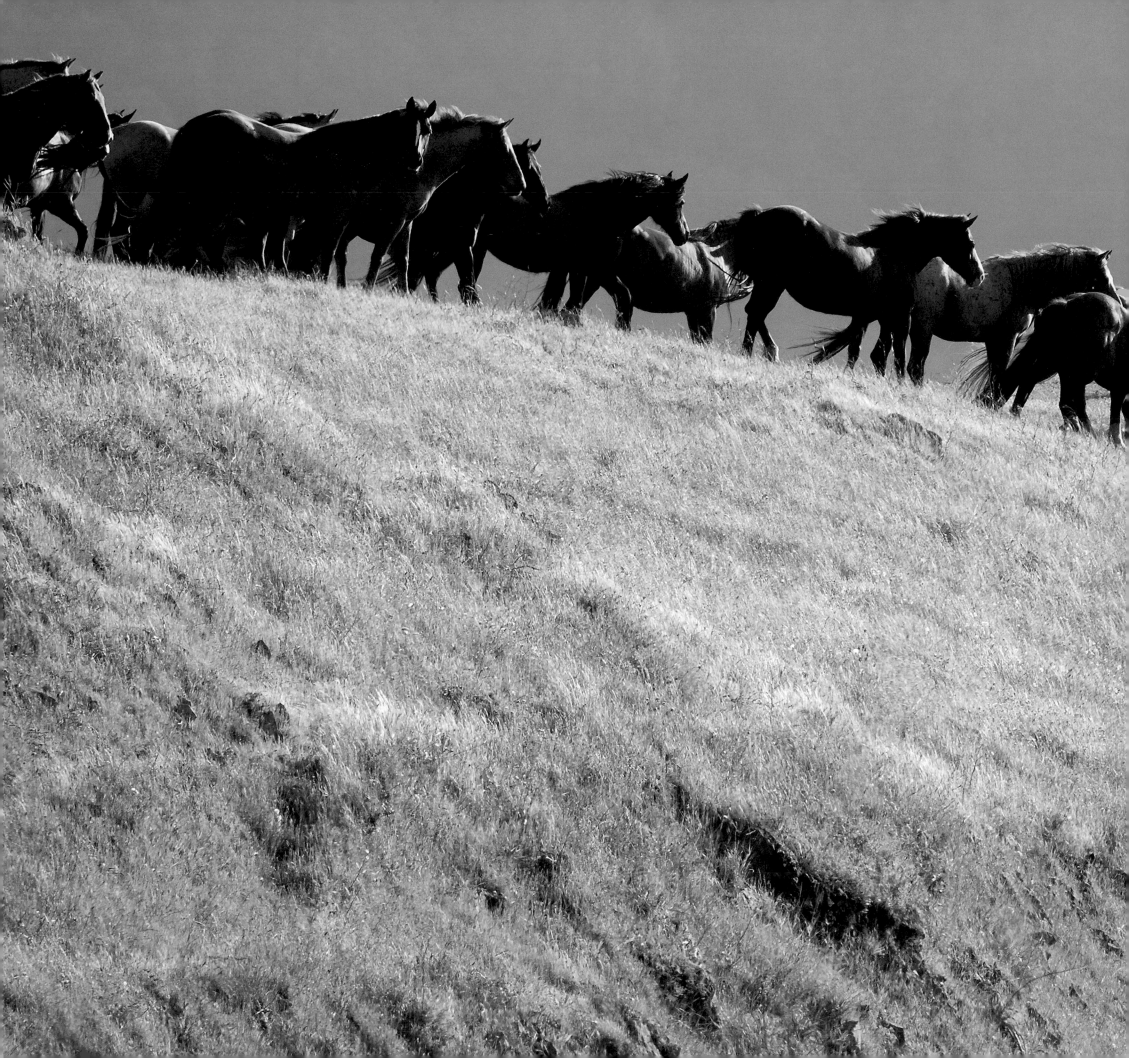

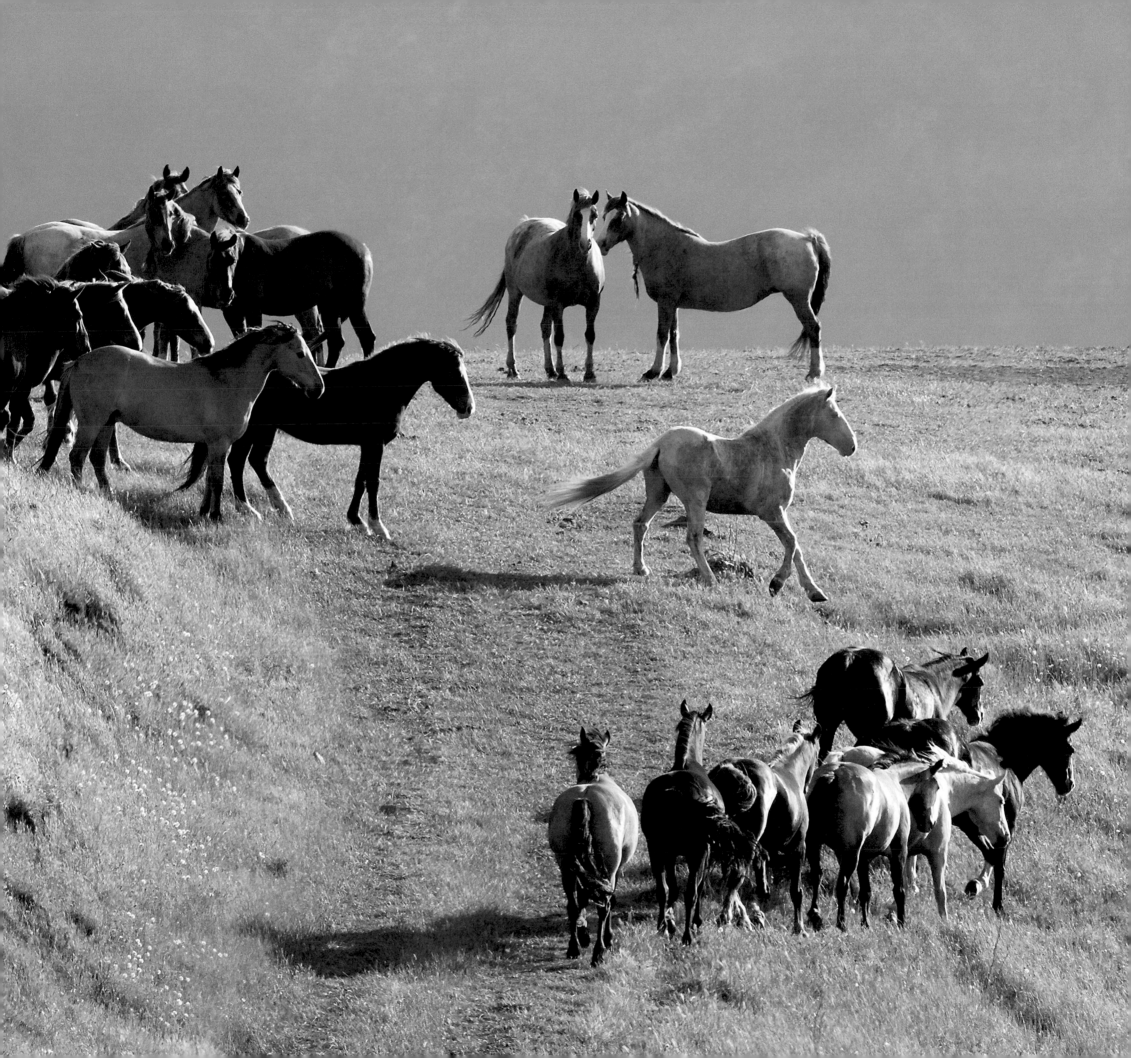

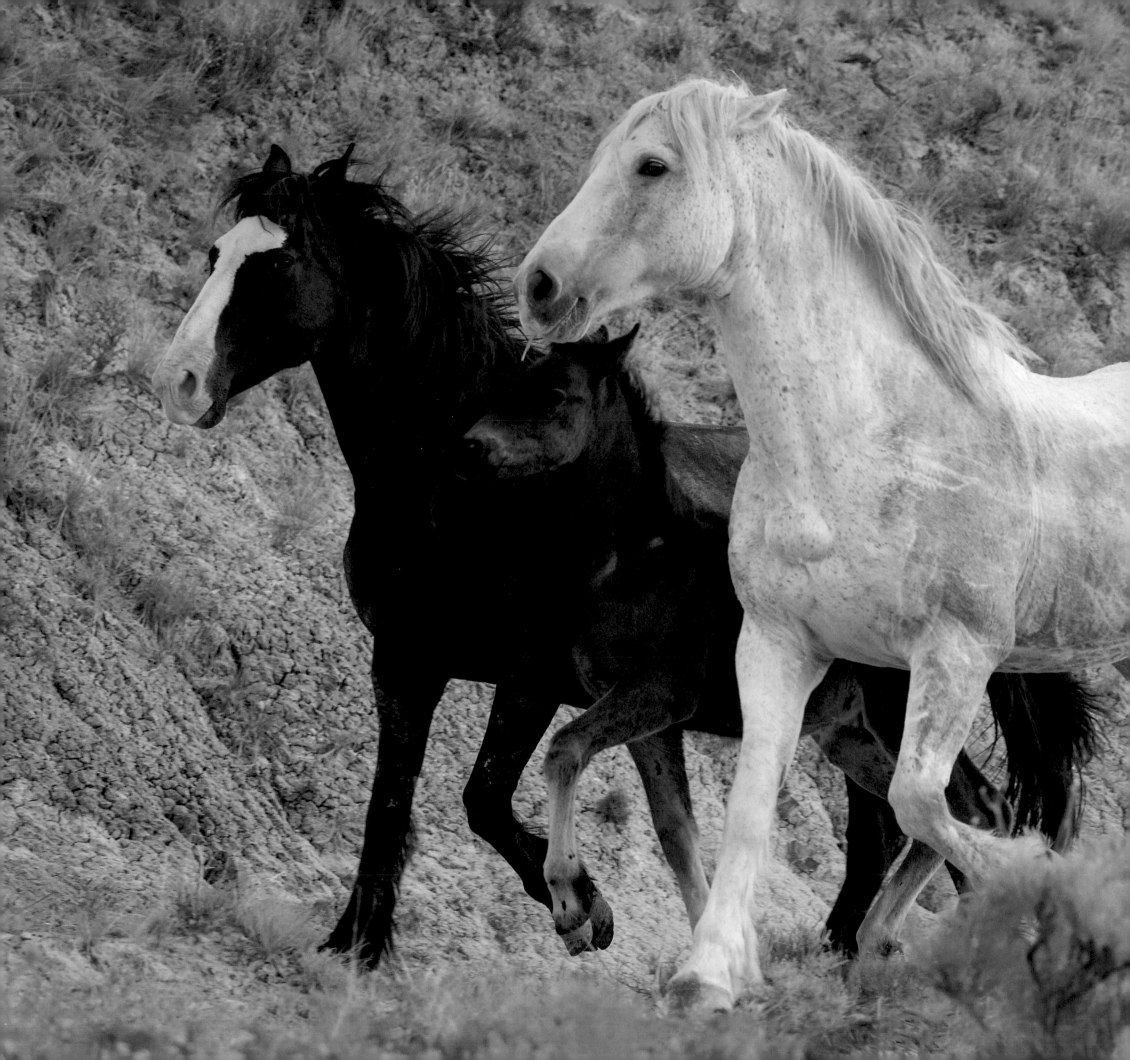

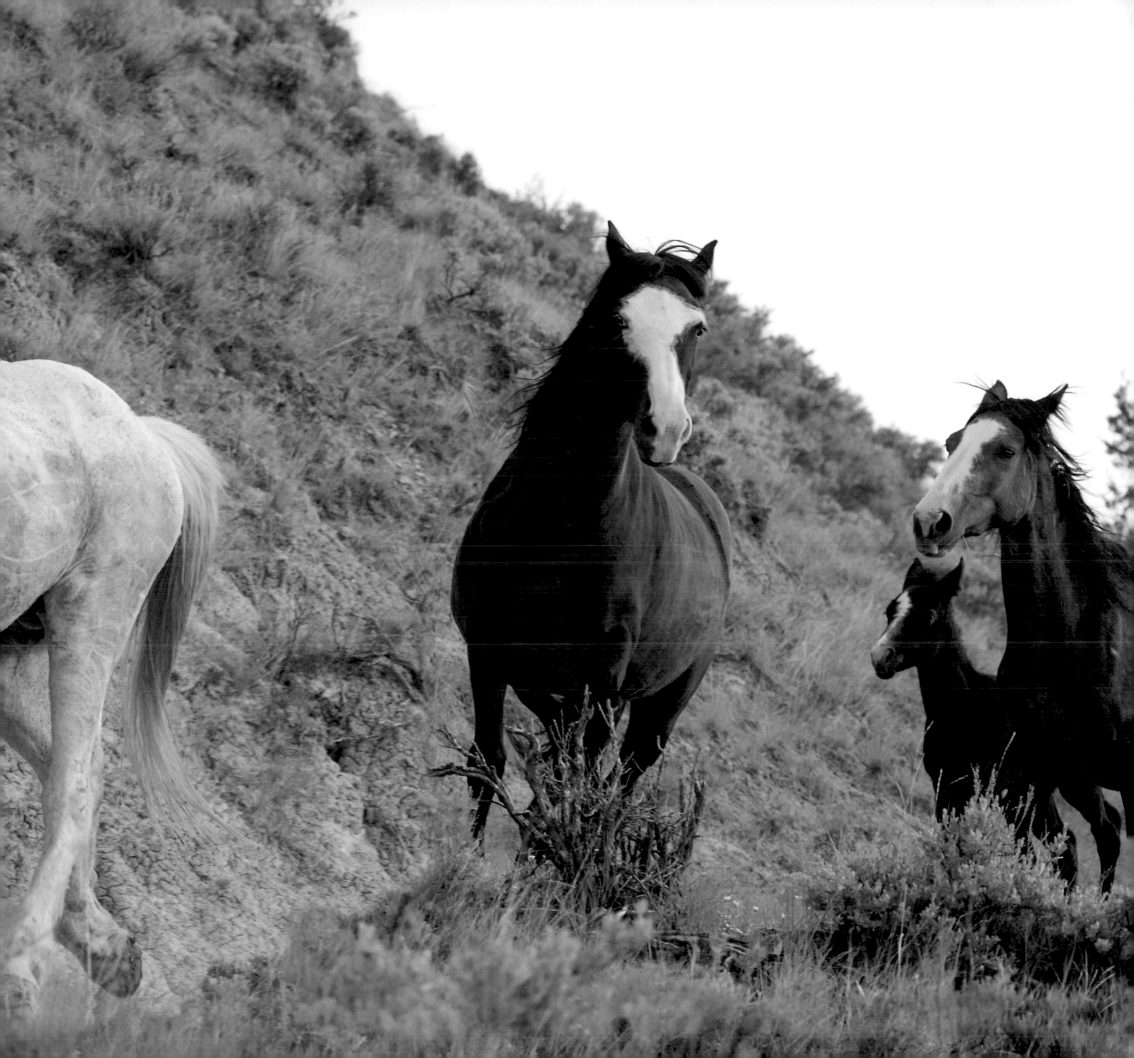

For my sons

Jan and Kristofer

And all of the ponies and horses

I have owned and loved, especially

Dakota, Adam, Alana, Frosty, Salt & Pepper

Contents

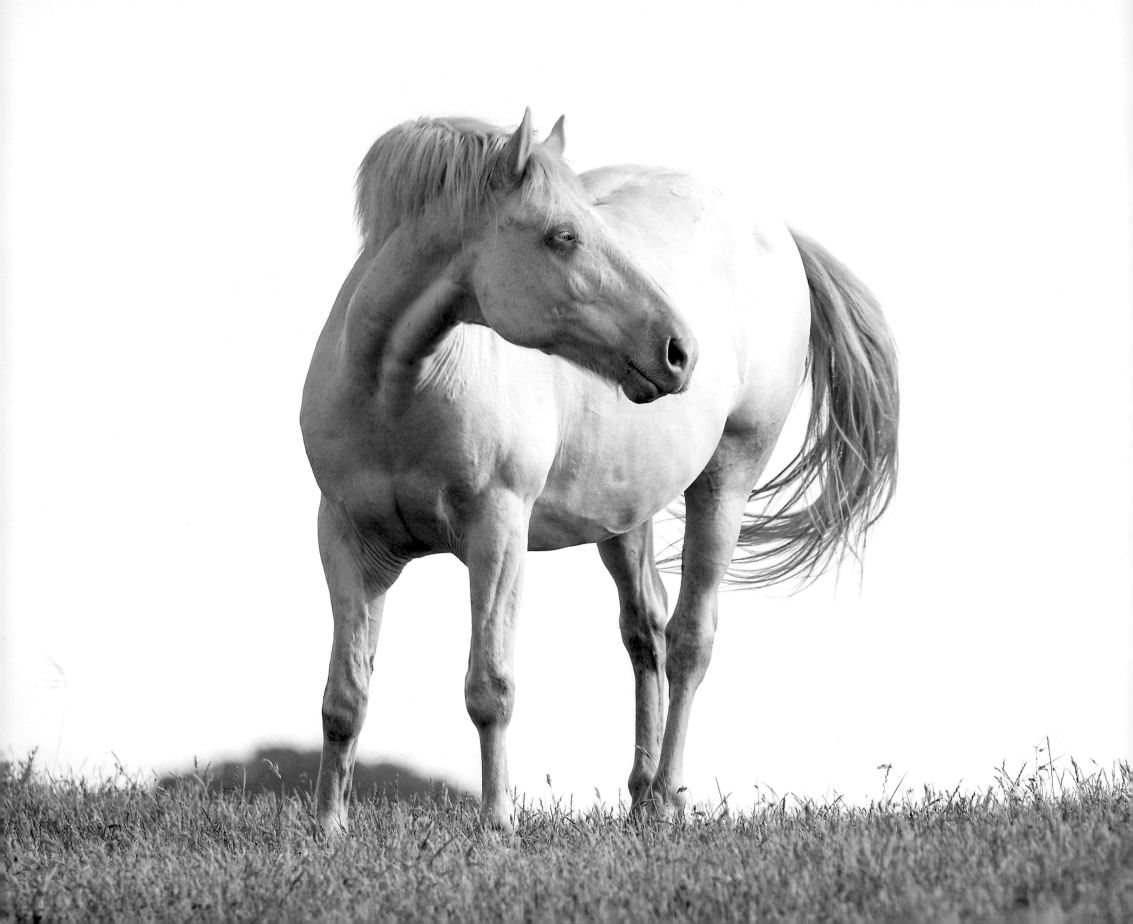

My Passion, My Mission

*W*hen I first began photographing wild horses, I knew very early on that I wanted to photograph the horses through the changing seasons, to show their character and their interactions through the changing weather and the changing colors and light.

I wanted to capture it all, even the life cycles of these magnificent animals: the tender newborns and their protective parents during the first buds of spring. The folly and growing rebelliousness of teens during the blazing heat of summer. The strength and swagger of maturing horses amidst the brilliant colors of fall. And even the resilience and dignity of the older horses in the crystal light and often brutal storms of winter.

Photographing in the wild requires great patience and readiness, but it's often the unexpected actions I find intensely rewarding. One day, as I sat atop a butte in Theodore Roosevelt National Park observing several bands of horses below me, a golden eagle soared up from below and hovered not far above me, floating in the breeze. It took my breath away.

Likewise, one afternoon while I was observing and photographing a band of horses a coyote walked right through the band and passed within twenty feet of me. He completely ignored the fact that I was there. An hour later, I turned around to leave and that coyote was still there, twenty feet away, searching for a prairie dog dinner.

I feel at peace in the wilderness among all these wild things. Open spaces, no fences, together amongst the wild horses I feel like an explorer, like photographer William Henry Jackson [1843–1942] first witnessing the American West through the lens of his view camera.

I was born loving horses. The same excitement I had as a three-year-old seeing any horse, I still feel that today. When I am photographing them, I always need to temper my excitement and remember to breathe, frame and shoot calmly in spite of what action may be exploding in front of me.

Growing up in a volatile family, I became a trained observer of the nuances of human expression and interaction and that carried over to horses. I was blessed to have my first pony

1

when I was six. Sixty years later I am still riding my horse six days a week and I love every minute of it. Having worked with horses through the years, translating wild horse behavior came easy for me. Observing the bands of wild horses, I could see the family unit played out in all its variations:

- A proud sire protective of his band. Meeting the challenges of any intruders with arched neck, nostrils flaring, a show of muscle and might meeting any stallions wanting to hijack his mares.

- A protective mamma tending to her newborn, nuzzling and licking it.

- A crabby aunt nipping at a foal to watch its boundaries.

- Sibling colts and fillies playing with each other. Games of running, leaping and bucking.

What really helps me is being able to anticipate the actions of the bands and their members. When a lone bachelor appears on the horizon, a battle is imminent. A sleeping foal wakes up and will nurse right away. A mare will stray too close to another band stallion and action may come swiftly from her stallion, unless he is letting her flirt, which they do sometimes. If there are two or more foals in a band, eventually they will play with each other. All this is in their nature.

My constant challenge is finding the delicate balance between a documentary photograph and one that goes beyond documentary to have meaning about all life and all time.

In the footsteps of Henri Cartier-Bresson and his search for "the decisive moment," I knew that I had to understand band behavior in order to anticipate where to be, when the action might occur, and how to use light, darkness, and composition to make a compelling statement about what I am witnessing.

Through these pages I hope to honor wild horses everywhere and underscore their right to remain wild and free, just as they have for centuries. I hope too that by seeing the beauty of these wild horses, and understanding their behavior, readers will feel moved to act on their behalf, protecting them as we would our own families, and treasuring them as a vital part of our American heritage.

Deborah Kalas

"Live each season as it passes; breathe the air,
drink the drink, taste the fruit, and resign yourself
to the influences of each."

— *Henry David Thoreau*

The Circle of Life

Stallion, mare, and foal
In cycle of seasons dwell,
Growing, young and old.

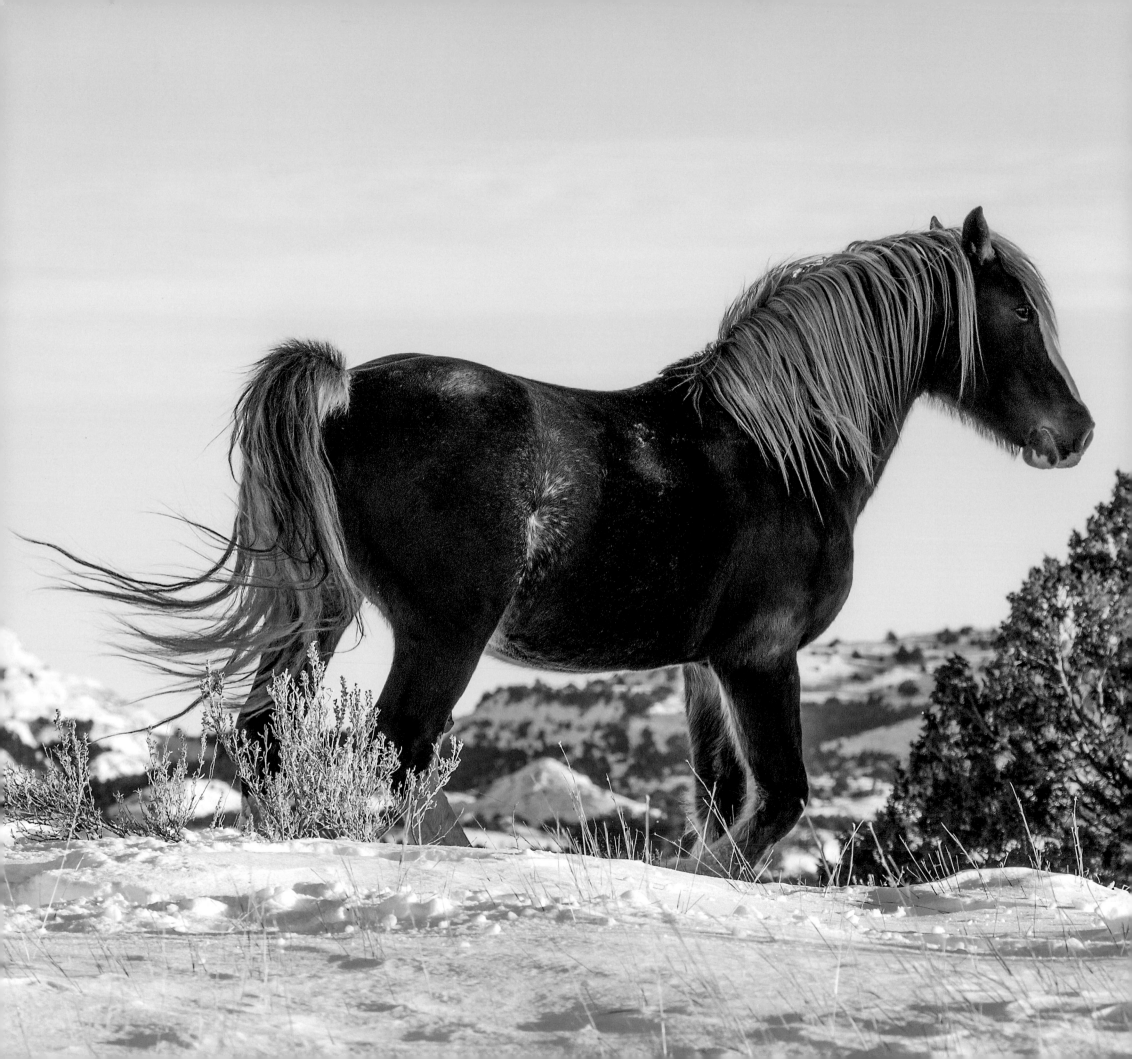

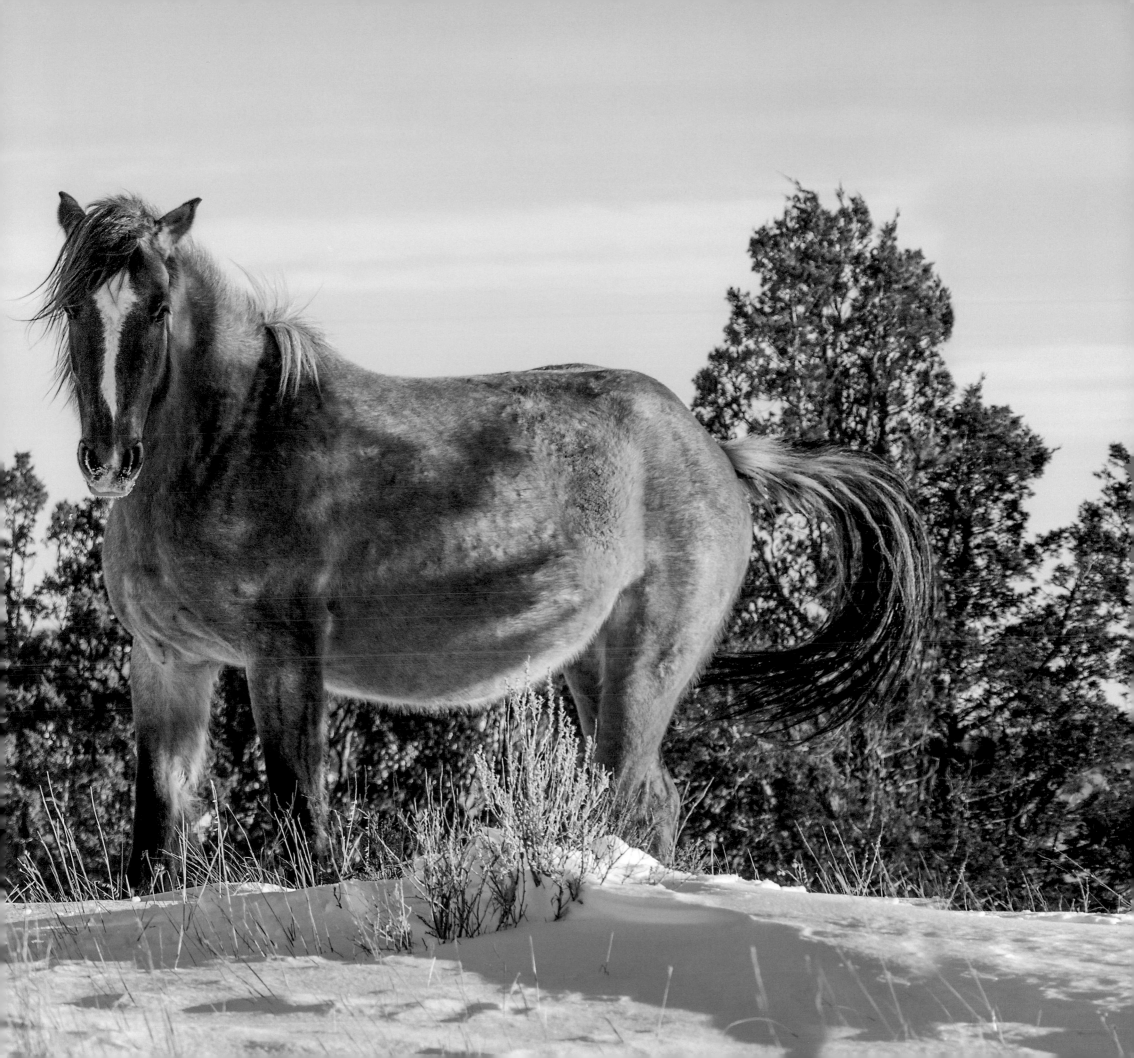

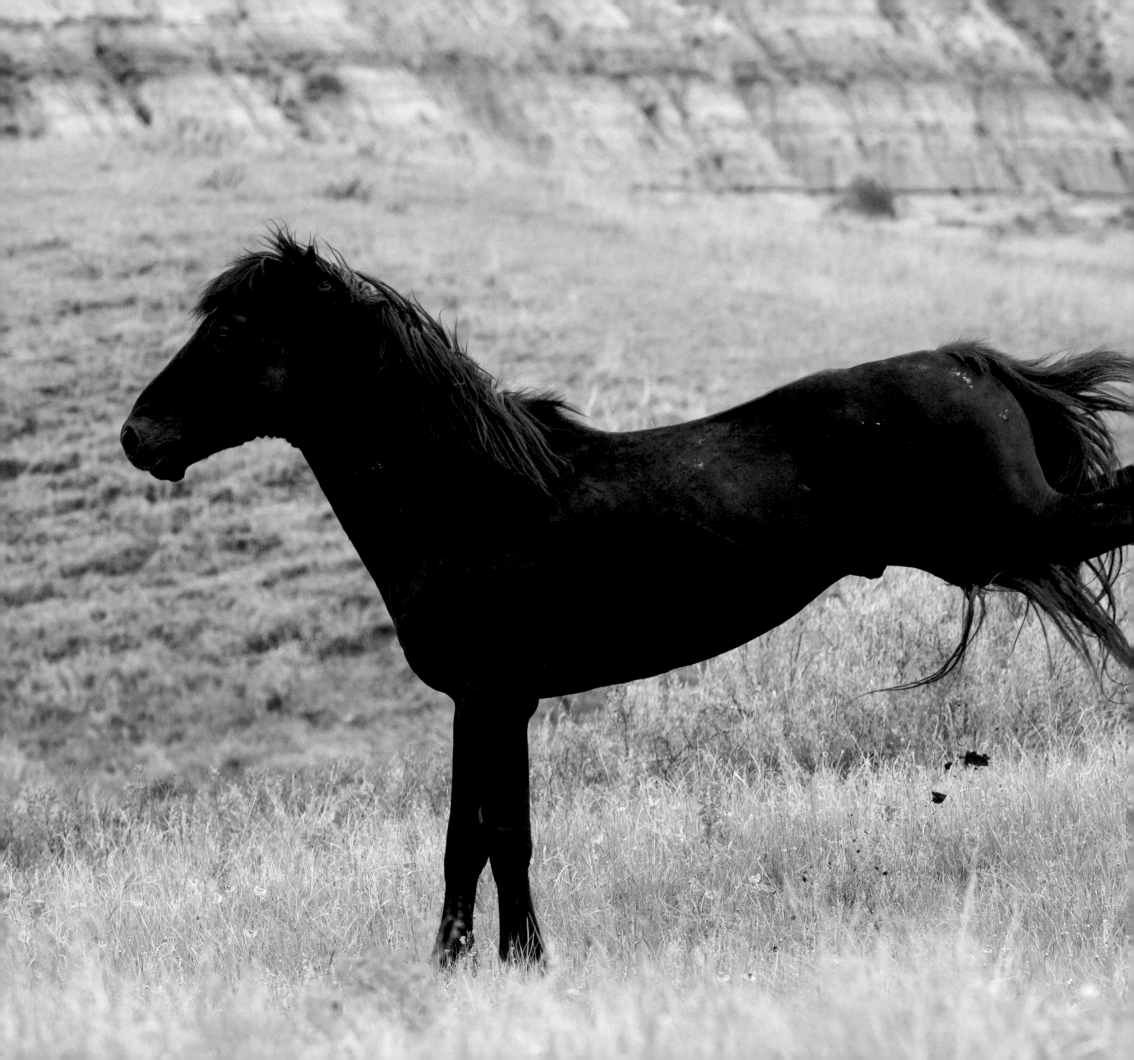

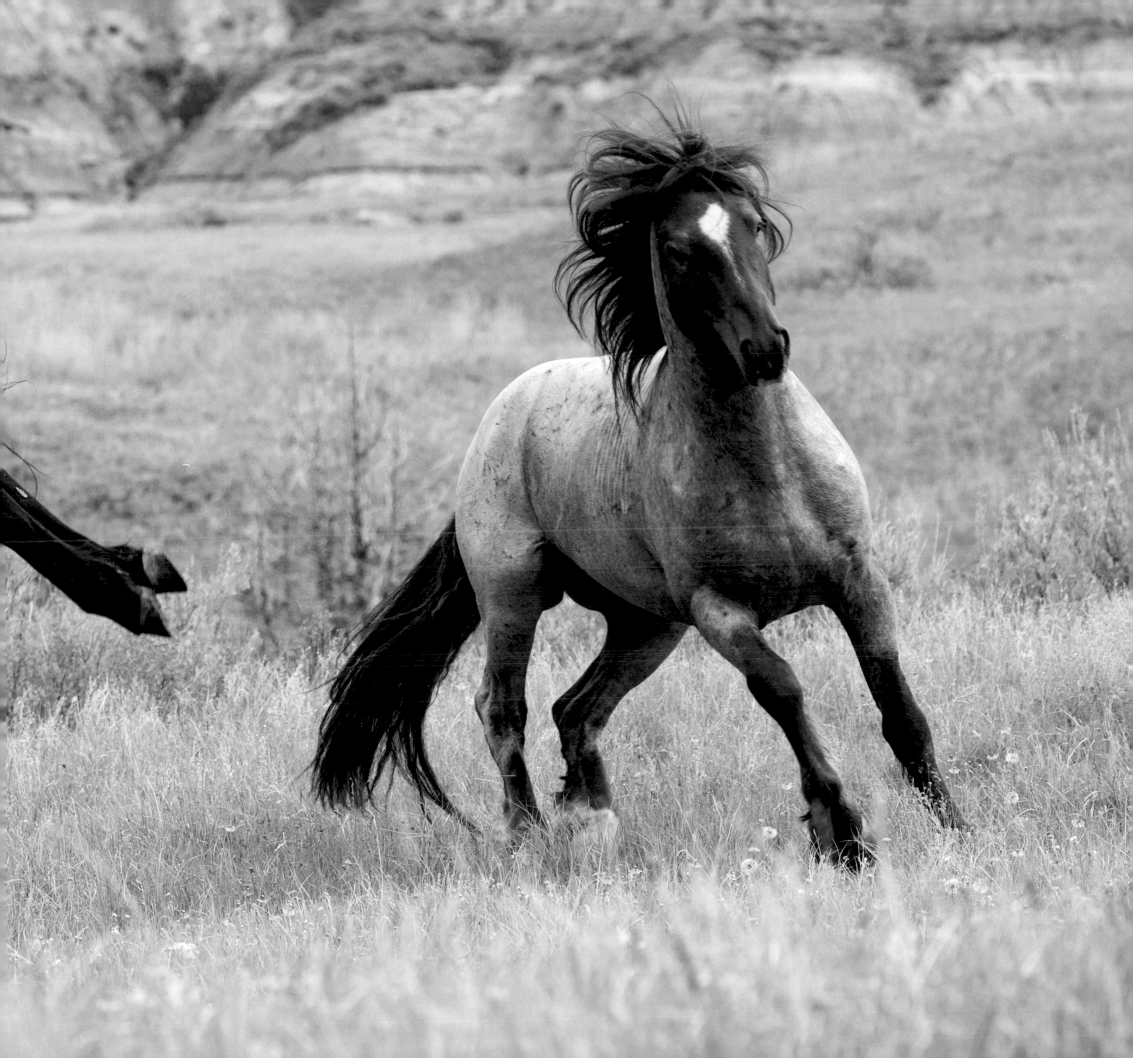

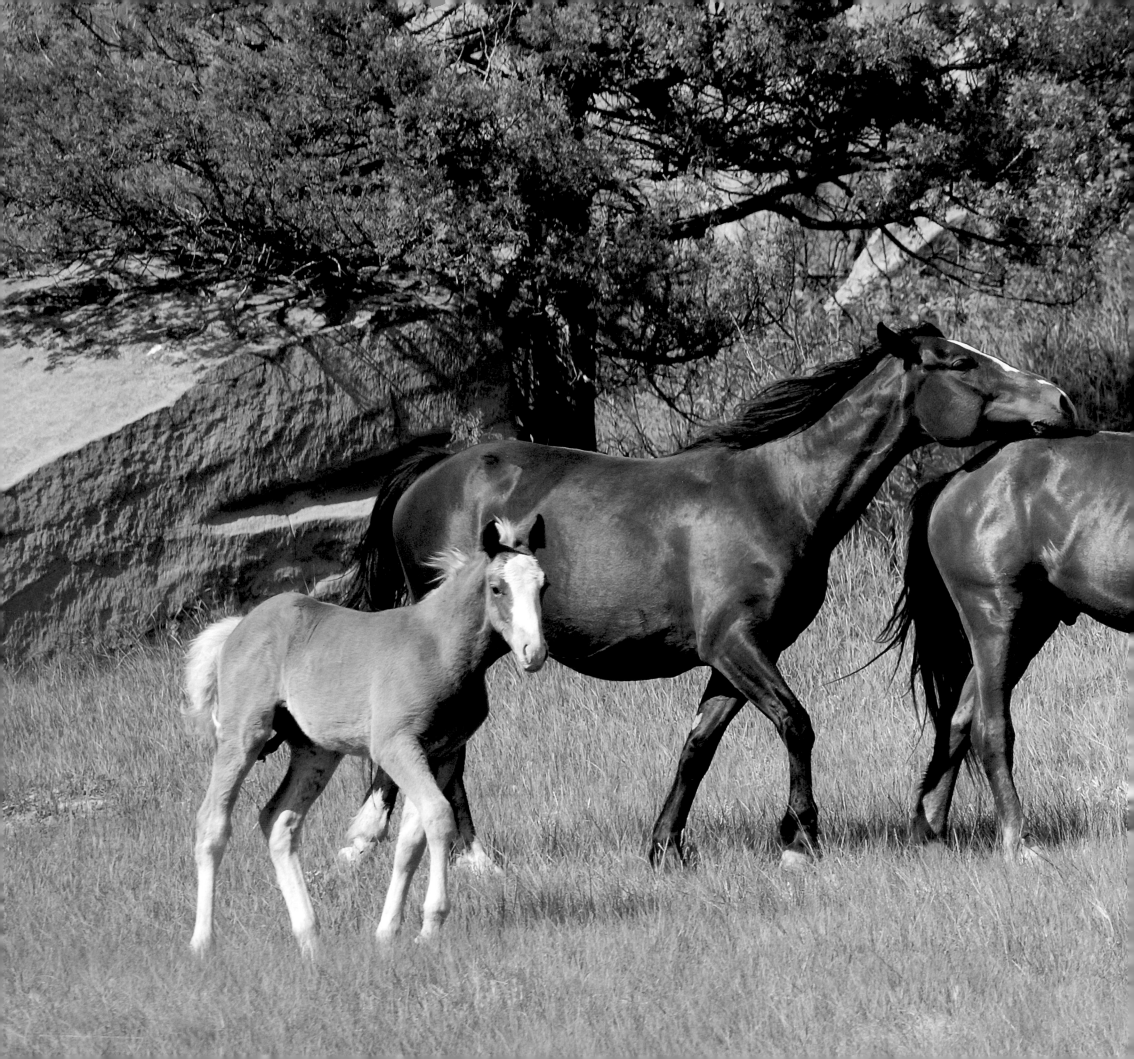

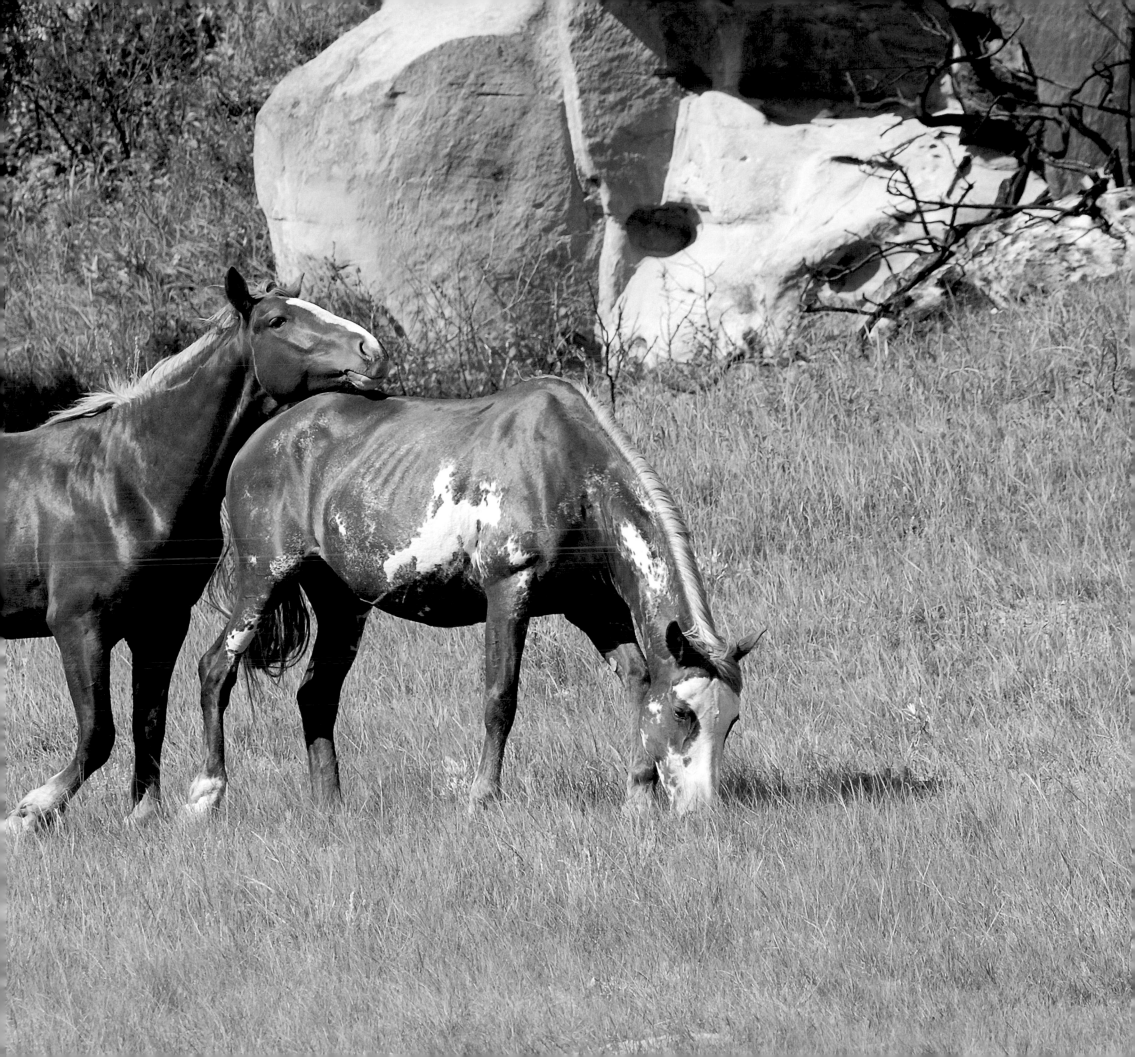

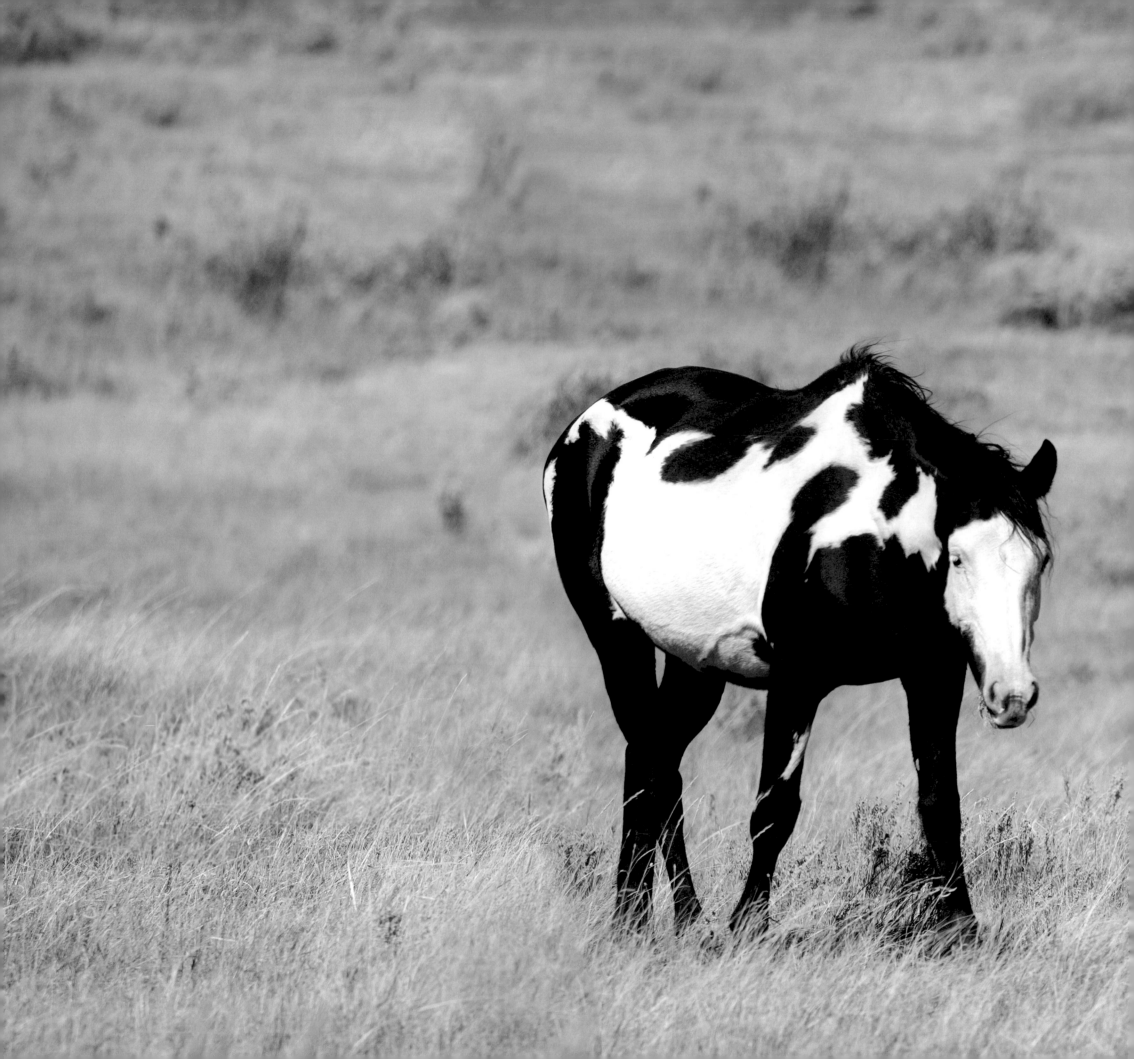

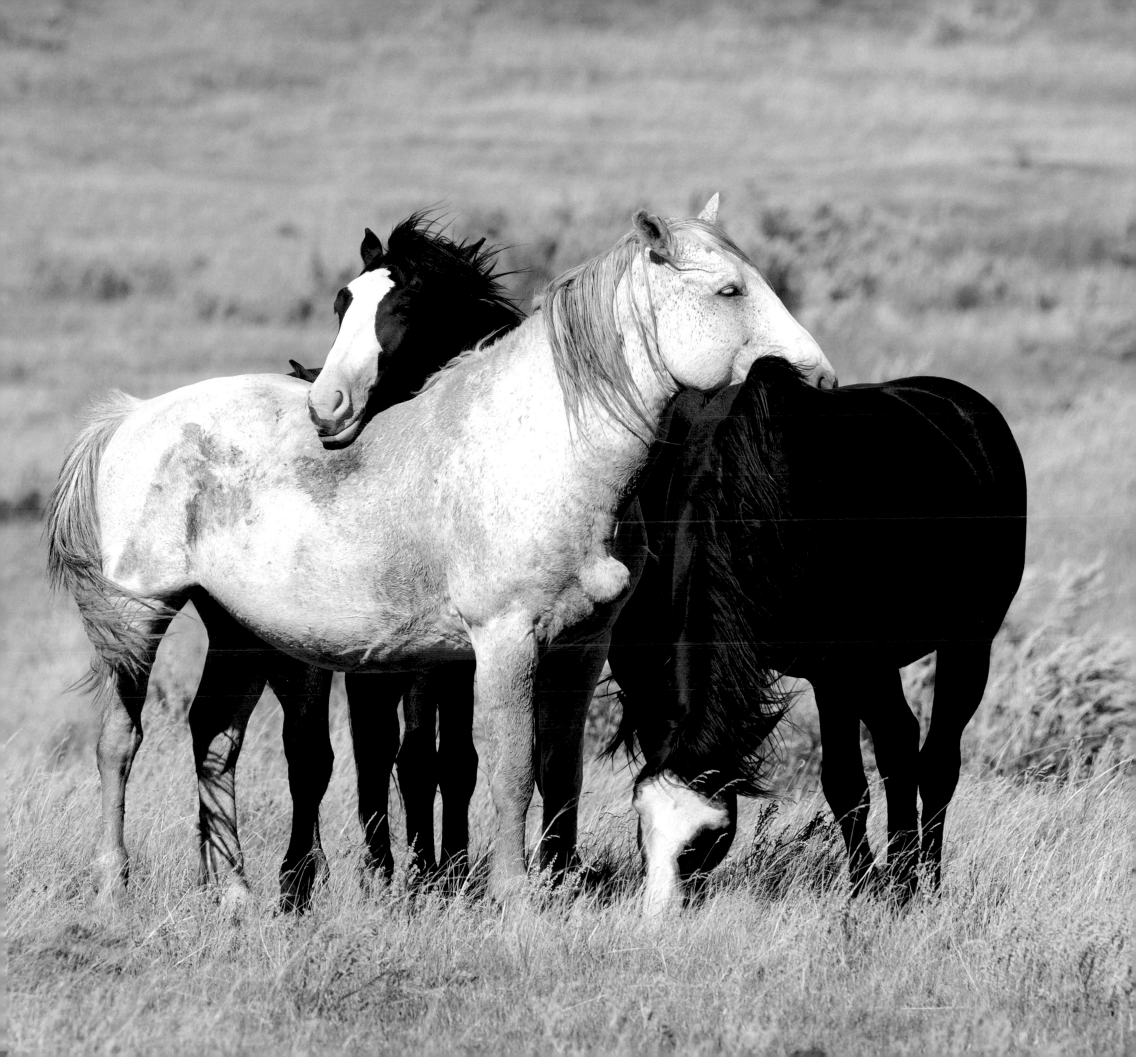

Wild herds move in groups known as "bands," and at the Theodore Roosevelt National Park I have come to know many of the horses by the names I am using here.

In this photo, the mare known as Mist has left Sidekick's band to flirt with the band stallion known as Thunder.

It happens occasionally that a band stallion will allow a daughter to flirt or even mate with another stallion and then return to her original band. Thunder and mare Mist had a few words together. Thunder proudly arched his neck and pranced in anticipation until Sidekick swooped in and pushed Mist back to his band. Some of Thunder's mares watched what was happening. The colt lying down sensed the action and sat up. His mother was standing close by. A few minutes later all was quiet, the drama had ended.

For the most part, many bands of stallions can often be found grazing in close proximity to each other. Scenes like this fill their days with both unexpected challenges and the pure contentment of living wild and free. ❧

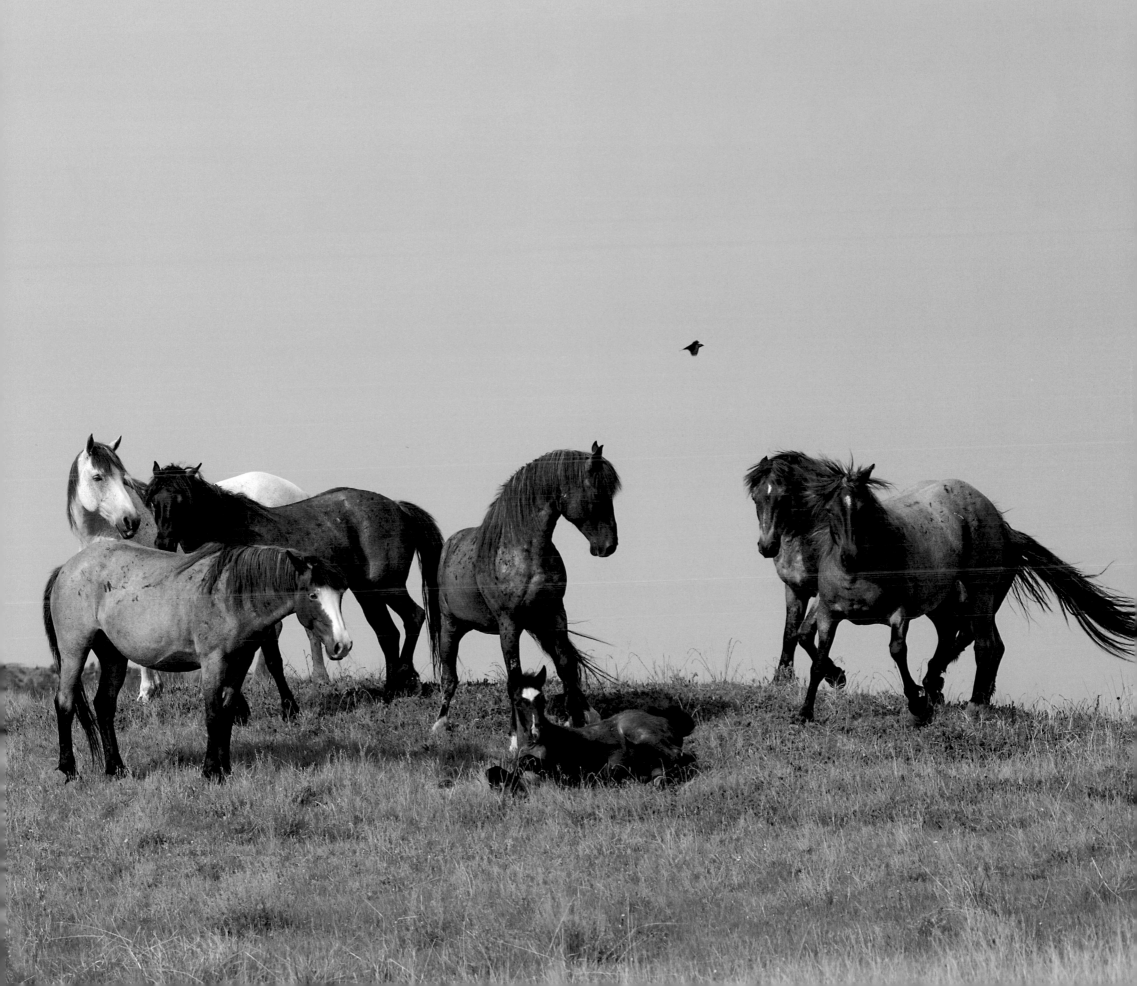

Winter

Horses eating snow,
Searching food, enduring cold;
Harsh winter landscape.

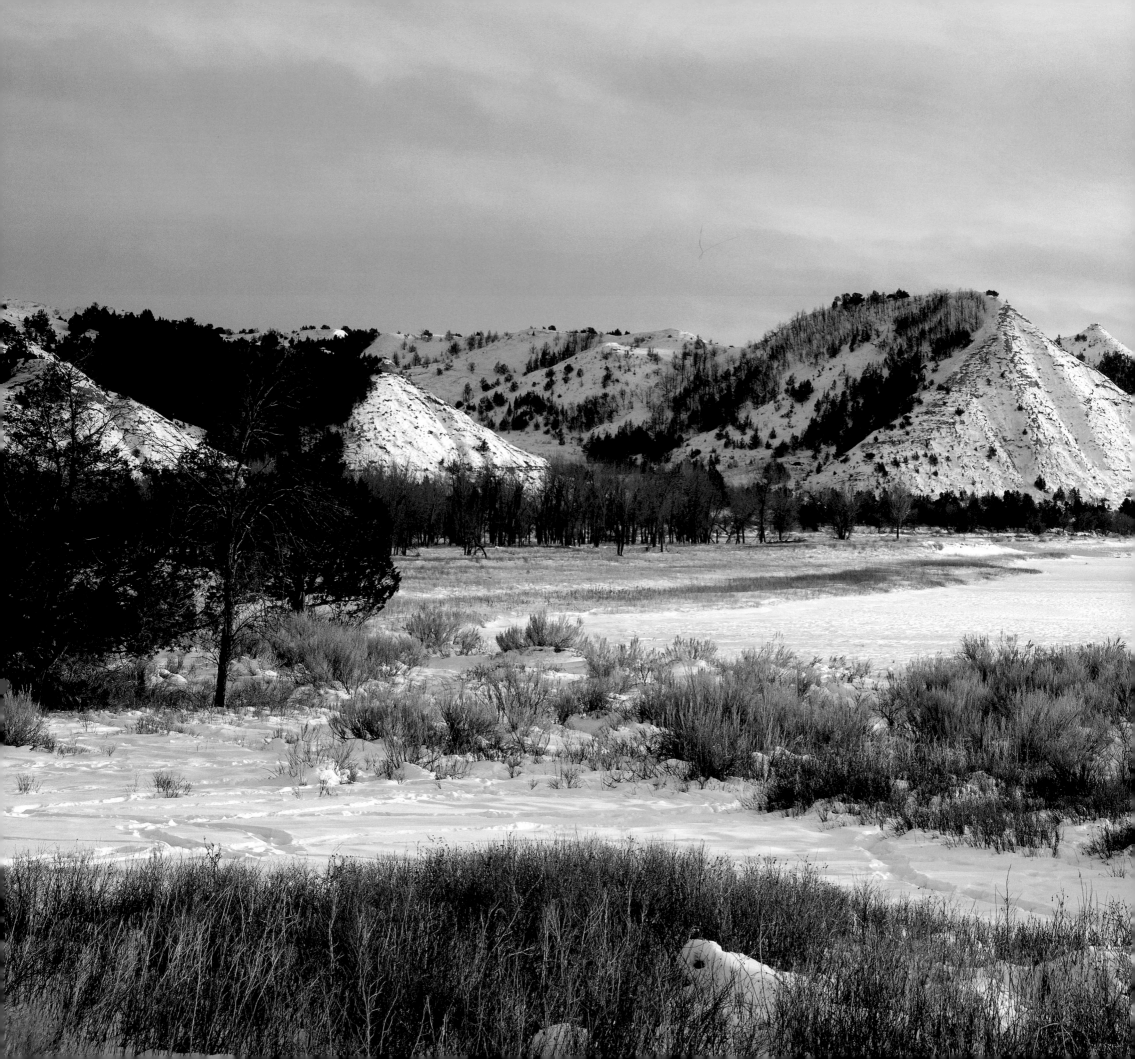

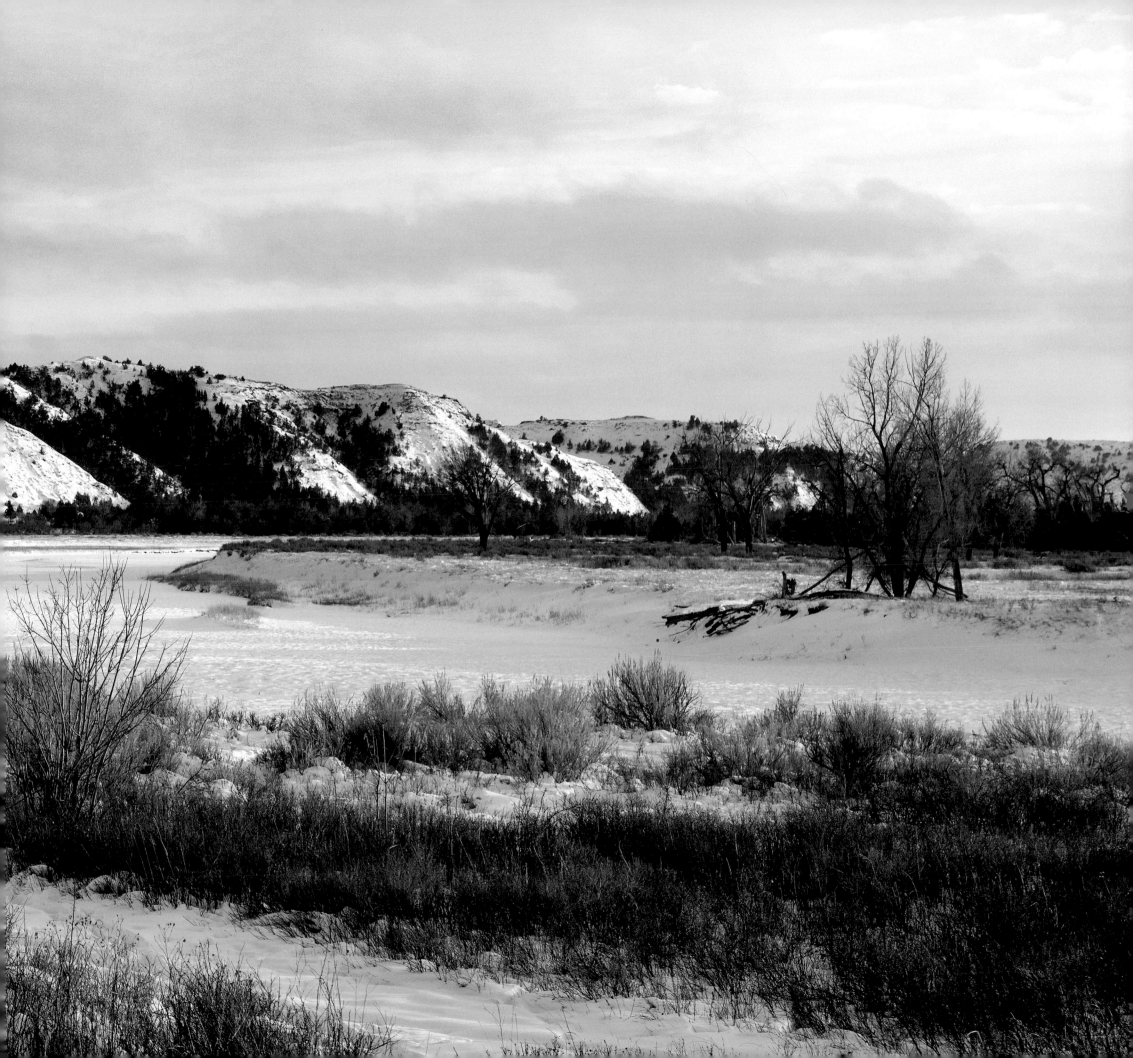

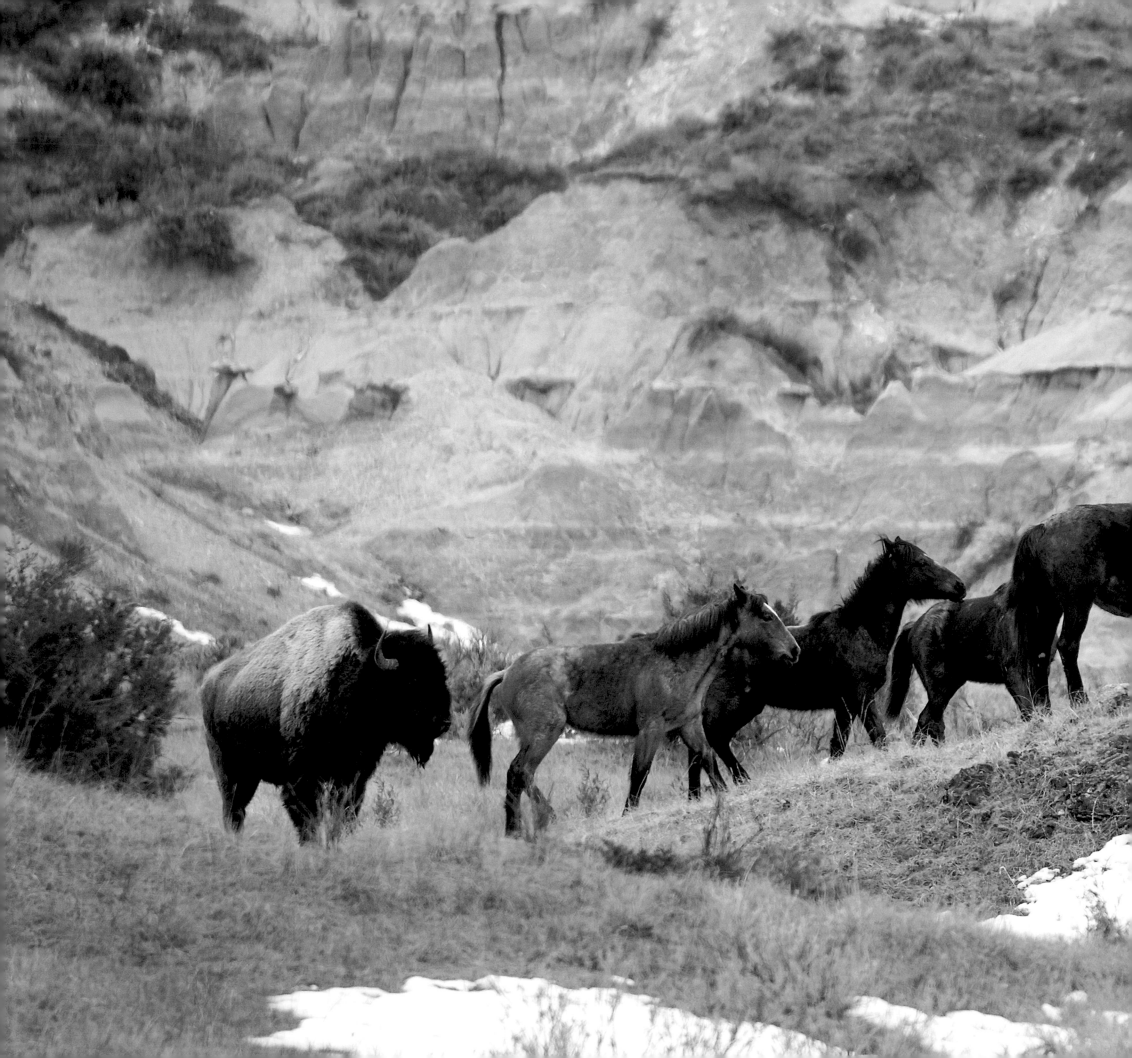

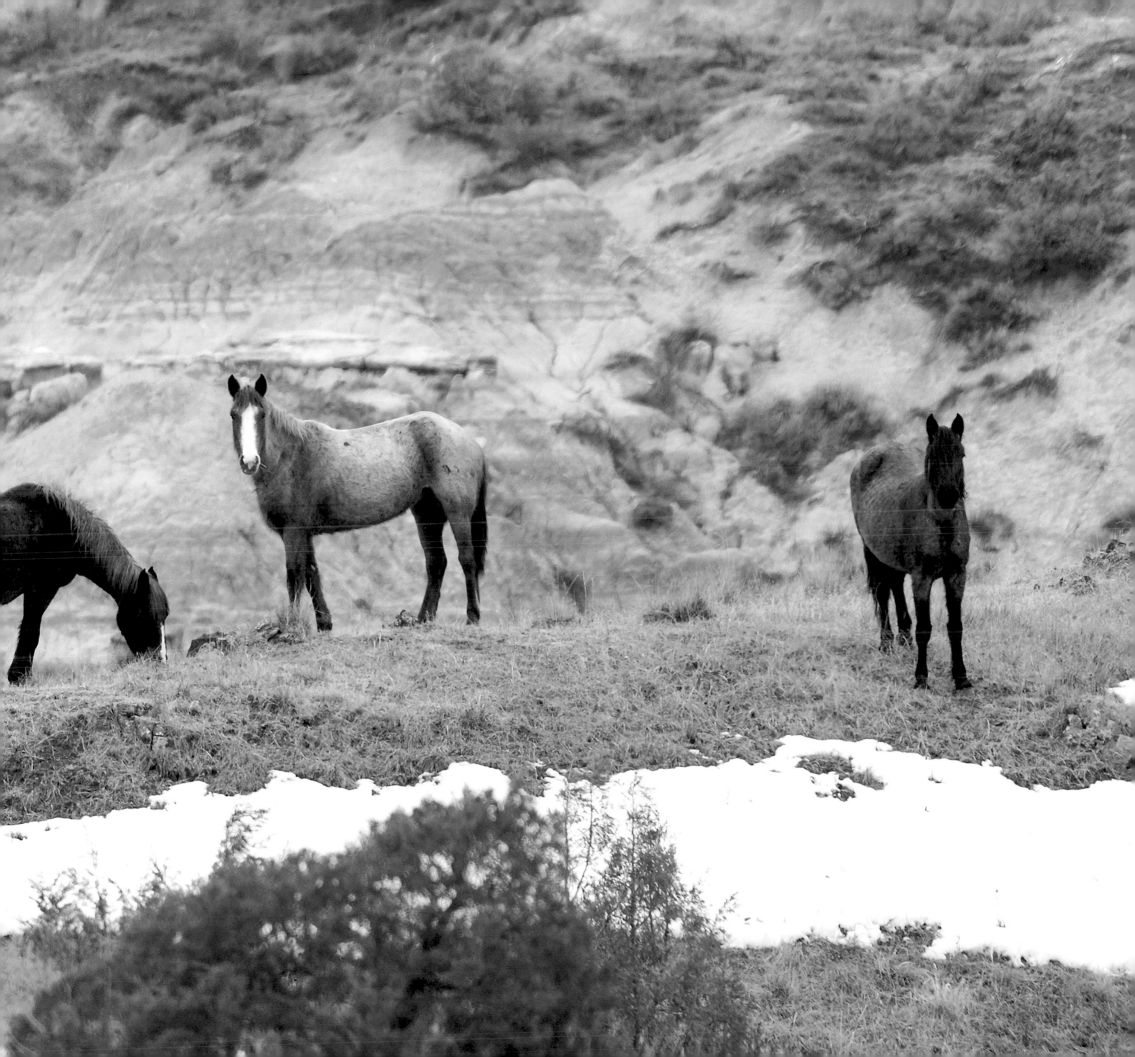

Band stallion Cloud had lost some weight during a bout of freezing windy nights and here he is digging in the snow.

What struck me most about all the wild horses I found in deep snow conditions was how hard they had to work to get any food. If they weren't pawing and struggling they weren't going to eat…

Bounding elk or fifty running bison could set the whole band into a tizzy, often sending them galloping from place to place, even in chest-high snow. For a filly born in early February, it could mean leaping exhaustedly through the snow to keep up.

Furry coats add a layer of warmth in the freezing temperatures. Friendships prevail. Stallions continue to flirt with their mares. Newborns huddle beneath their mothers' tails, between their legs, keeping as warm as possible. In spite of that, sometimes an ear tip is still lost to frostbite.

Here, springtime was right around the corner and already bison and birds are living side-by-side with the horses.

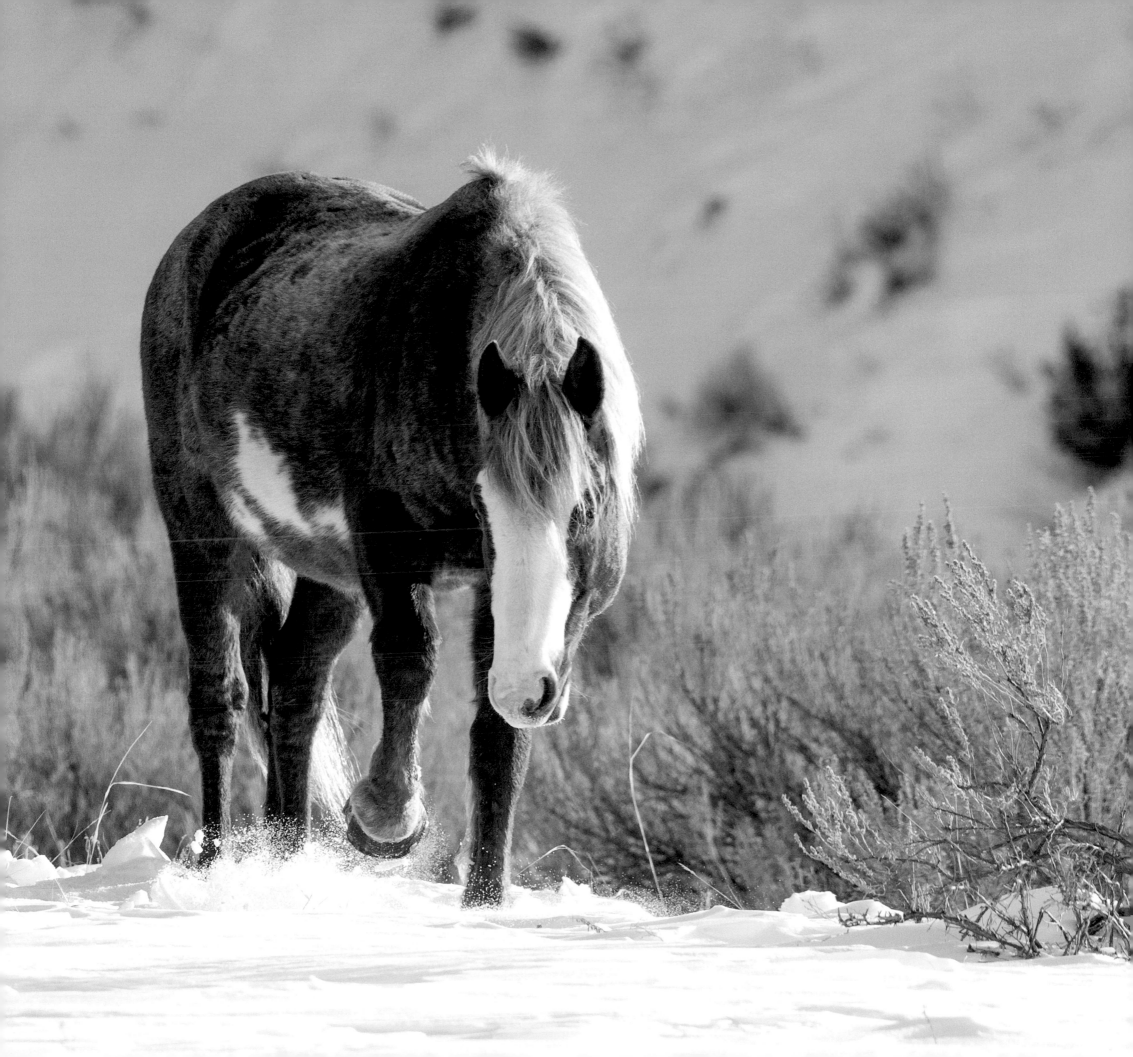

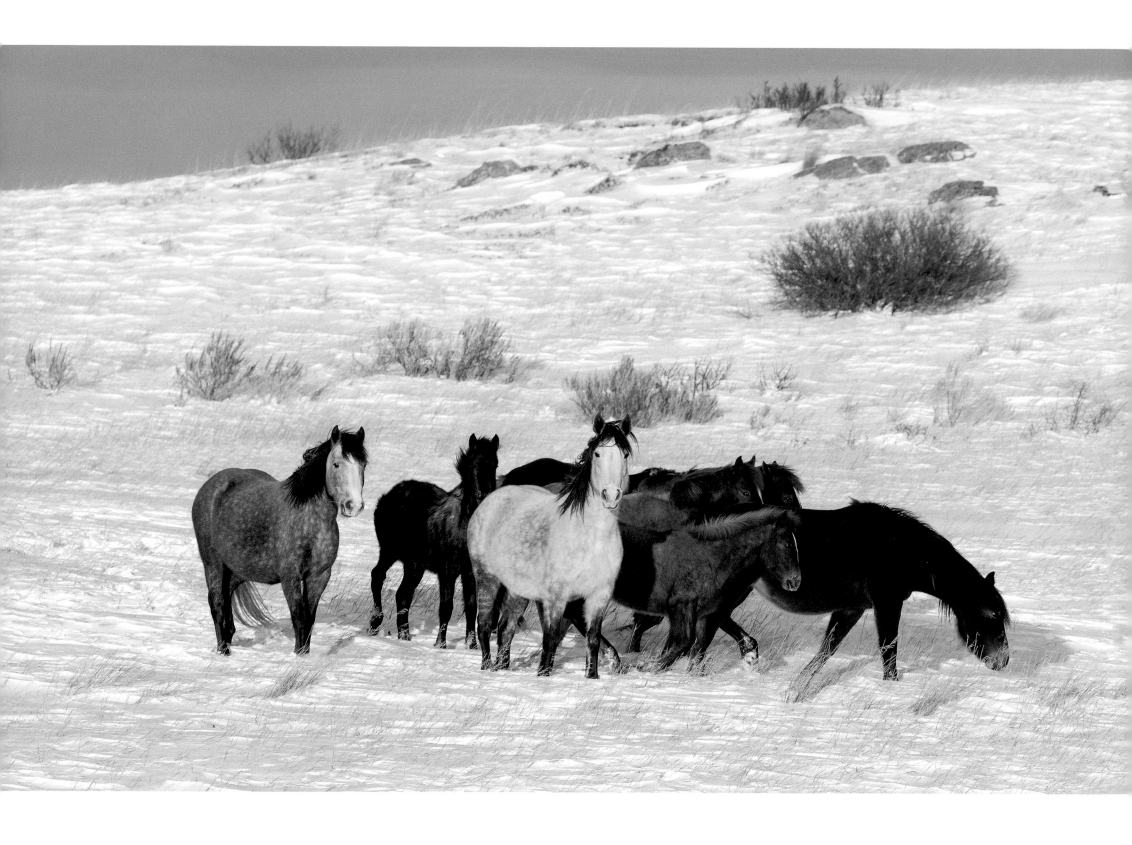

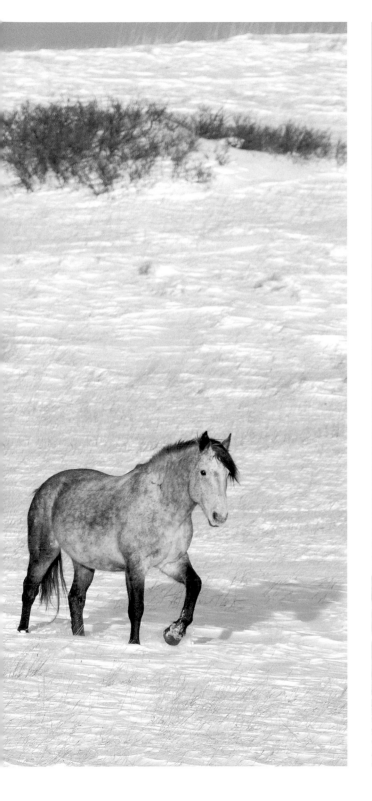

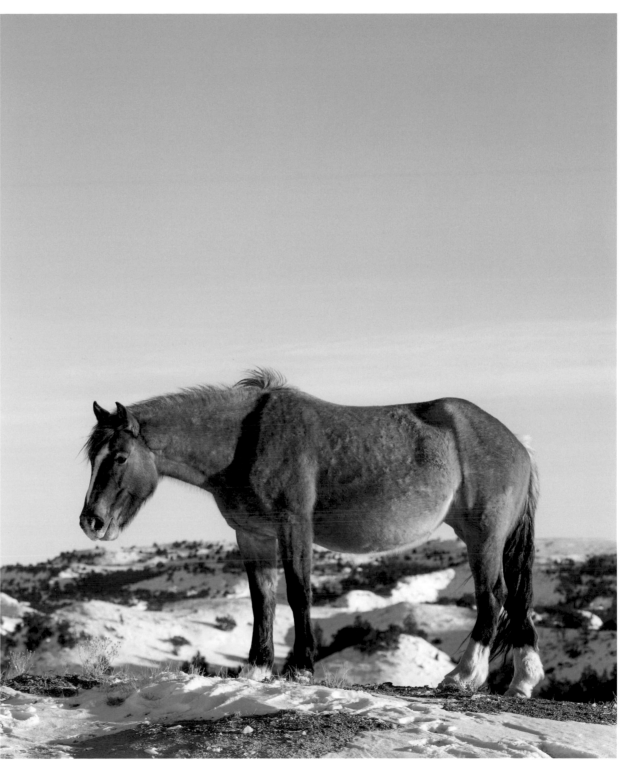

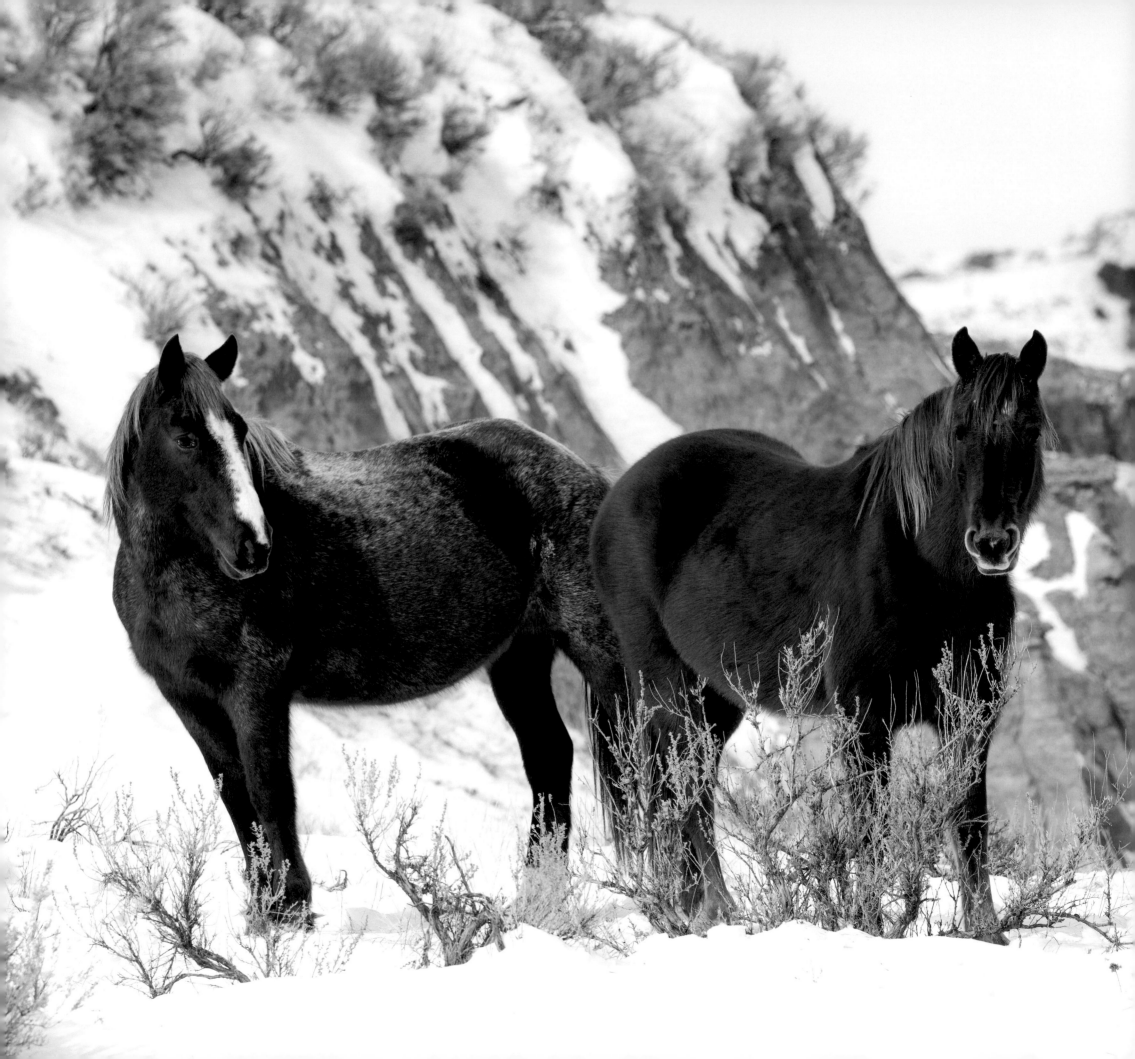

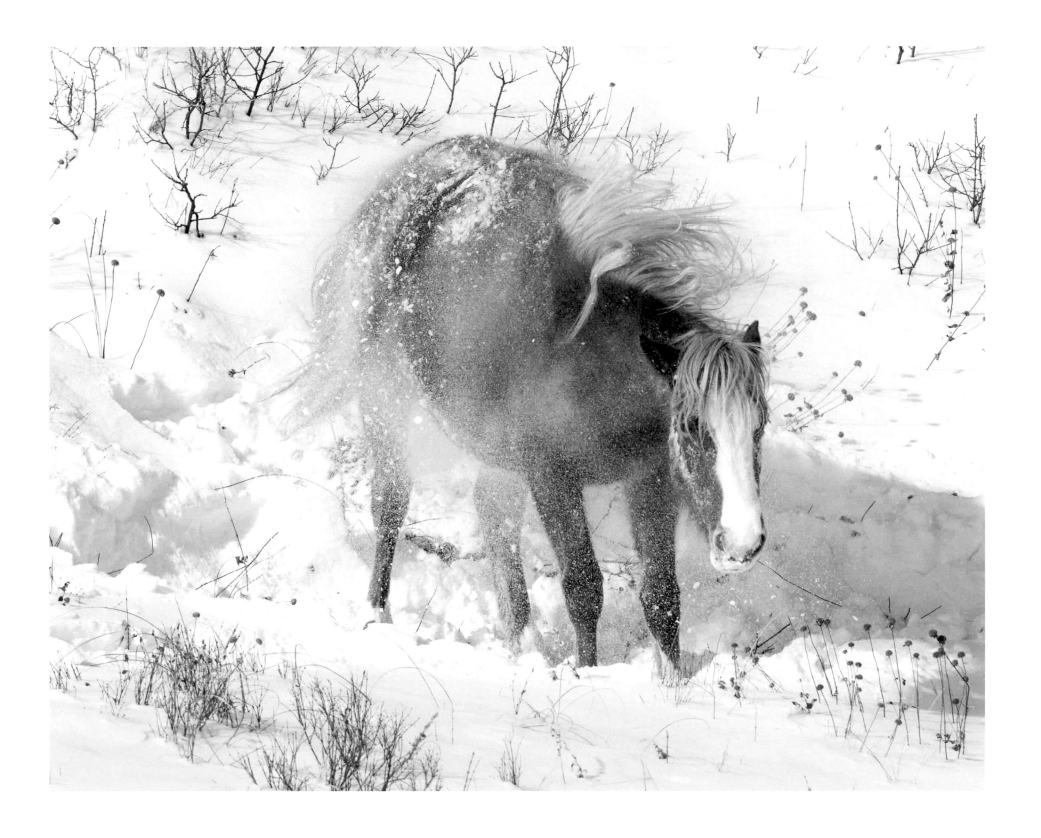

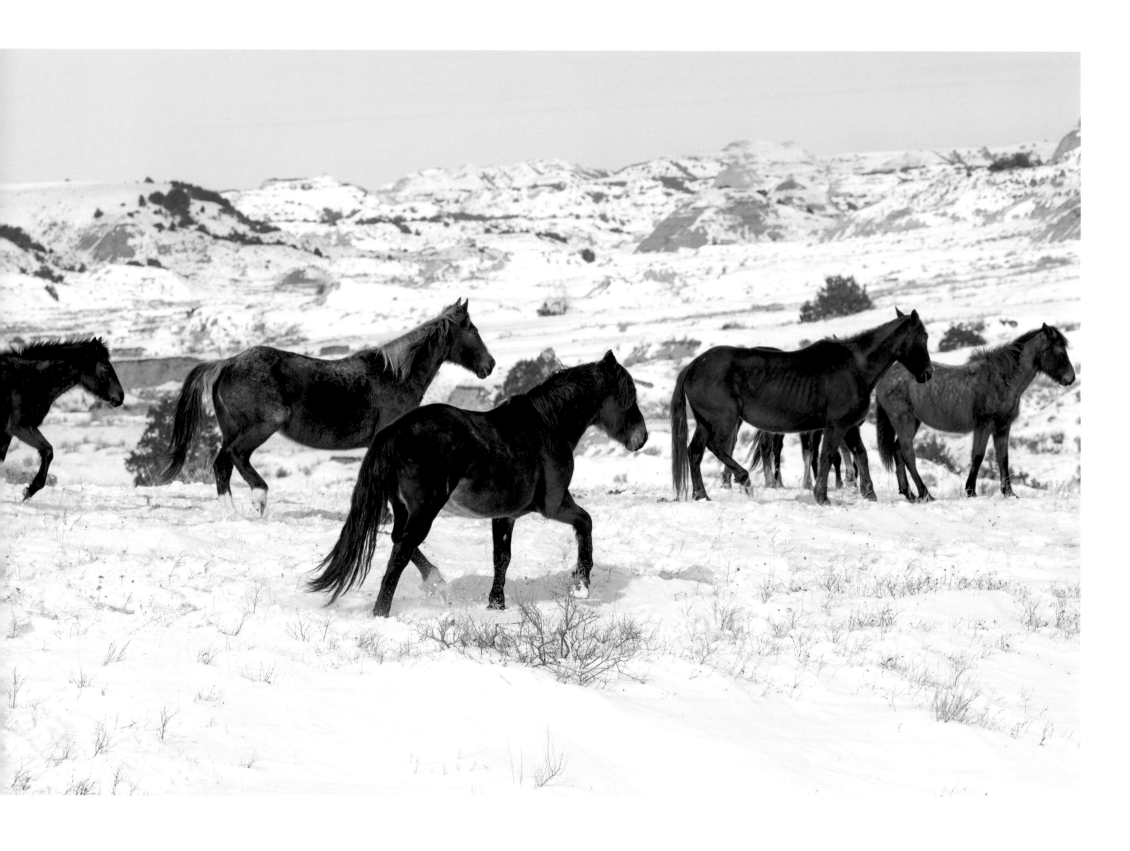

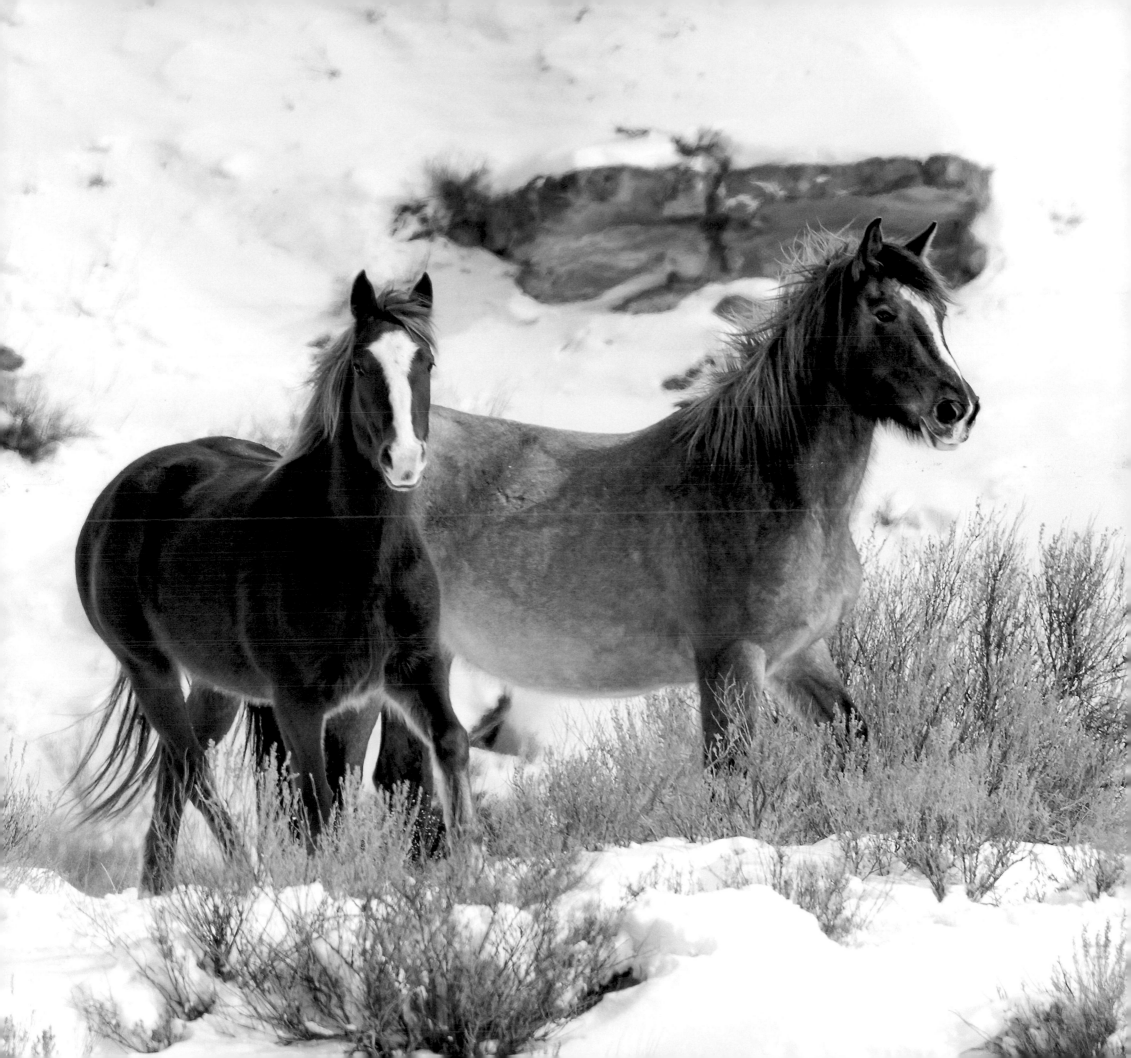

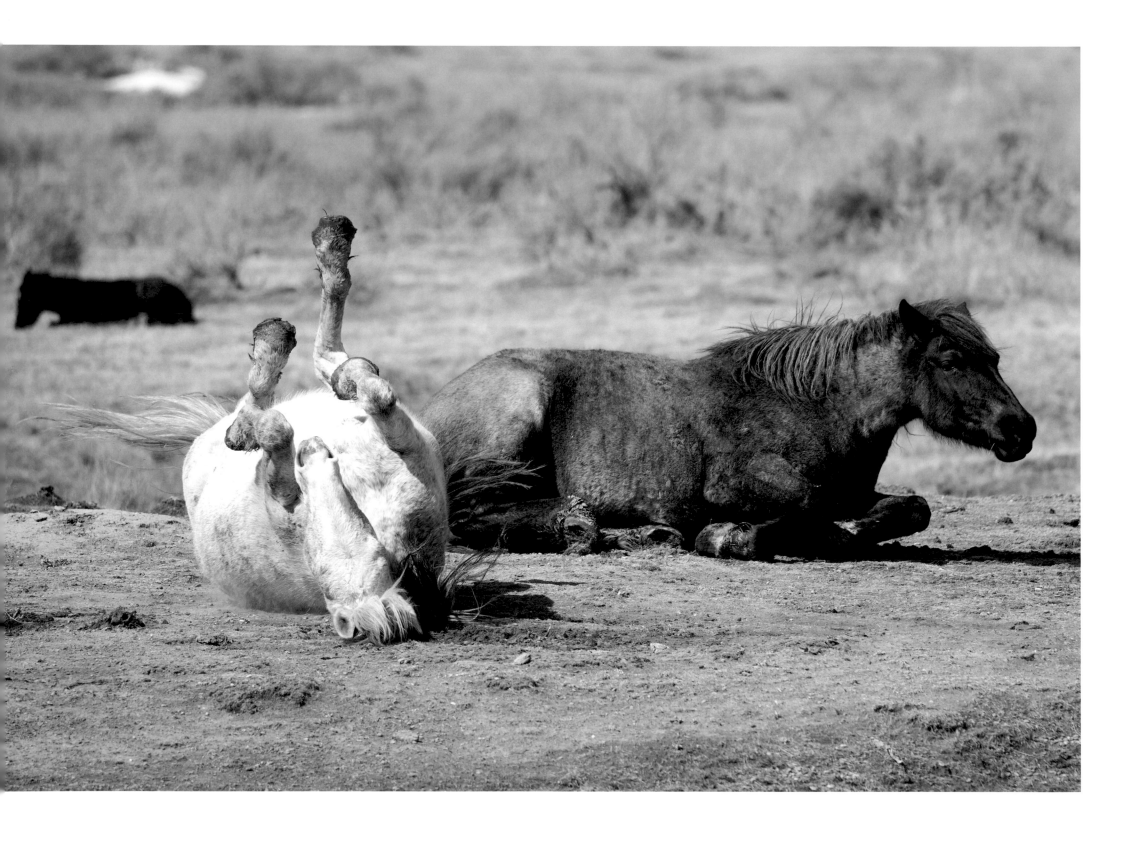

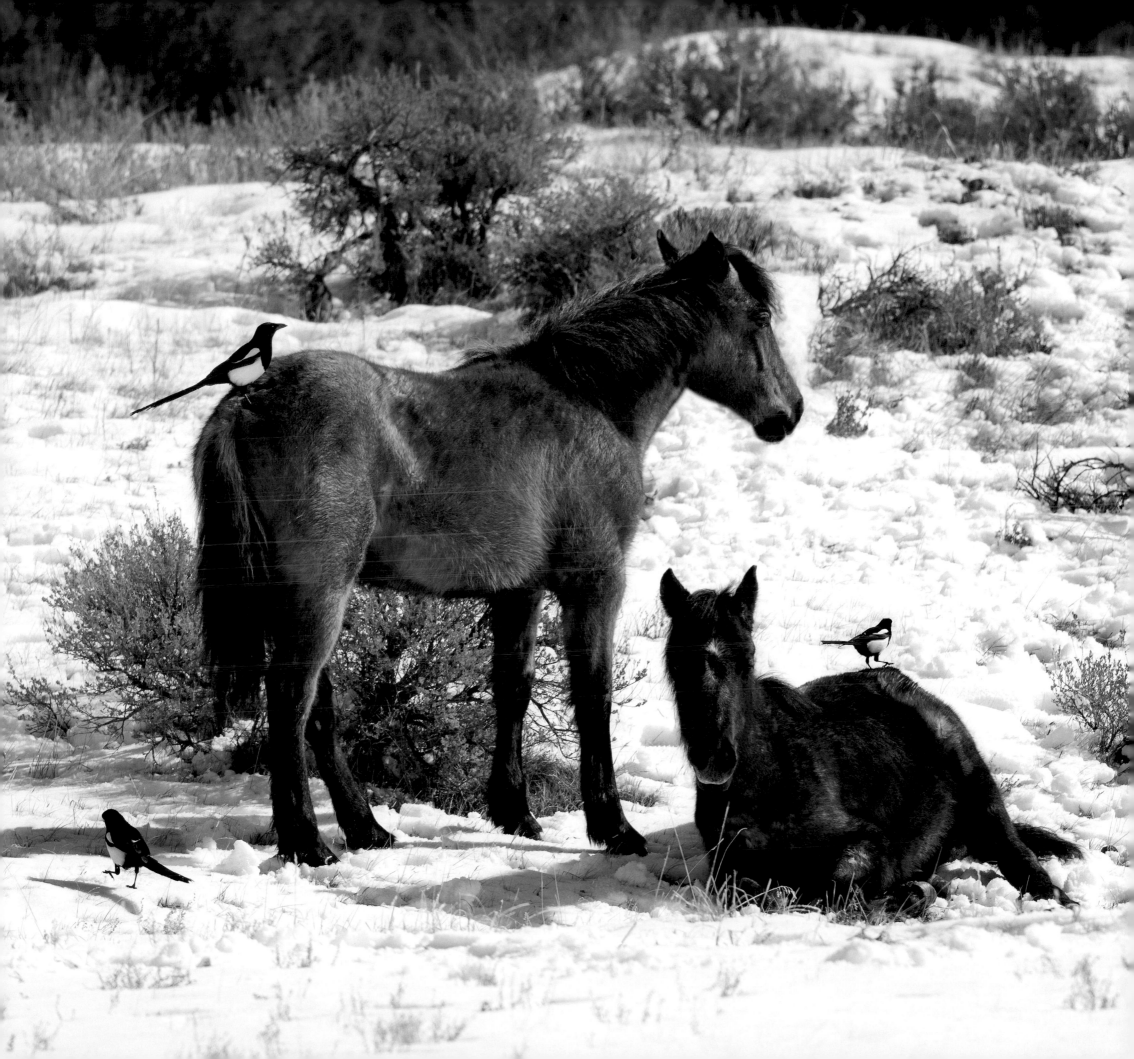

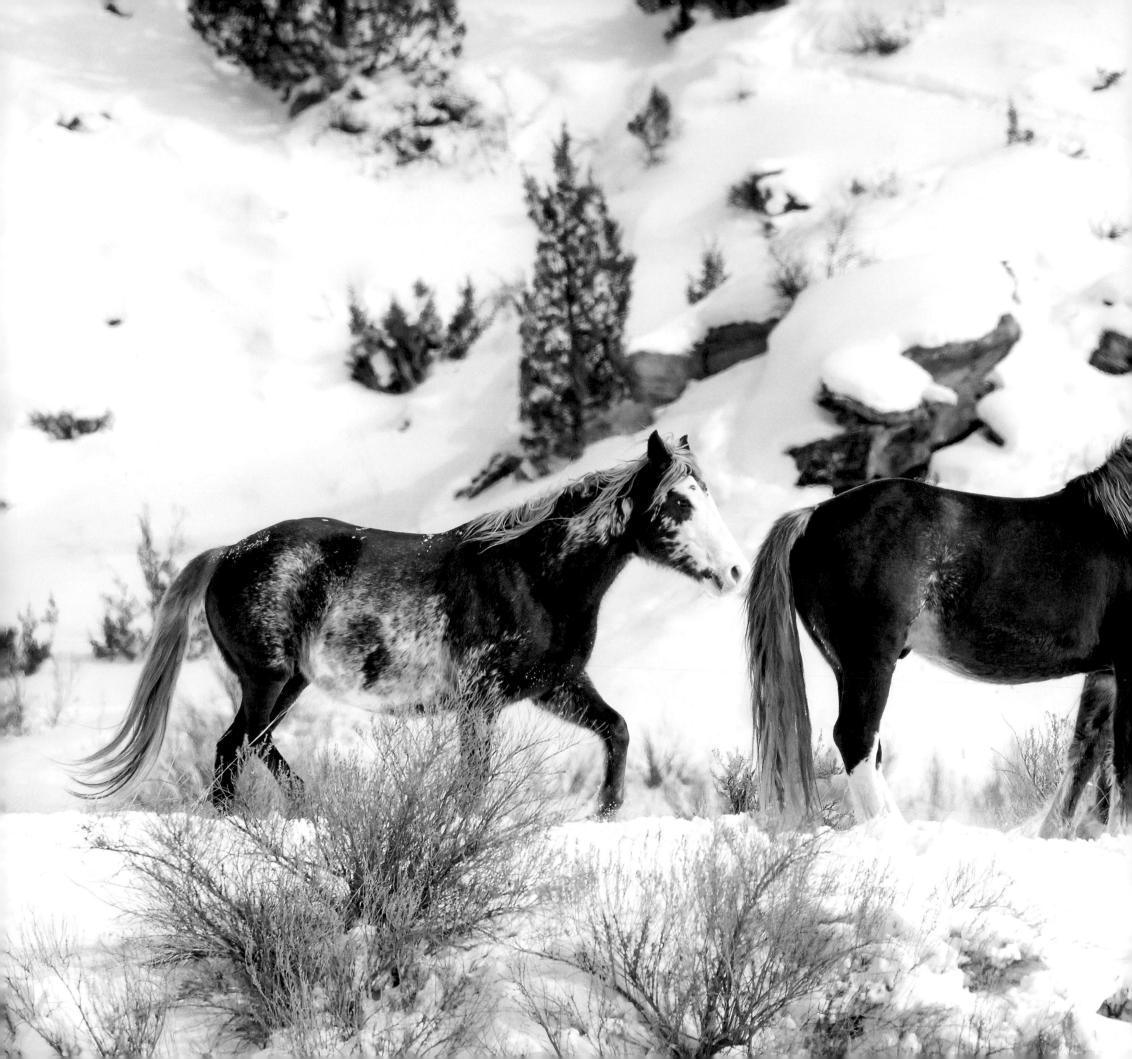

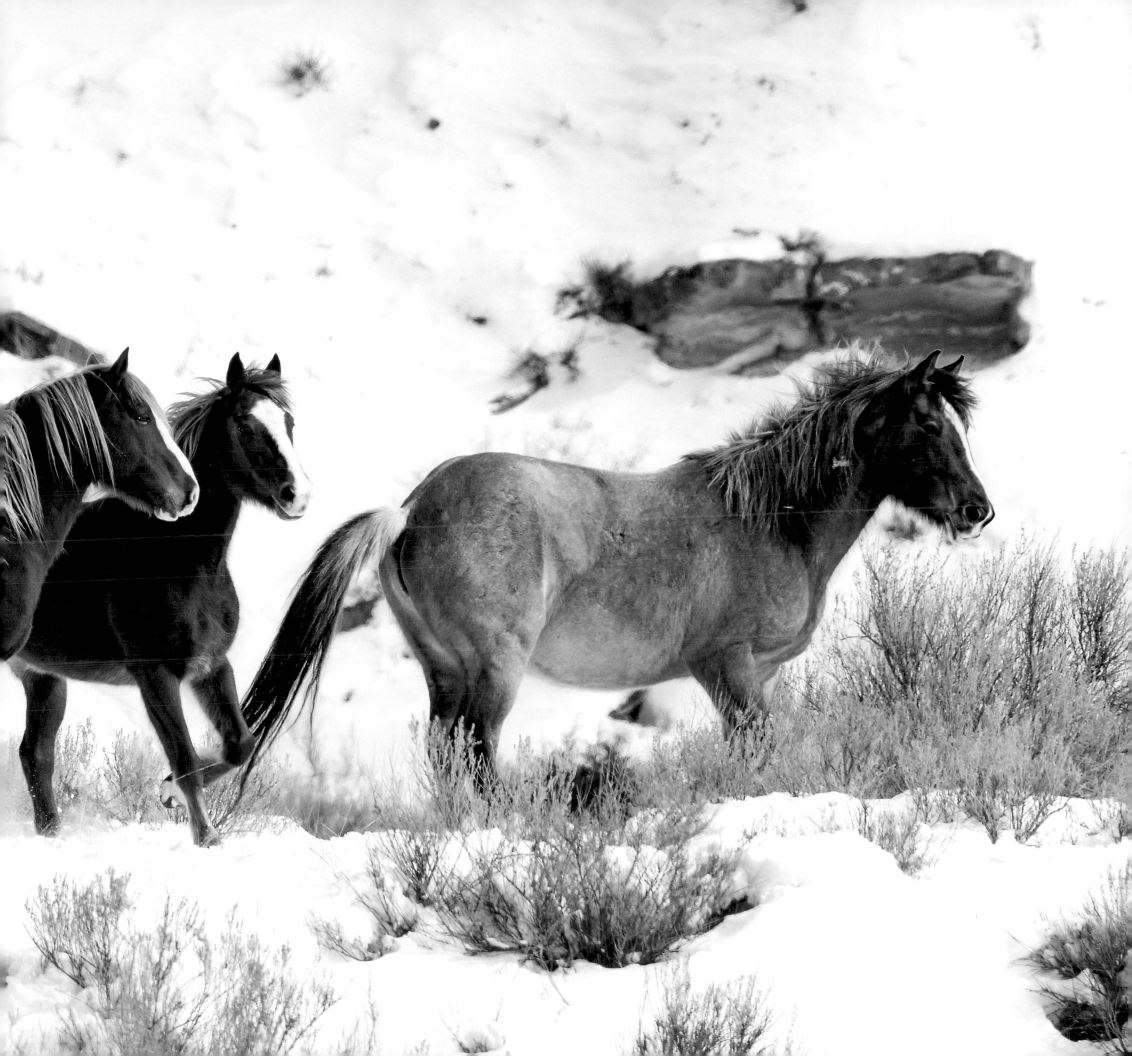

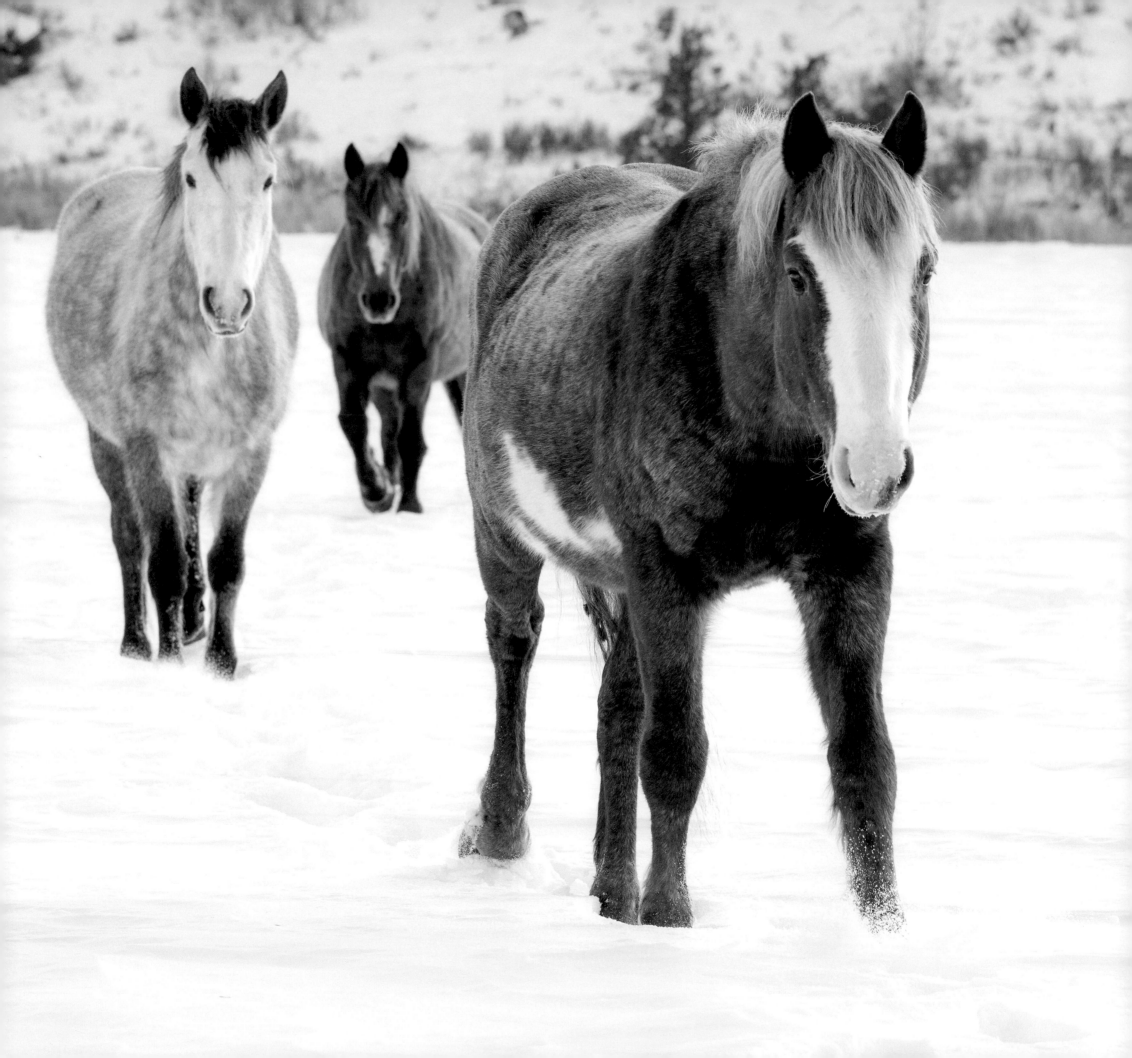

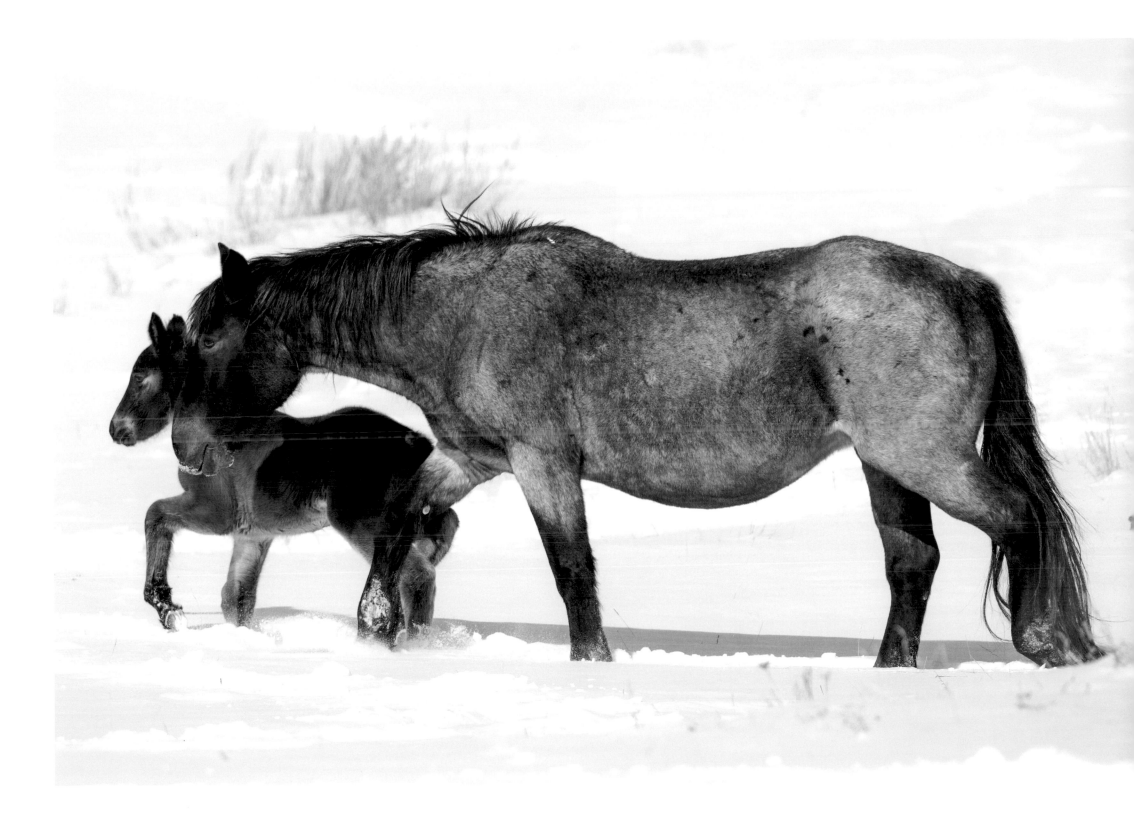

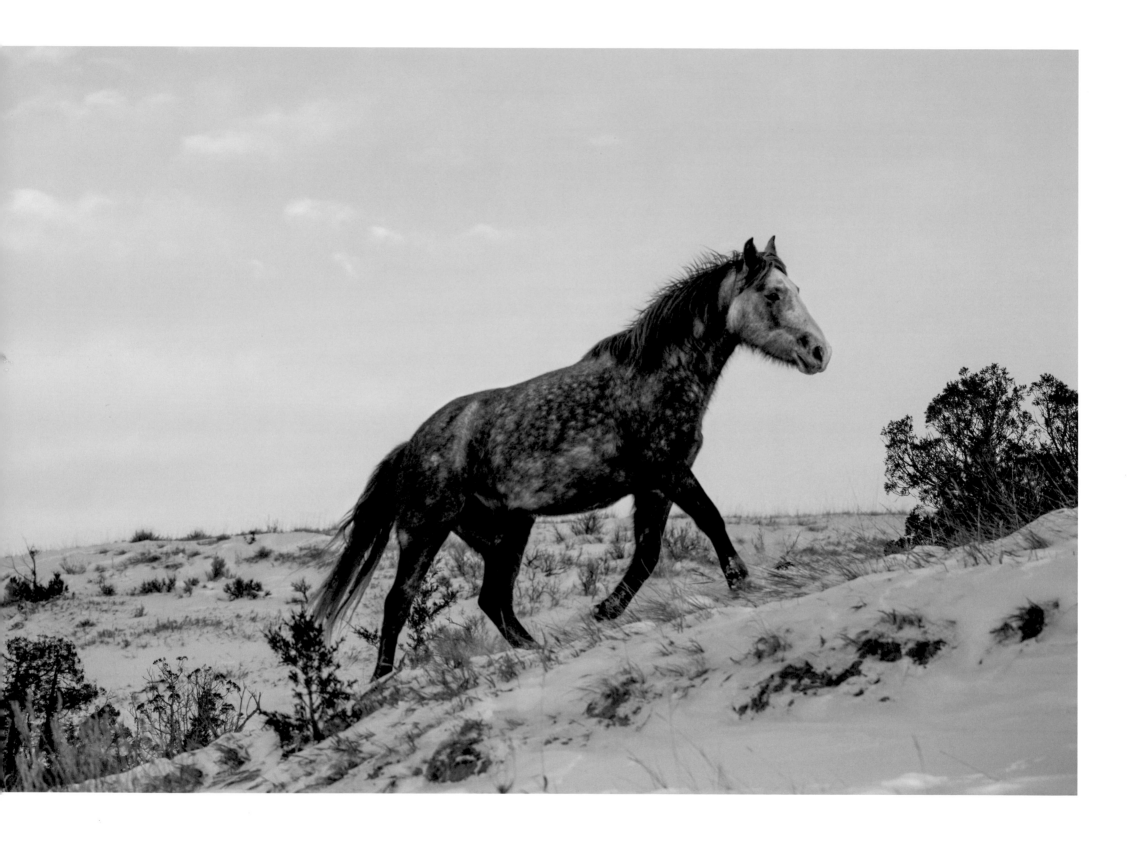

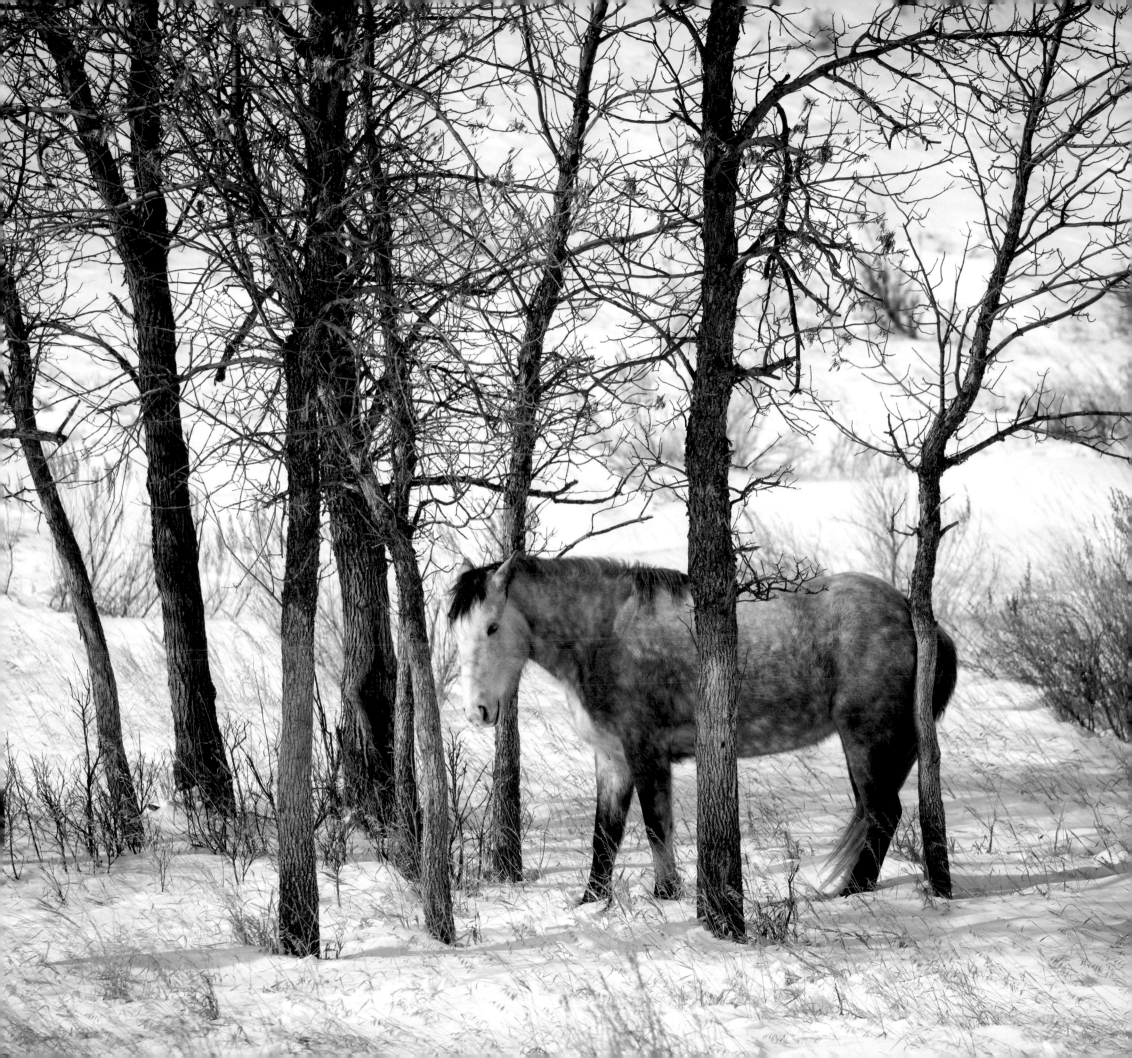

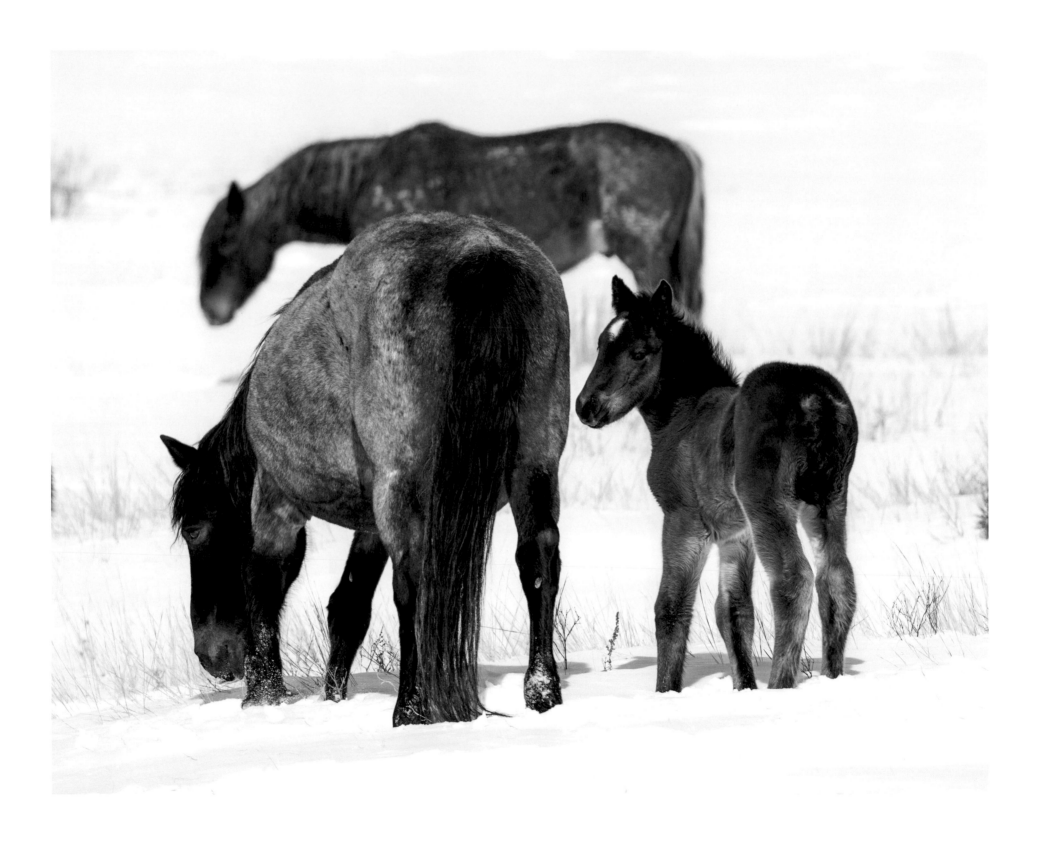

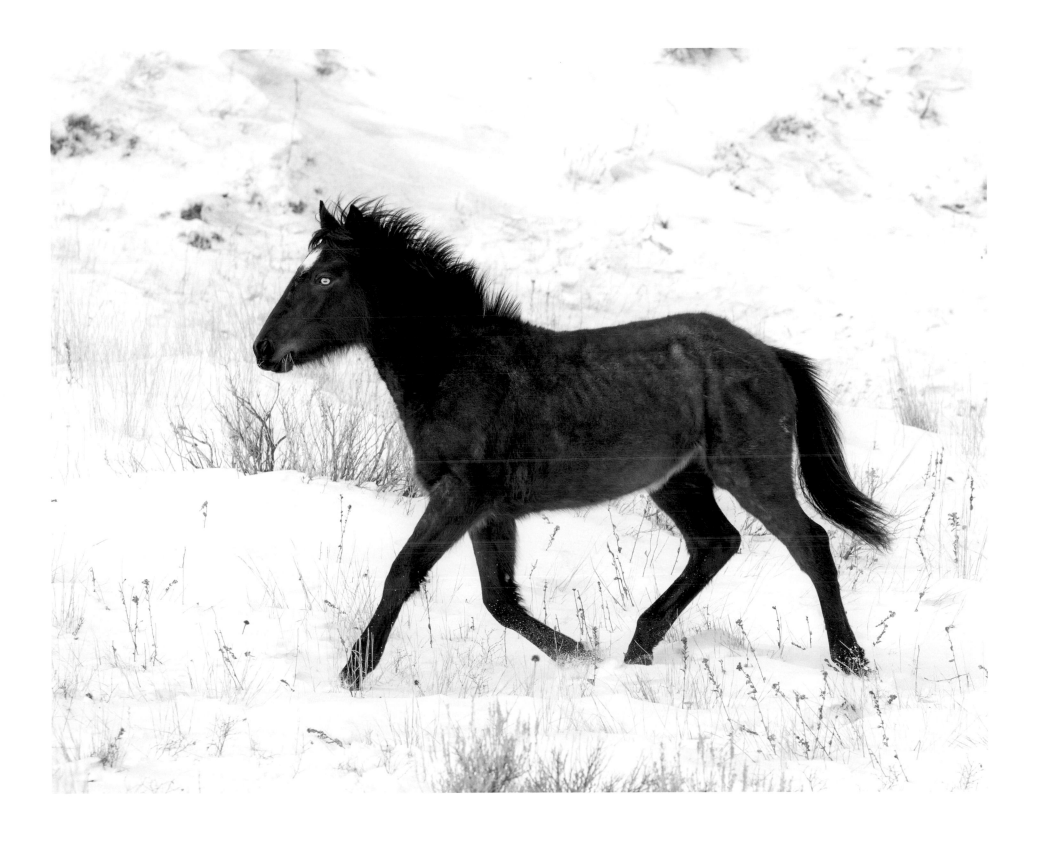

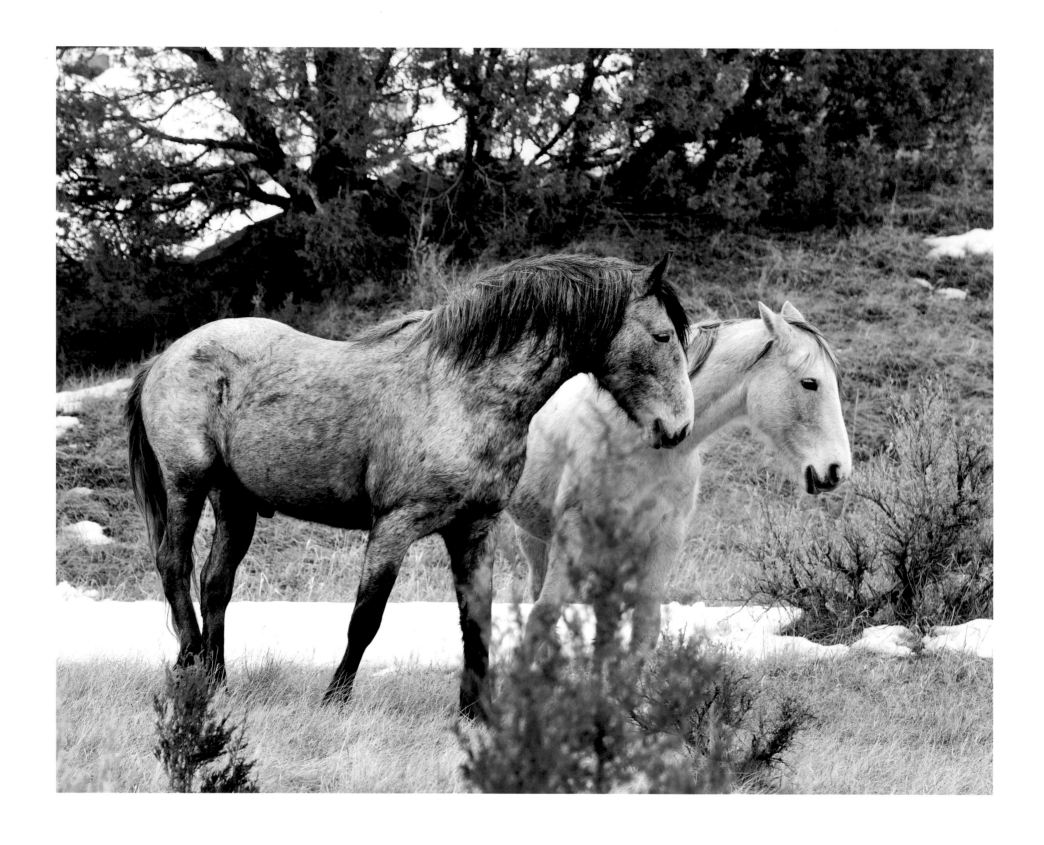

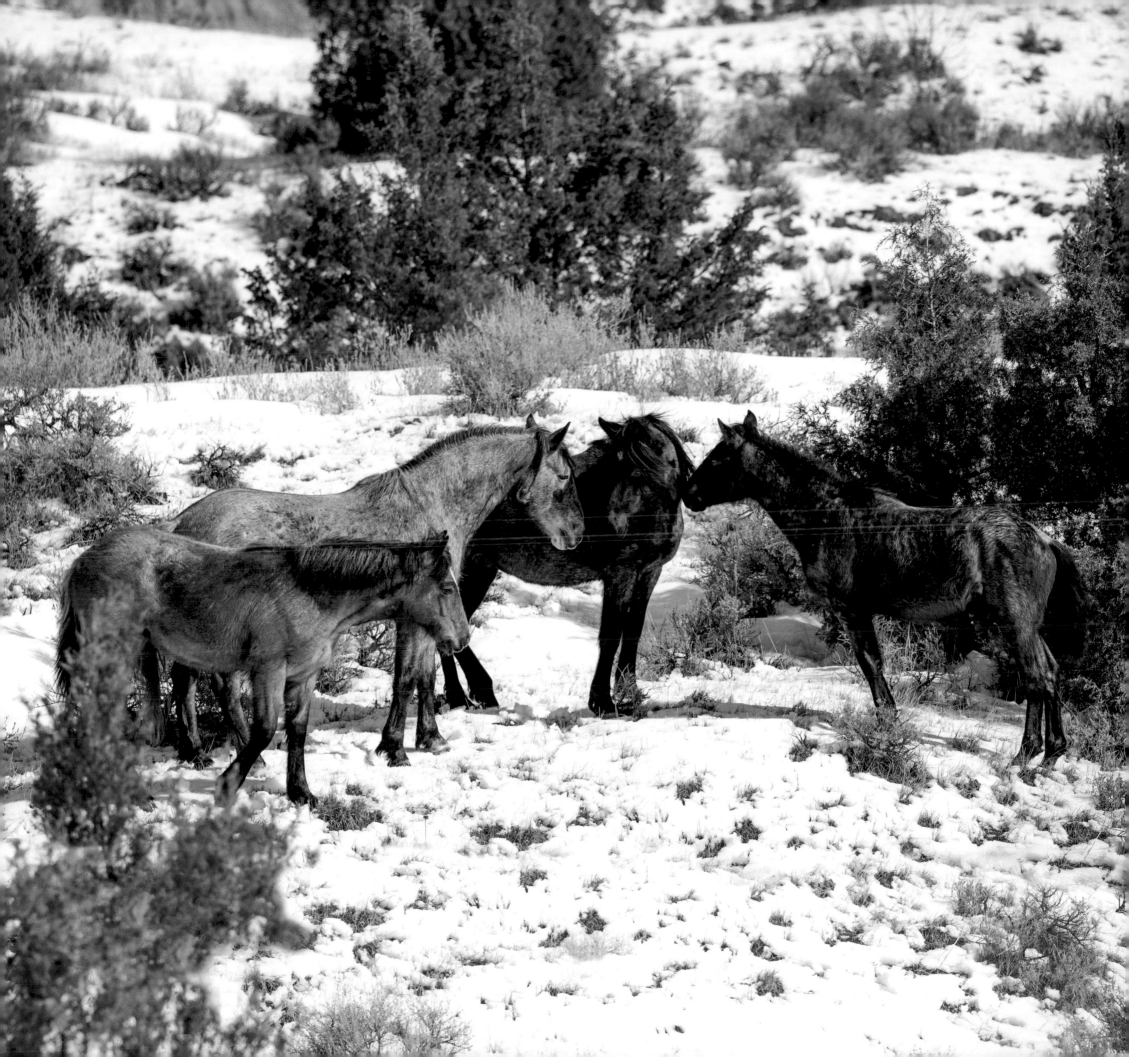

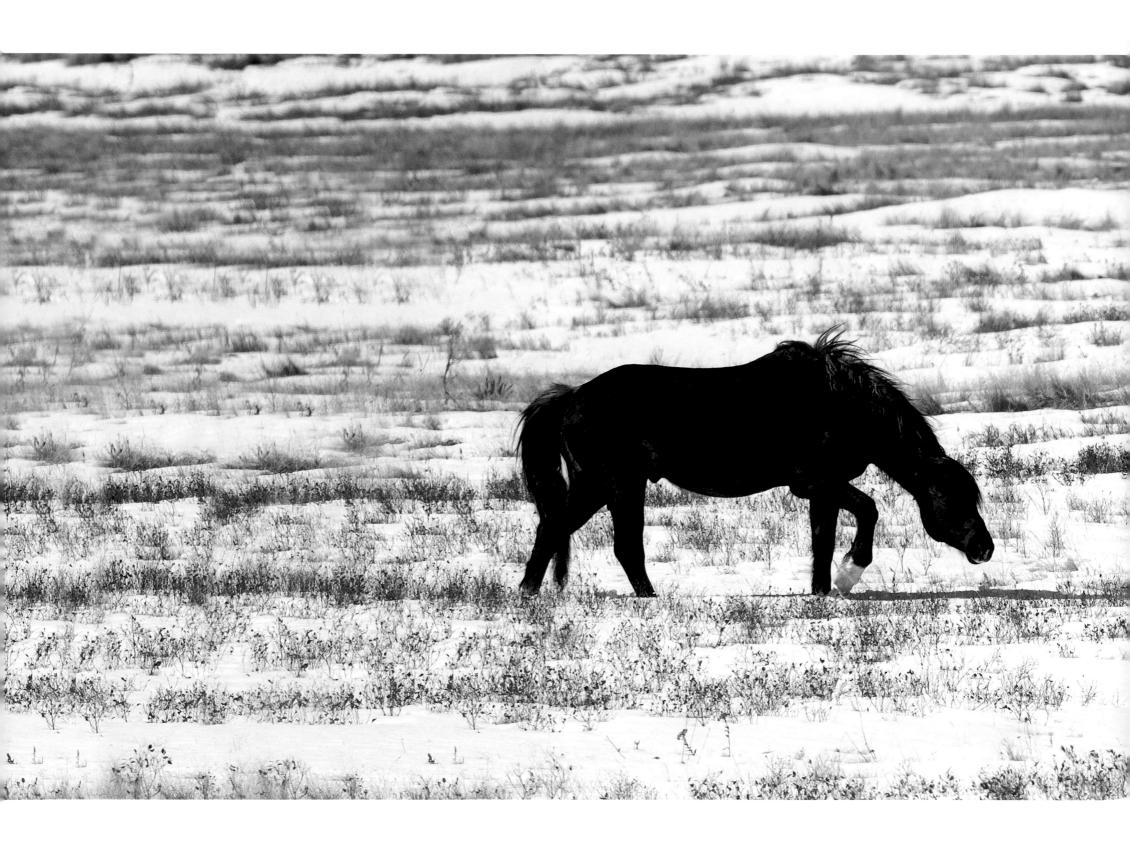

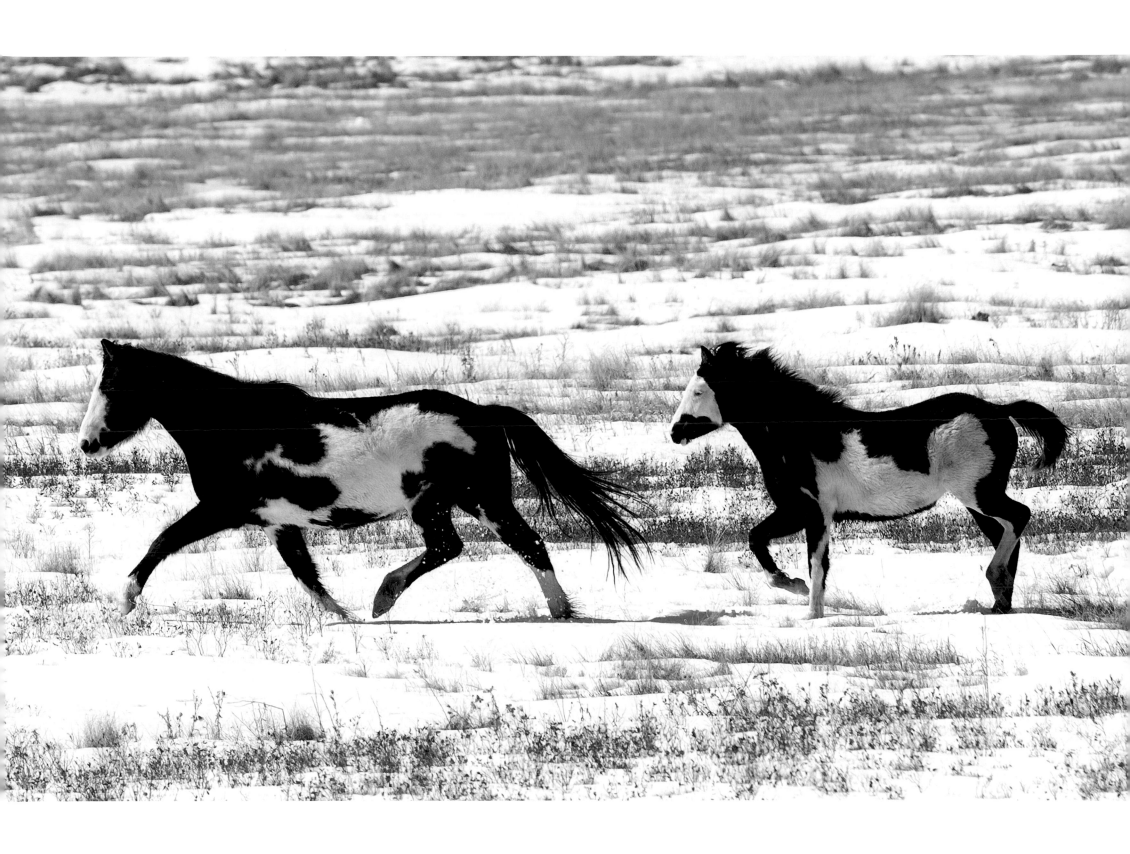

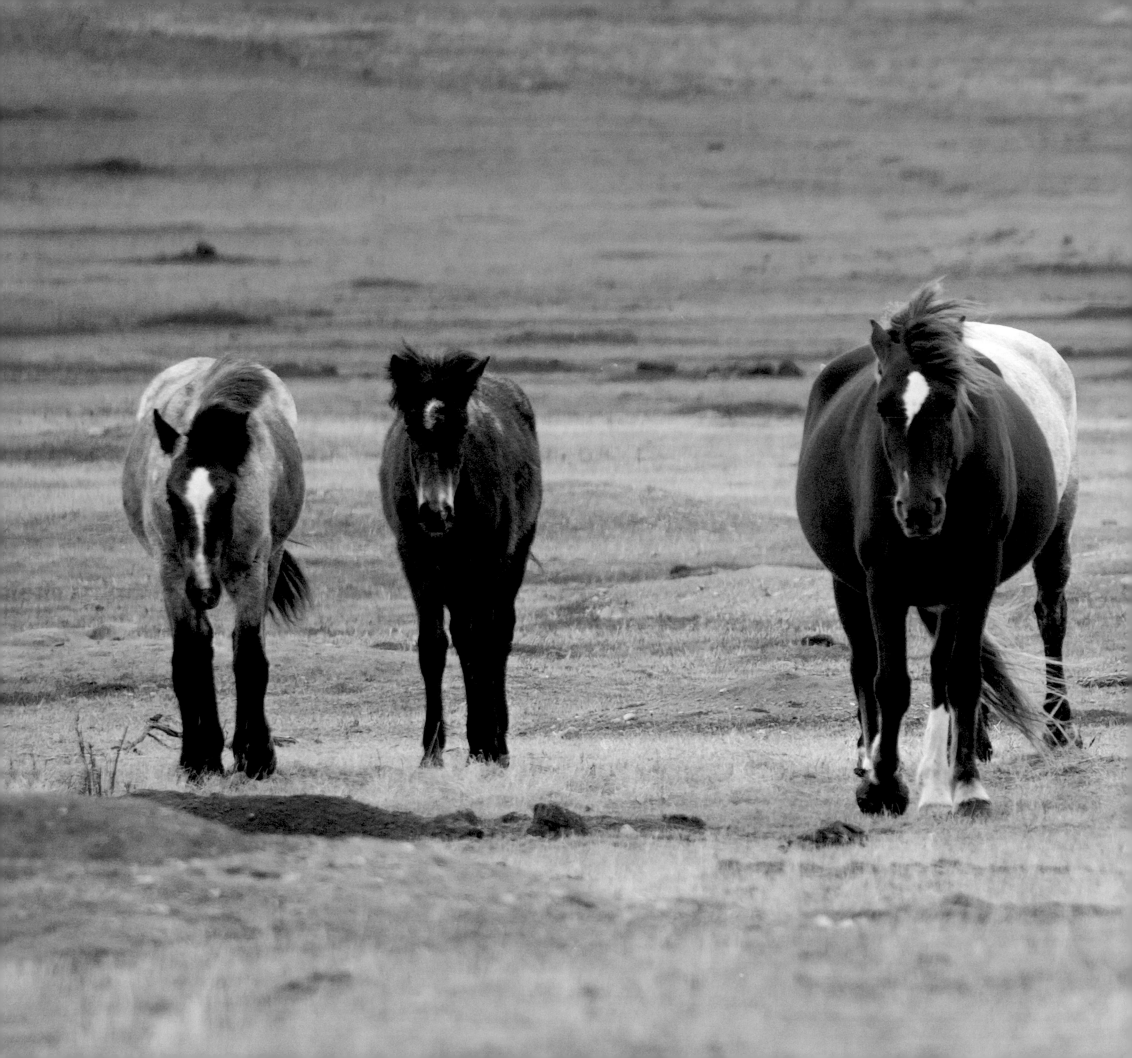

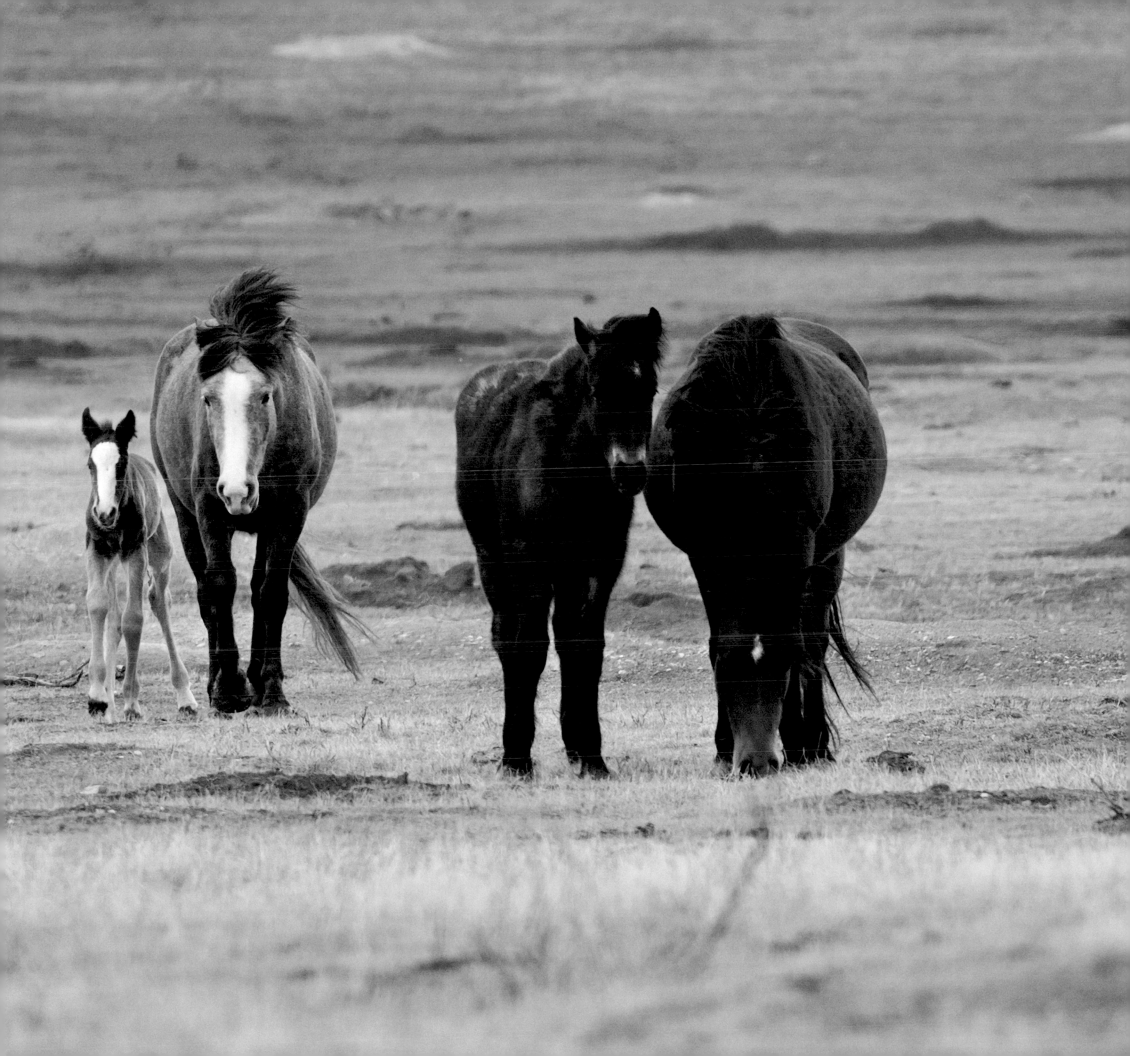

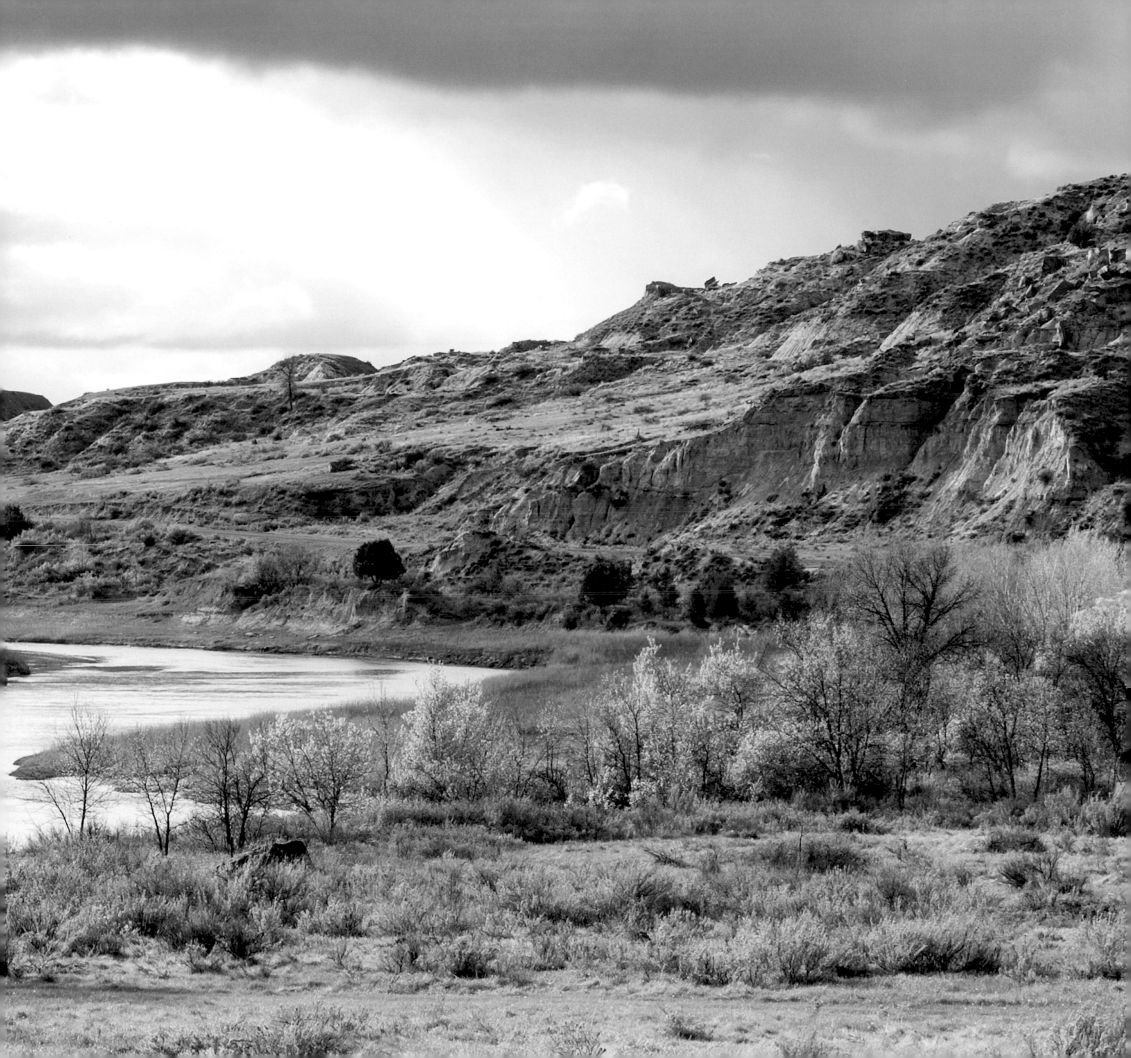

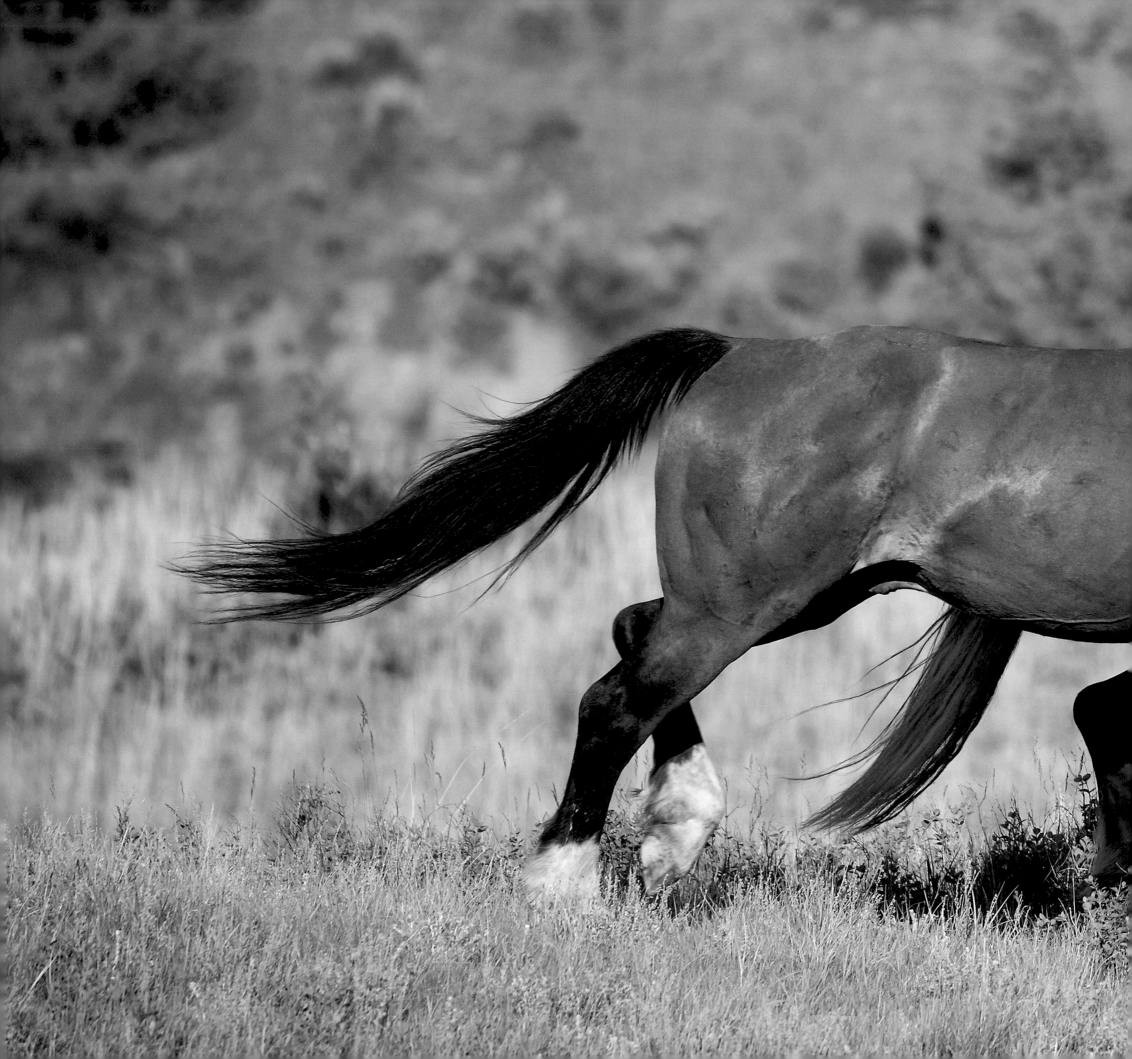

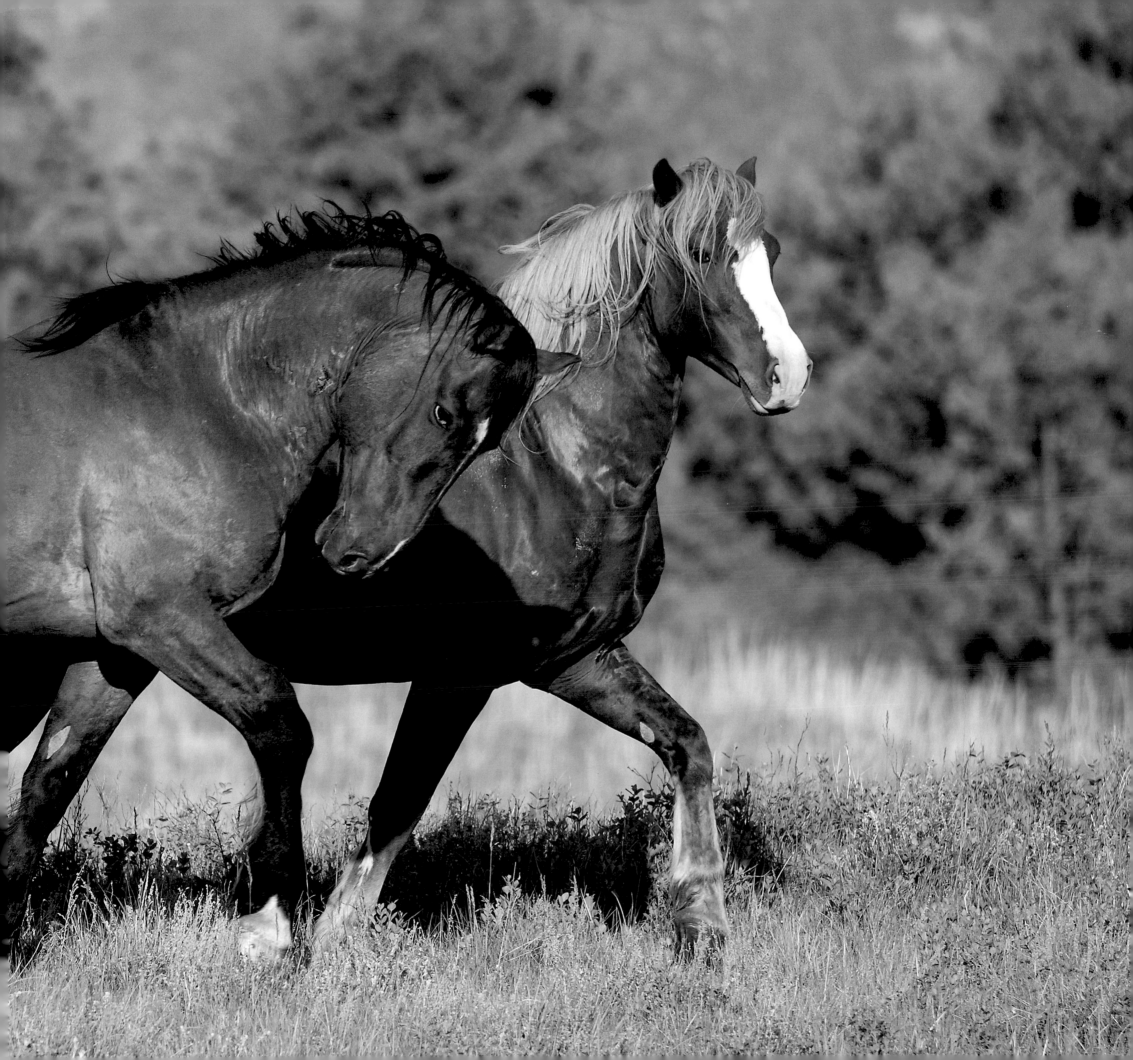

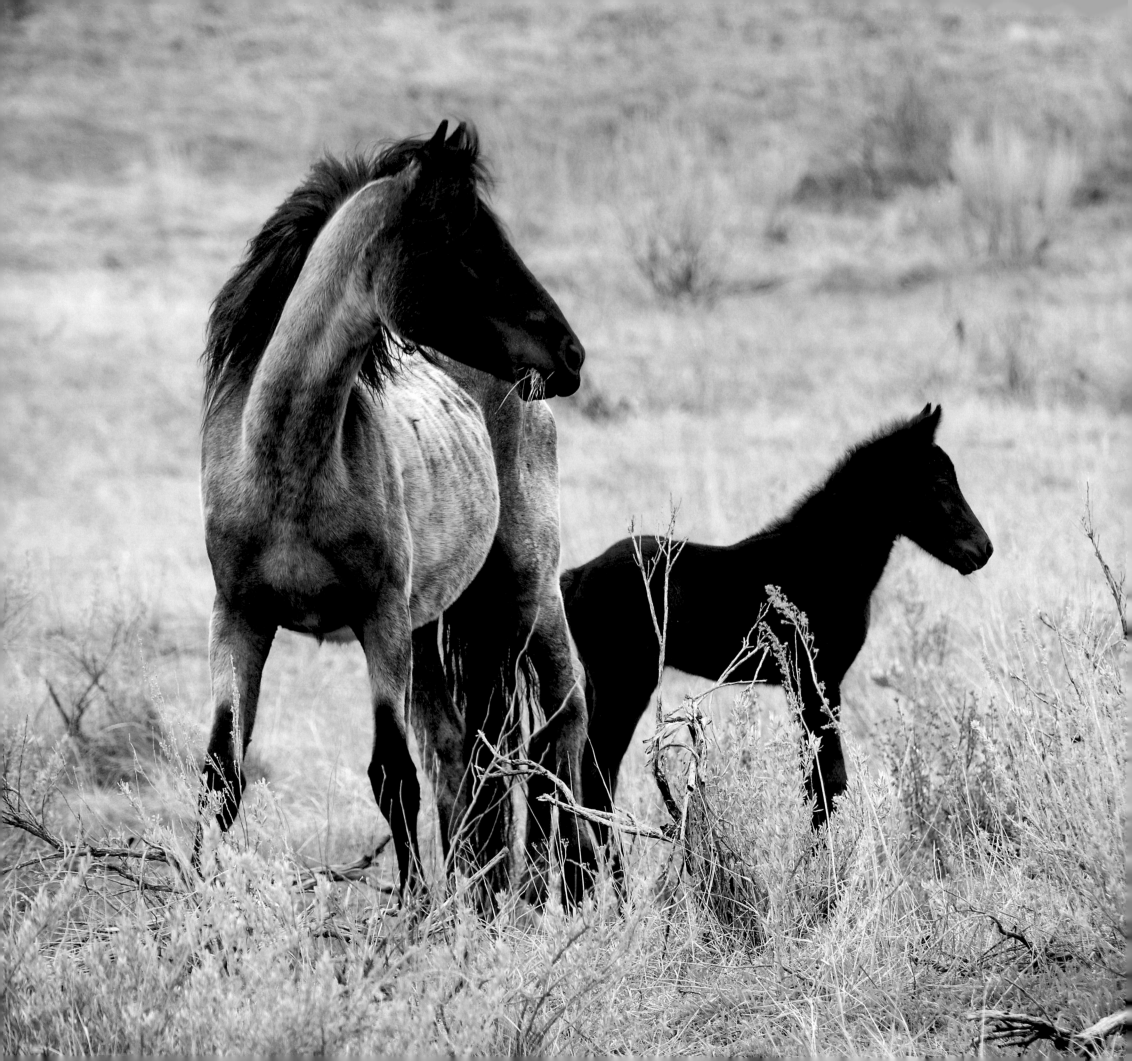

Cowgirl with her brand new foal, Rhode Island, had been grazing quietly when I found them. Her instinct was to nurture and protect her newborn colt. He pranced and leapt and galloped in circles with his mom, the center of his universe.

Springtime is all about new foals being born, and stallions posturing and protecting their bands from headstrong bachelors looking for mares to start their own band. Other band stallions may just want a larger number of horses and they too will step up and challenge whoever may be around. There is lots of drama.

In spring, mares are busy tending to their newborns. Nuzzling, licking and encouraging them to nurse to keep up their strength. New foals experiment with their legs, leaping and bucking around. Tiring quickly, naptime is a necessity. Meanwhile, all are instinctively alert to sudden movements or potential threats on the horizon—an awareness they develop from a very young age.

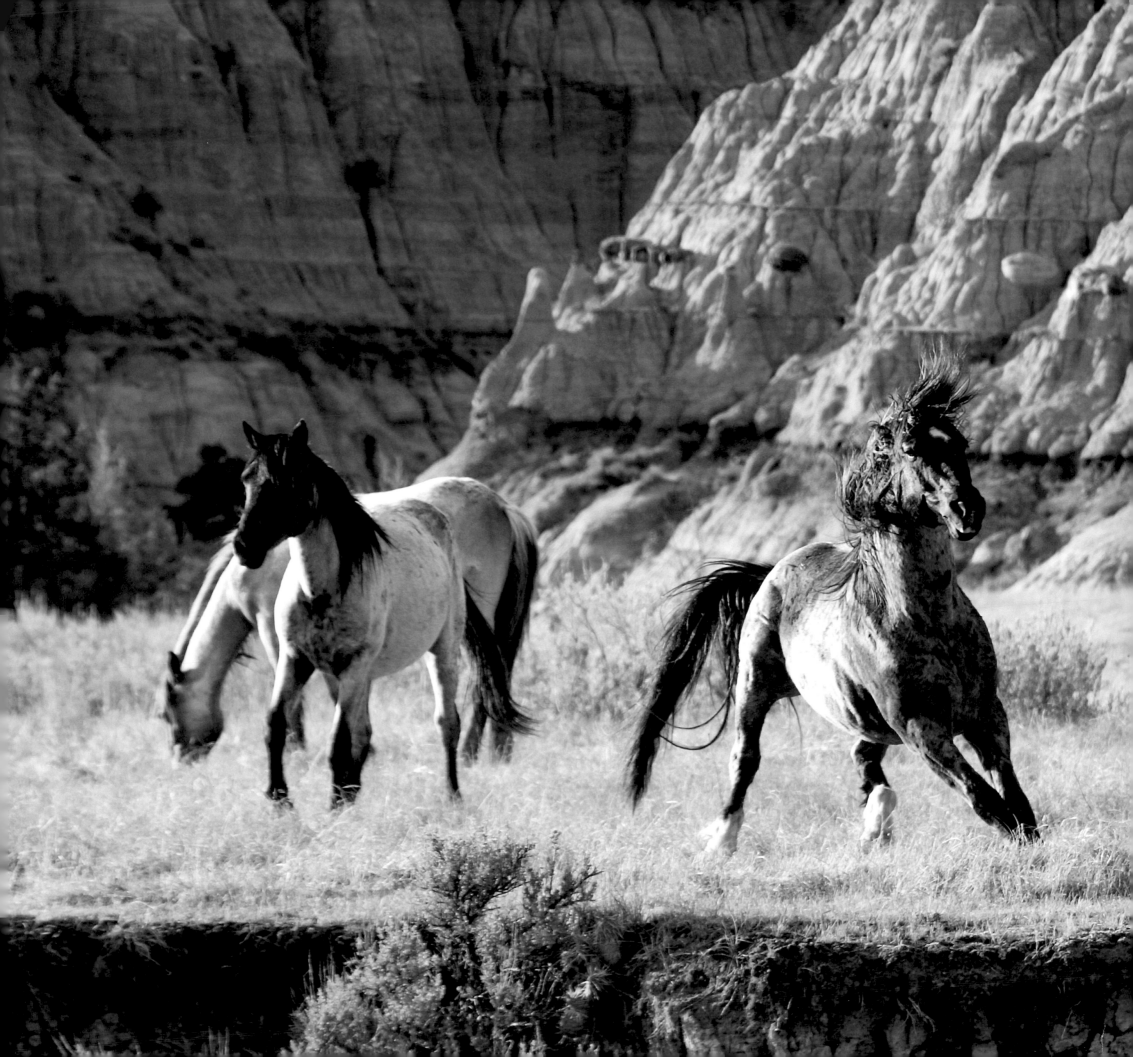

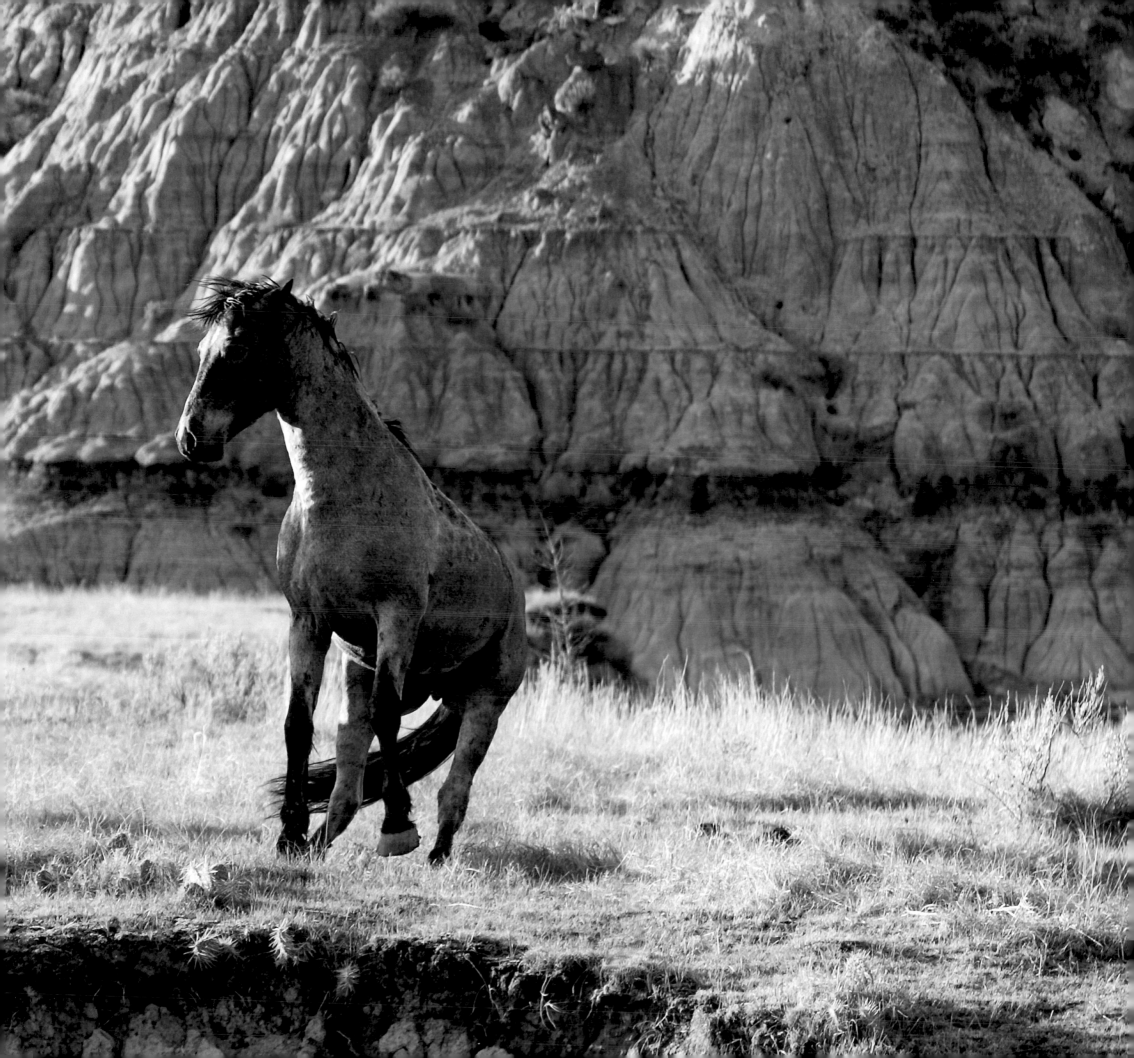

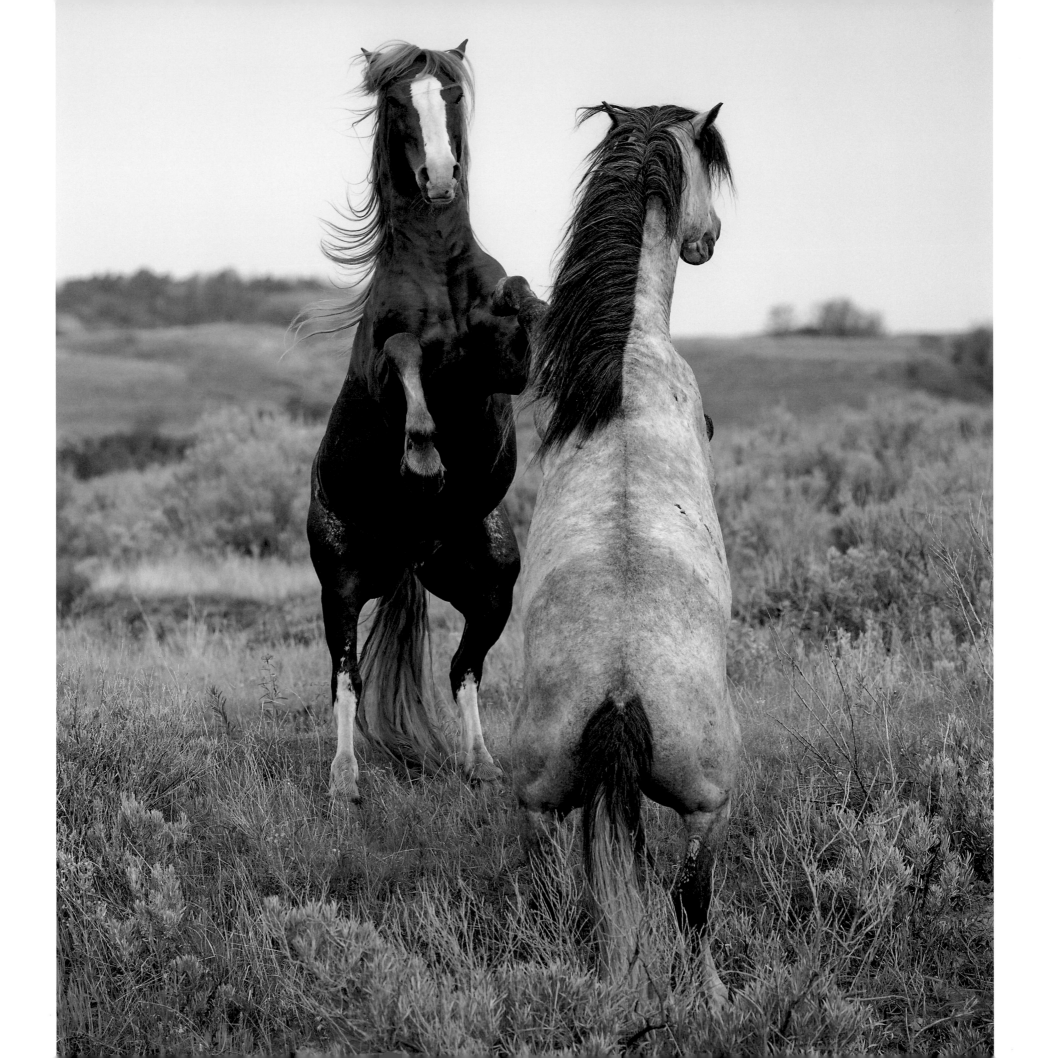

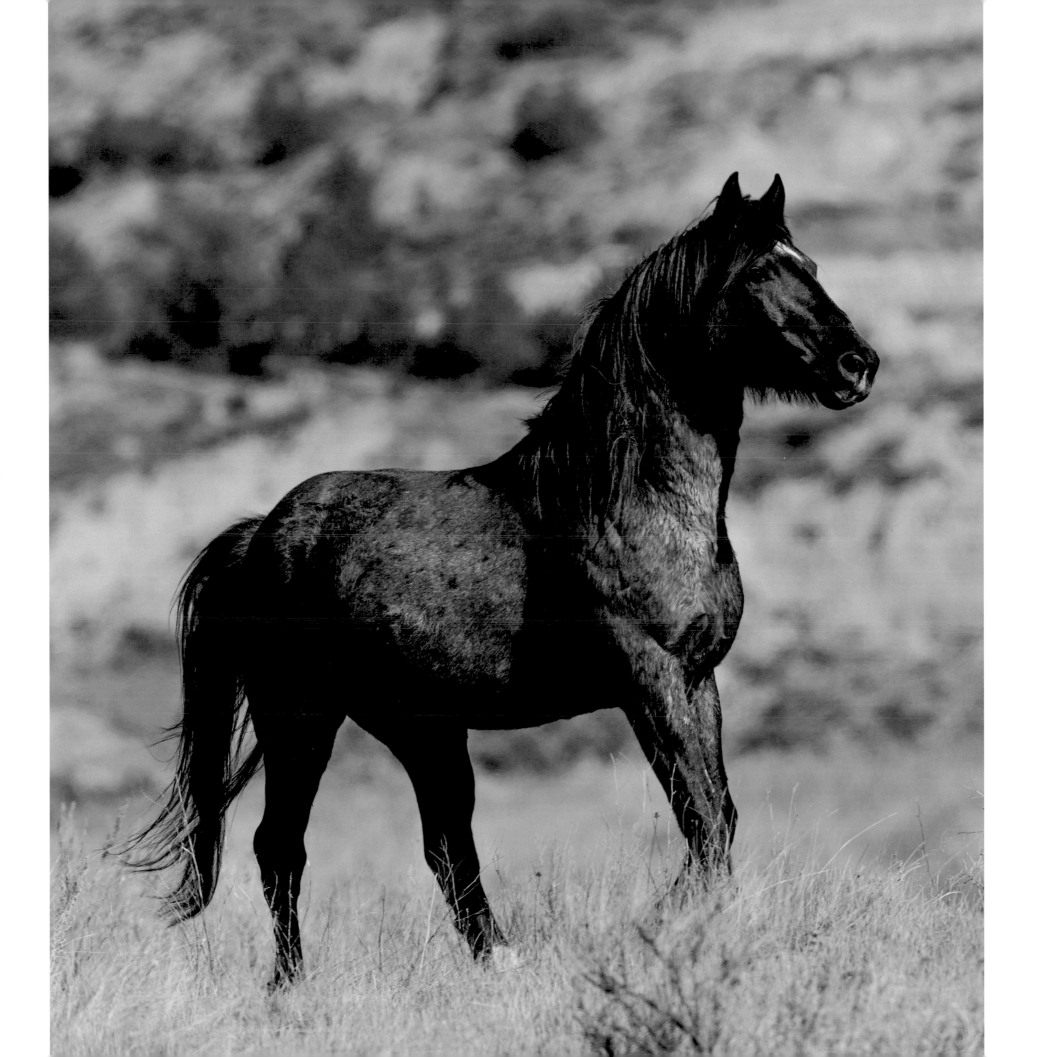

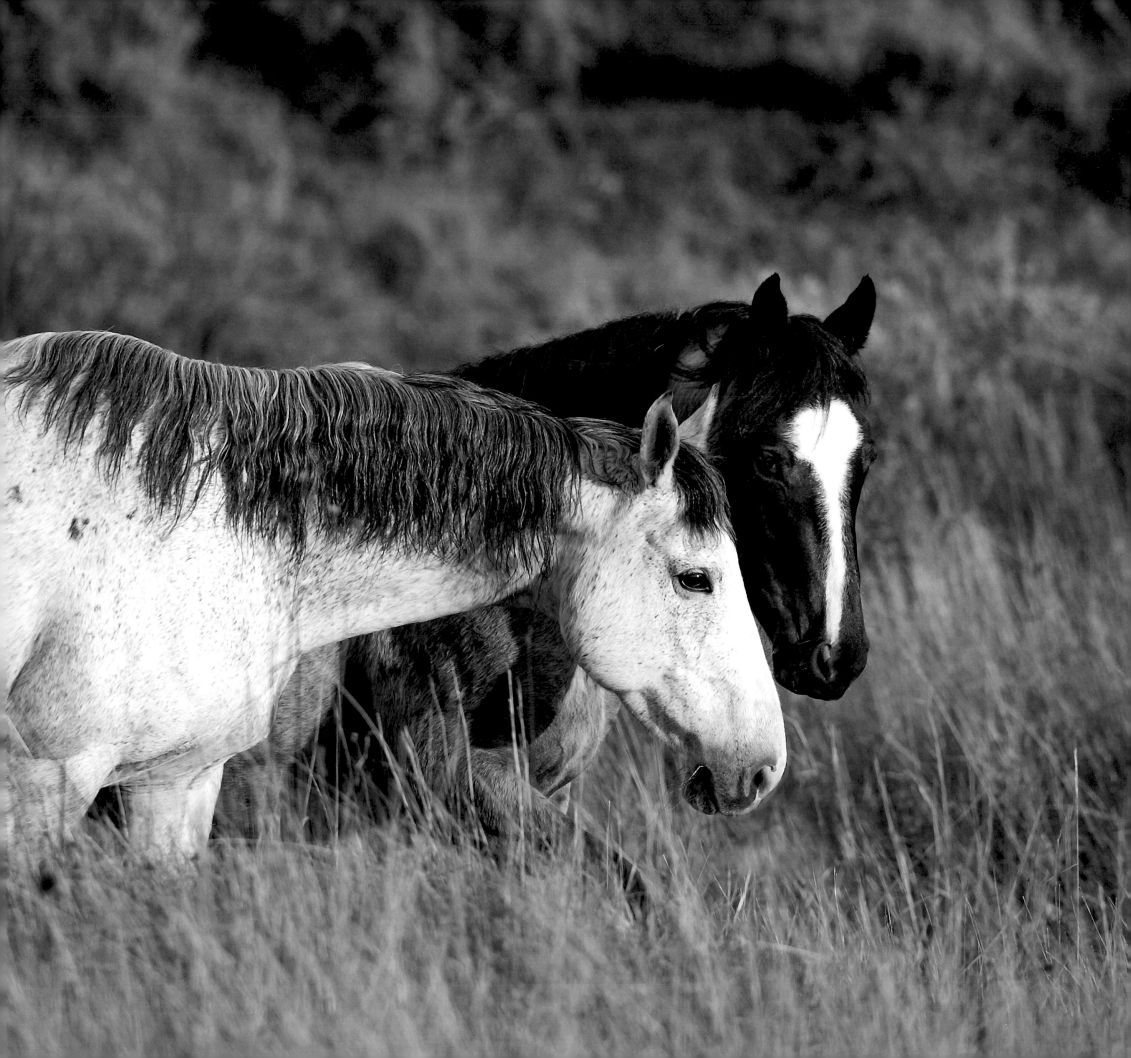

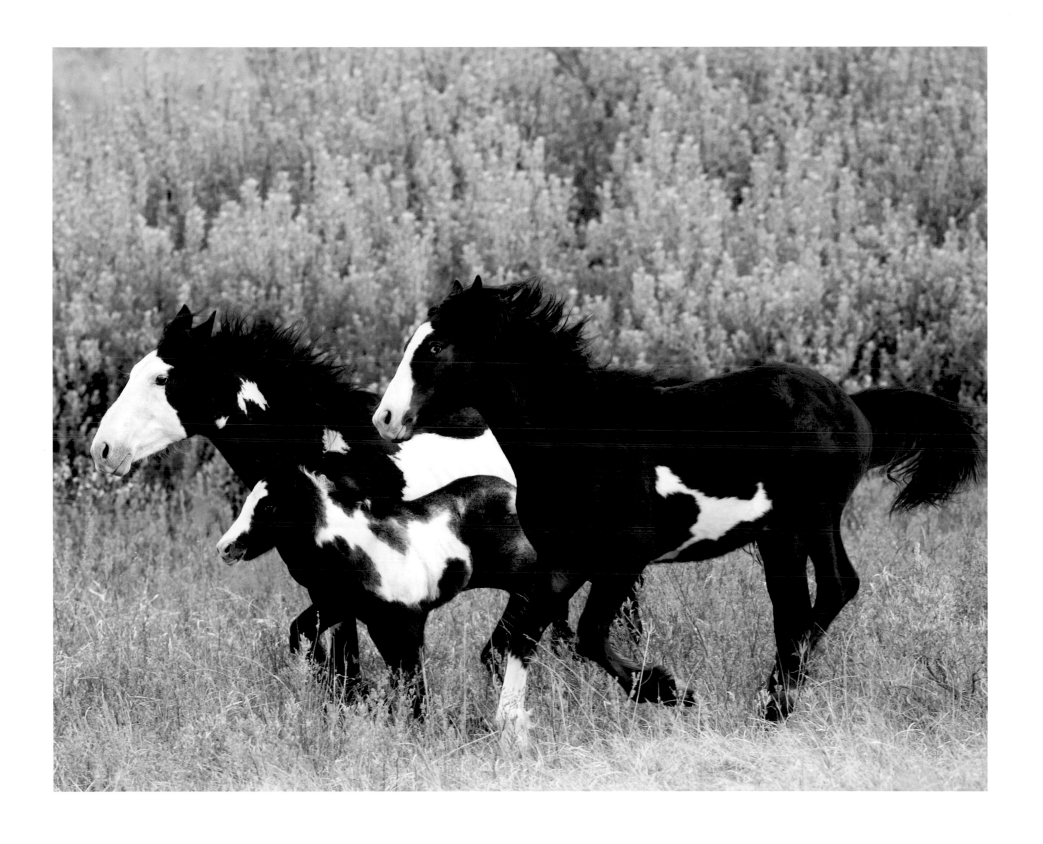

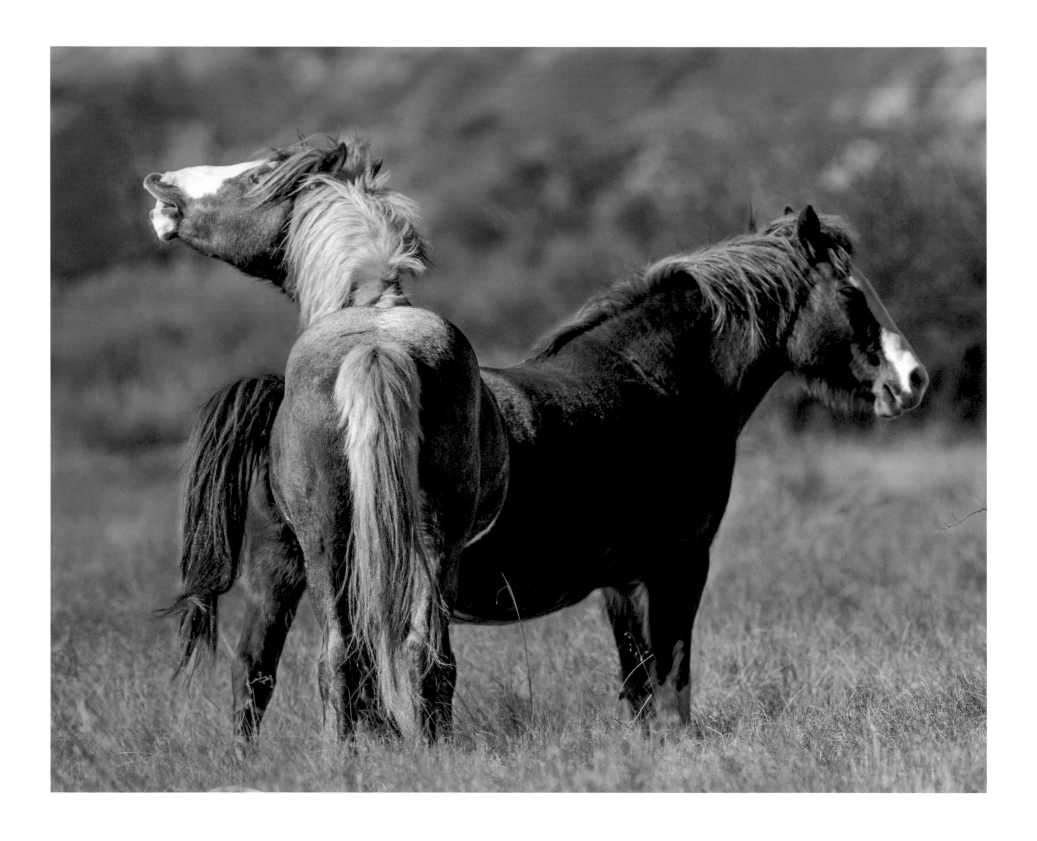

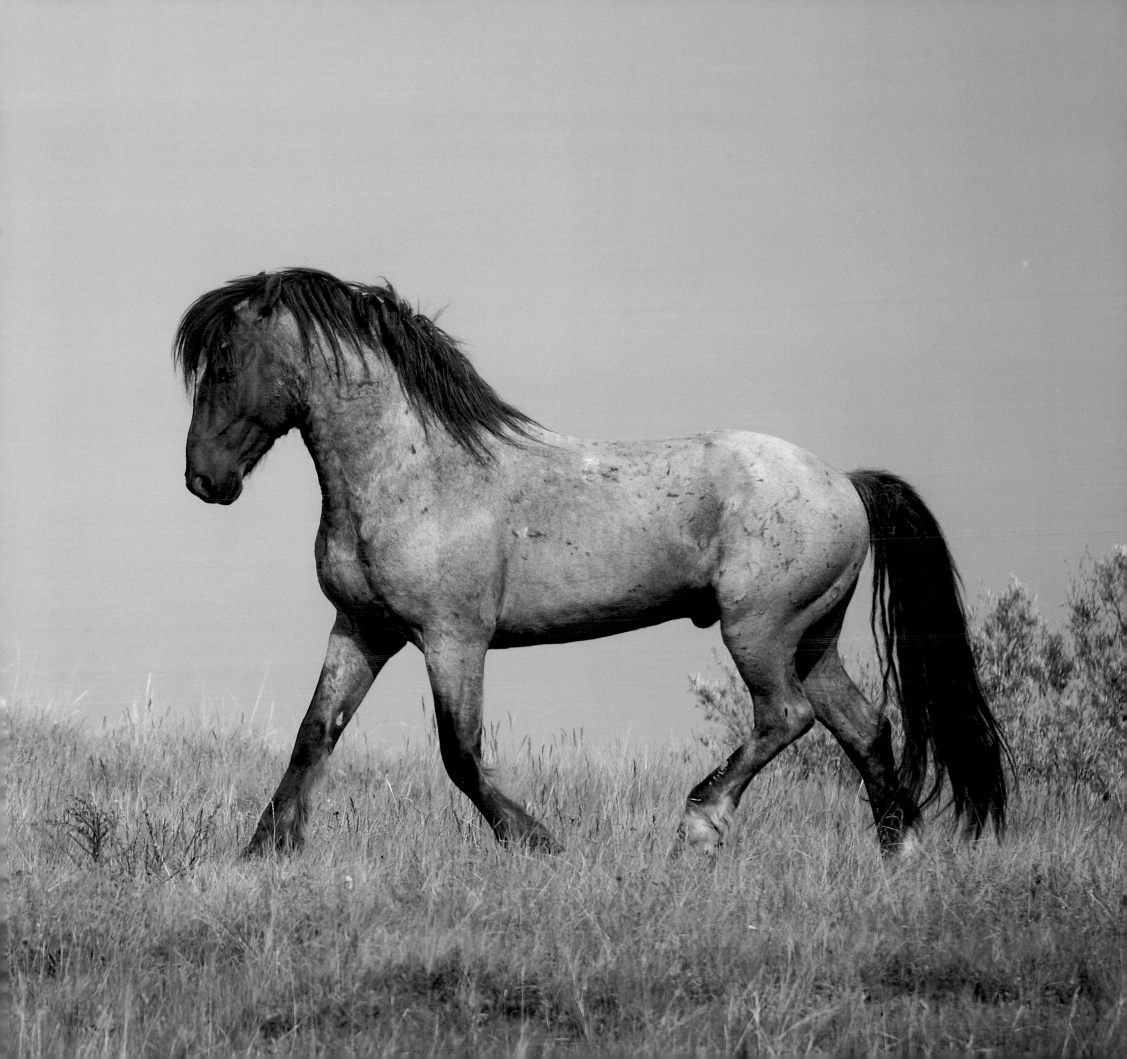

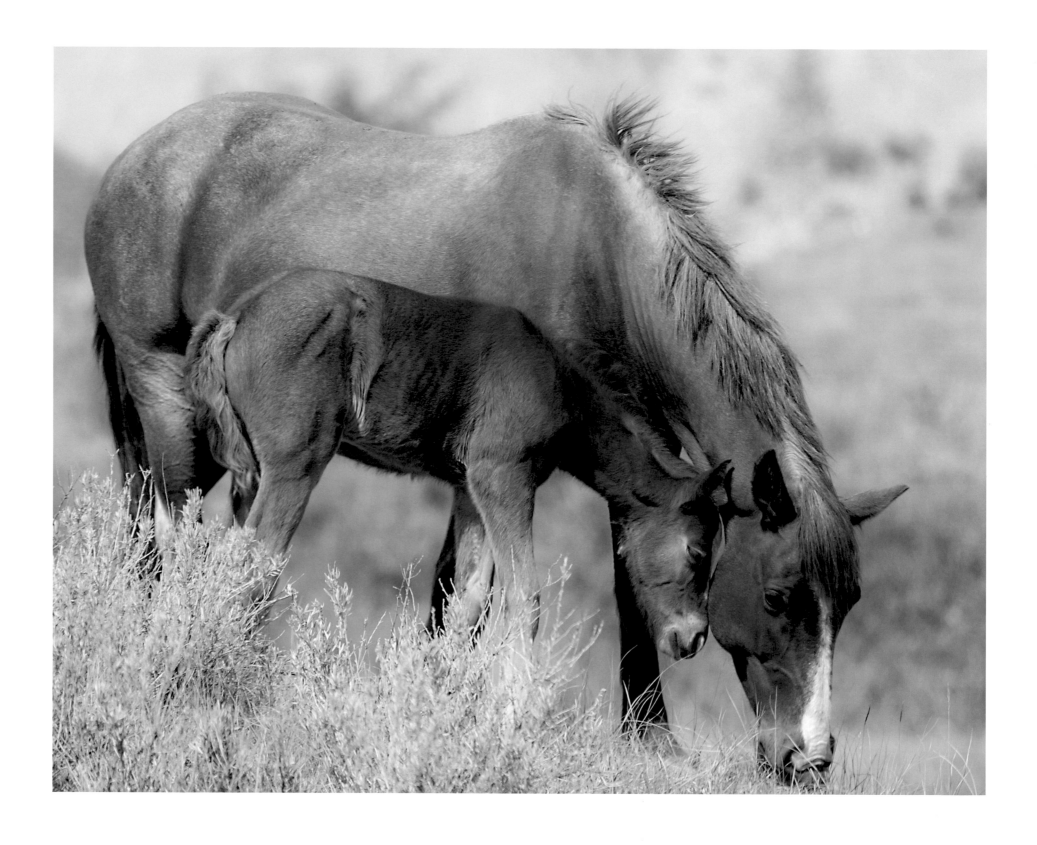

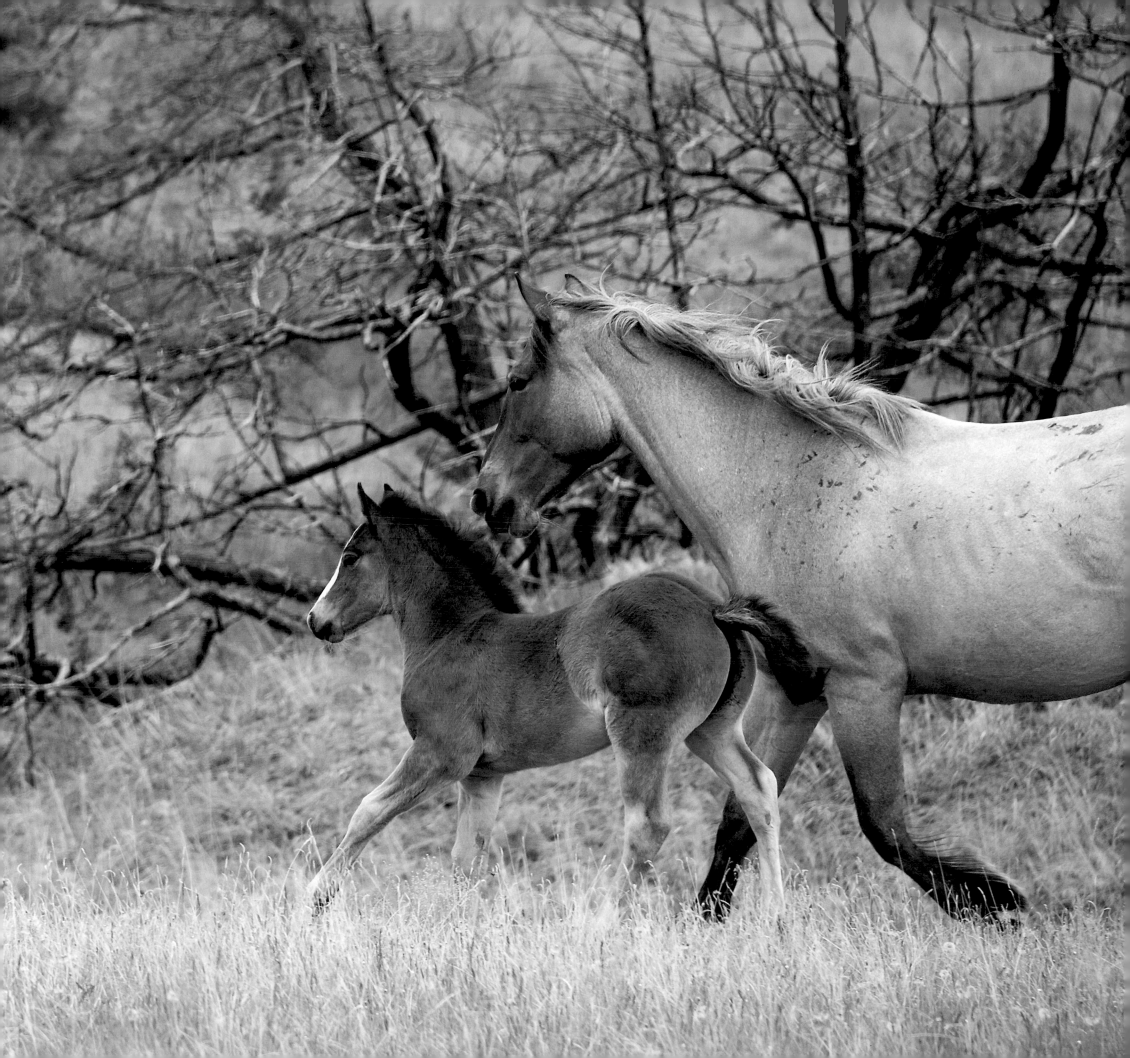

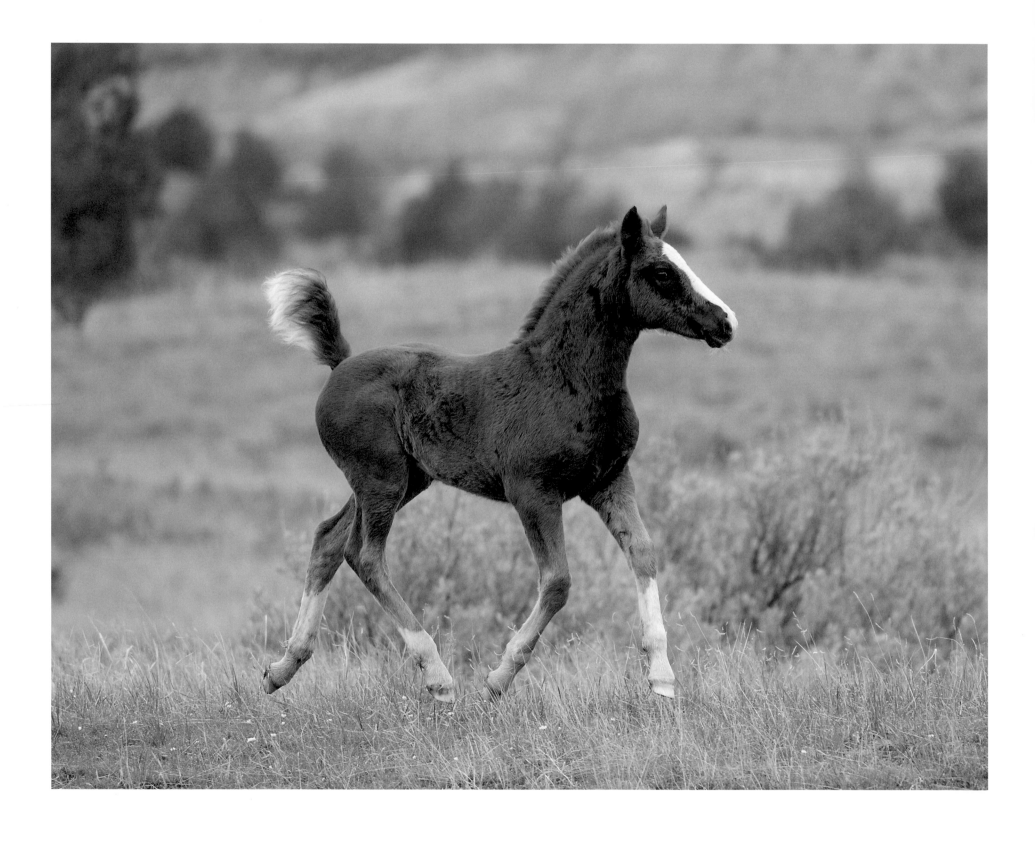

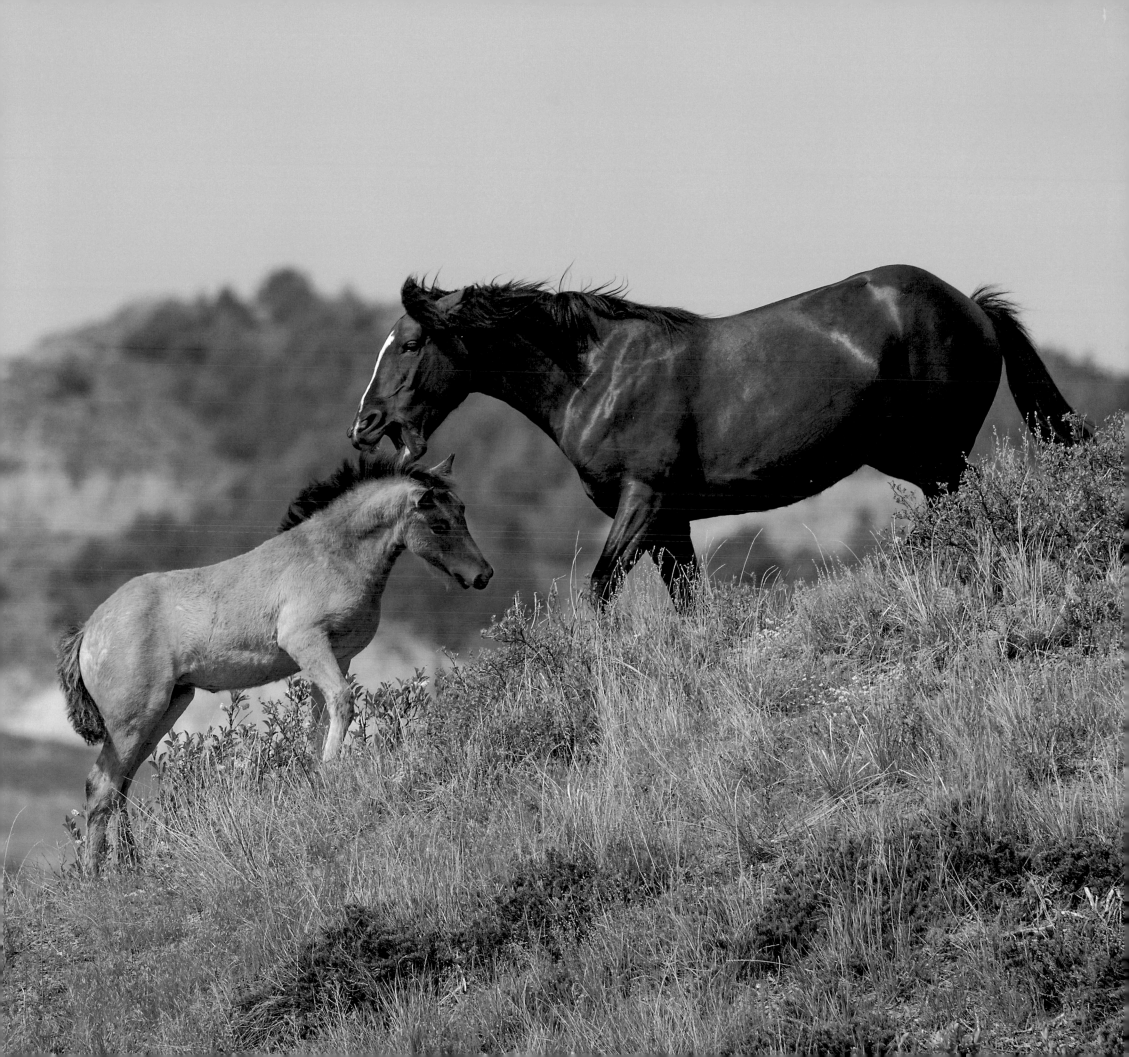

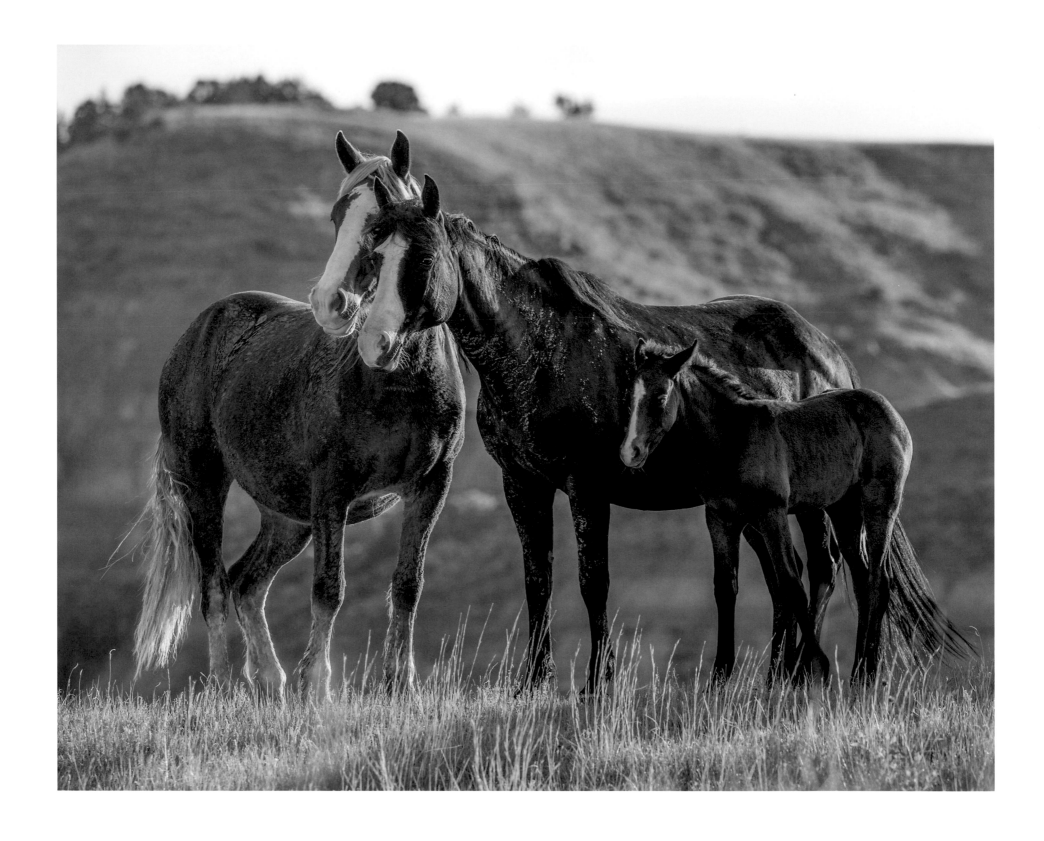

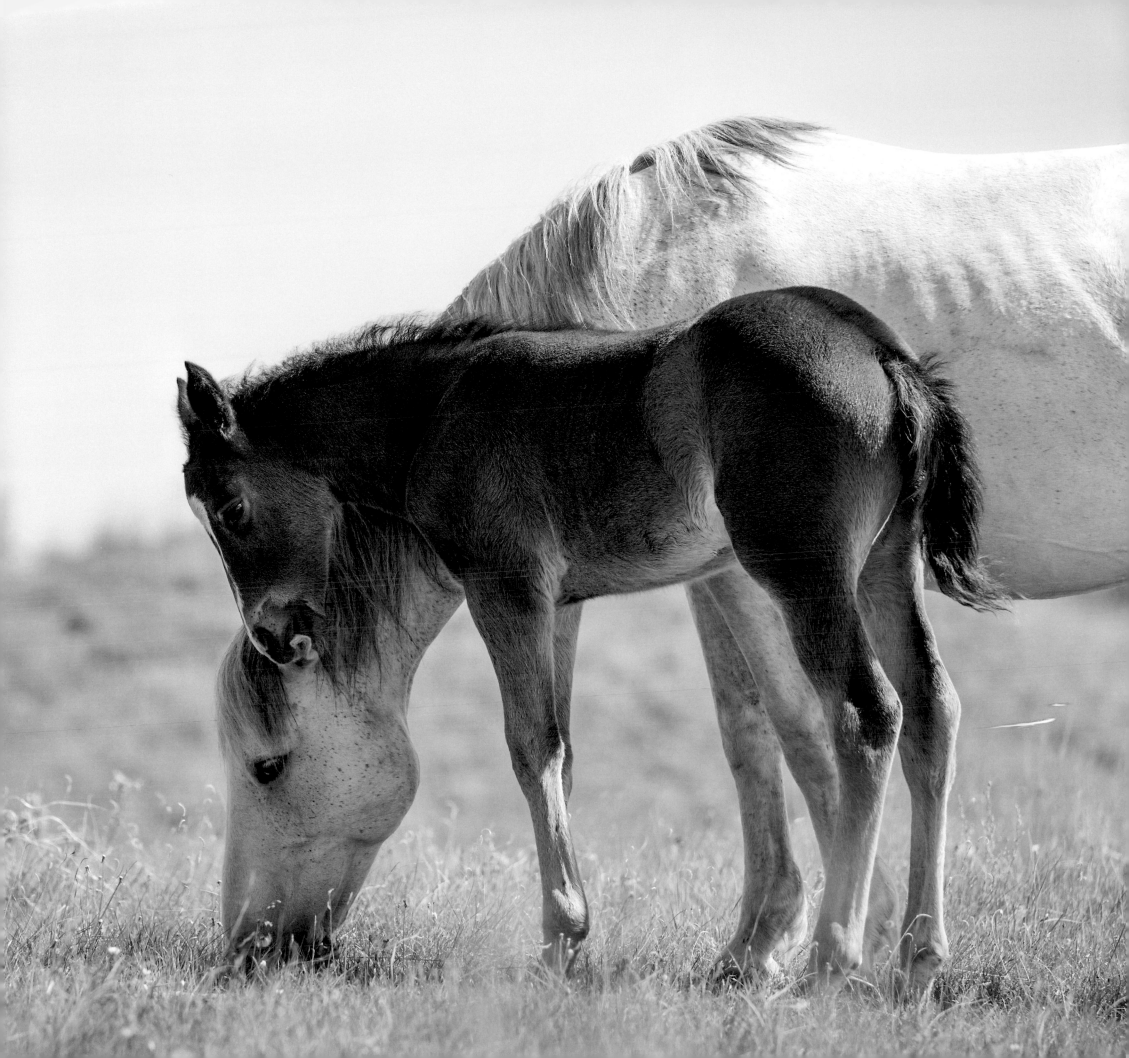

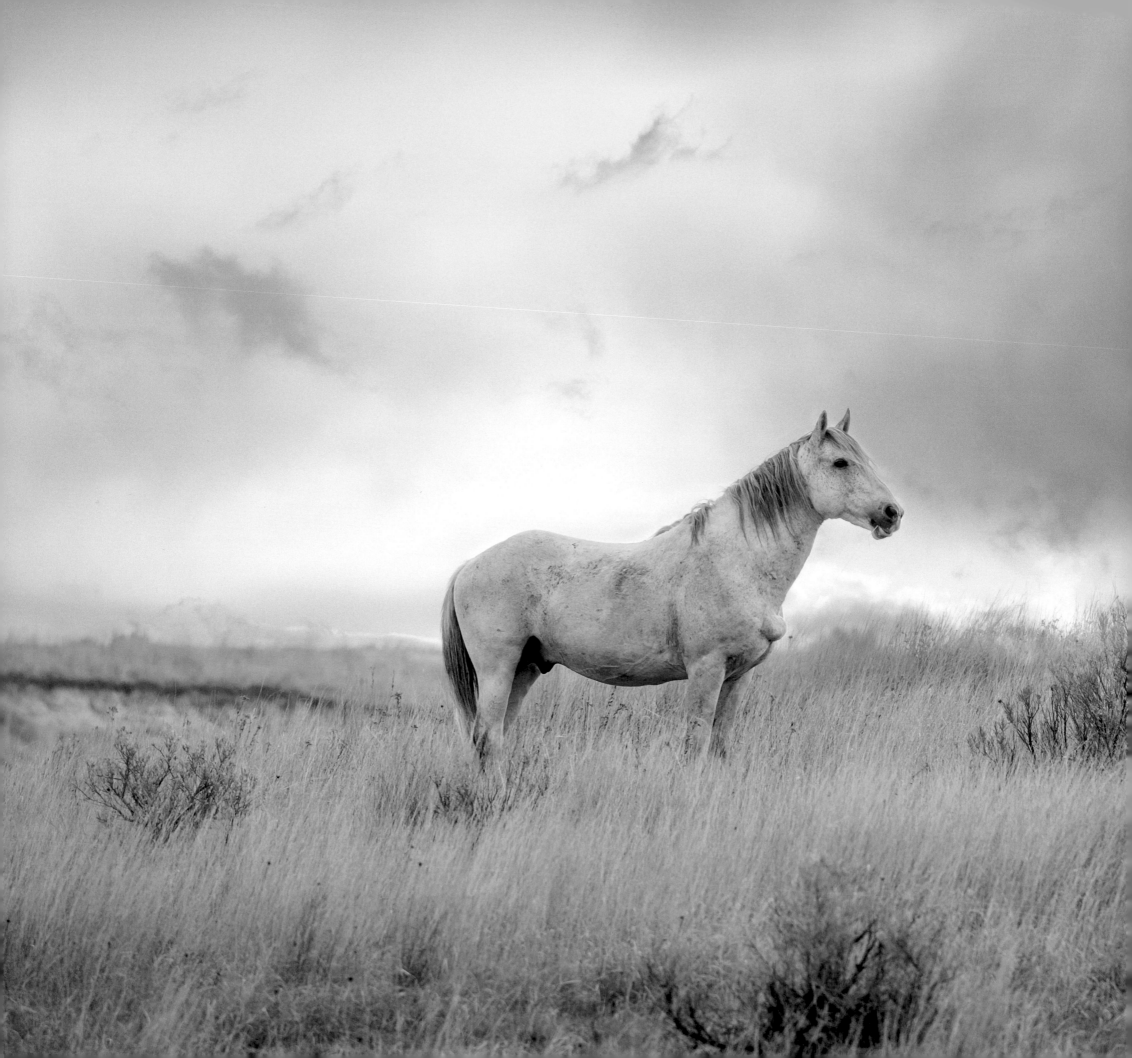

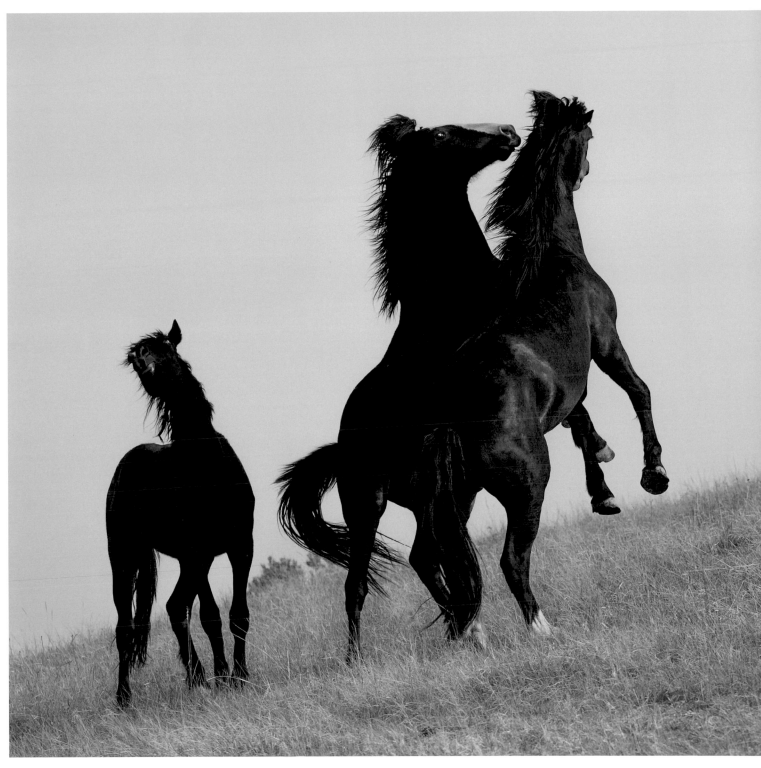

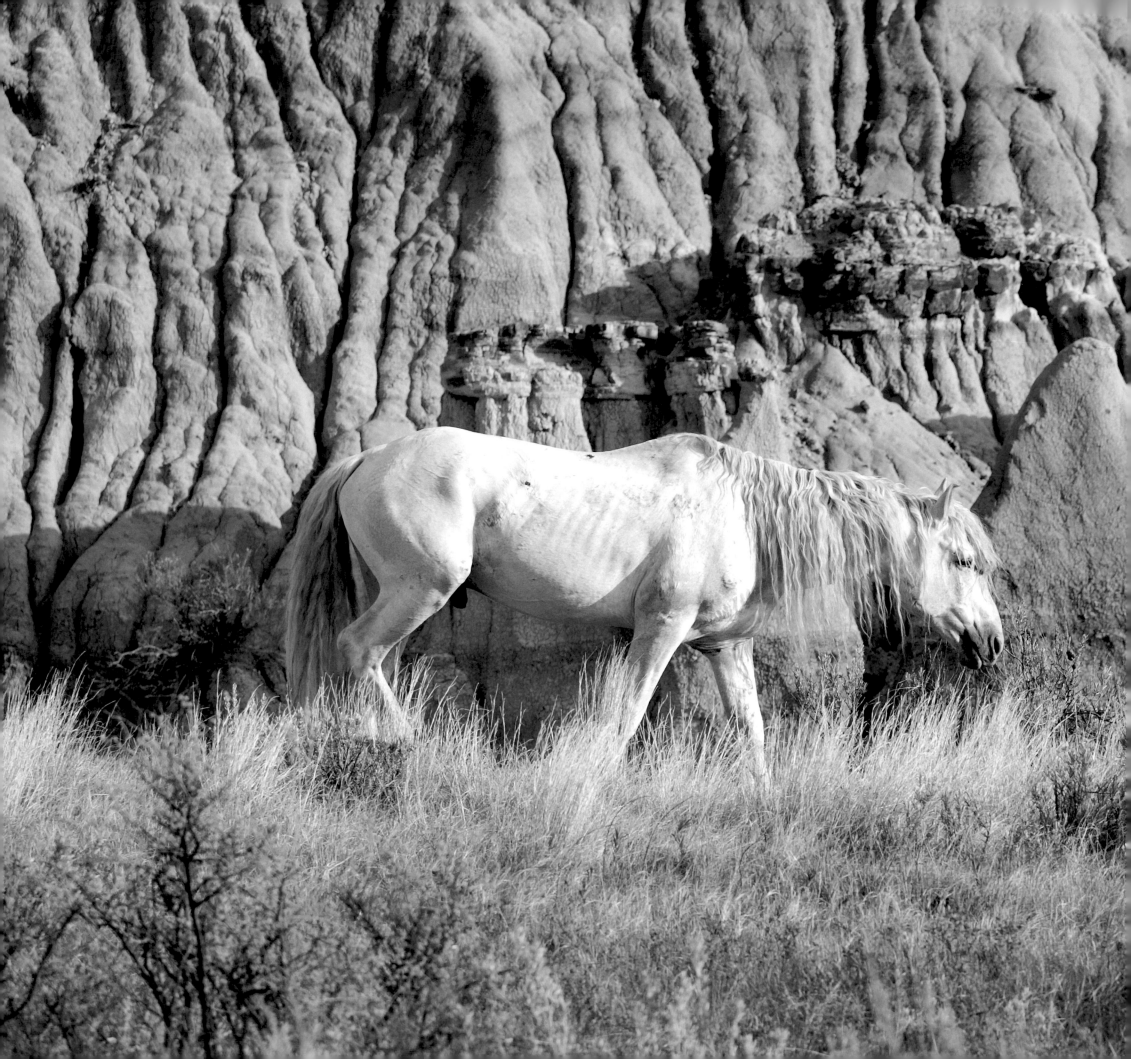

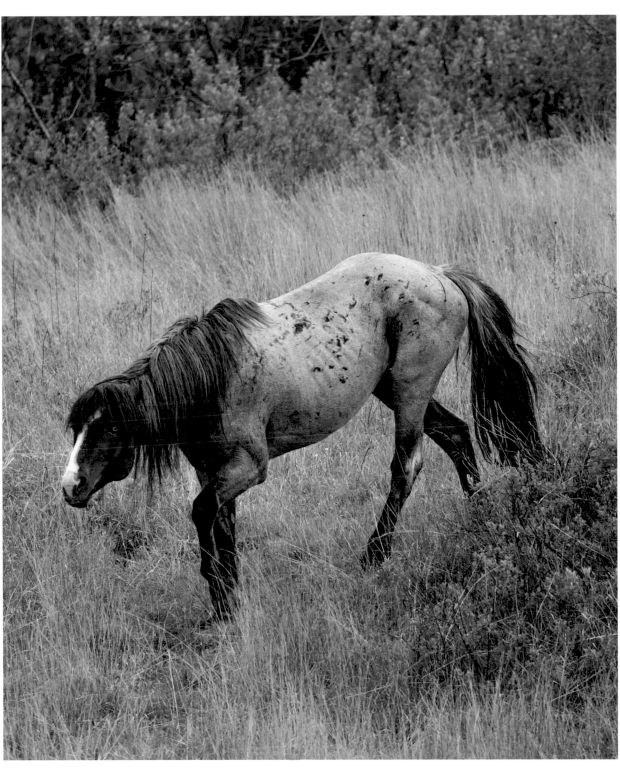

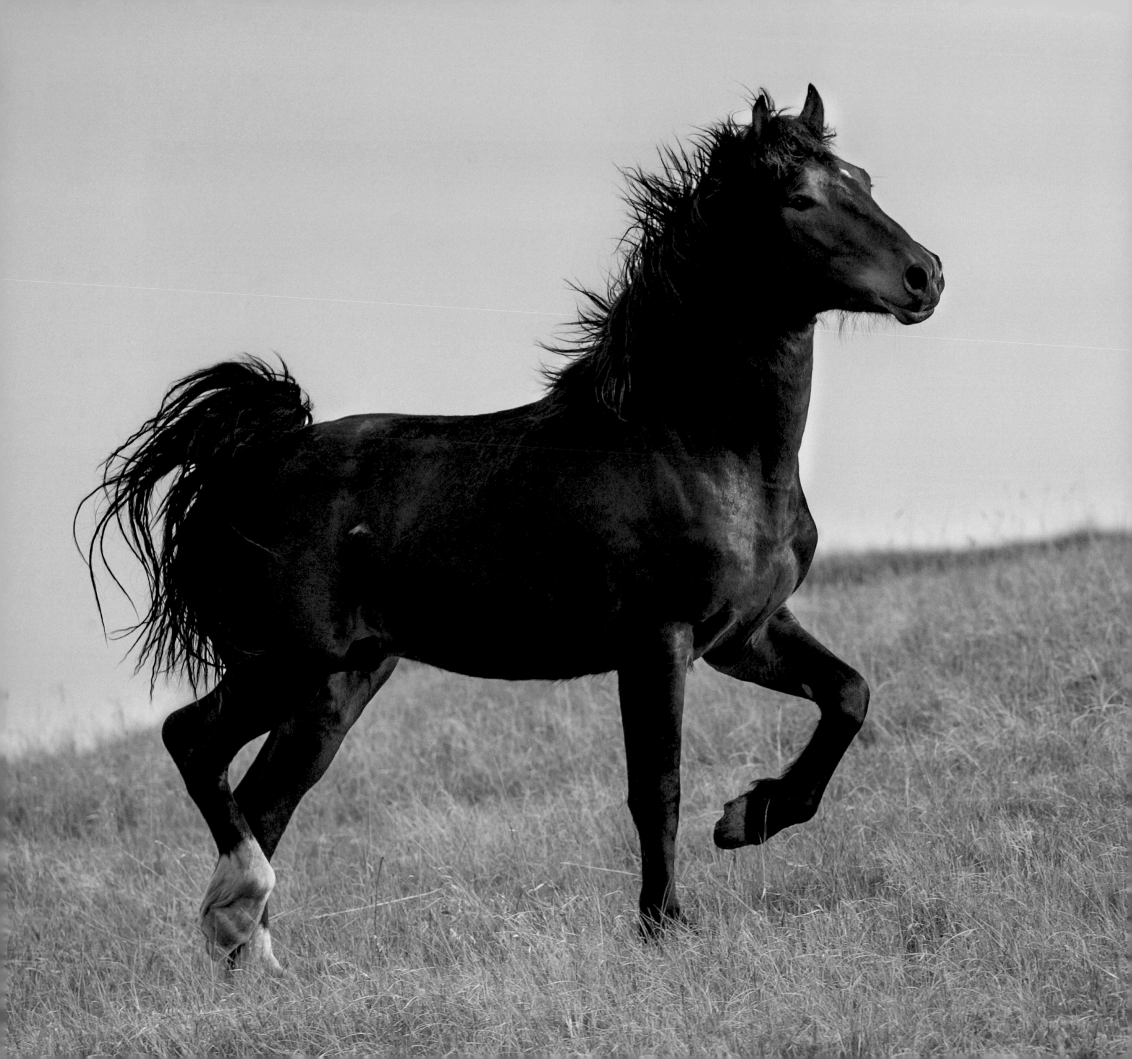

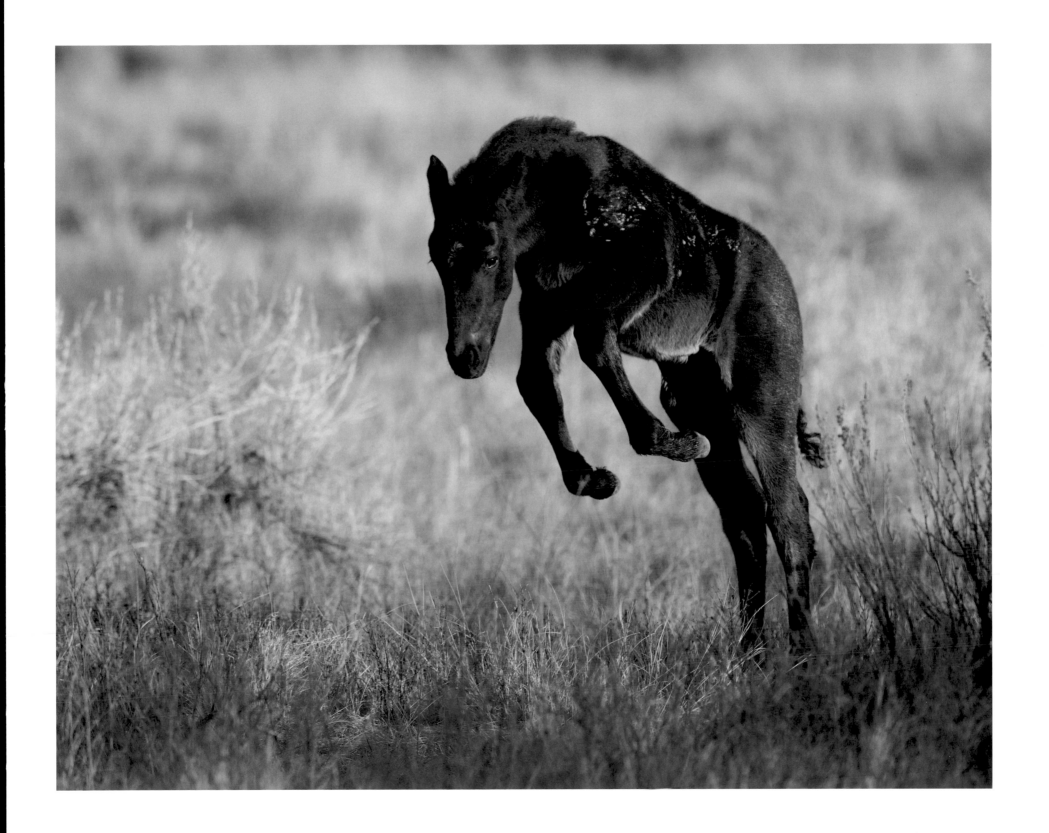

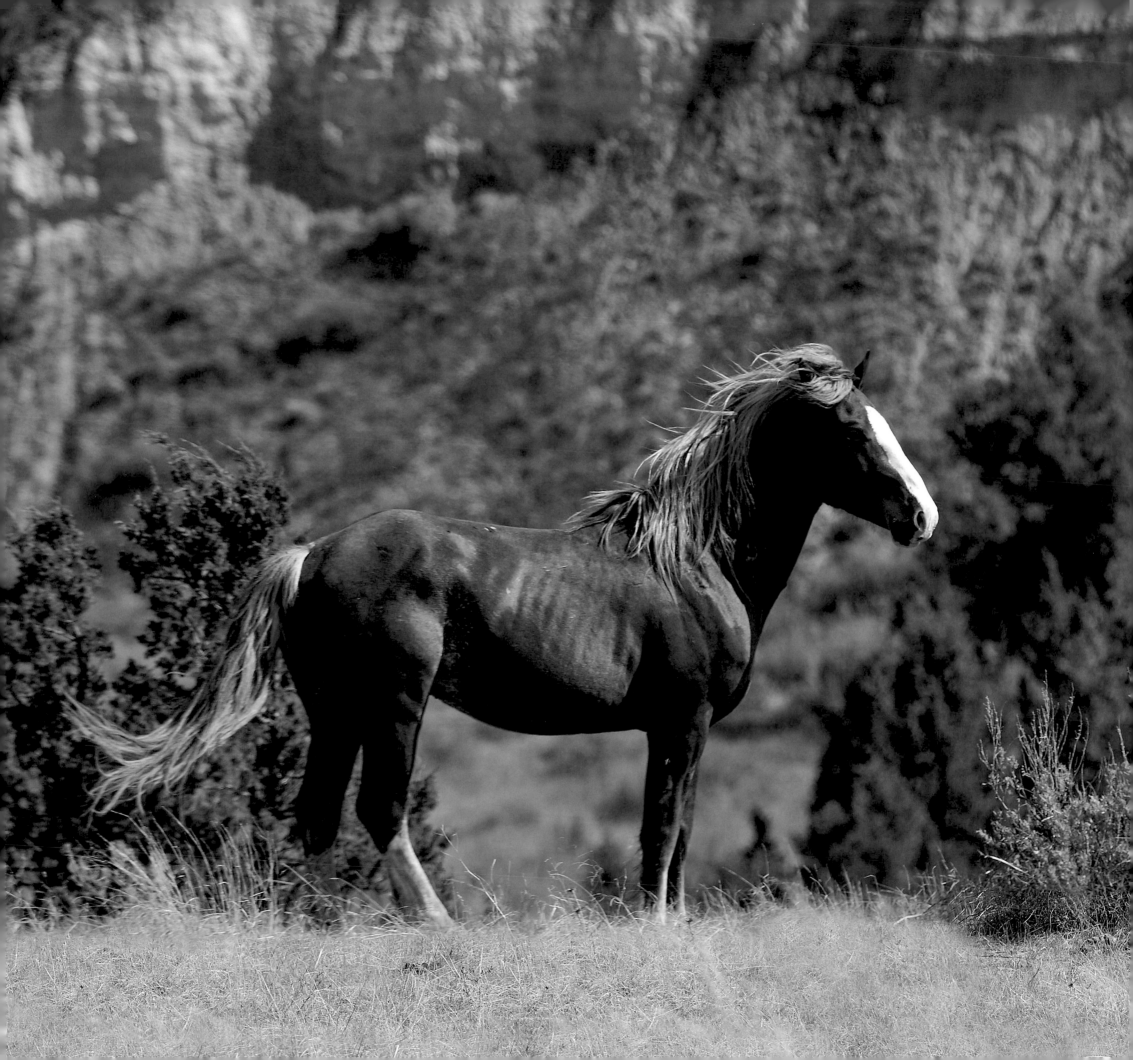

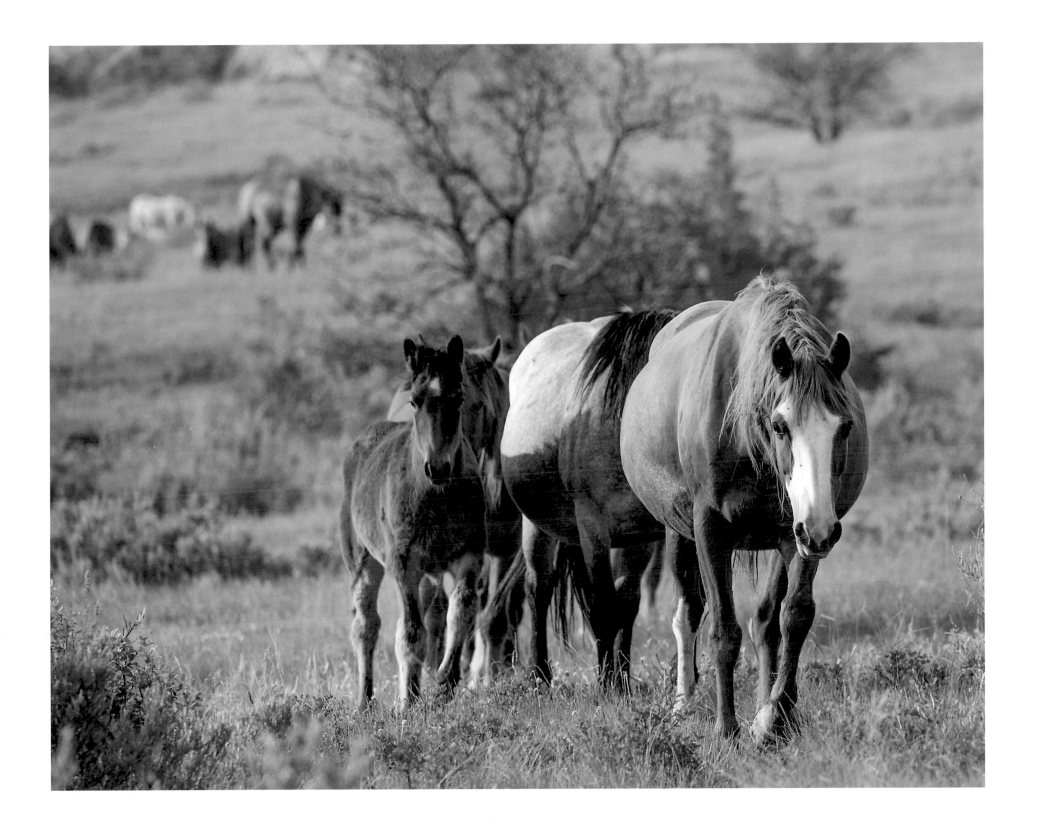

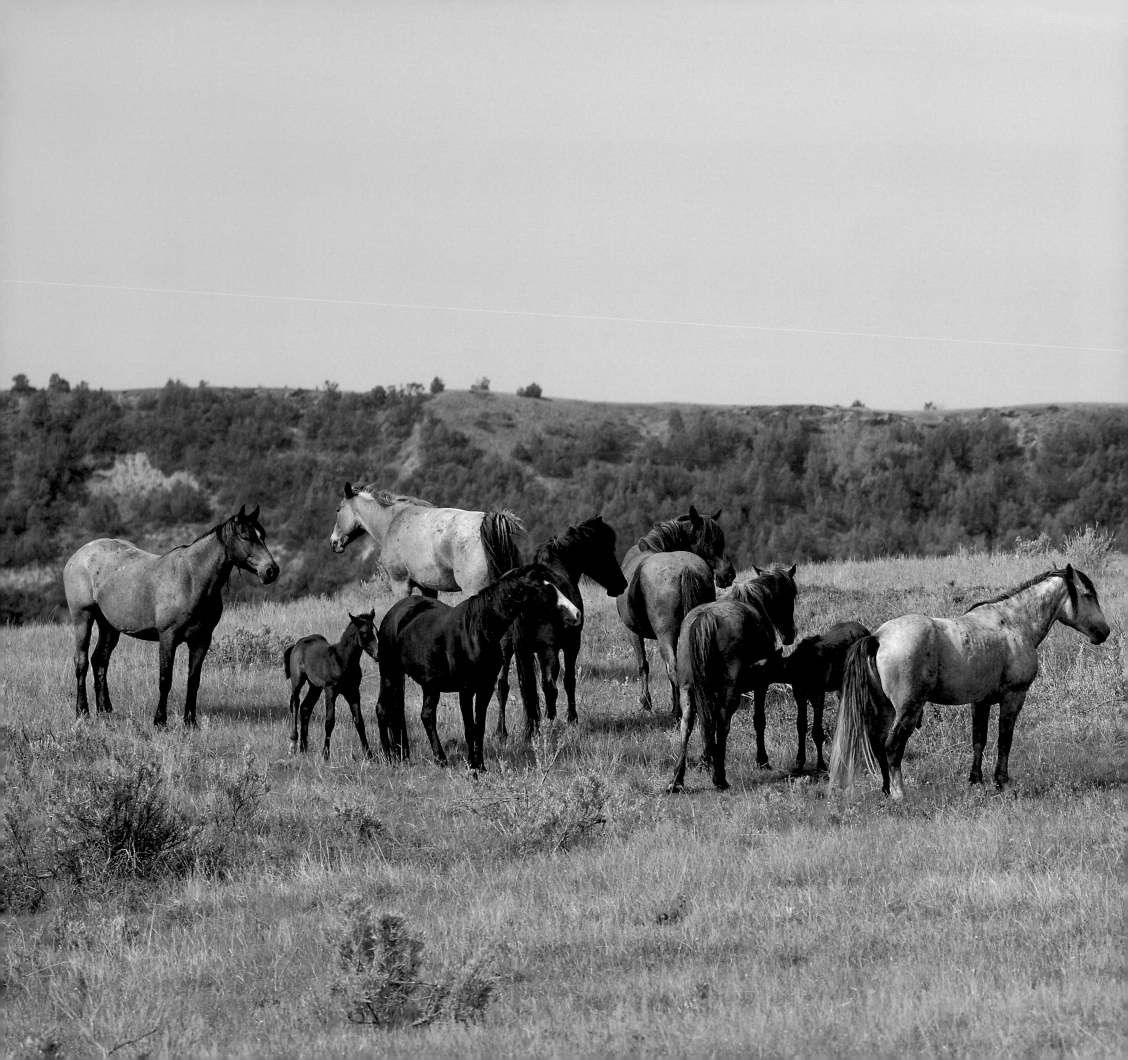

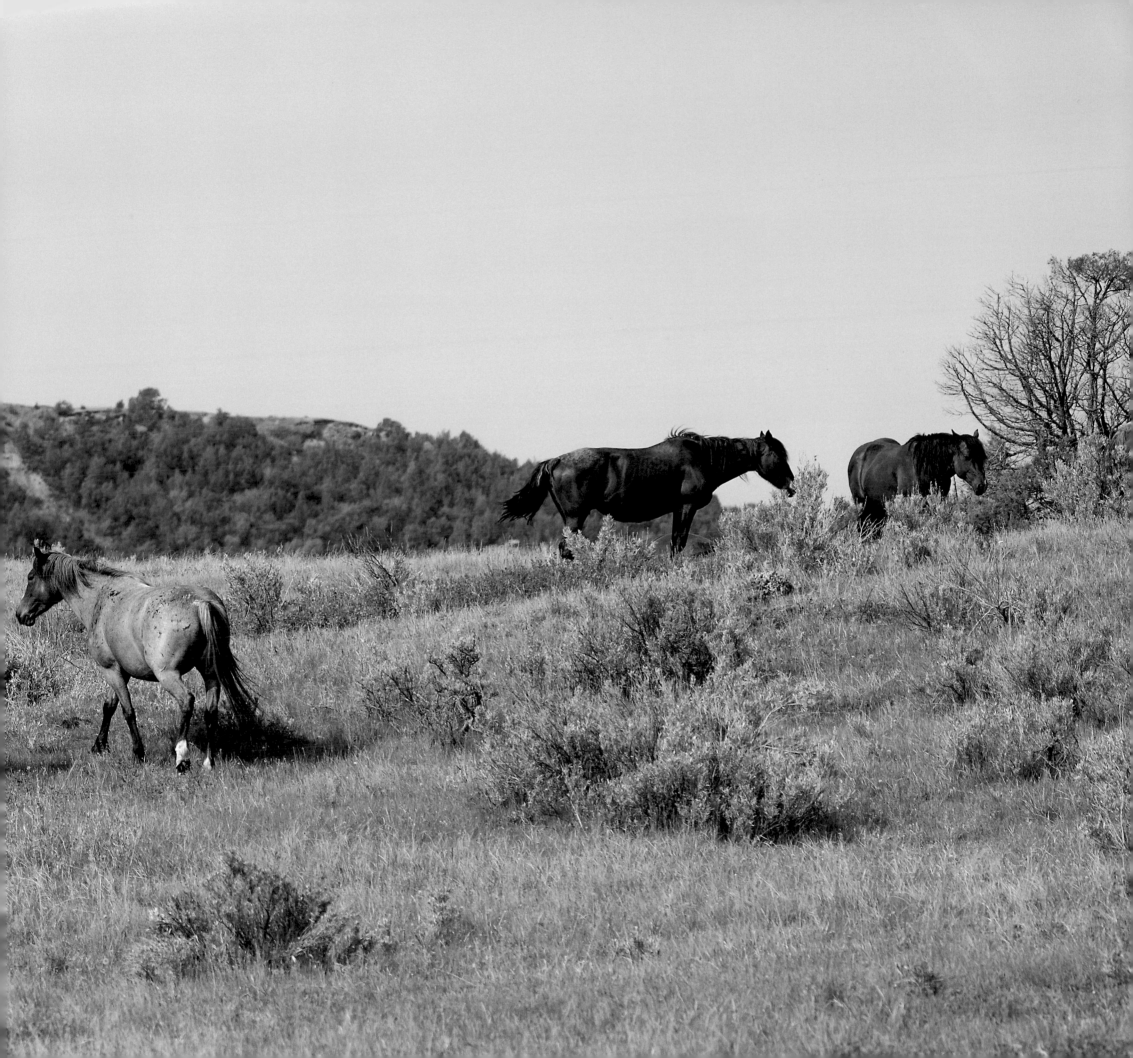

Summer

Bachelors challenge;
Horses huddle in the heat;
Strongest stallion wins.

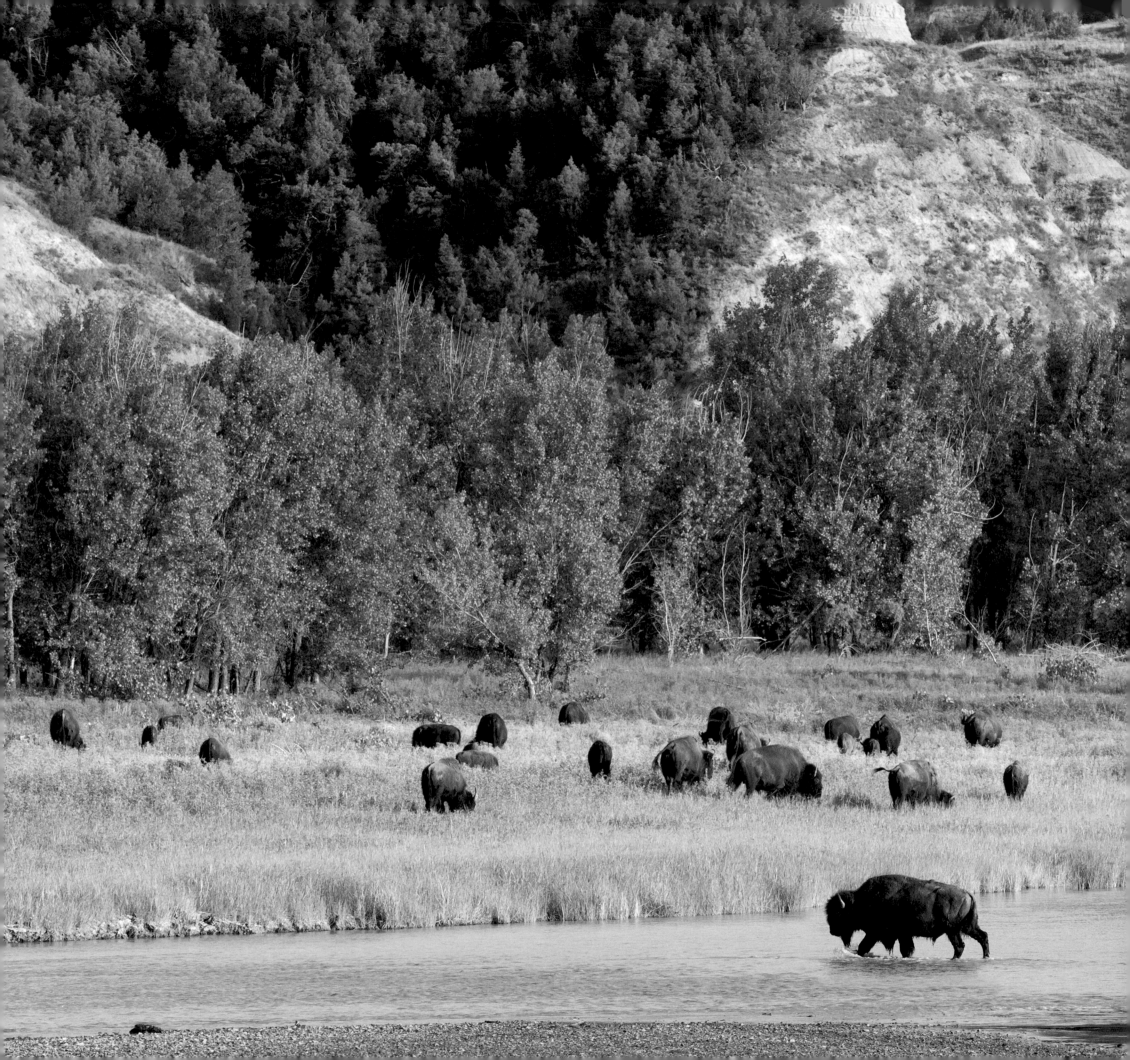

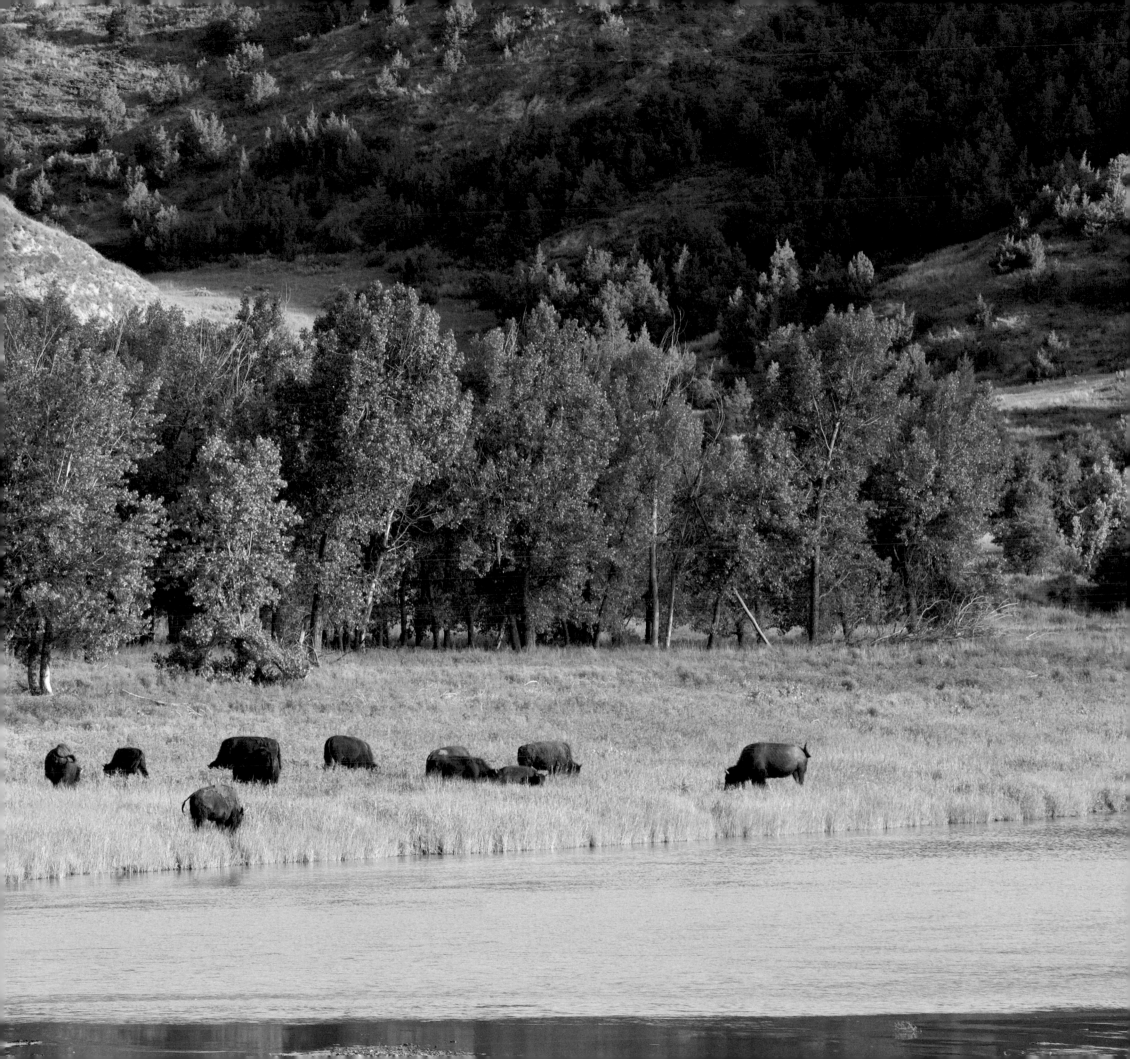

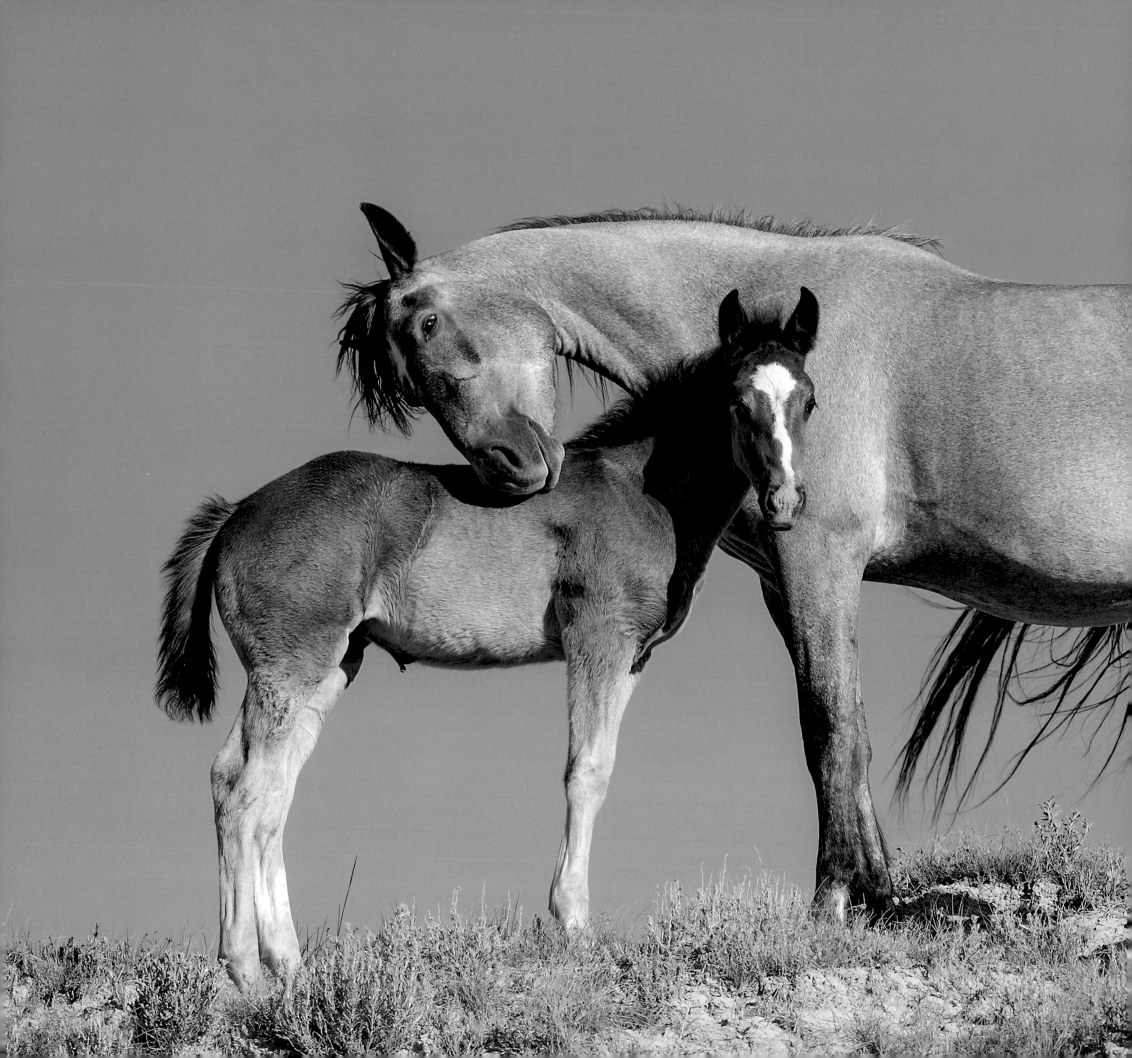

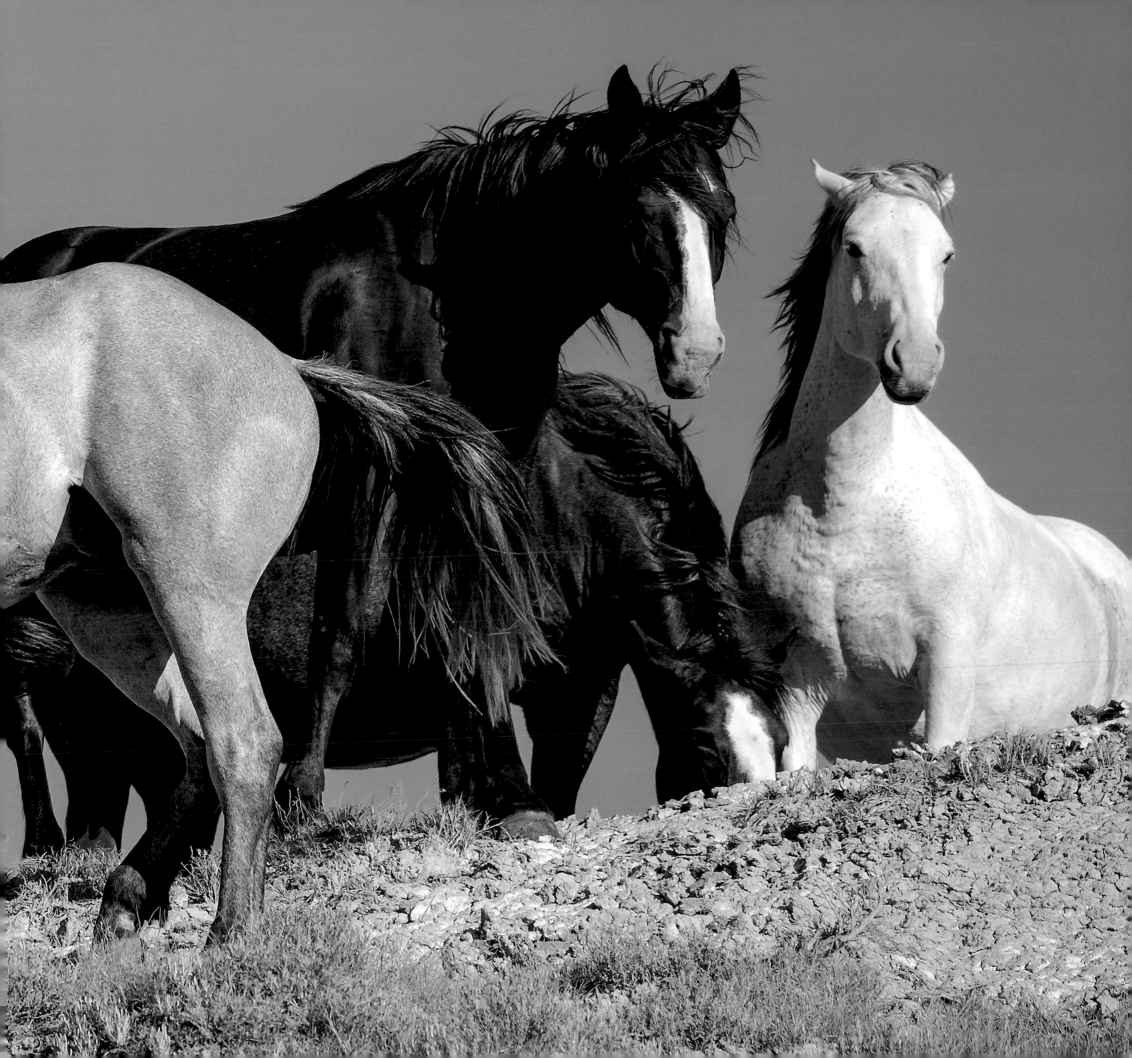

Indy and Volt, fighting like teenagers trying to establish their position in the band. In the unsettling heat of summer such roughhousing is common. Soon some of the colts will be pushed out by the band stallion to join other bachelors, or to face life on their own.

And if there is more than one foal in a band, by now they have become best friends, often sleeping side-by-side or chewing each other's ears or manes.

All the while, the high temperatures of summertime bring the horses close together in huddles, all swishing their tails to find relief from the swarming flies. To escape the heat, they may seek out shelter in caves, on top of a butte, or stand in the open hoping to catch a breeze, as they await the cooler days of autumn.

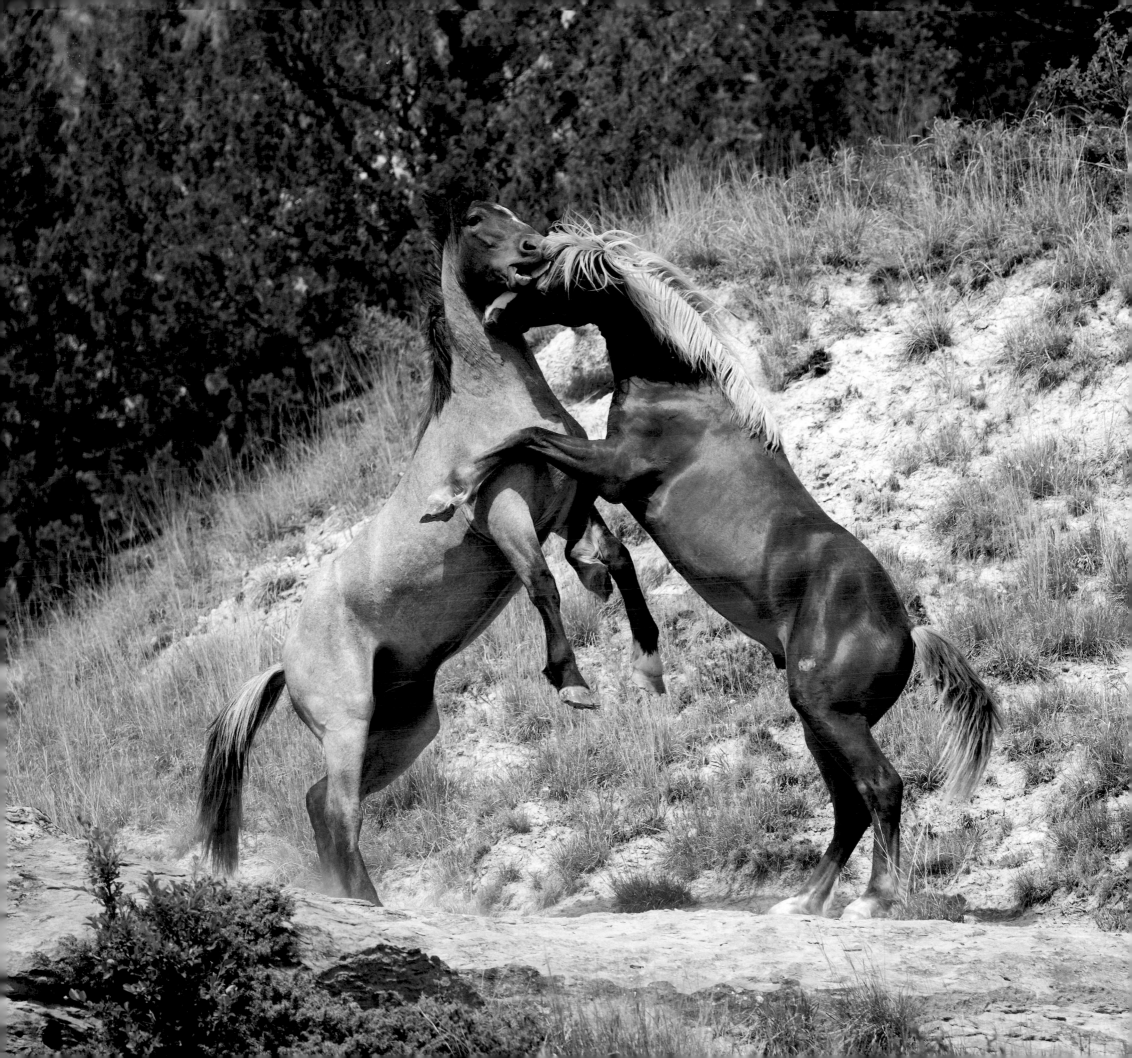

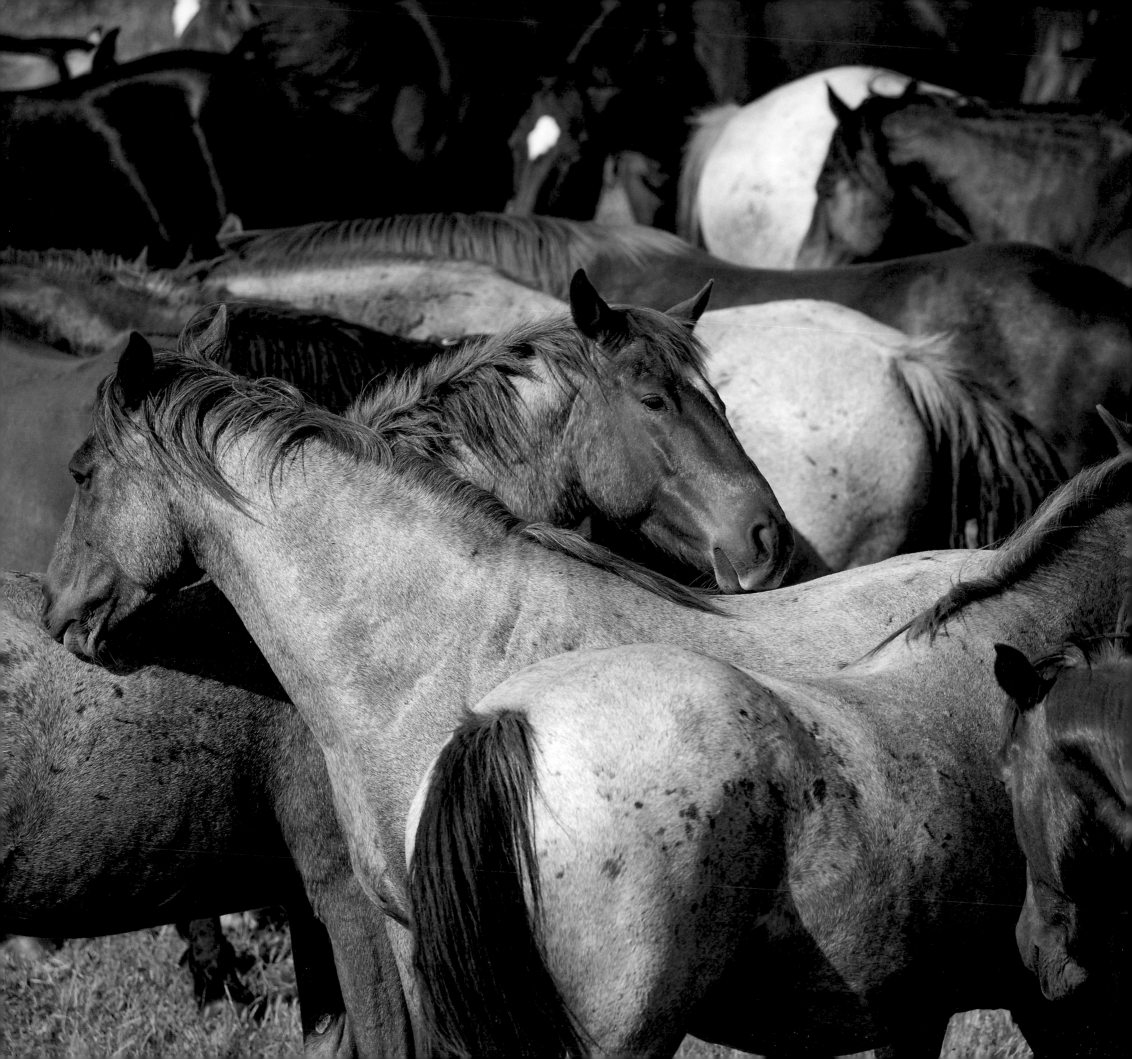

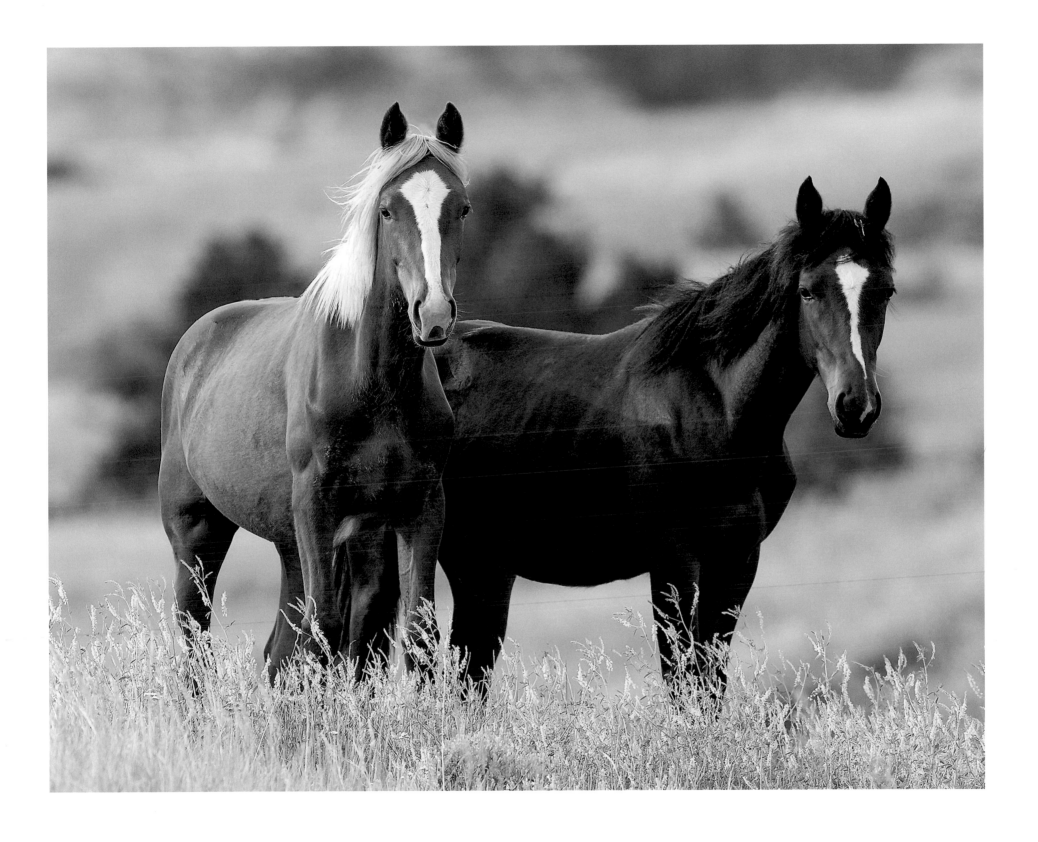

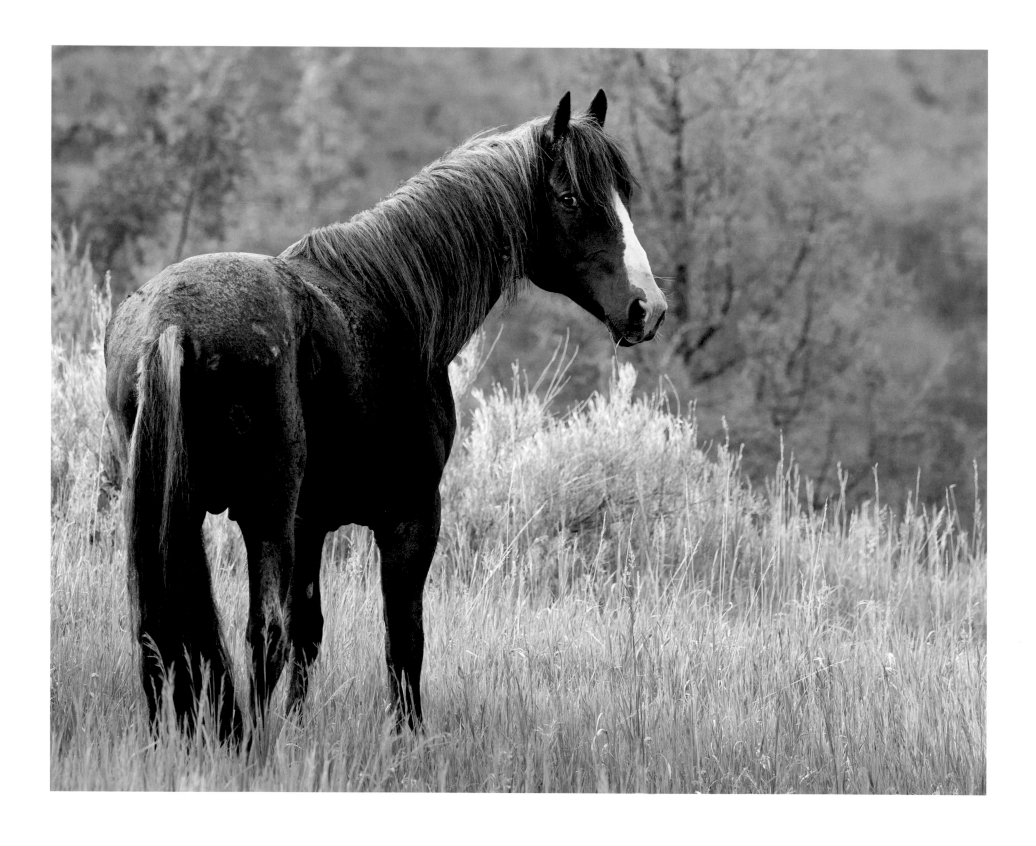

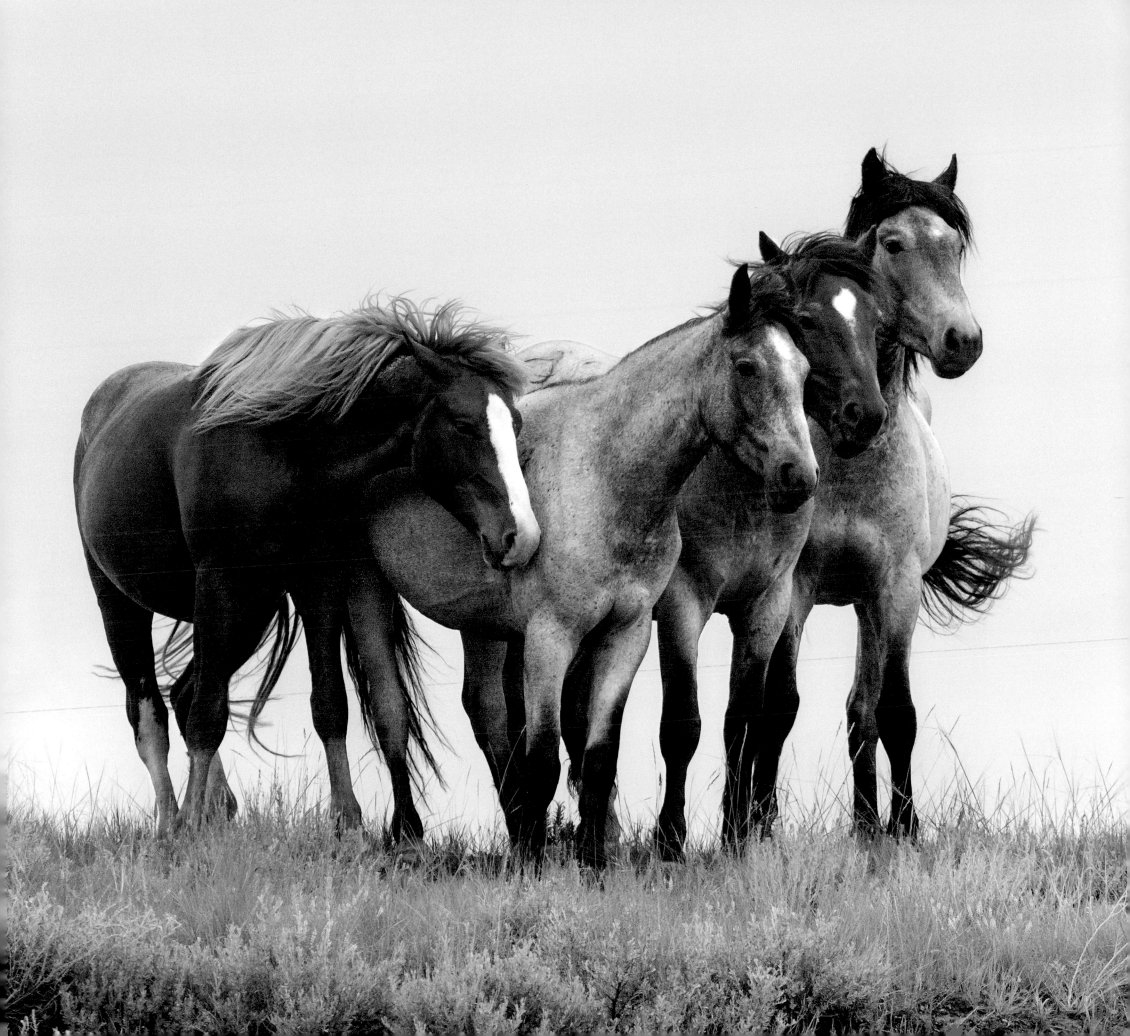

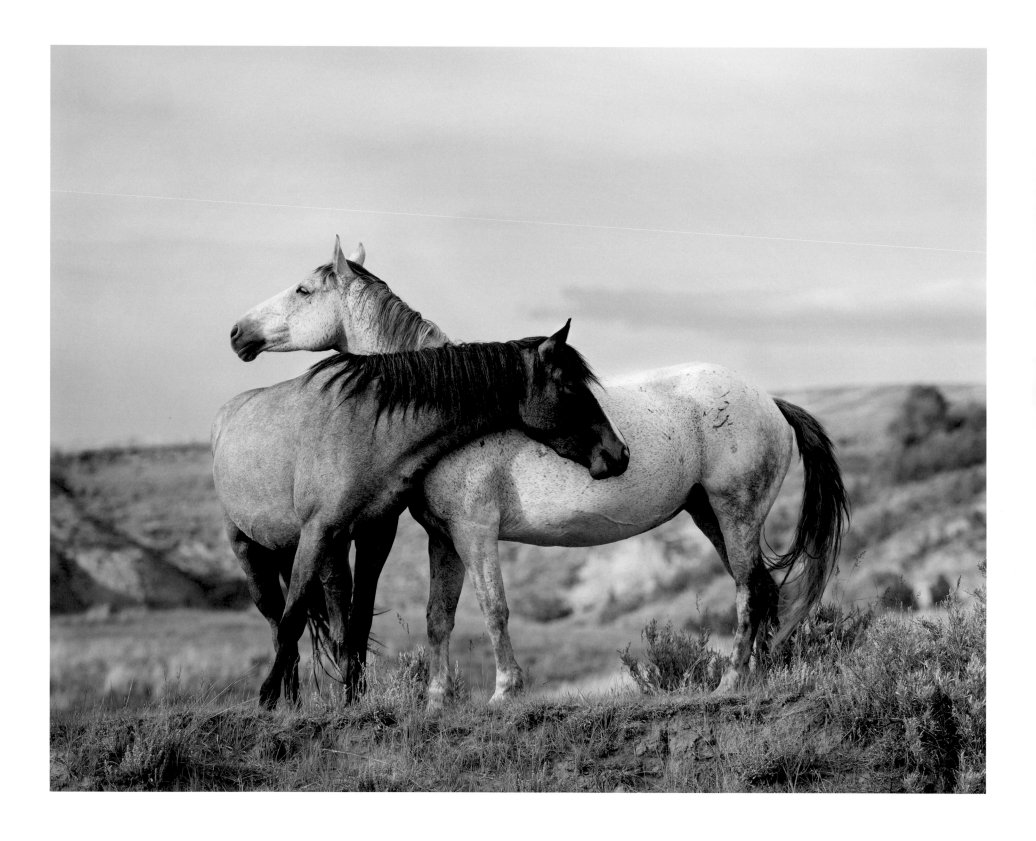

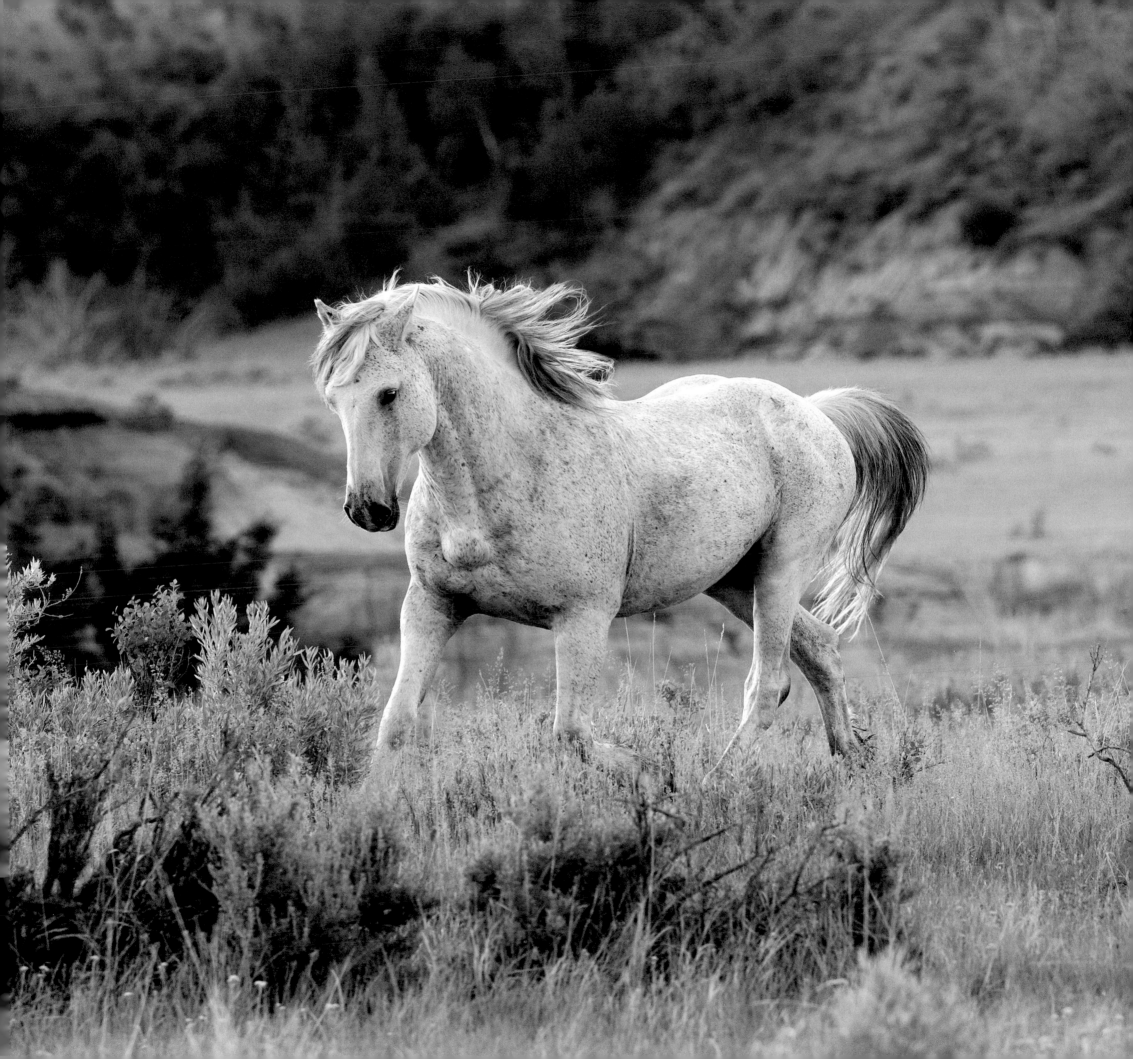

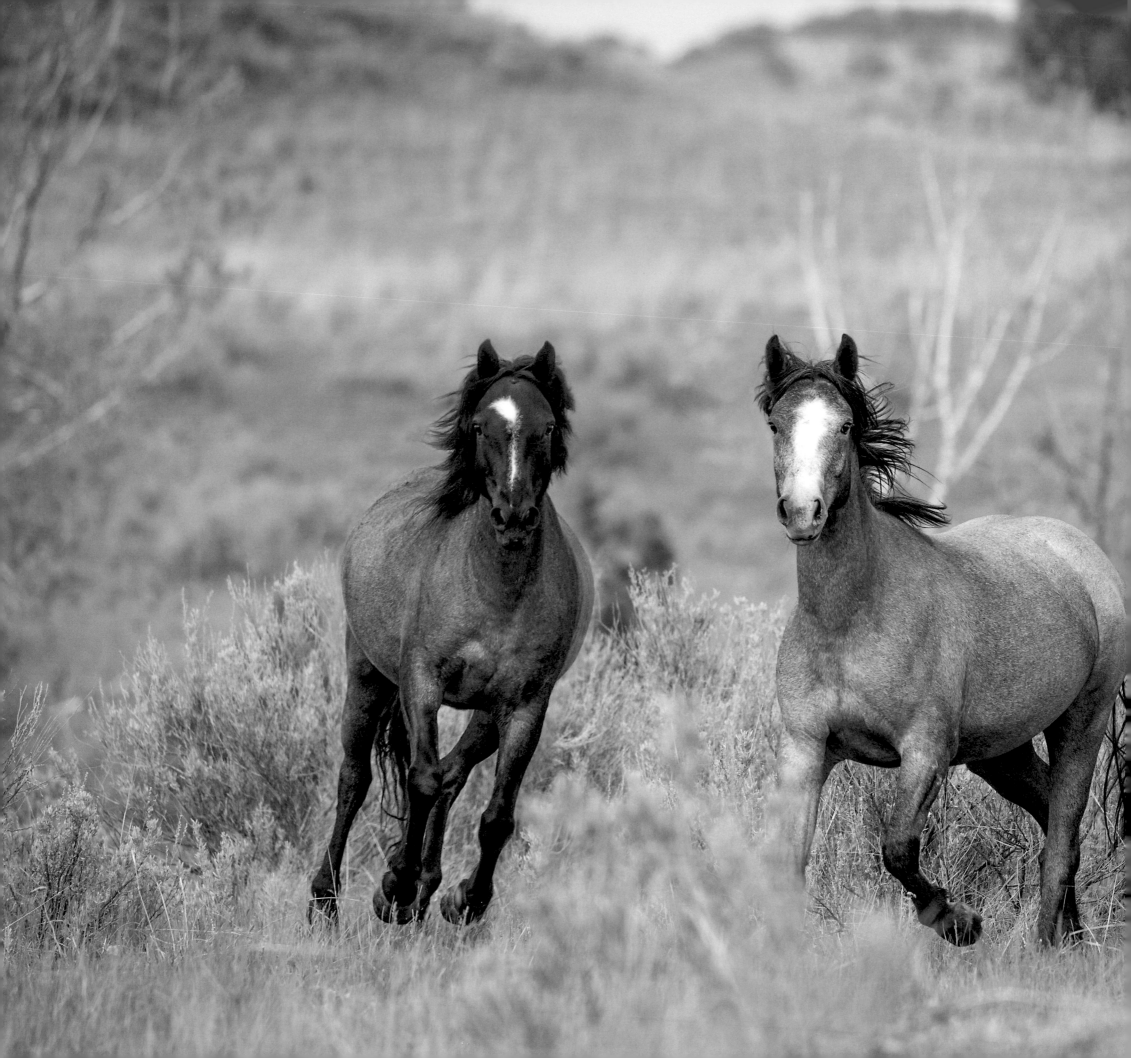

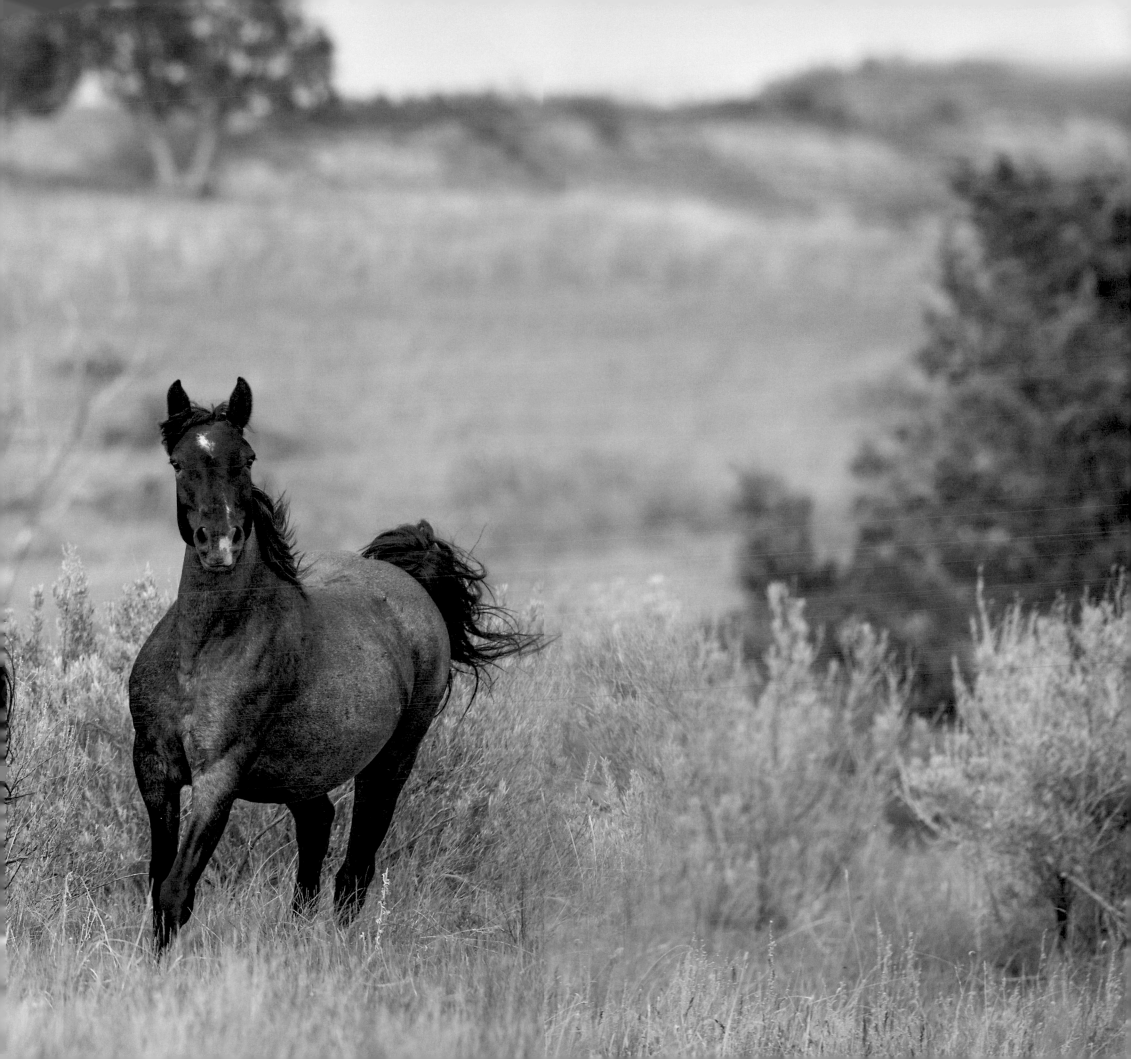

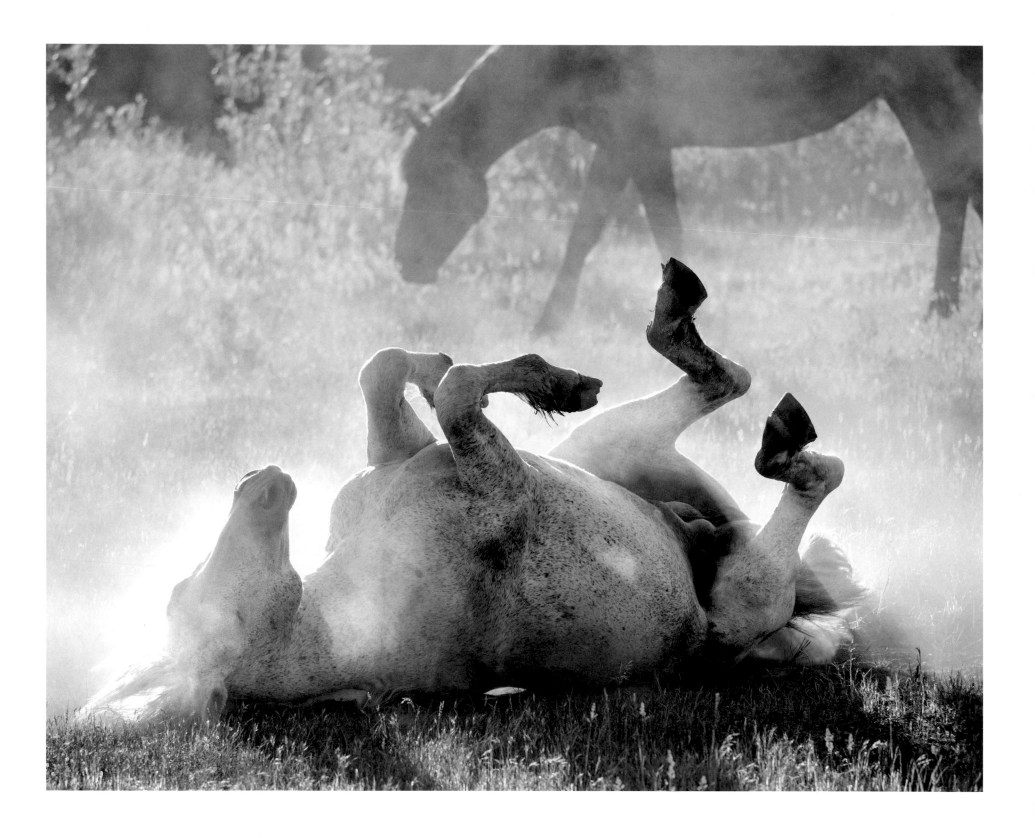

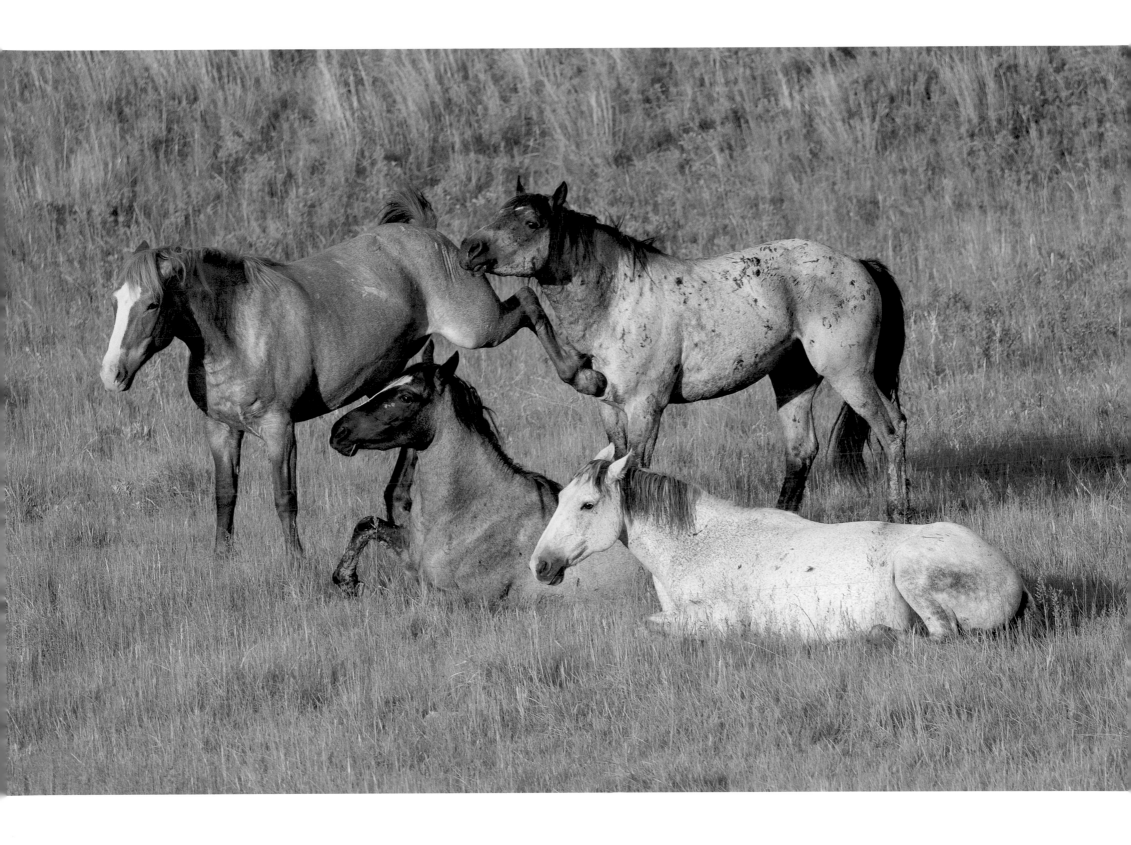

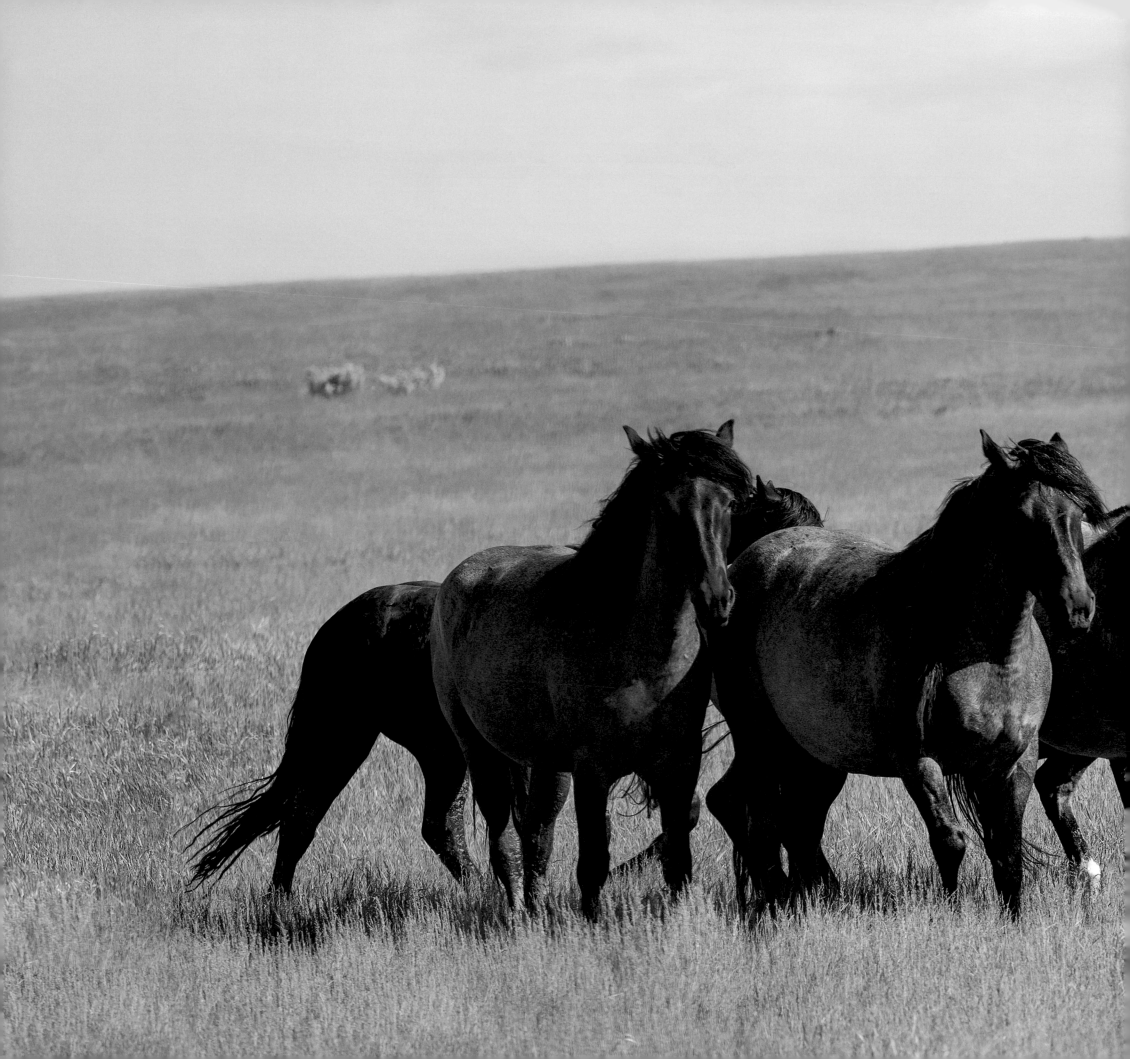

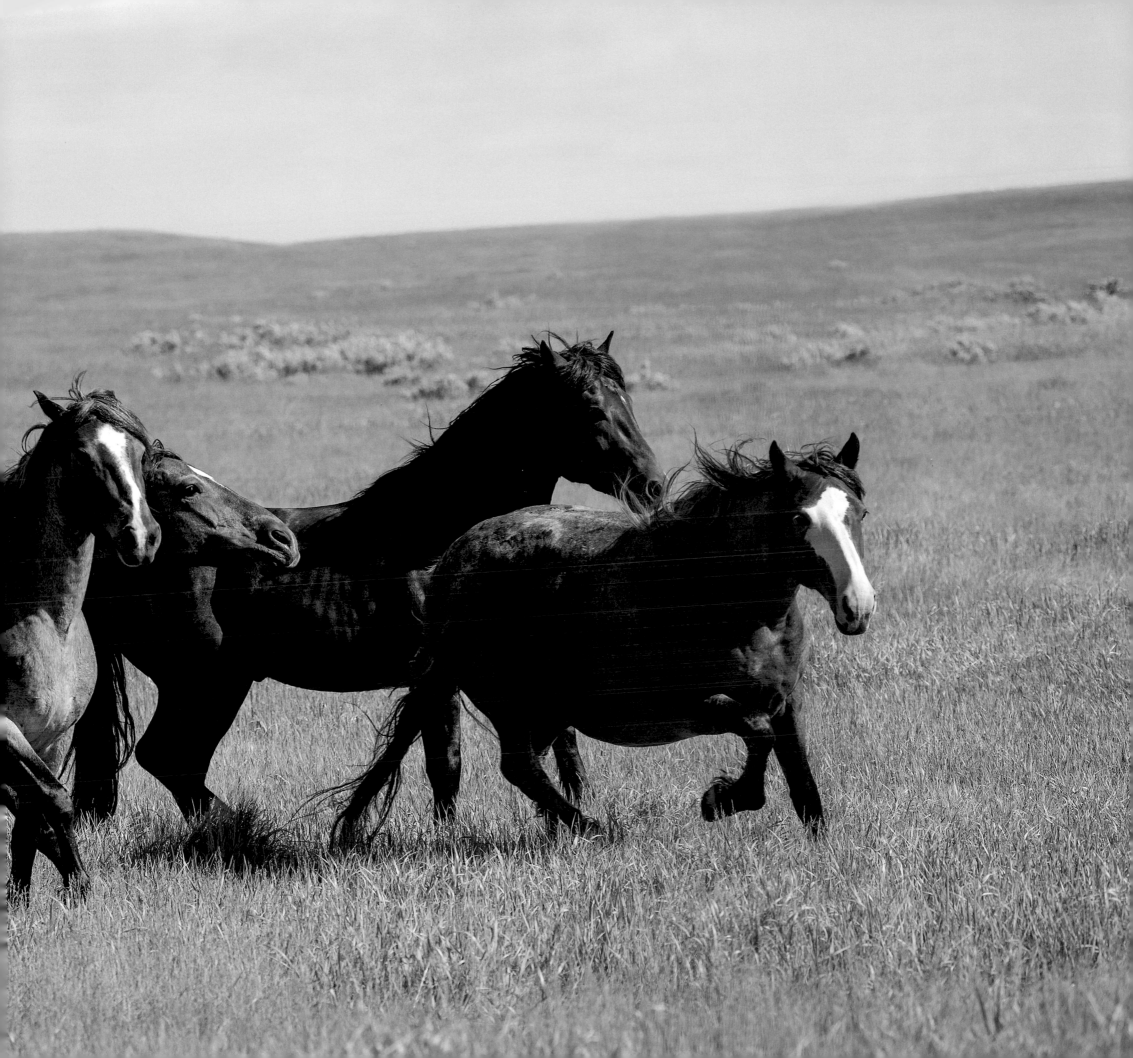

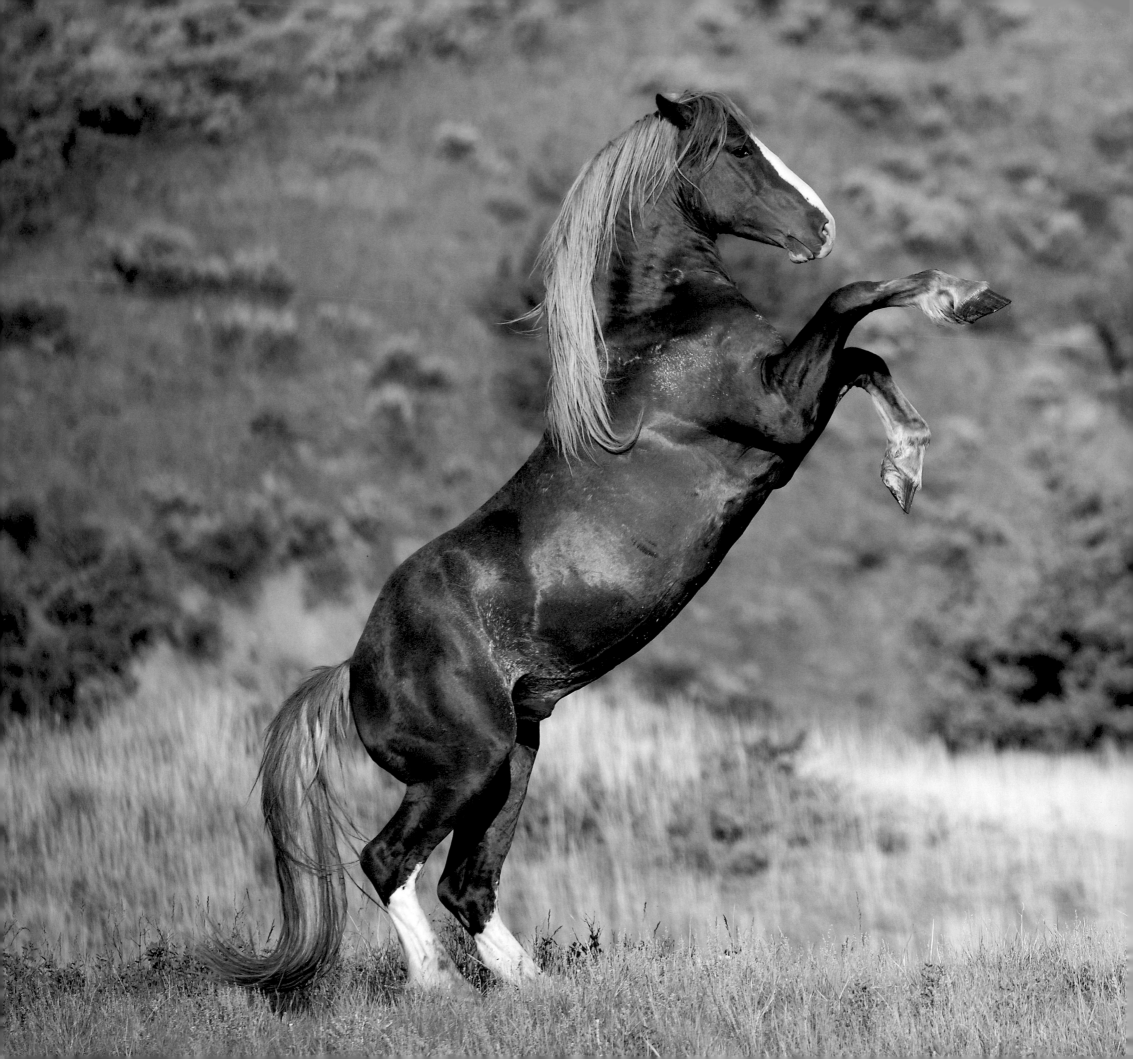

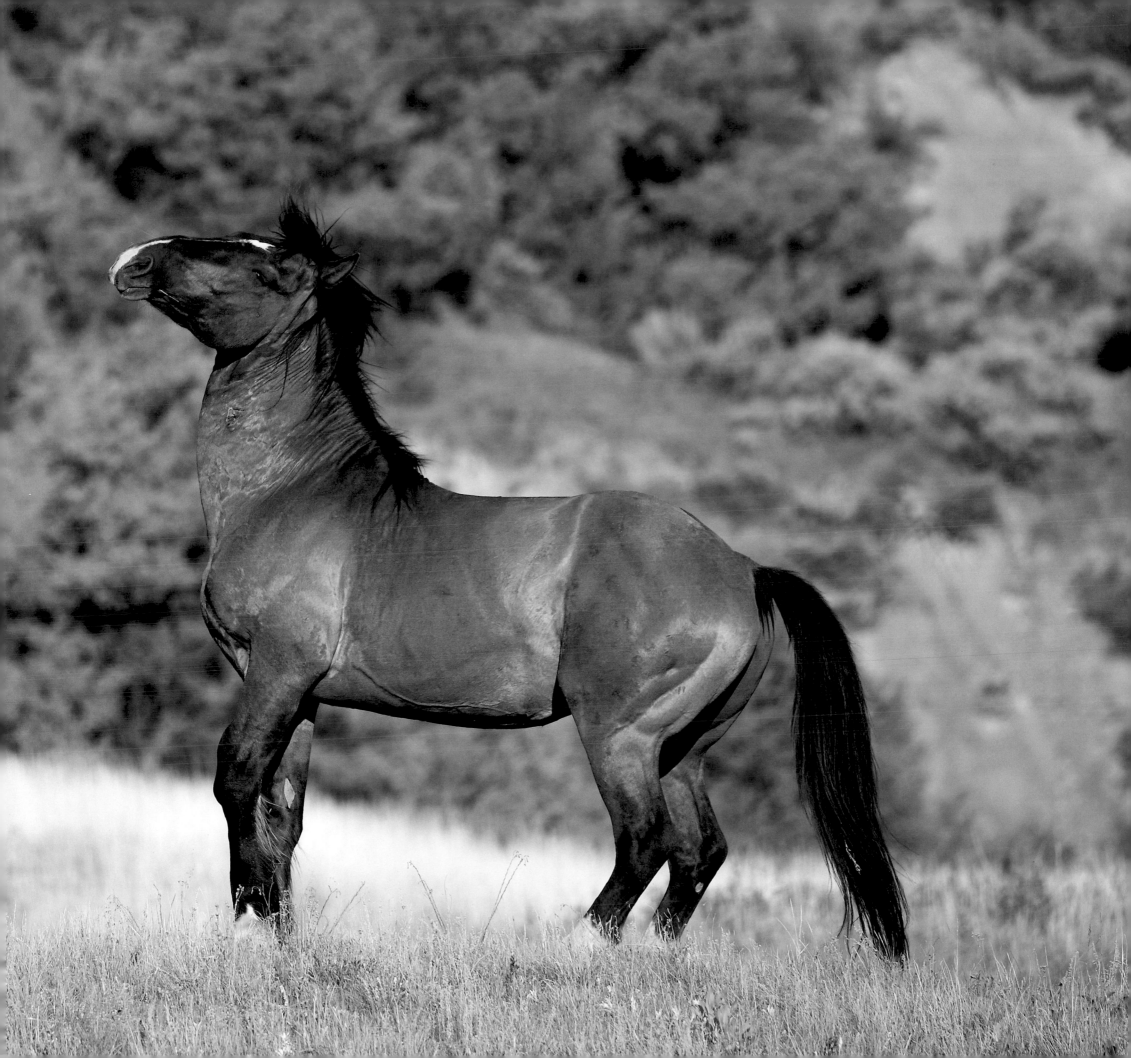

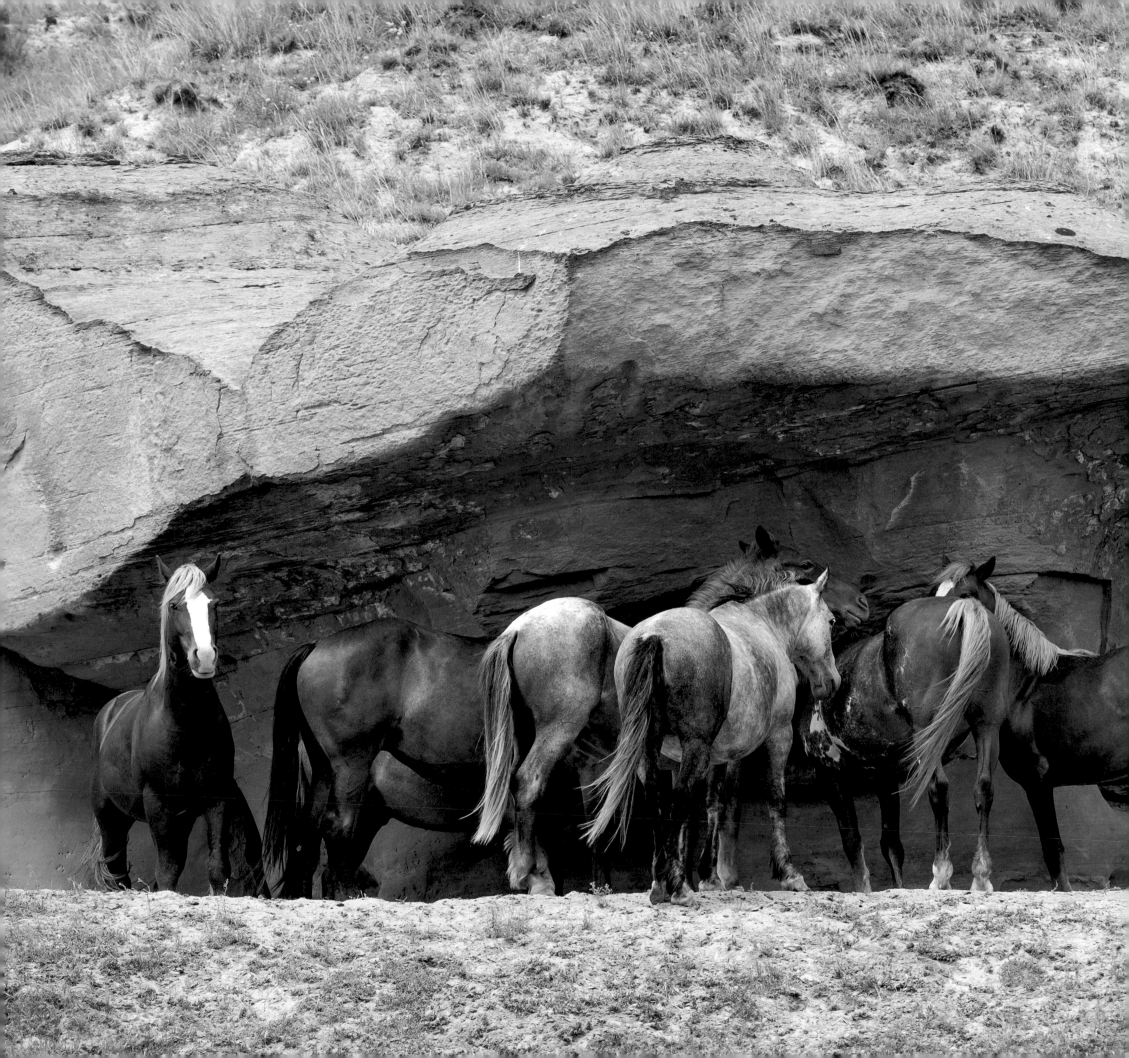

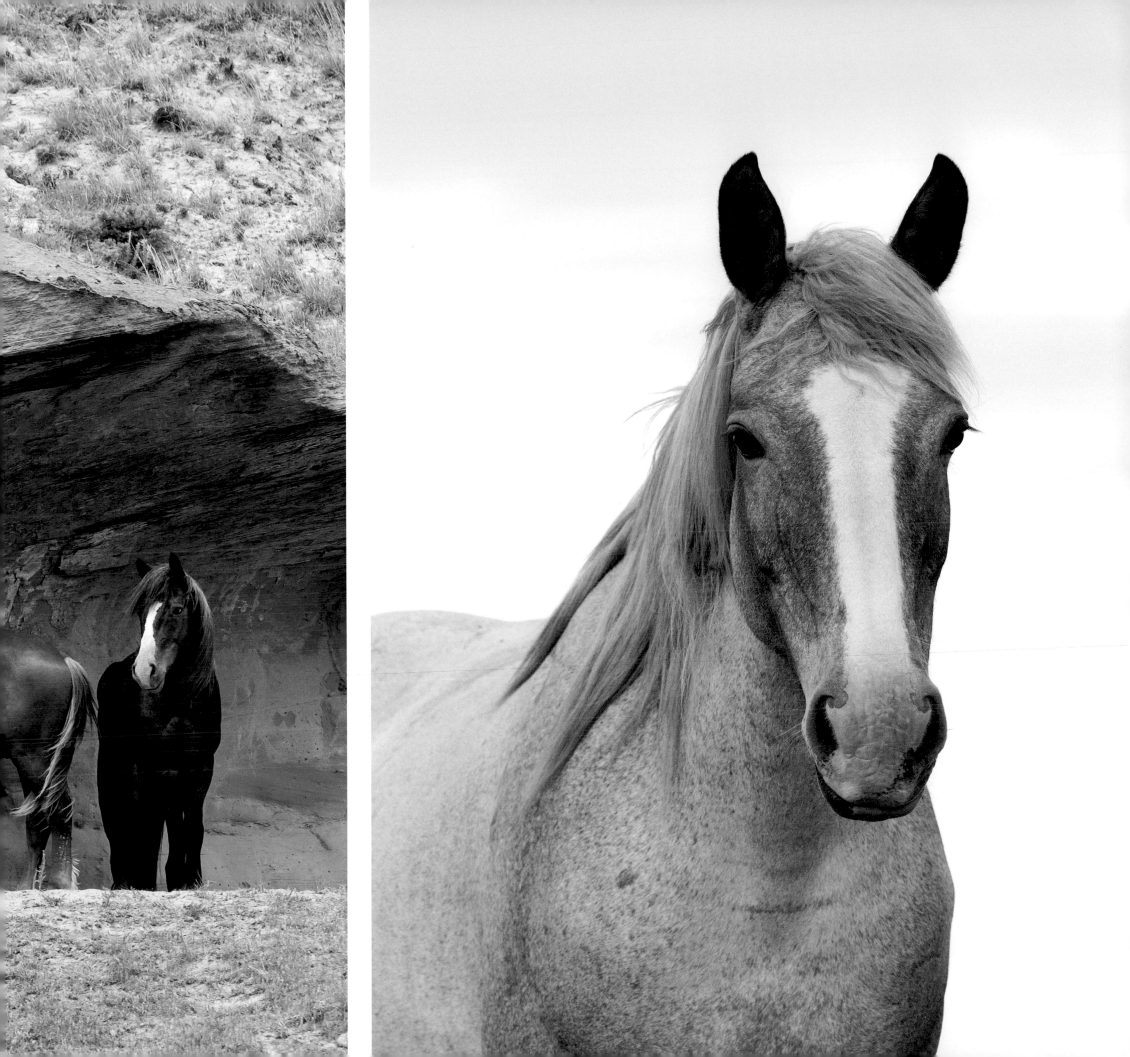

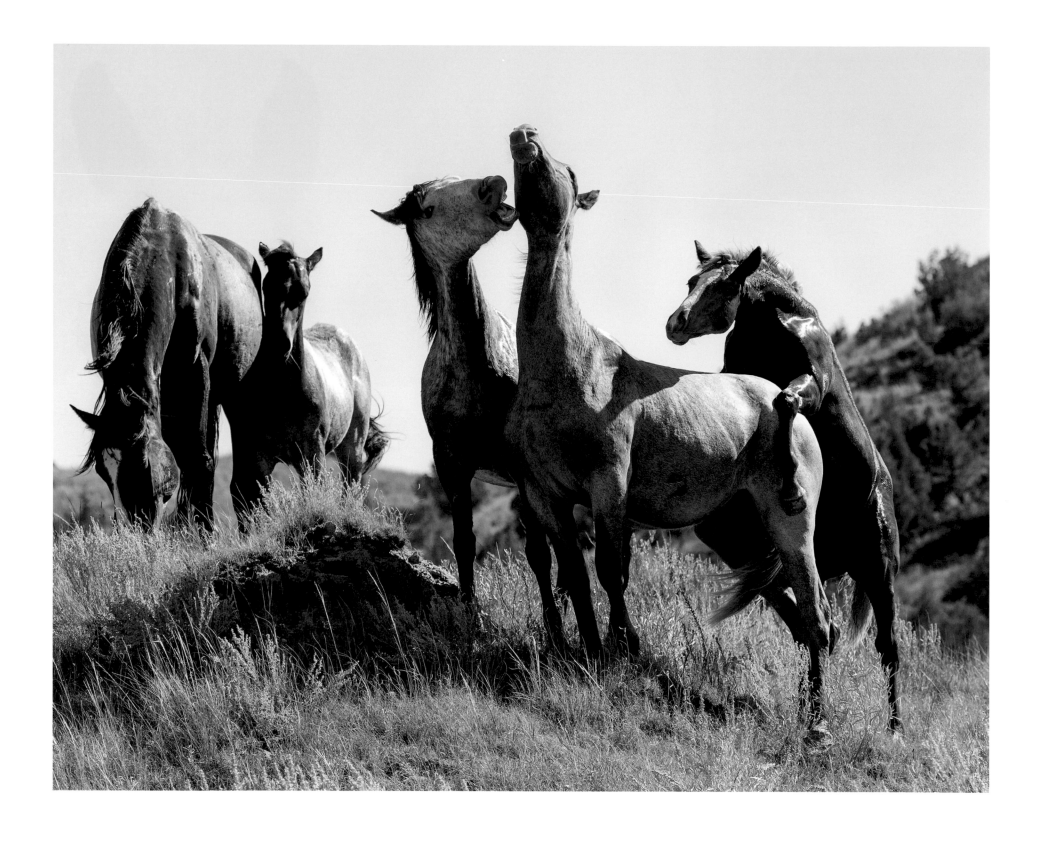

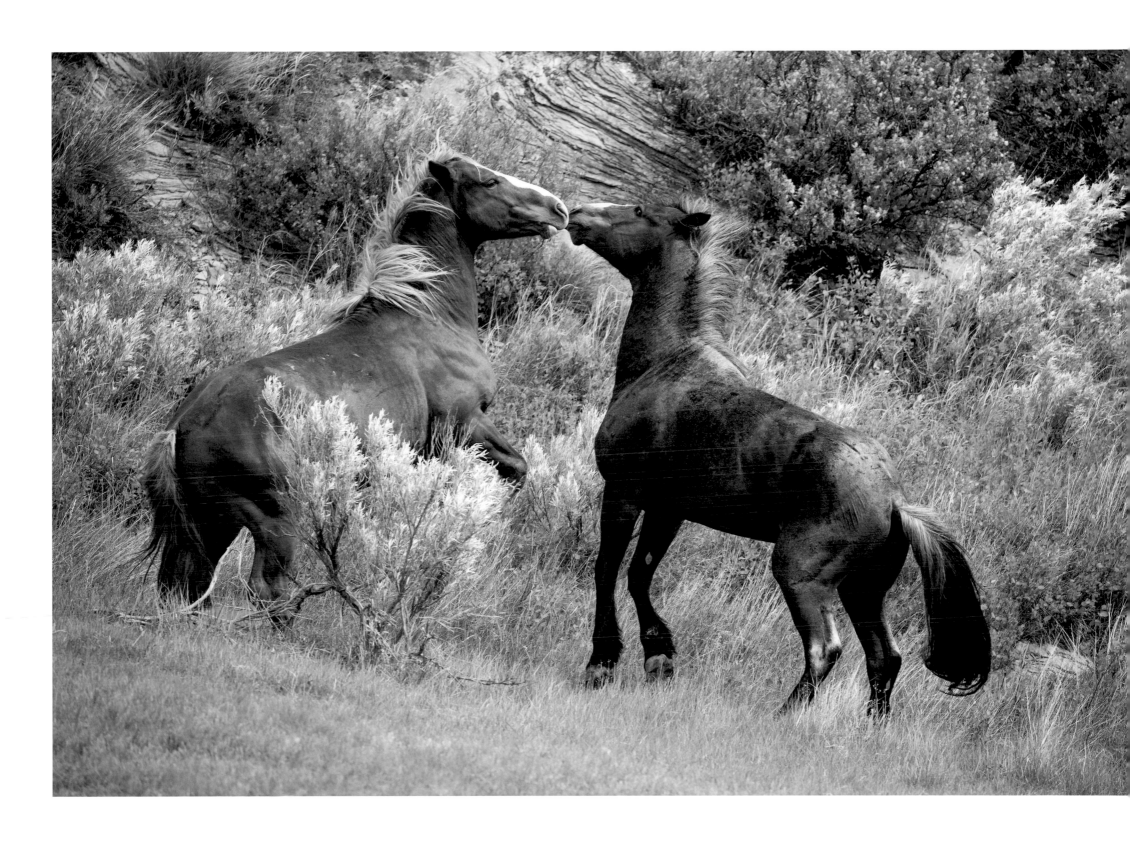

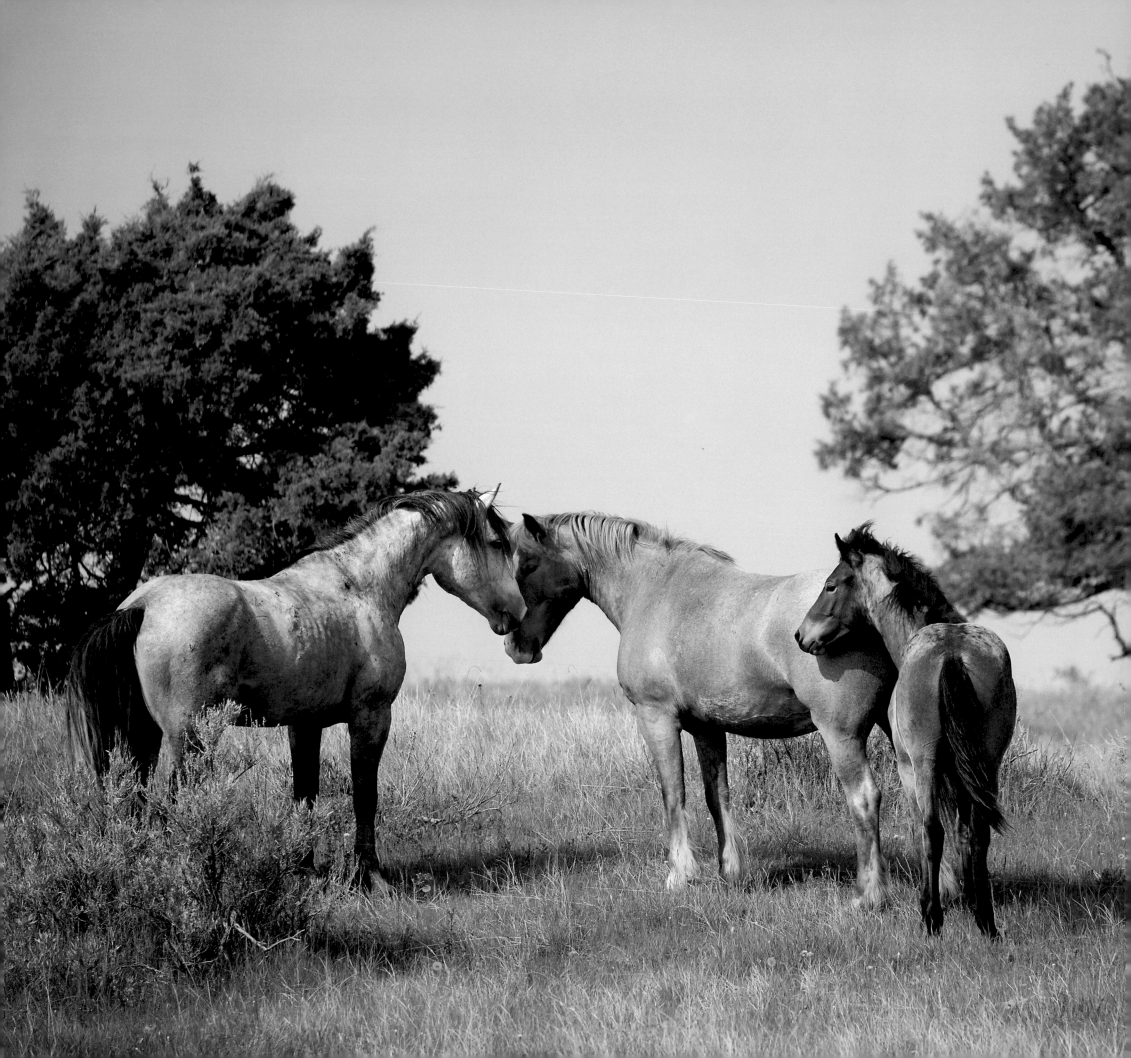

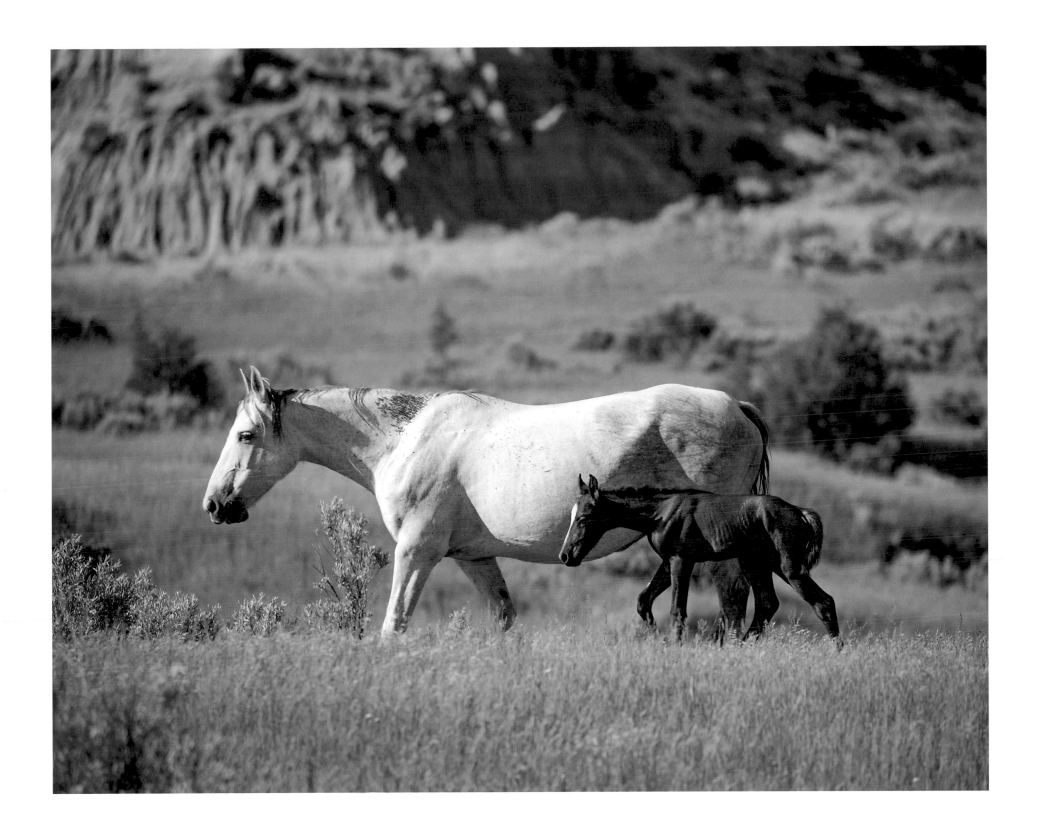

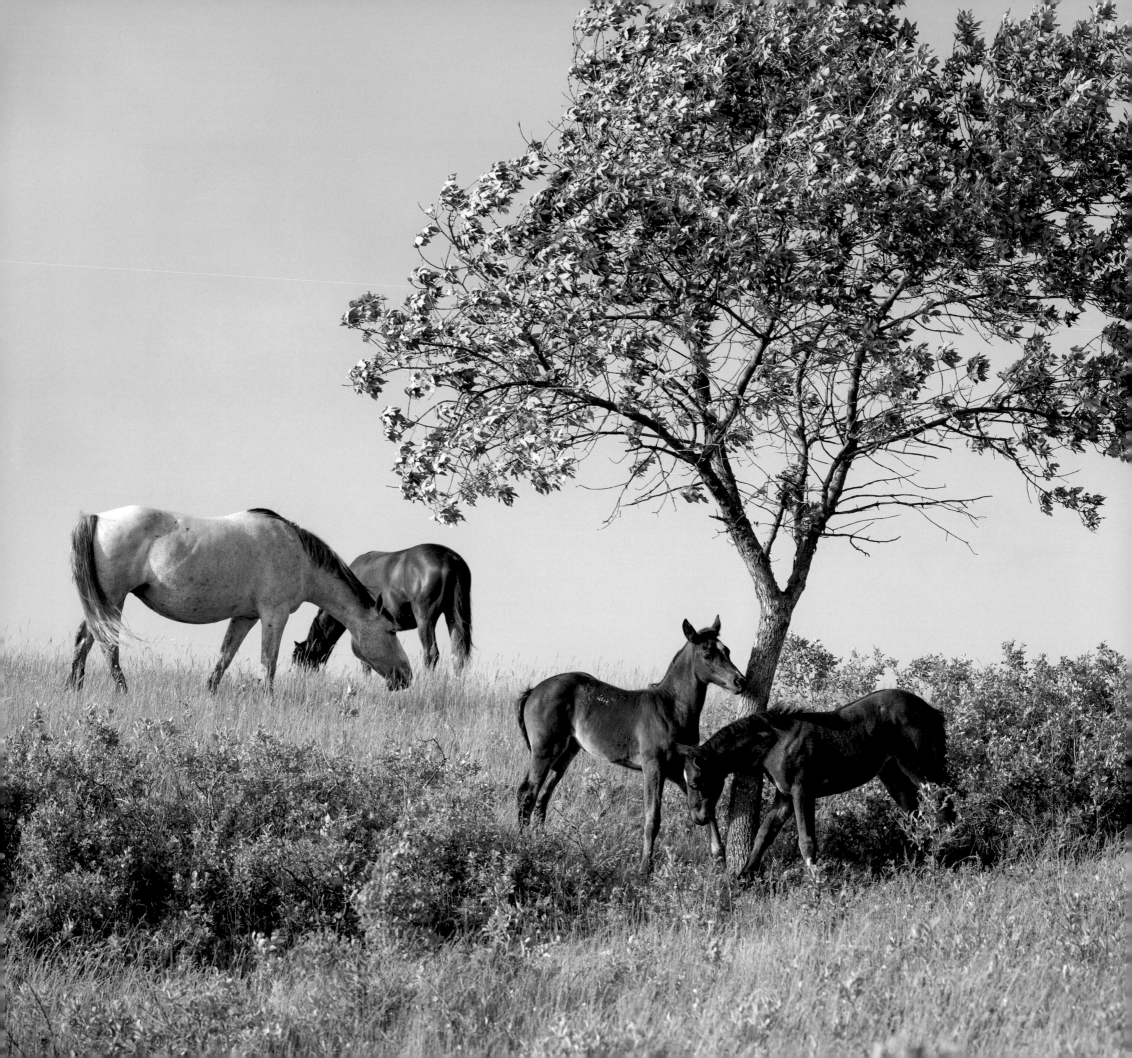

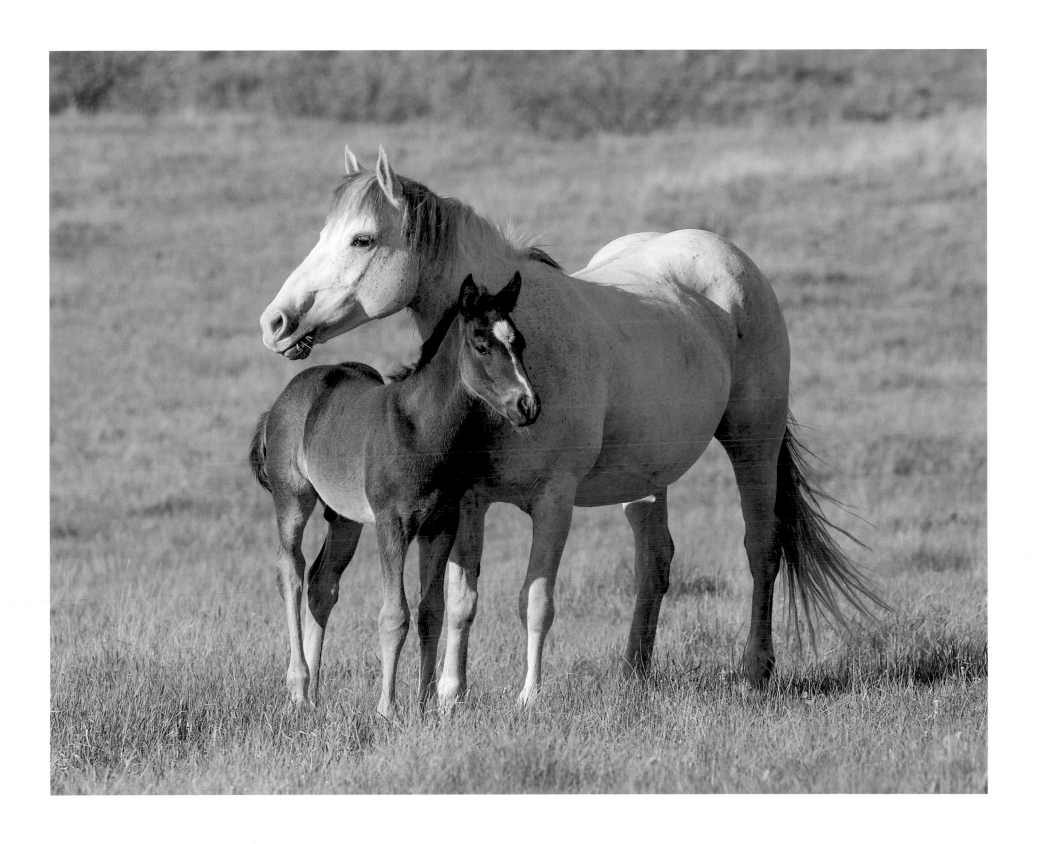

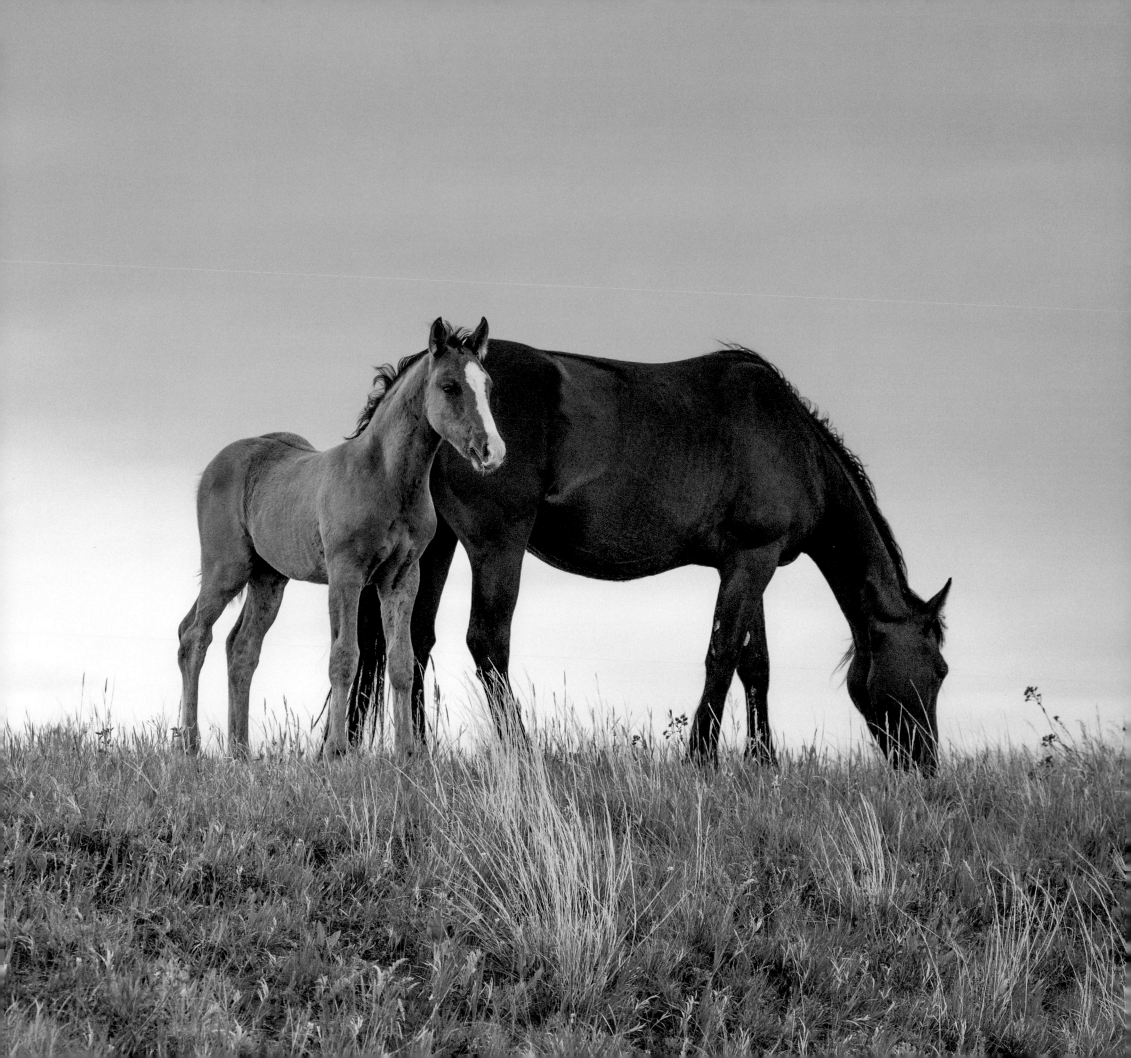

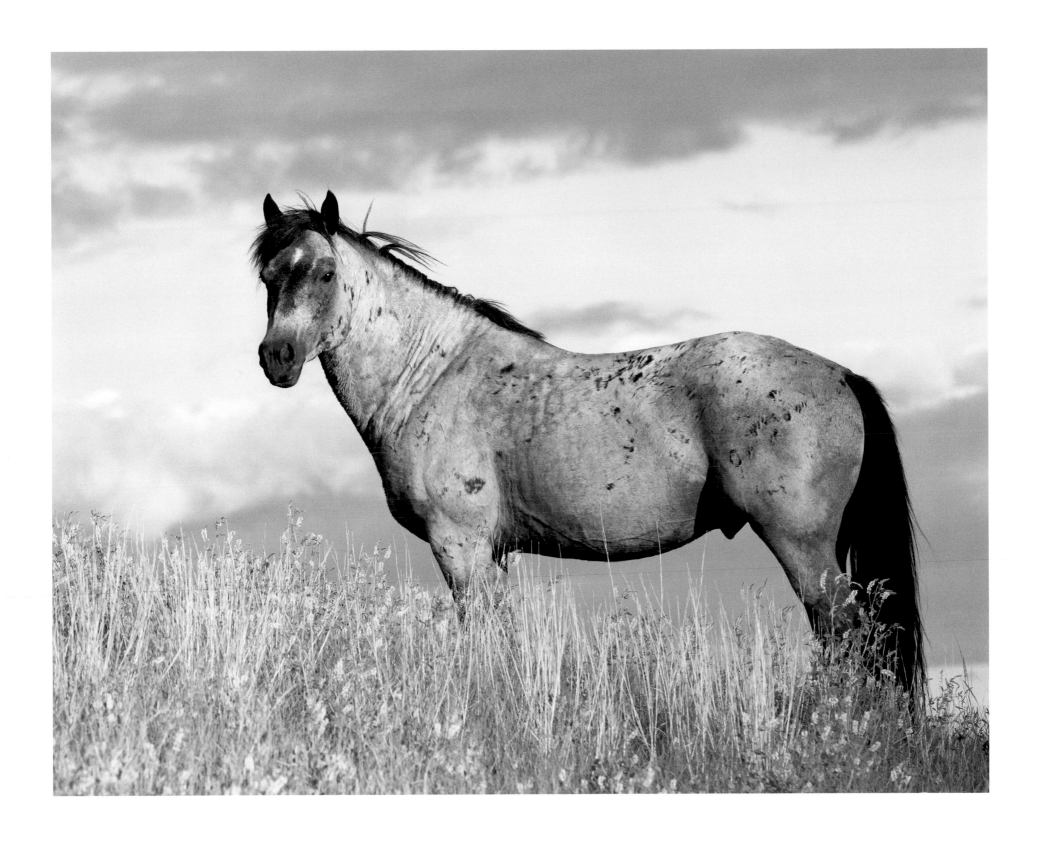

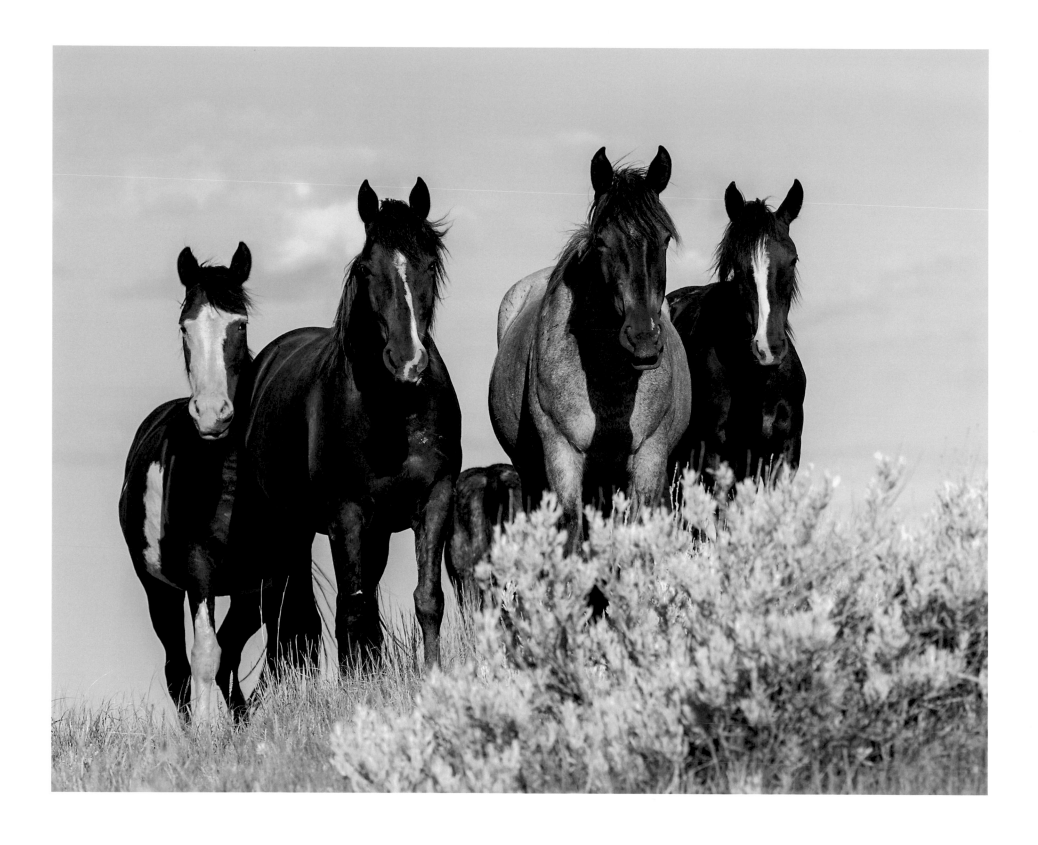

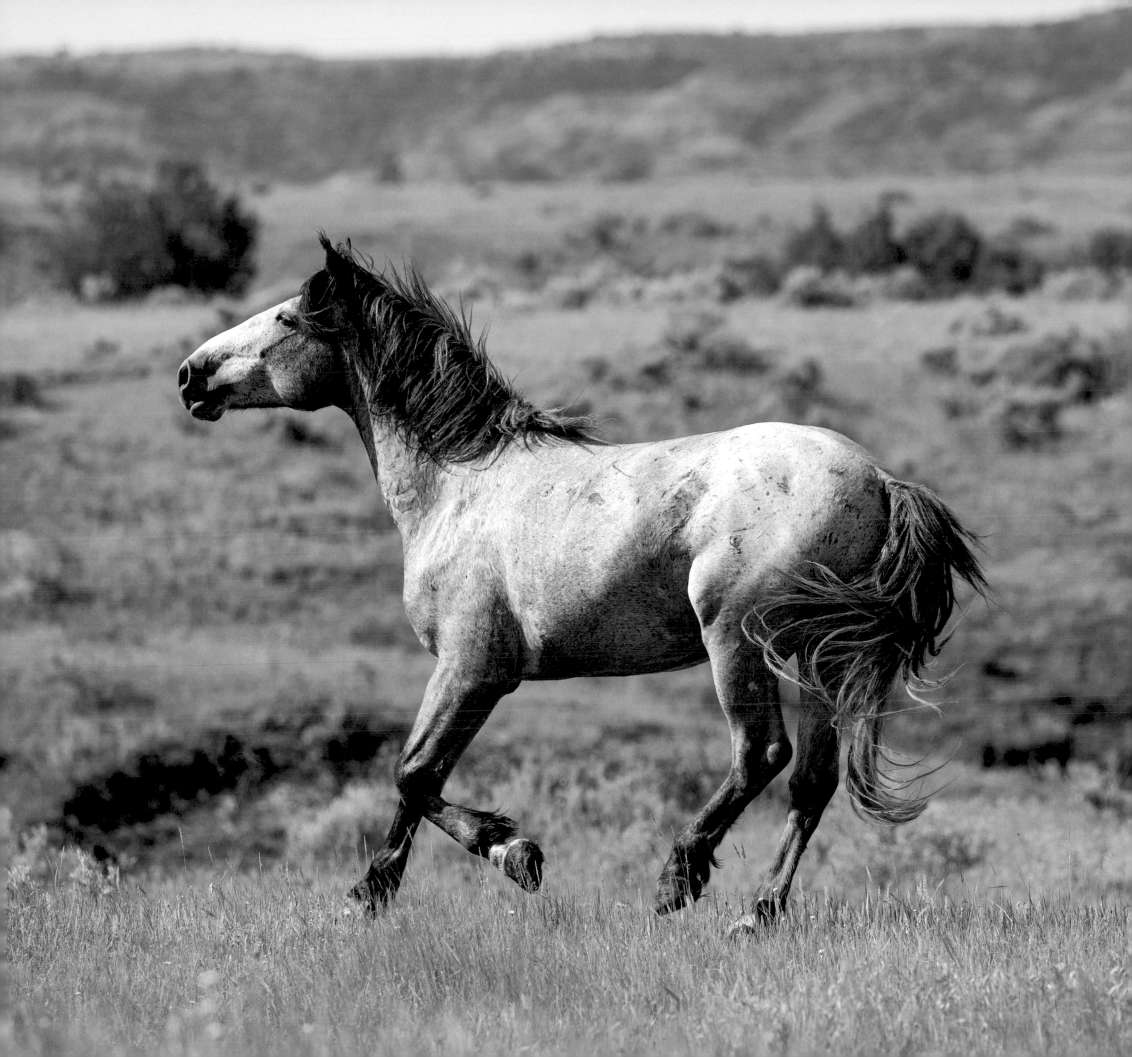

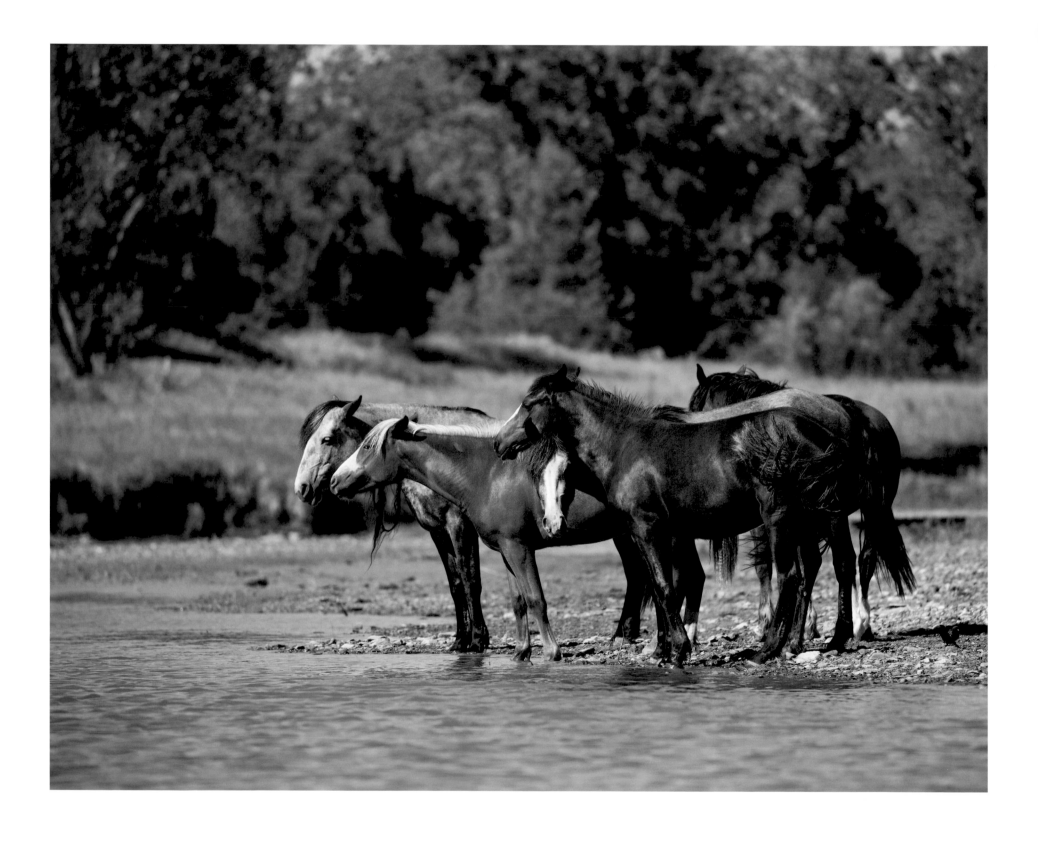

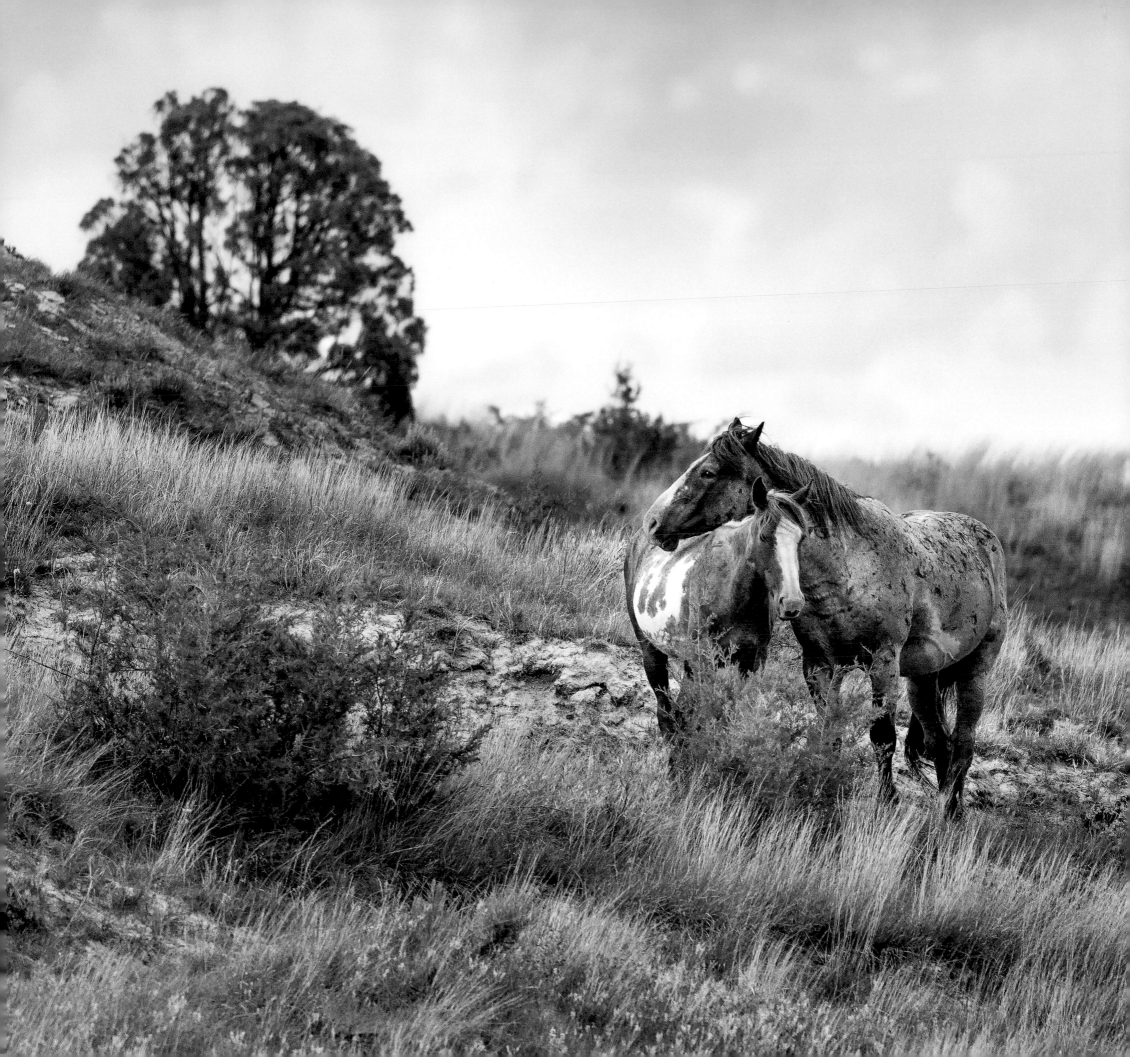

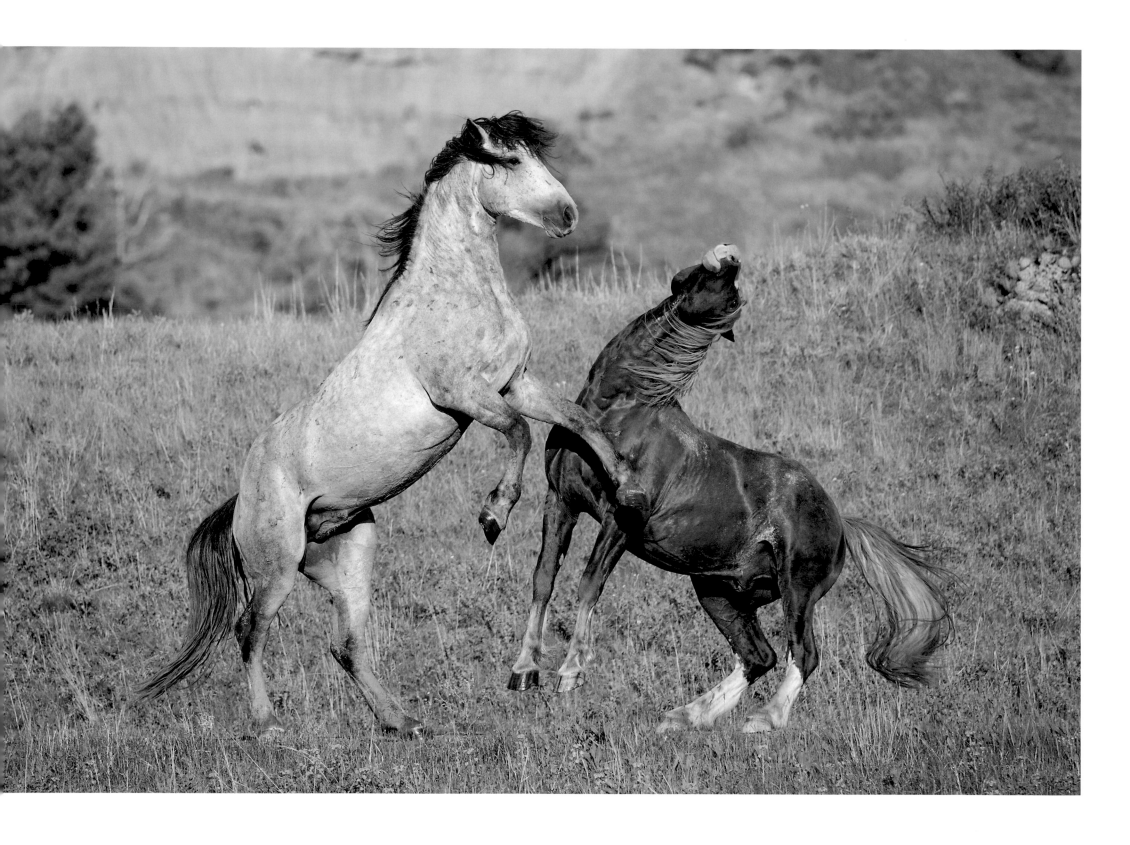

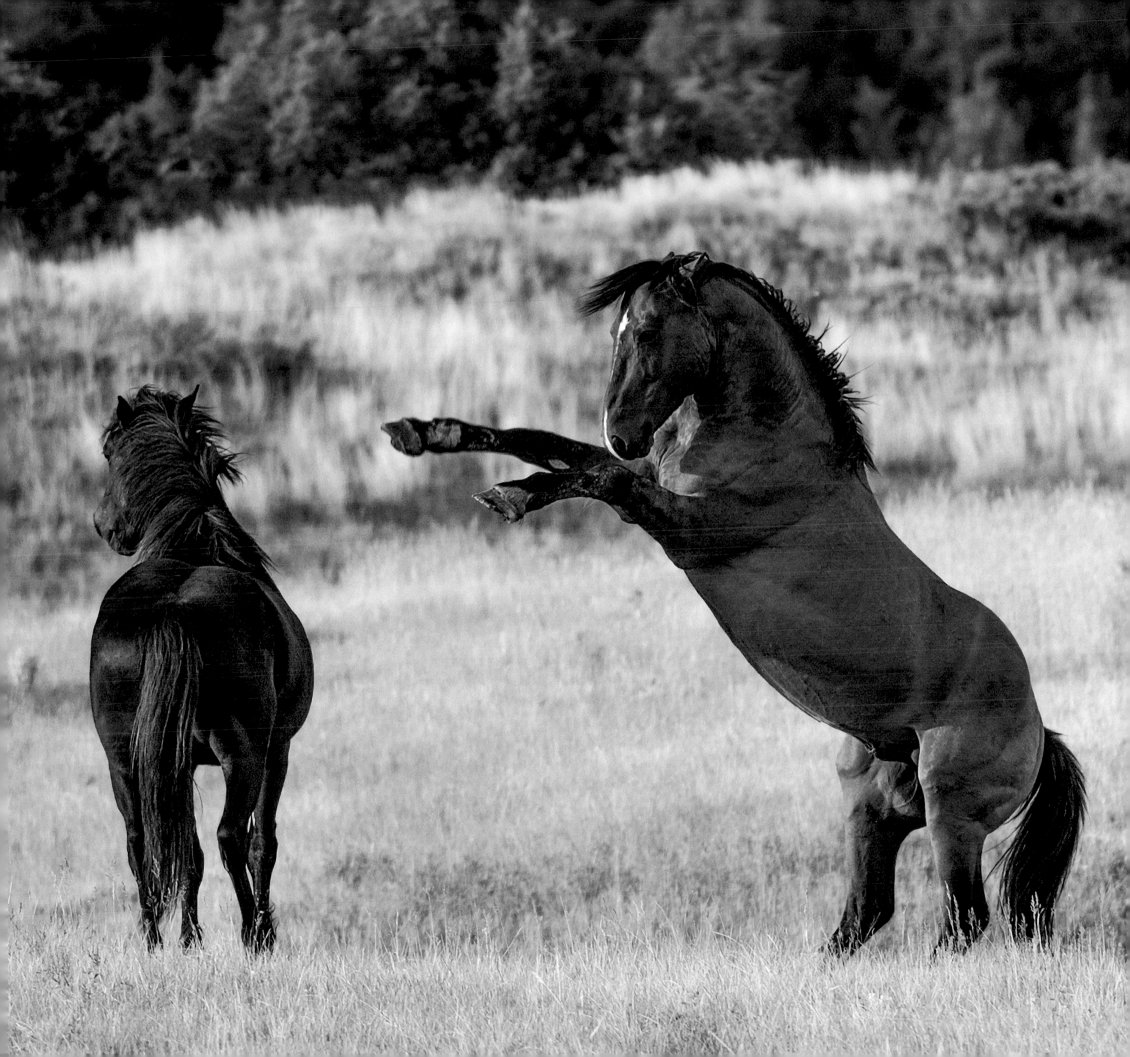

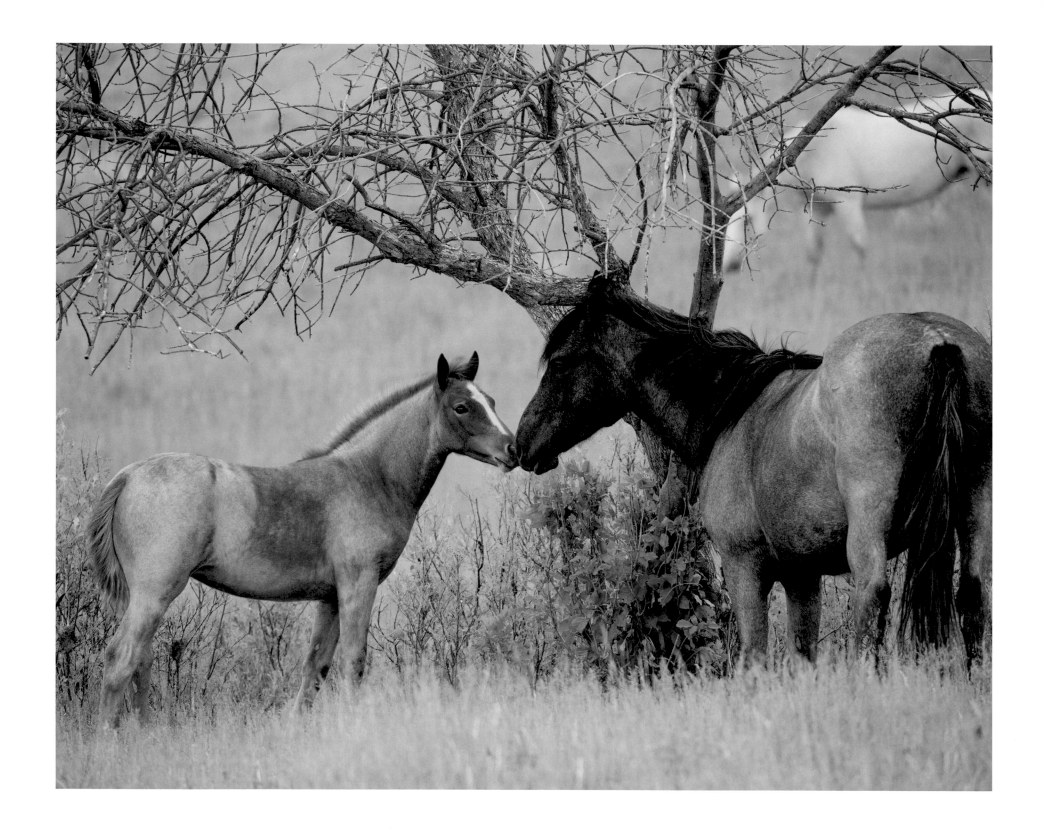

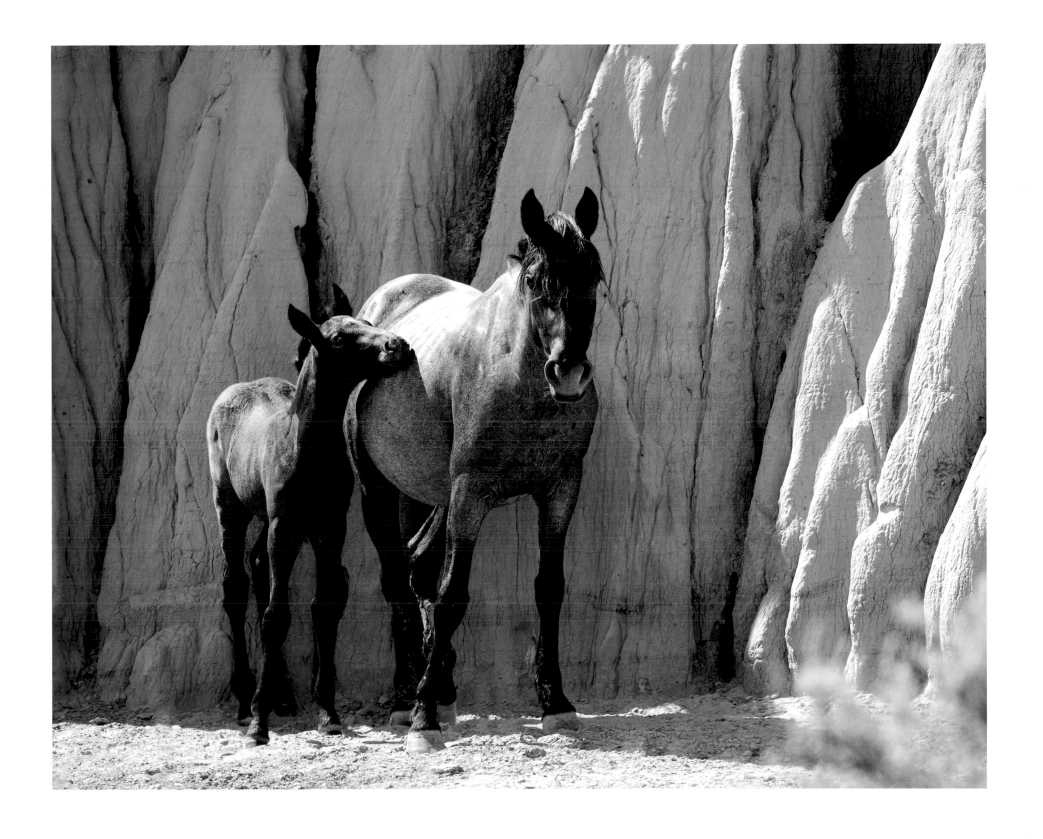

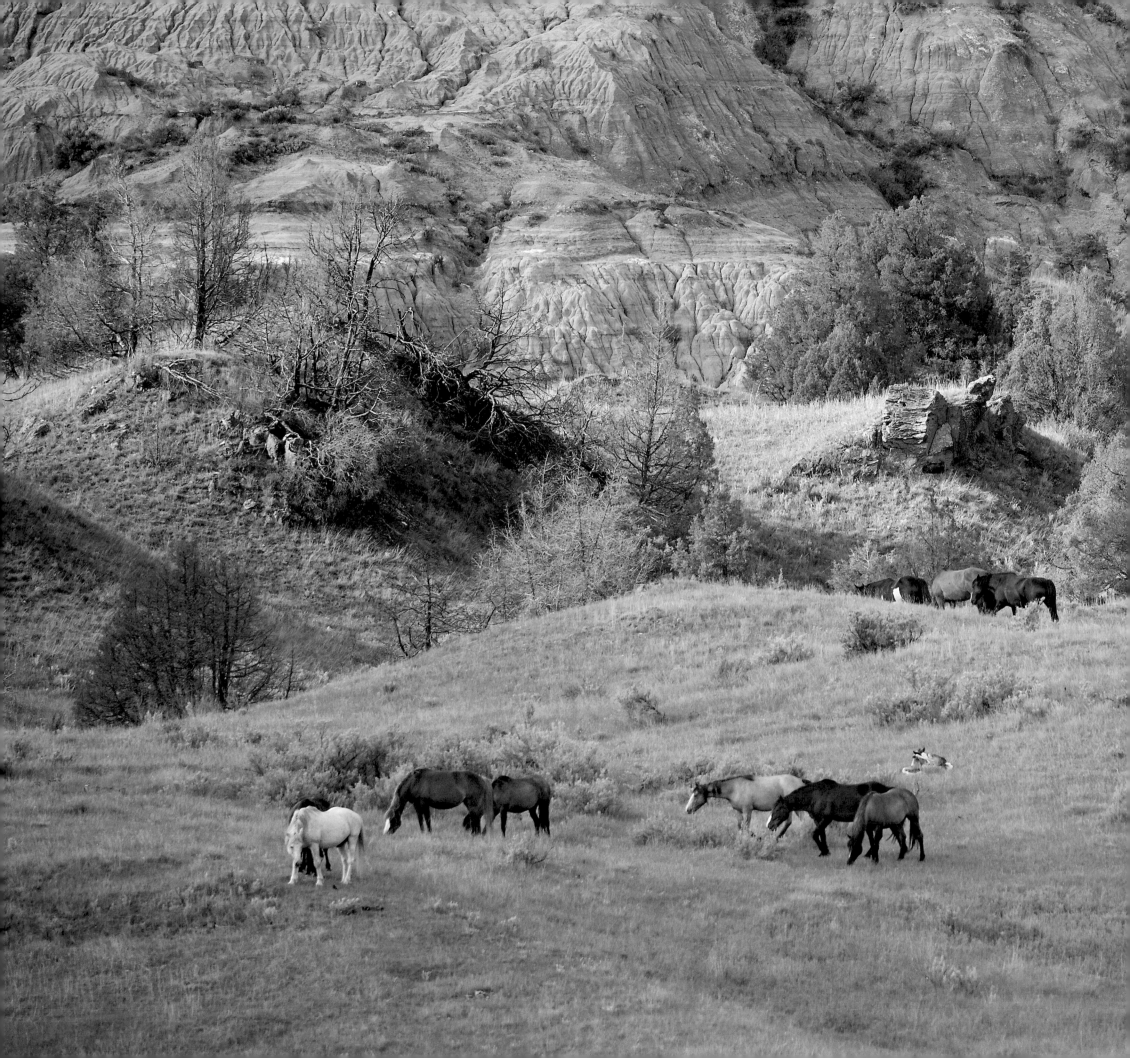

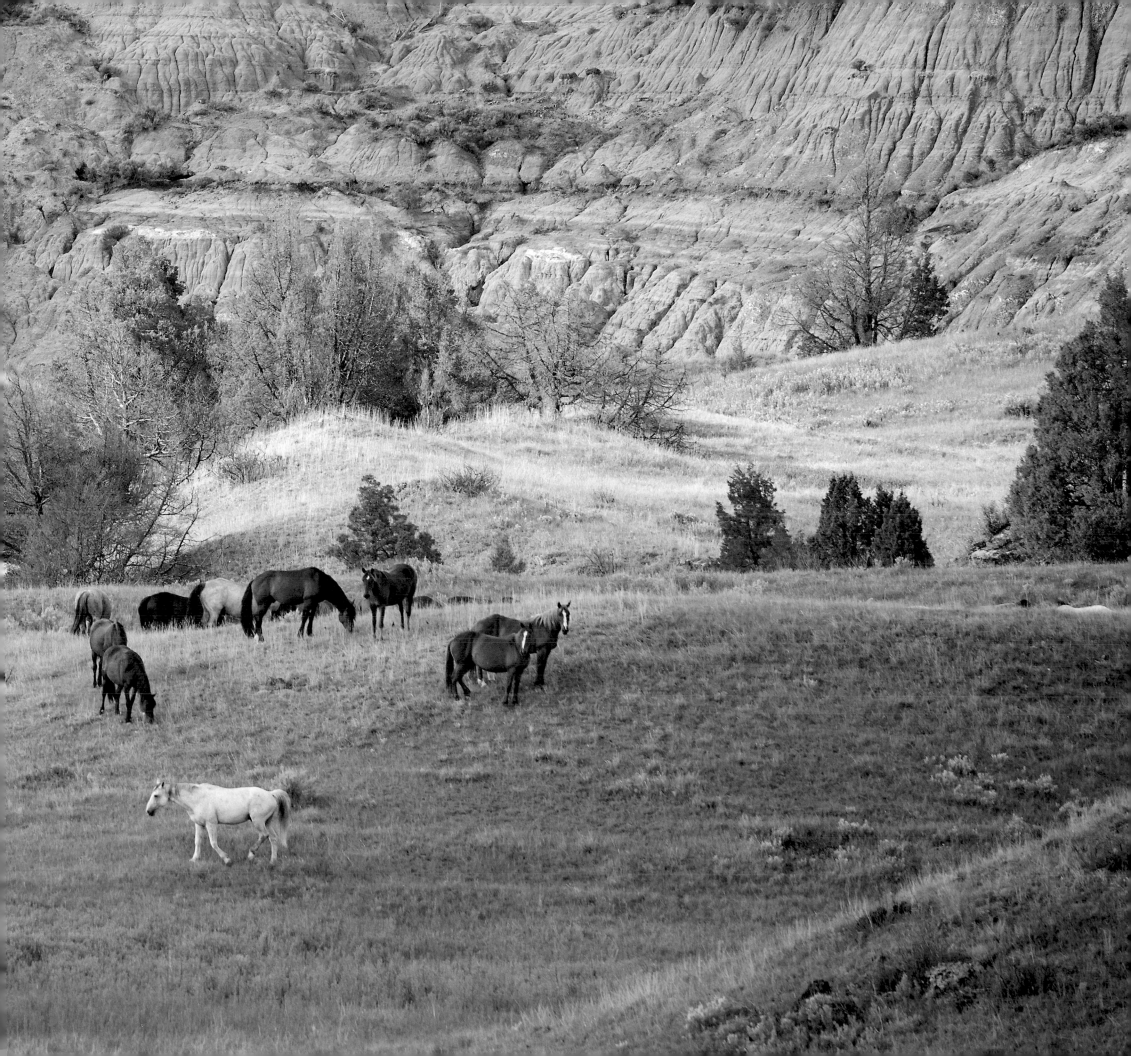

Autumn

Friendship bonds deepen;
Autumn colors paint the land;
All wildlife at peace.

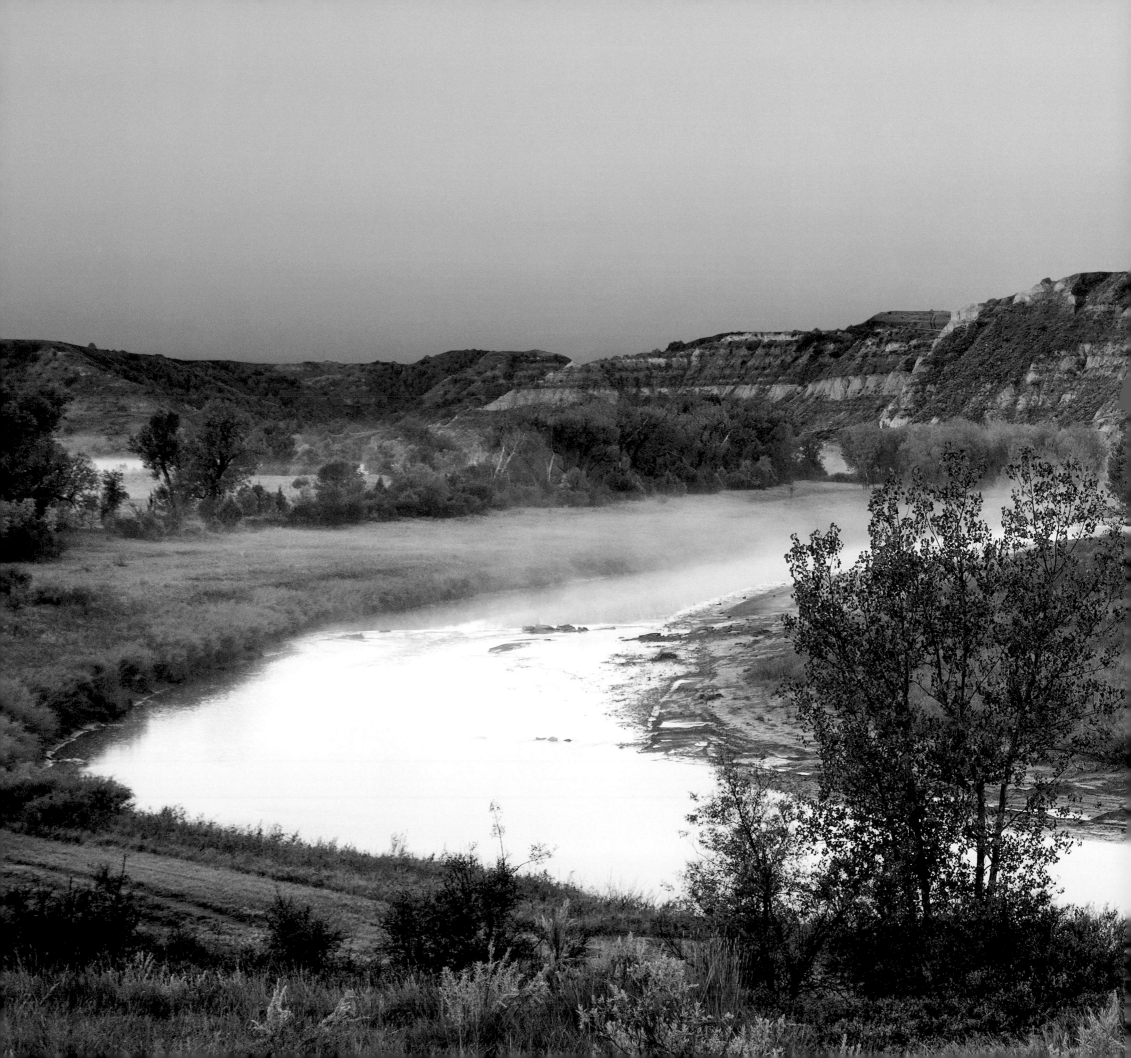

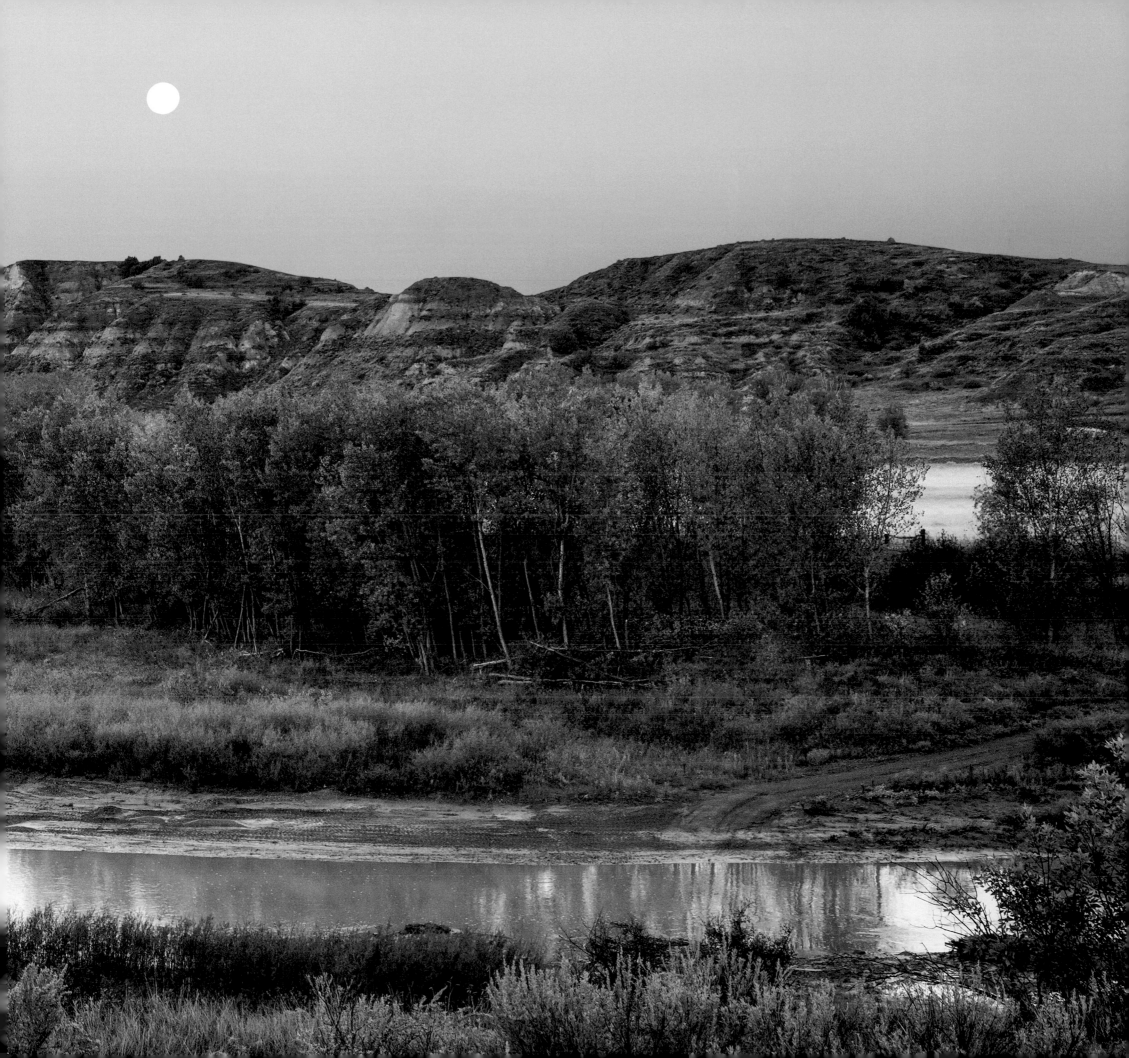

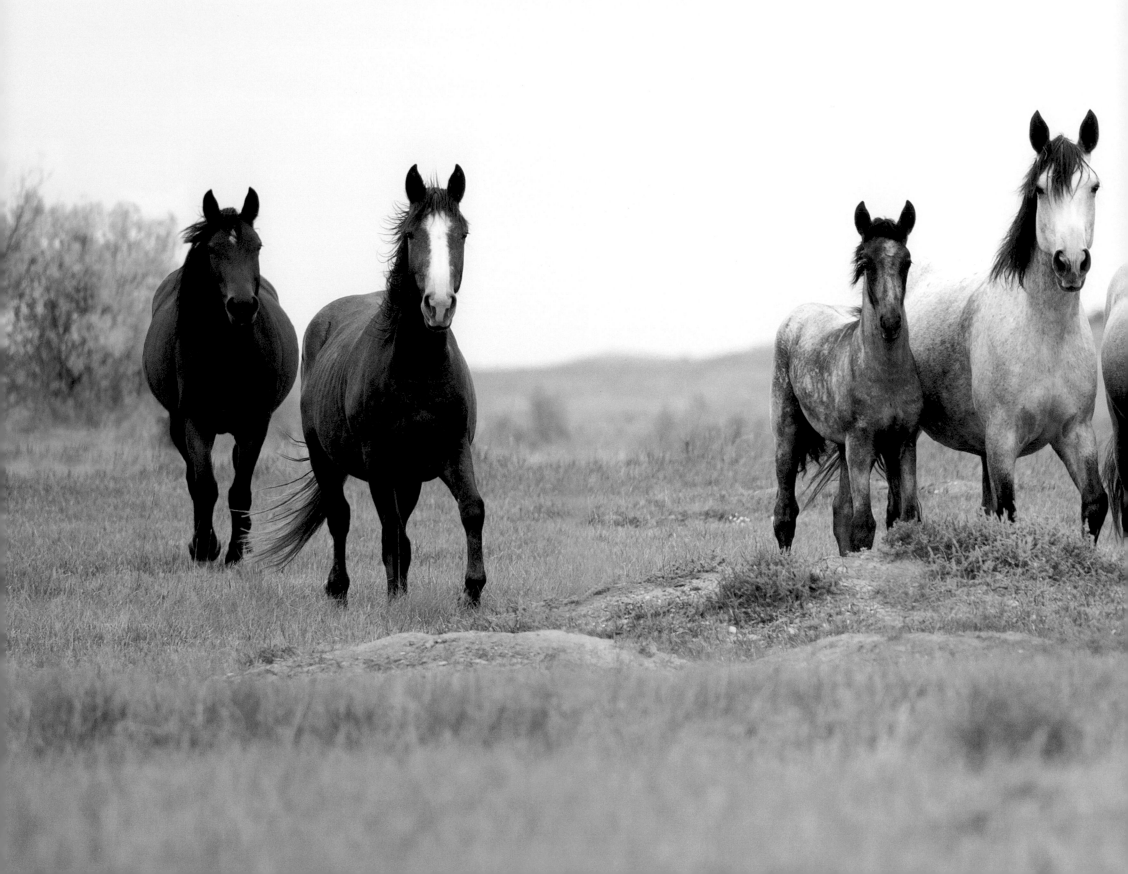

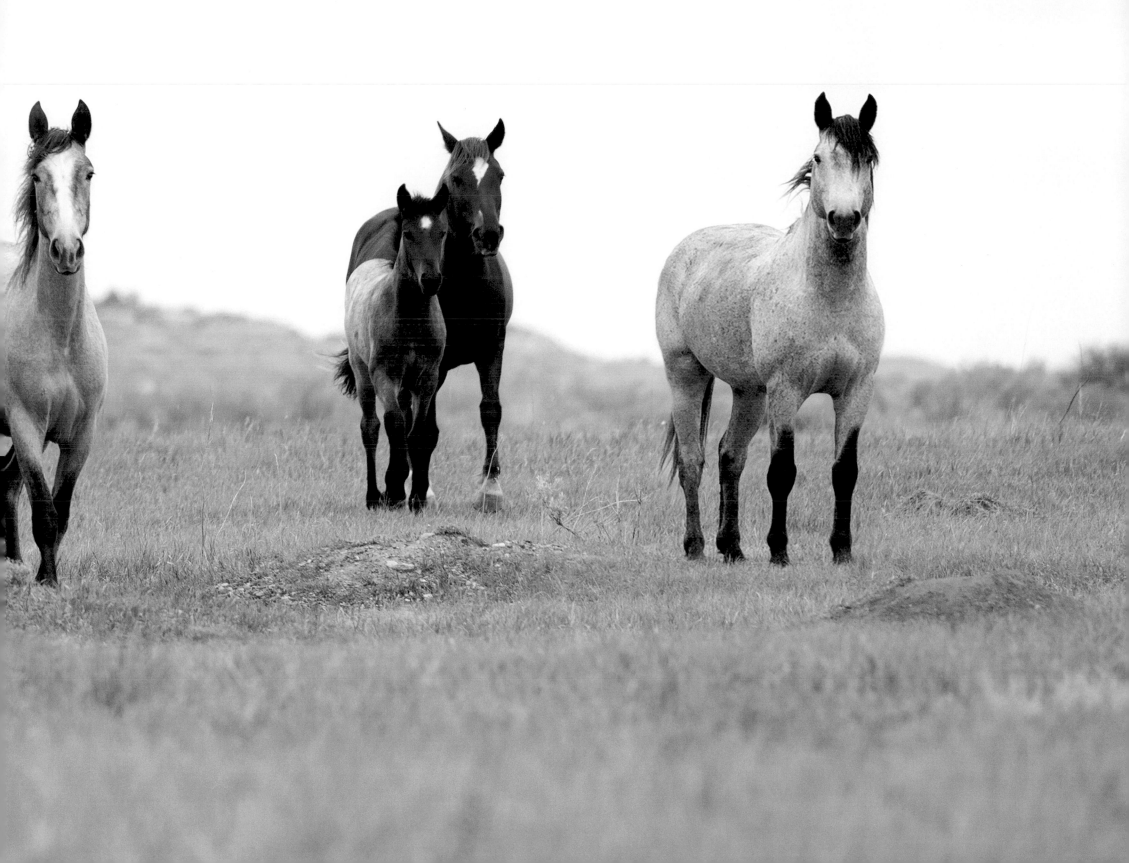

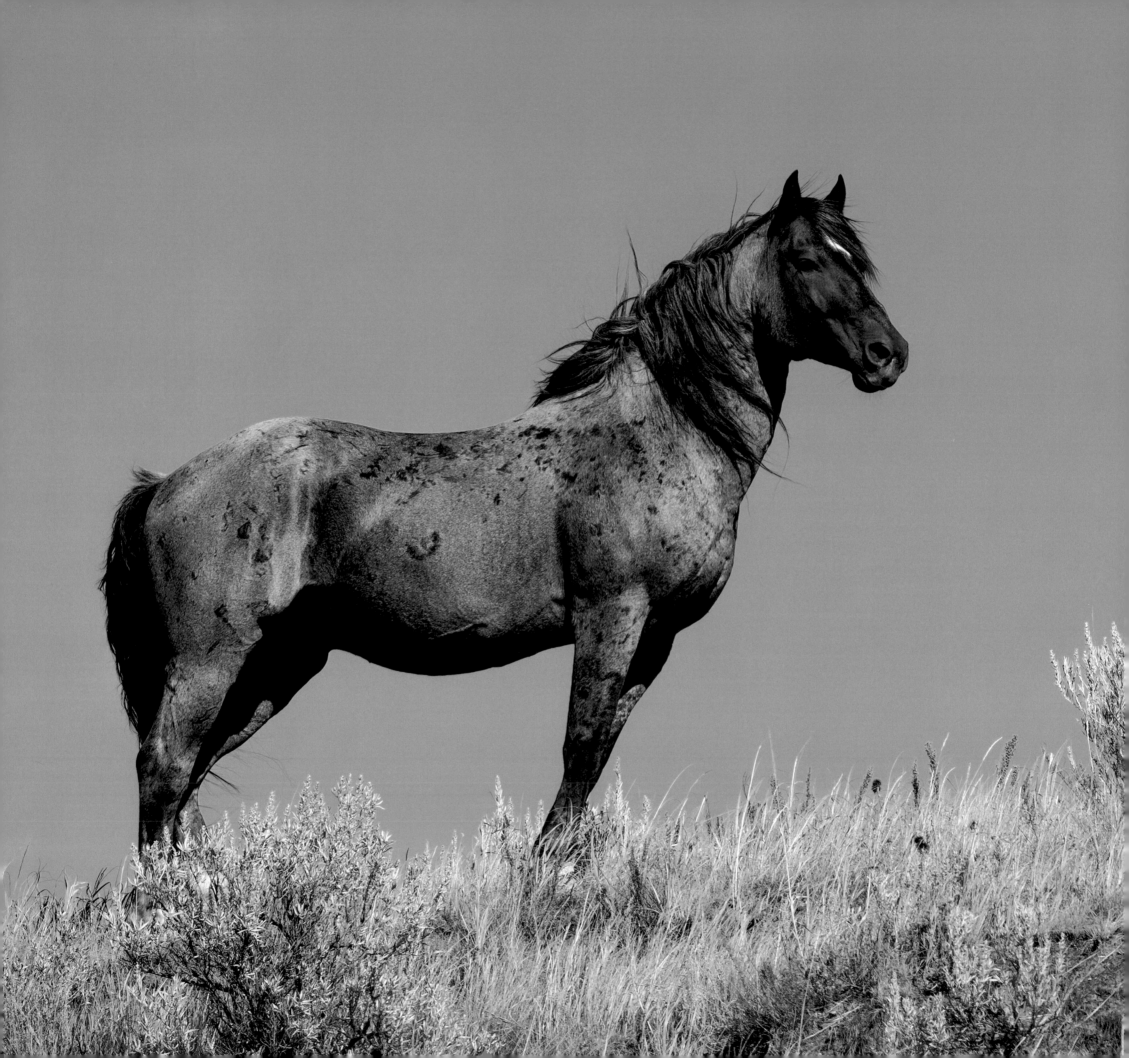

I had hiked into the area of the park known as The Flats when I suddenly spotted the band stallion Thunder. There was a huge bison grazing between me and the band and there was no rock or group of trees I could use for protection. The bison was a definite hazard!

A few minutes passed and a lone whinny sounded nearby. Thunder instantly raised his head, perked up his ears and took off up a large butte, with his band following behind. All the galloping horses rushed by the bison in front of me and scrambled up the cliff.

Thunder strode to the highest point and called out many times to locate whoever might be lost. His desire to protect his mares and foals from any danger was readily apparent.

Fall bands are content. Their bellies are filled in preparation for winter. The horses' coats are growing longer with the shorter days and cooling nights. Friendships and band bonding deepen among the many wild horses living in close proximity to each other. Very little challenging takes place. All wildlife seems at peace. ❧

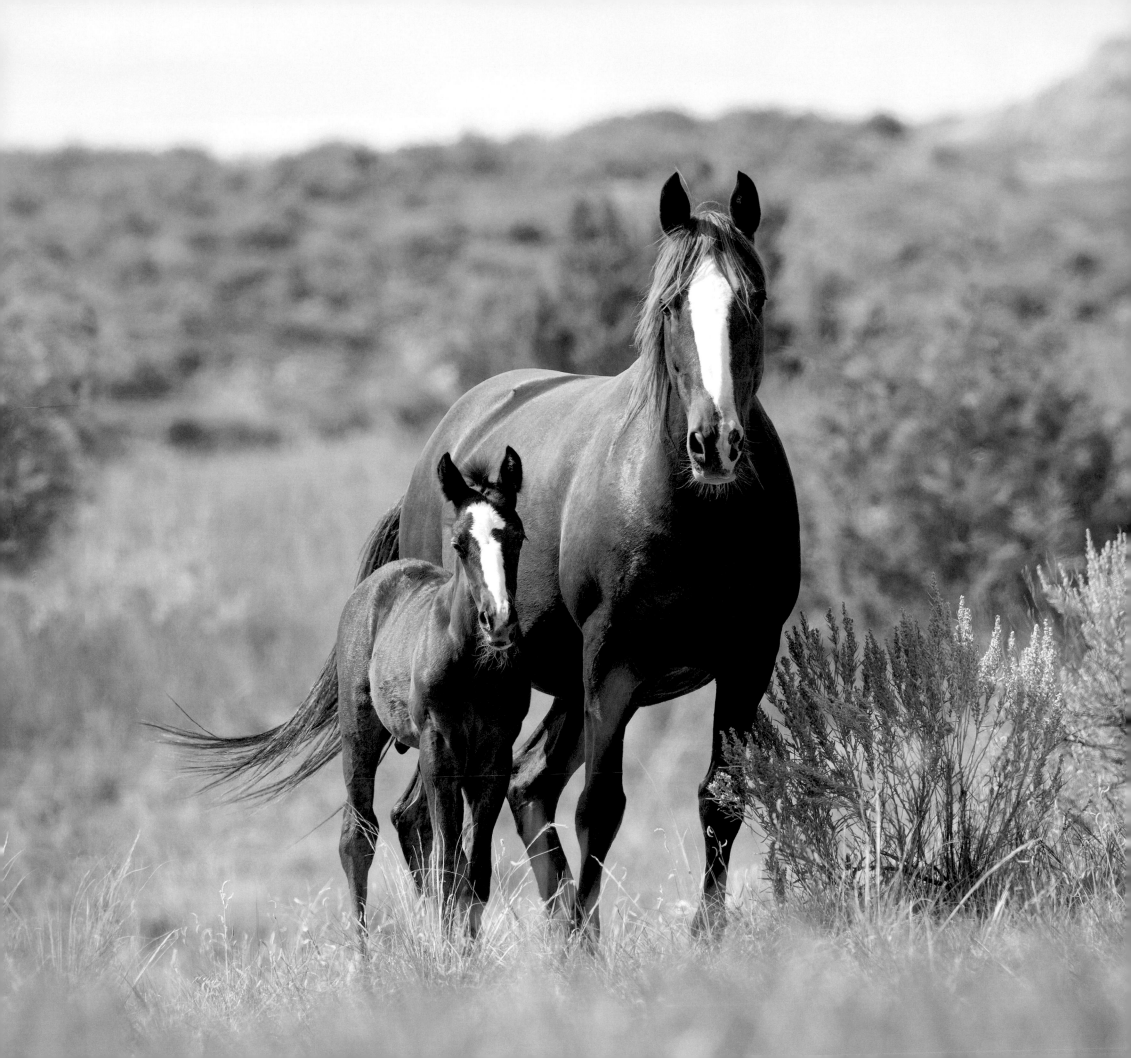

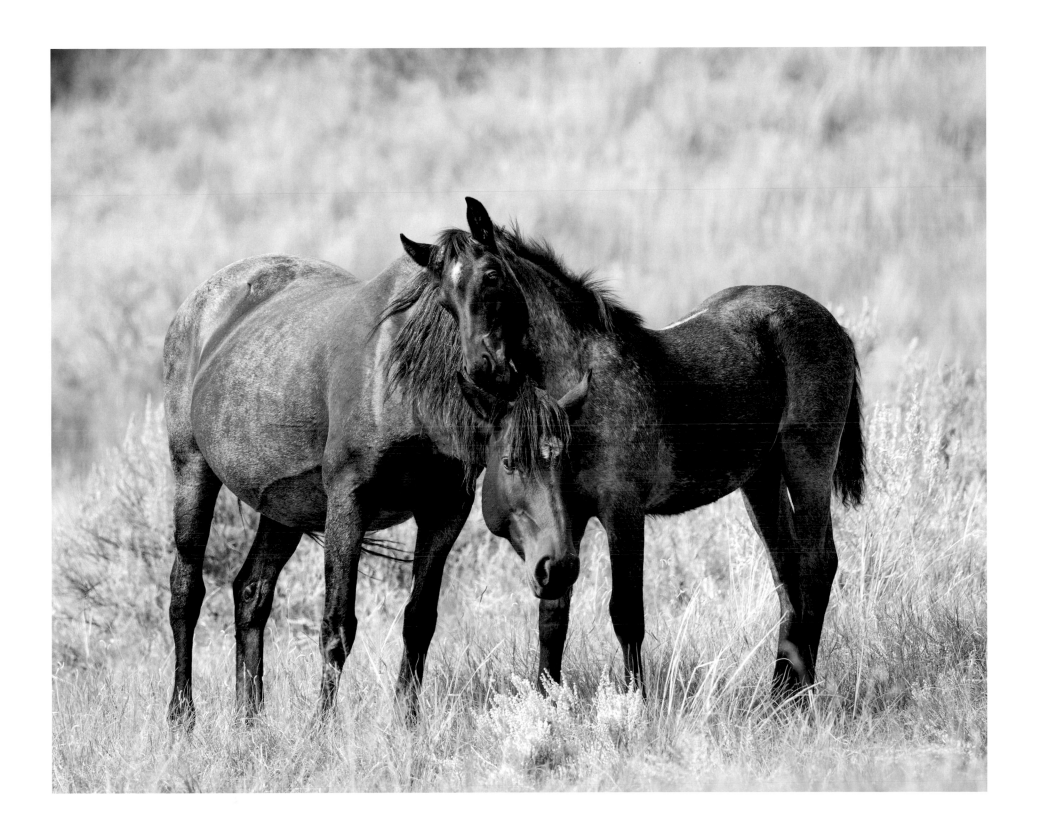

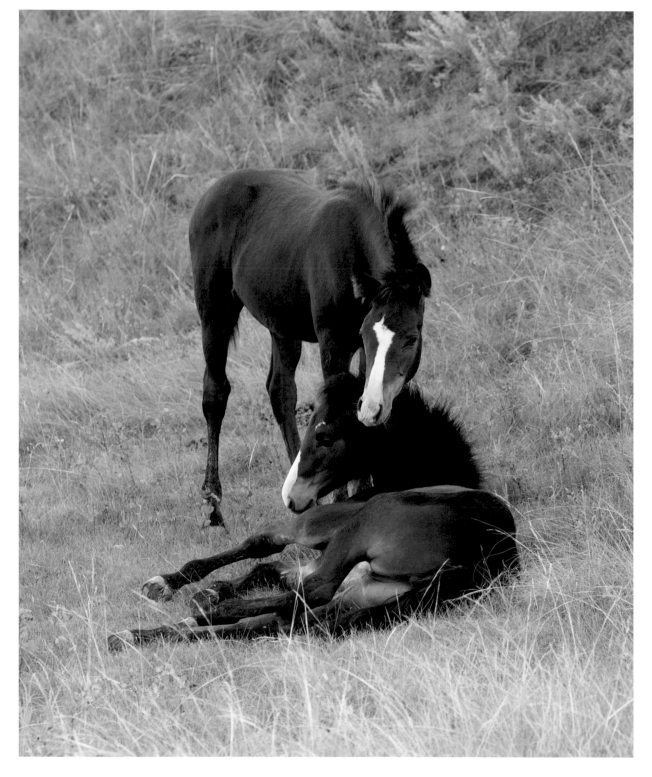
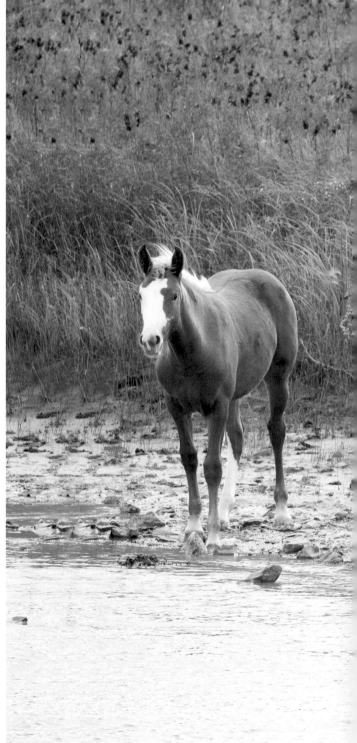

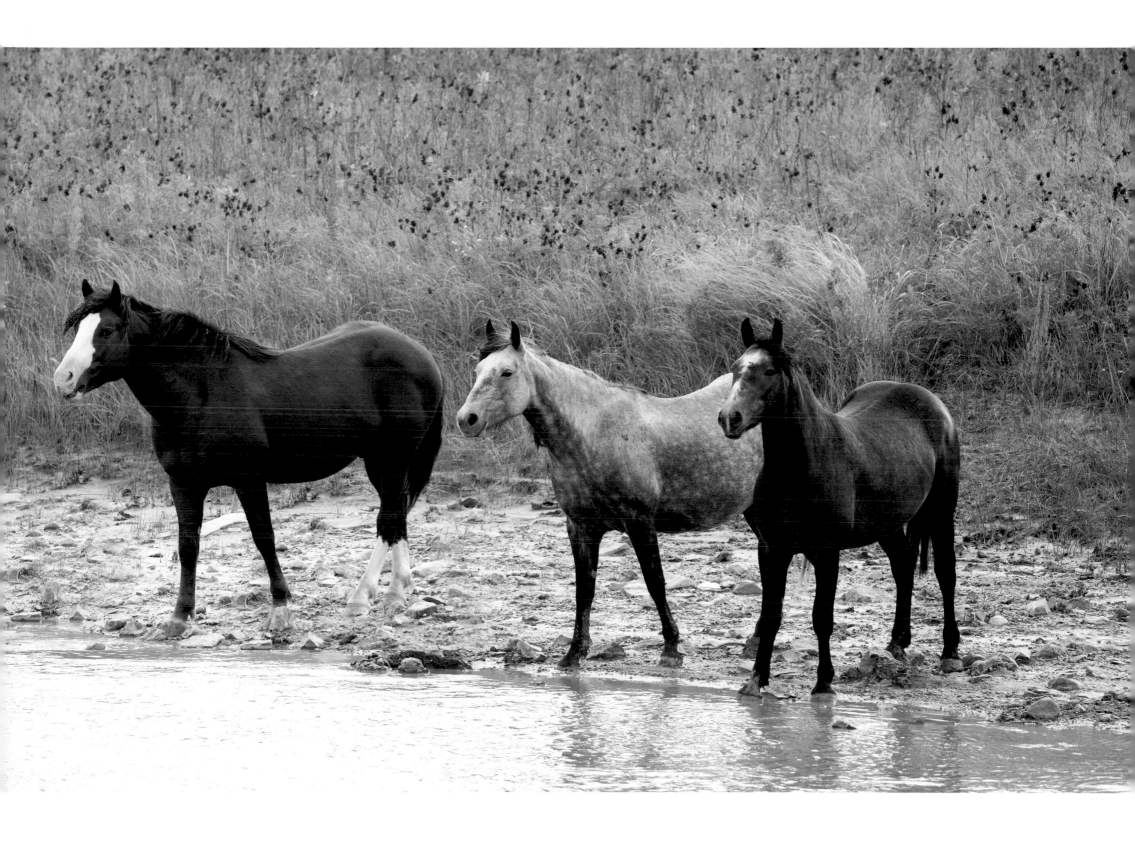

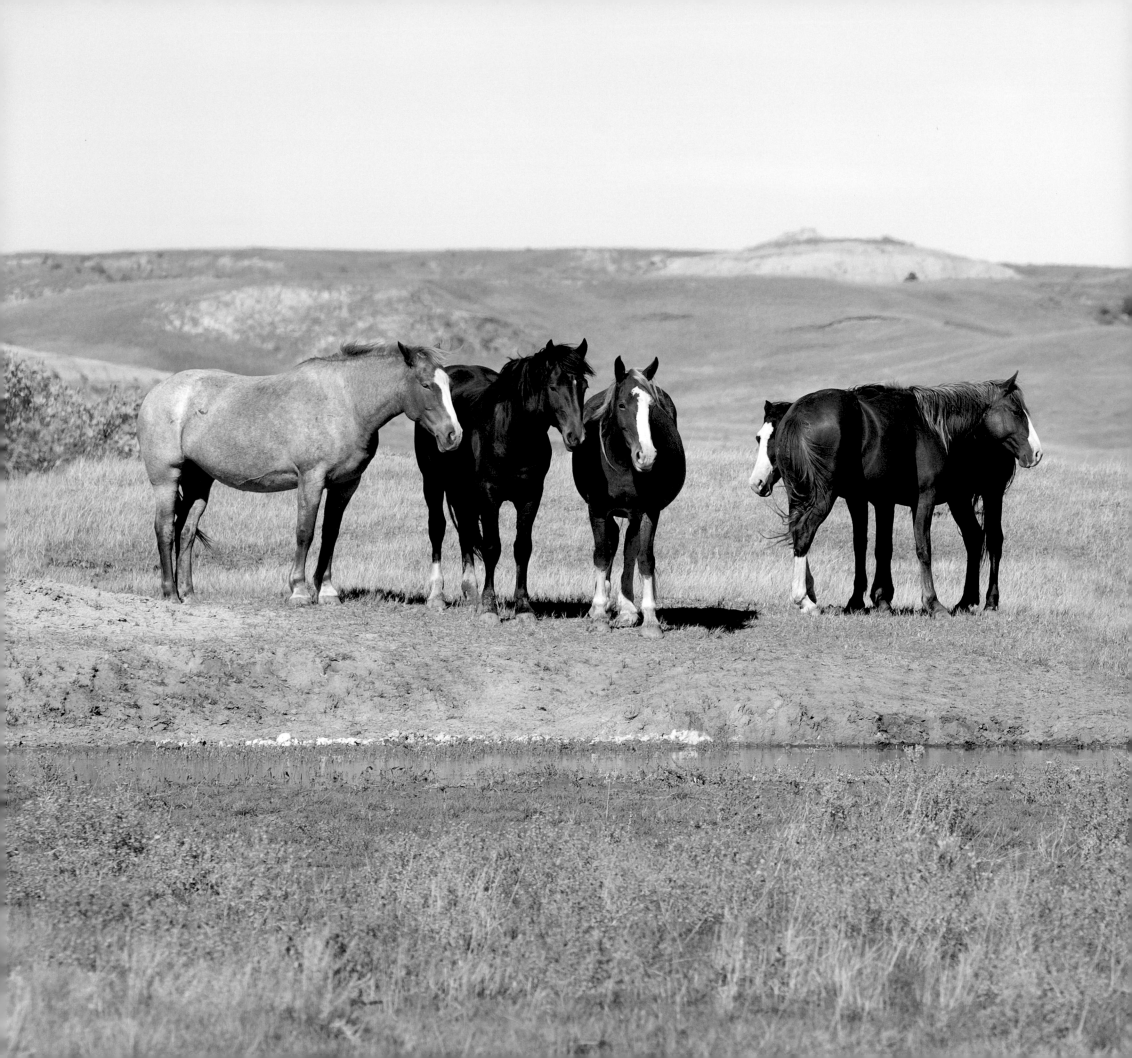

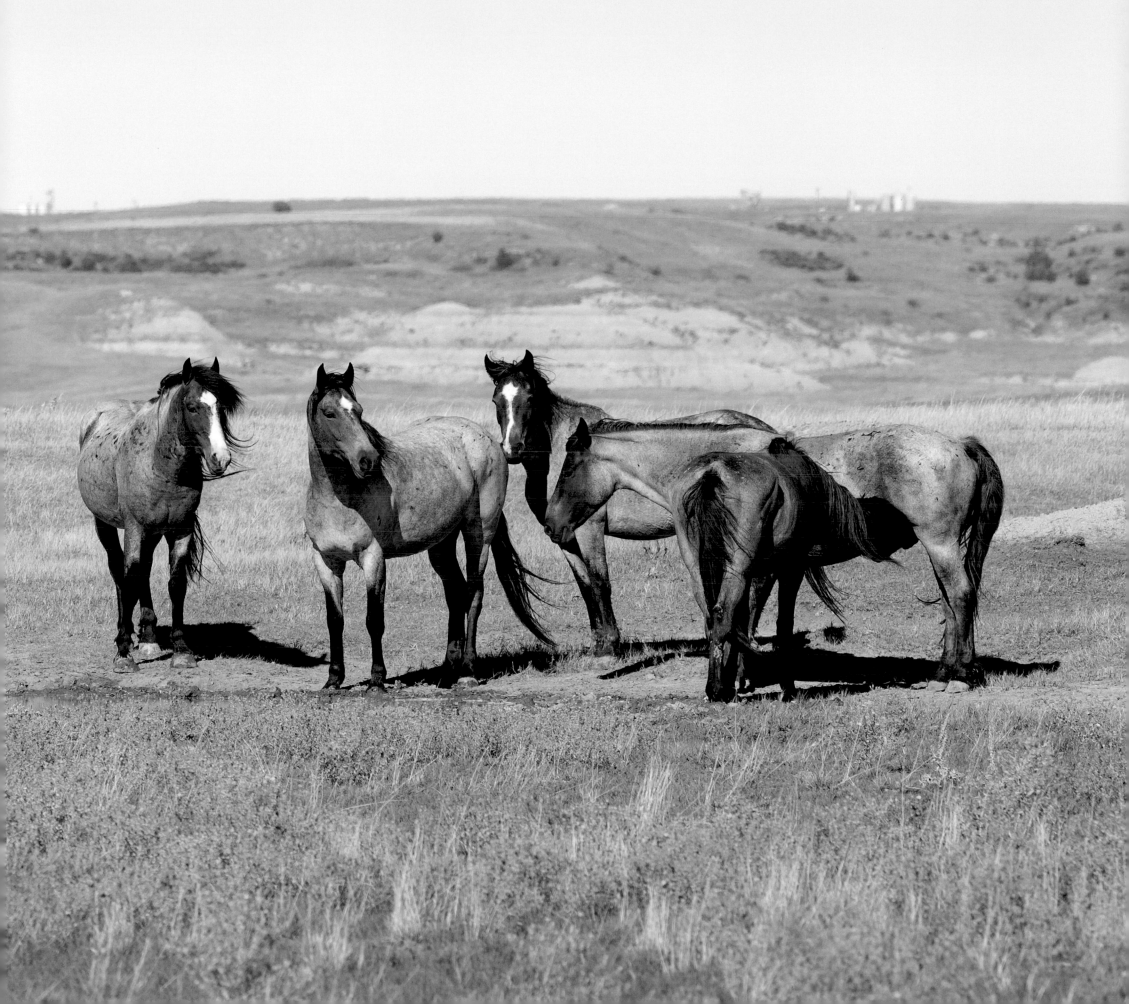

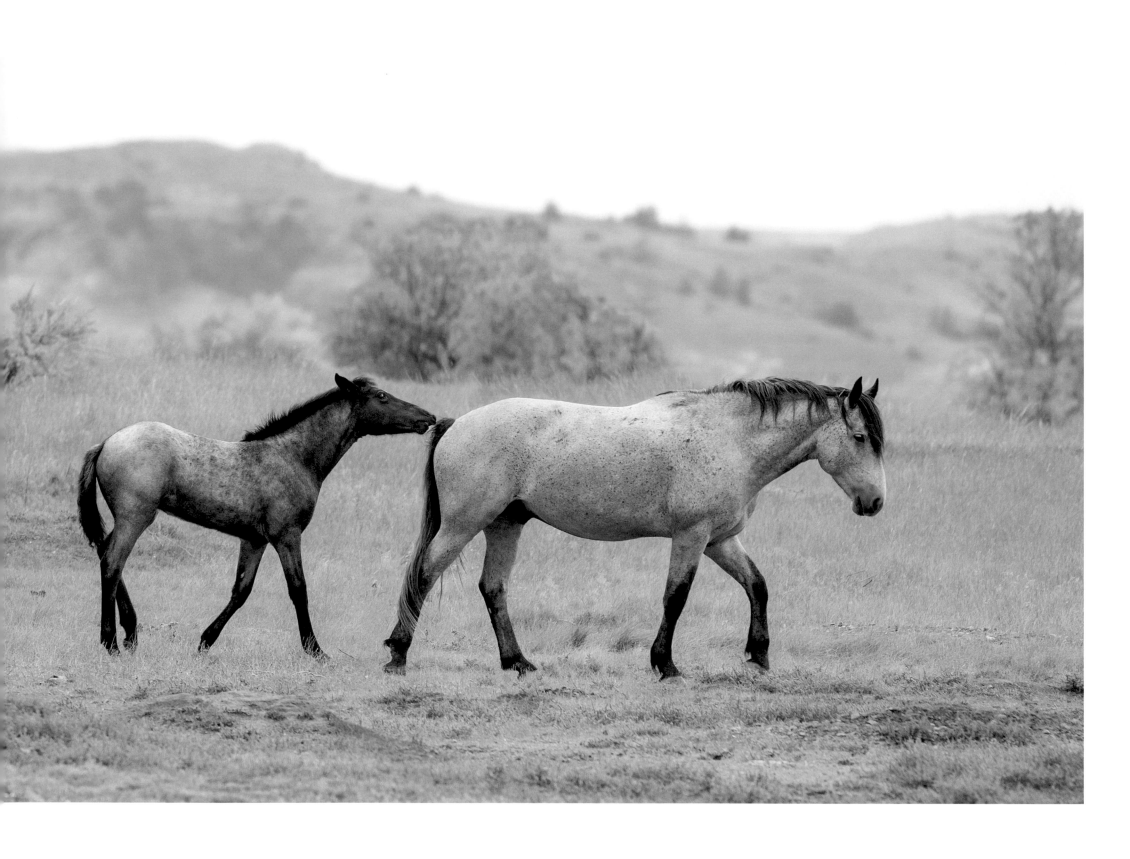

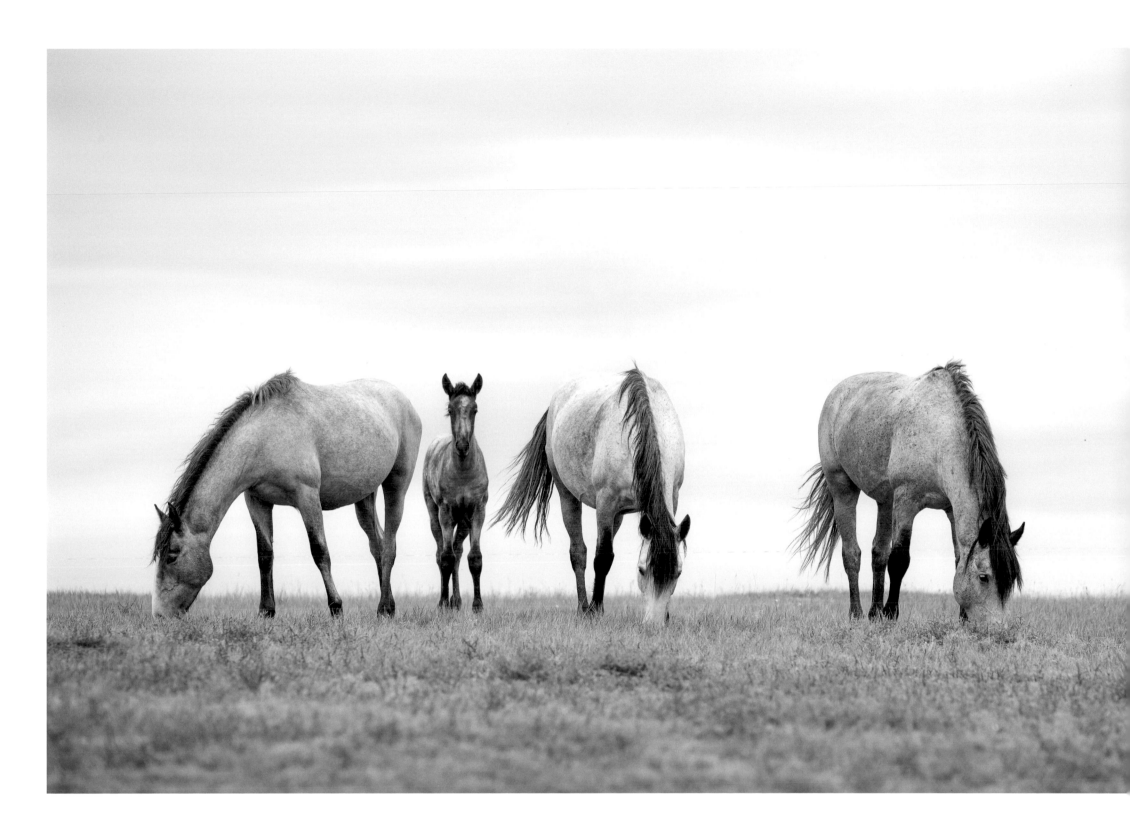

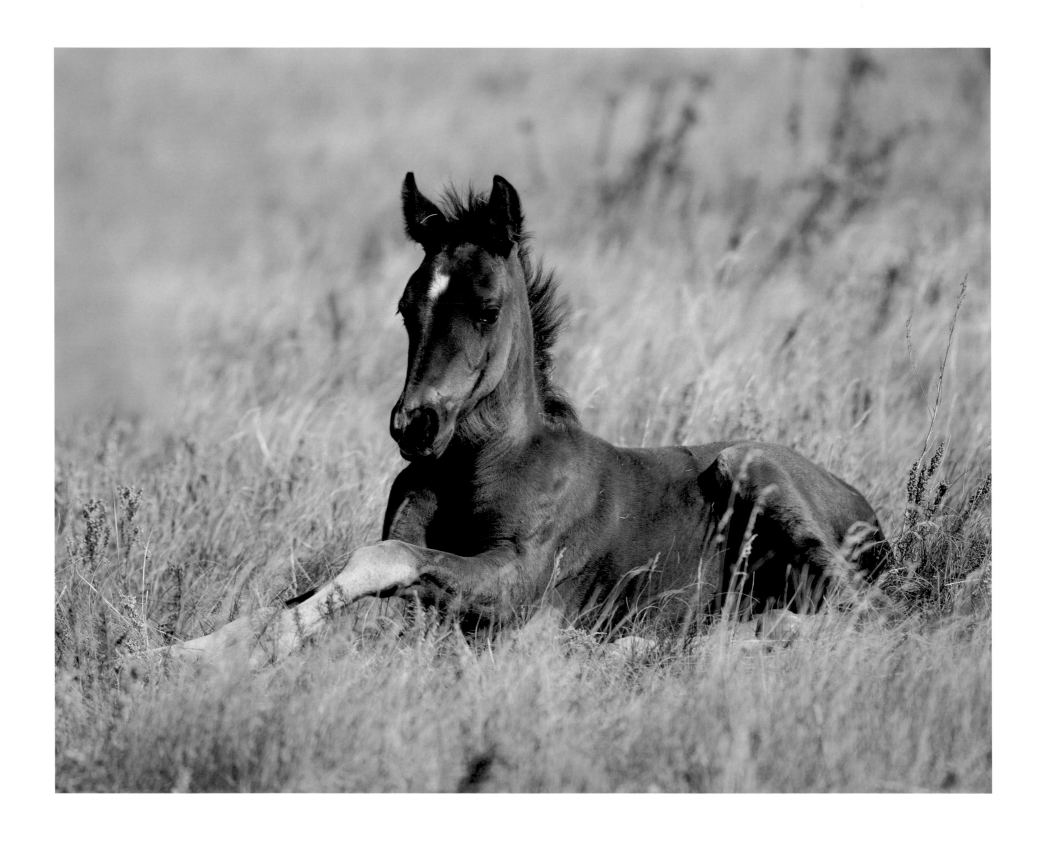

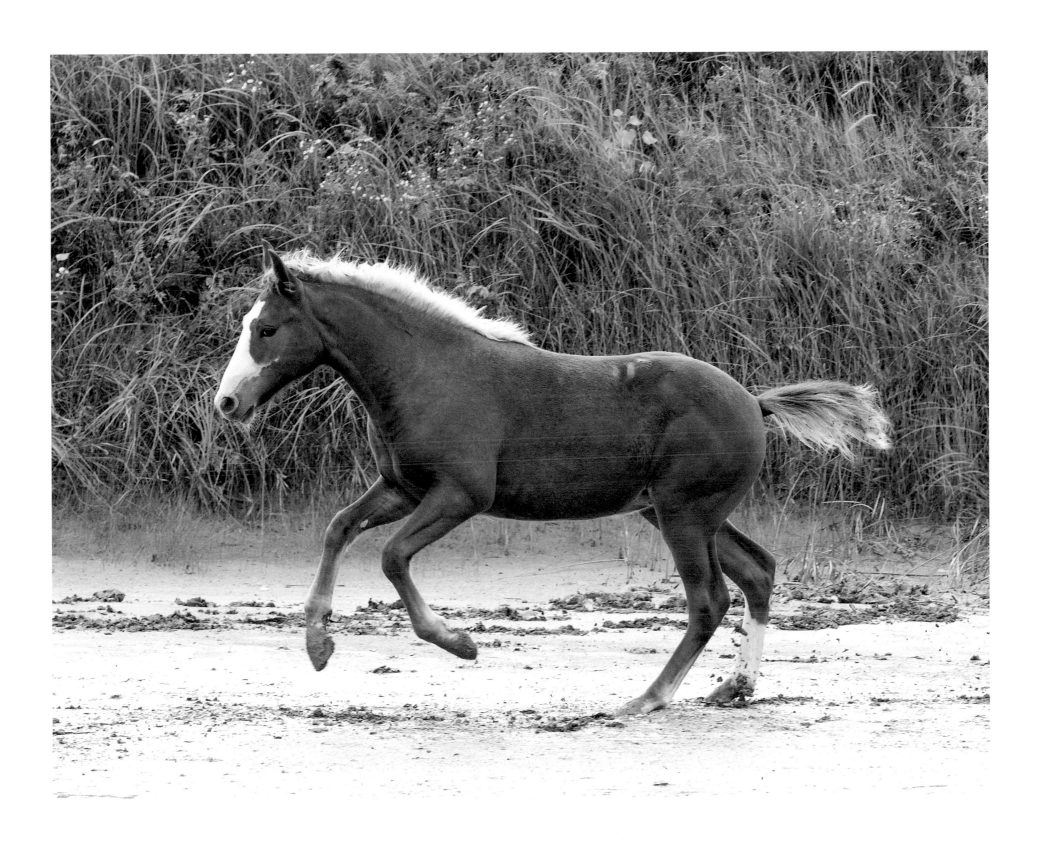

"That night he dreamt of horses
in a field on a high plain where the
spring rains had brought up the
grass and the wildflowers out of the
ground and the flowers ran all blue
and yellow far as the eye could see
and in the dream he was among
the horses. . ."

— Cormac McCarthy
All the Pretty Horses

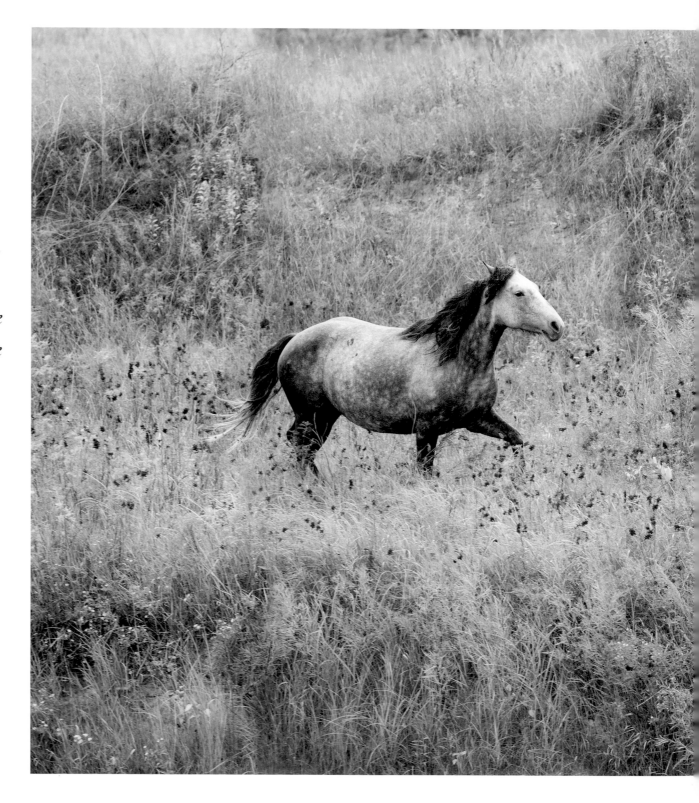

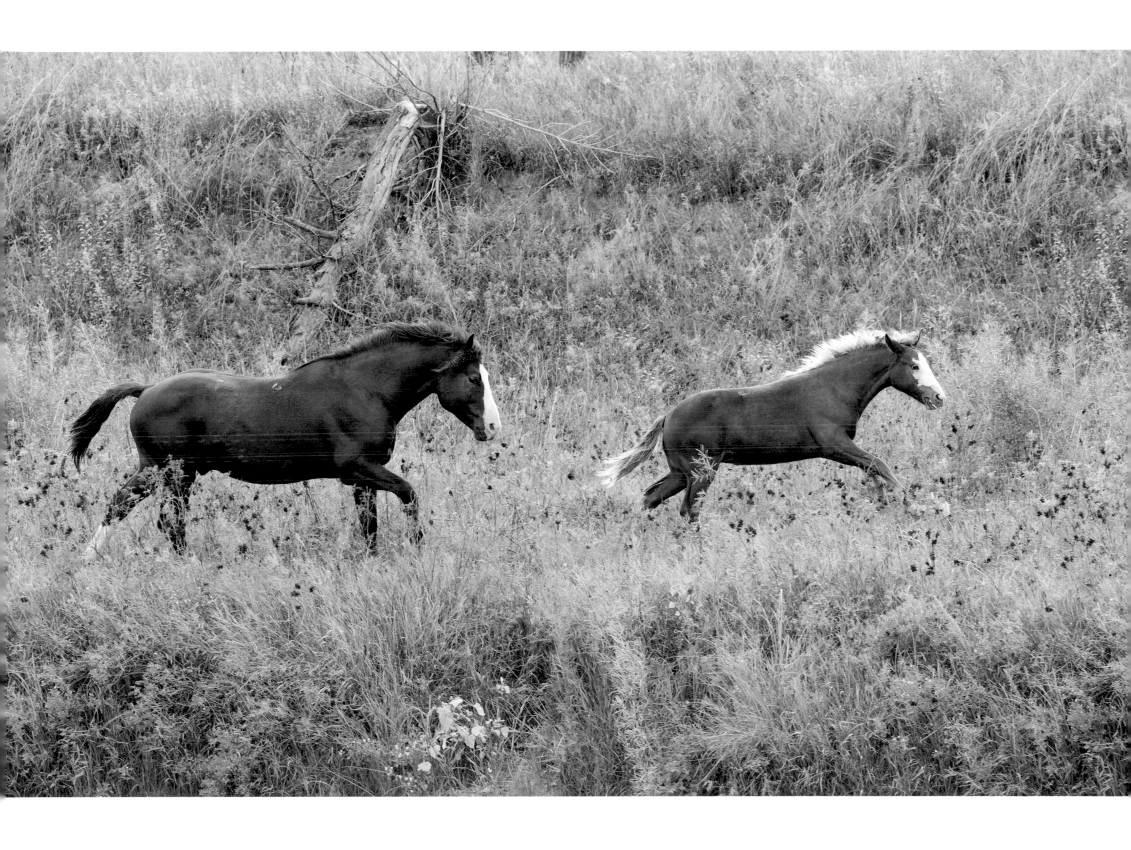

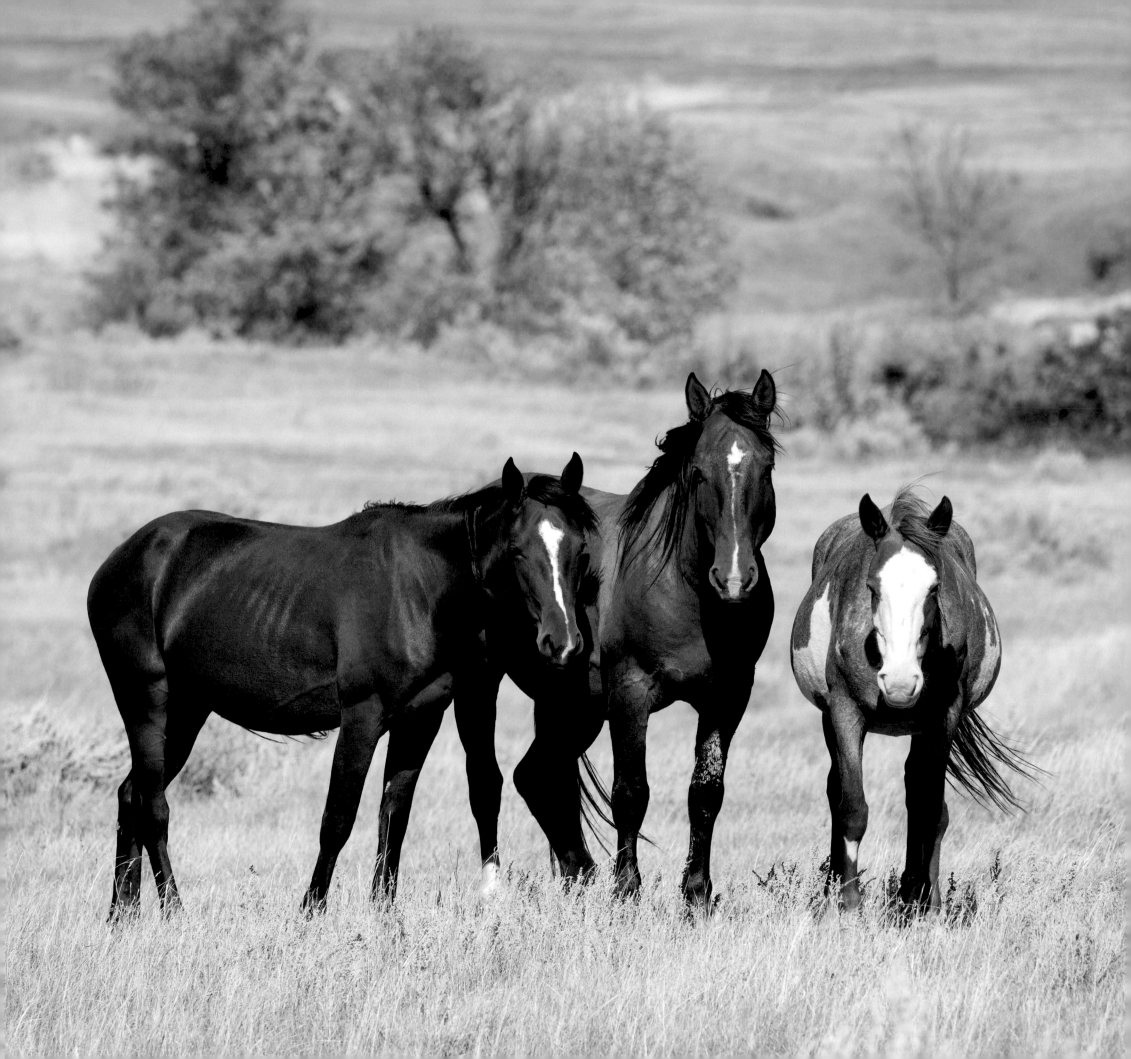

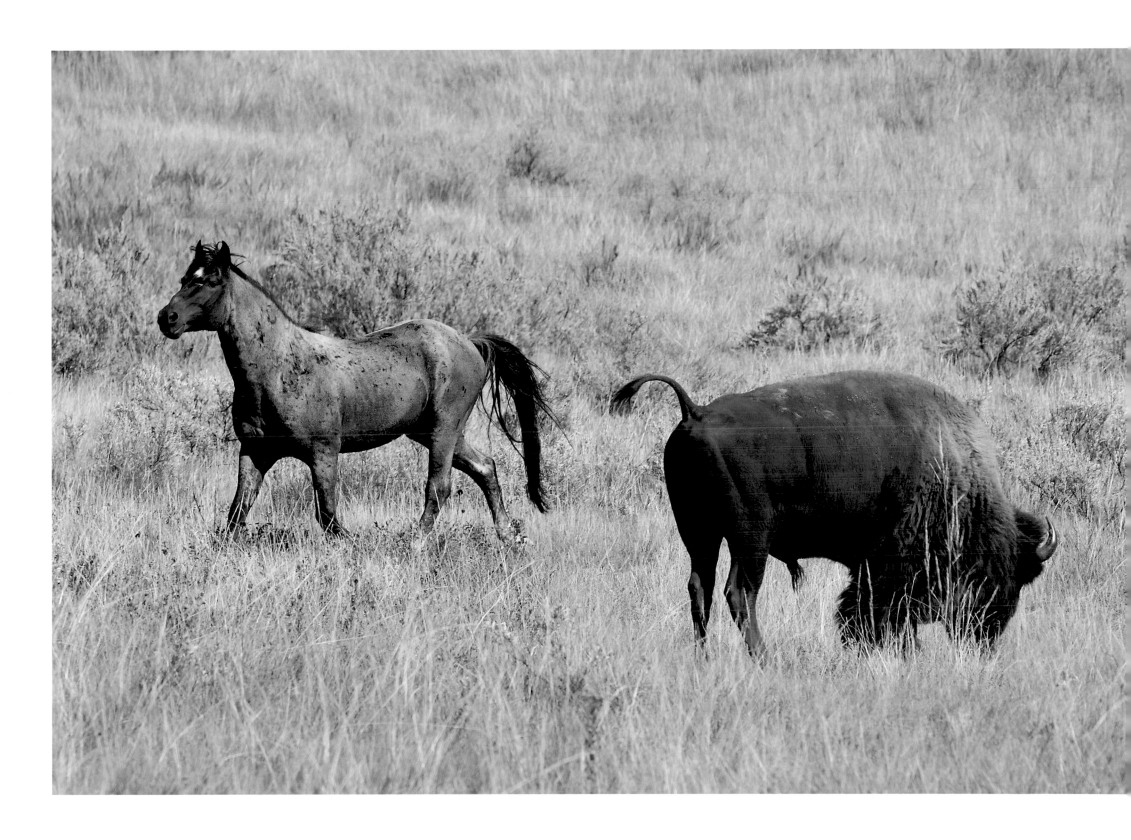

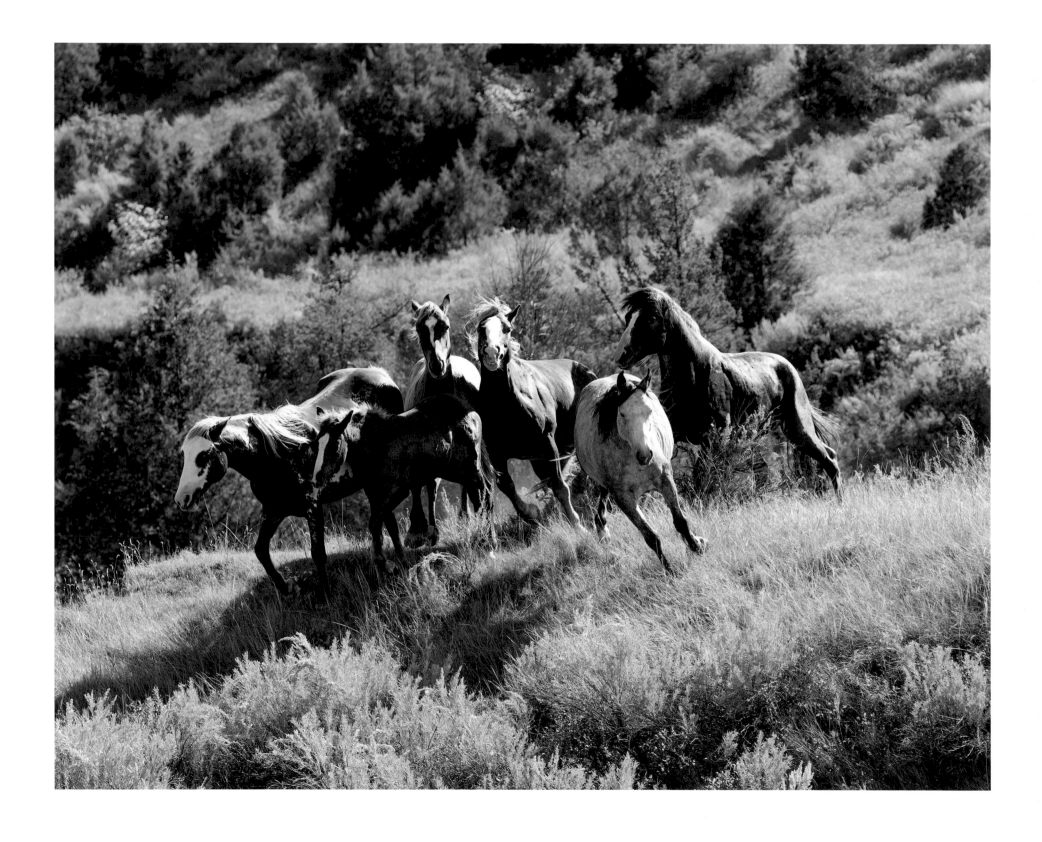

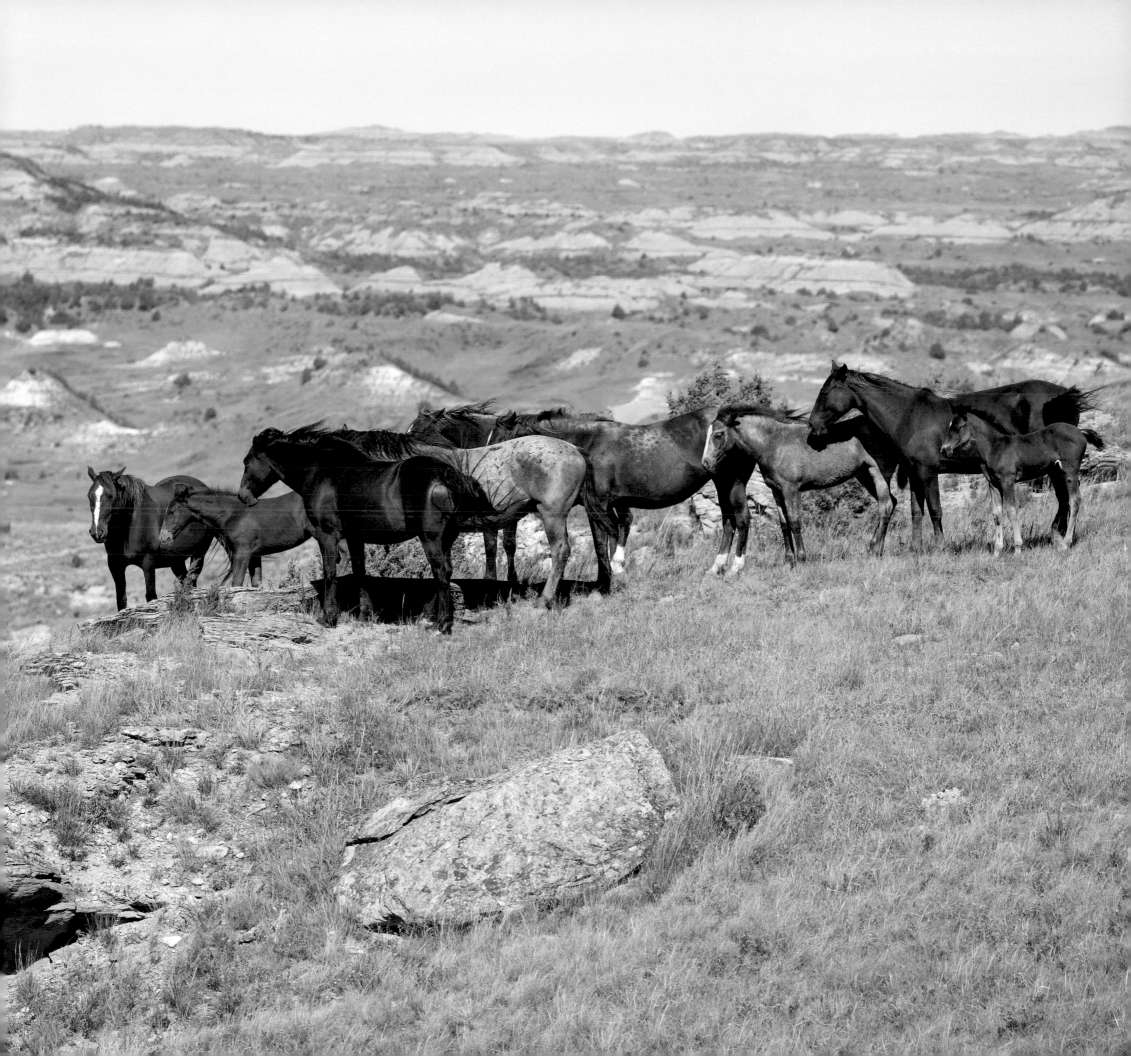

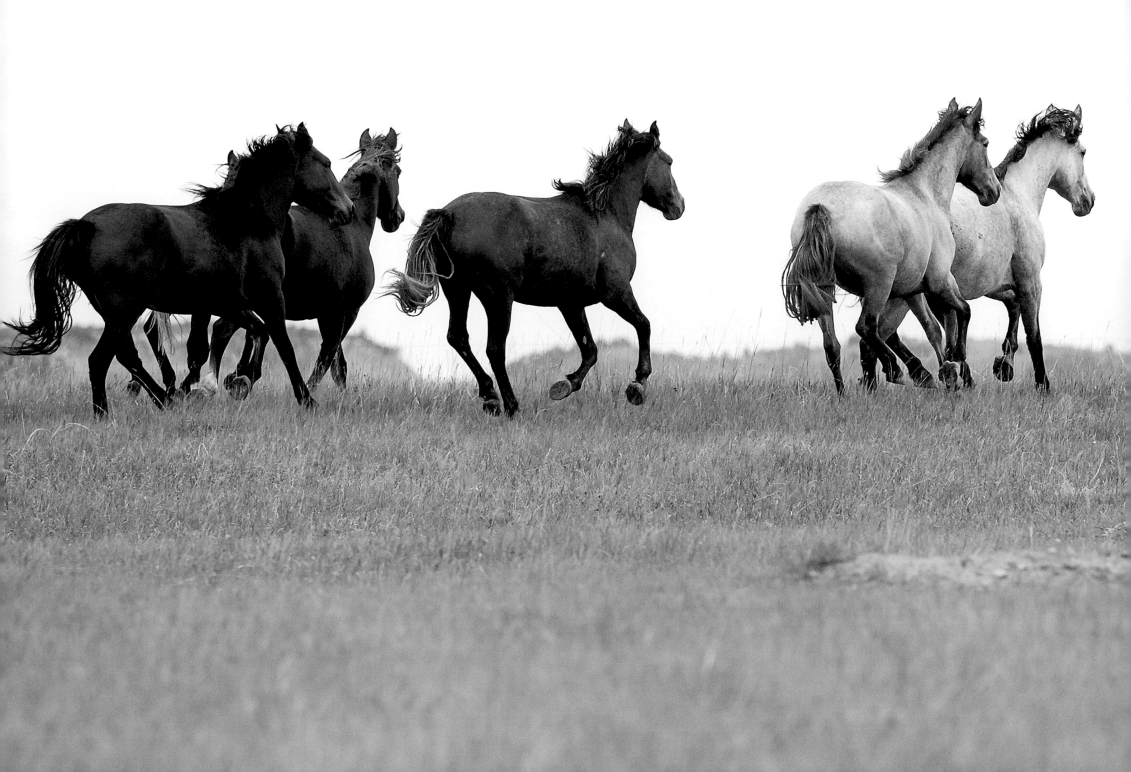

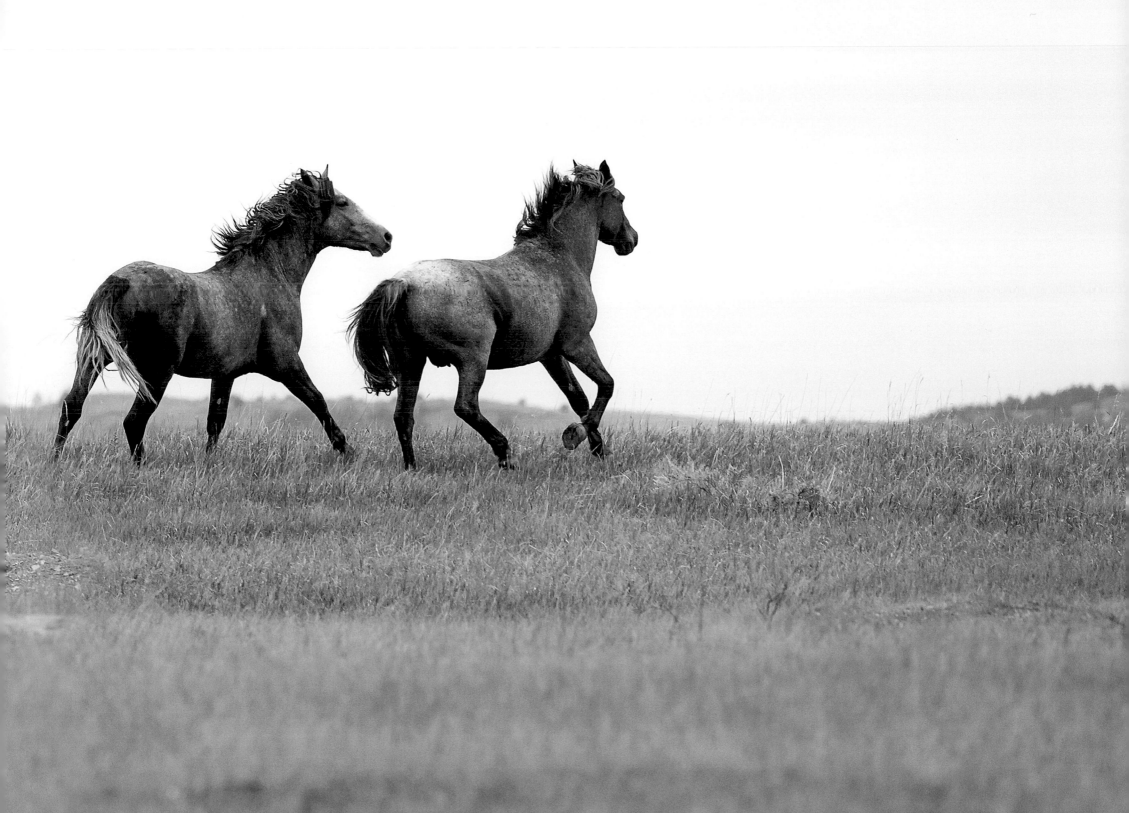

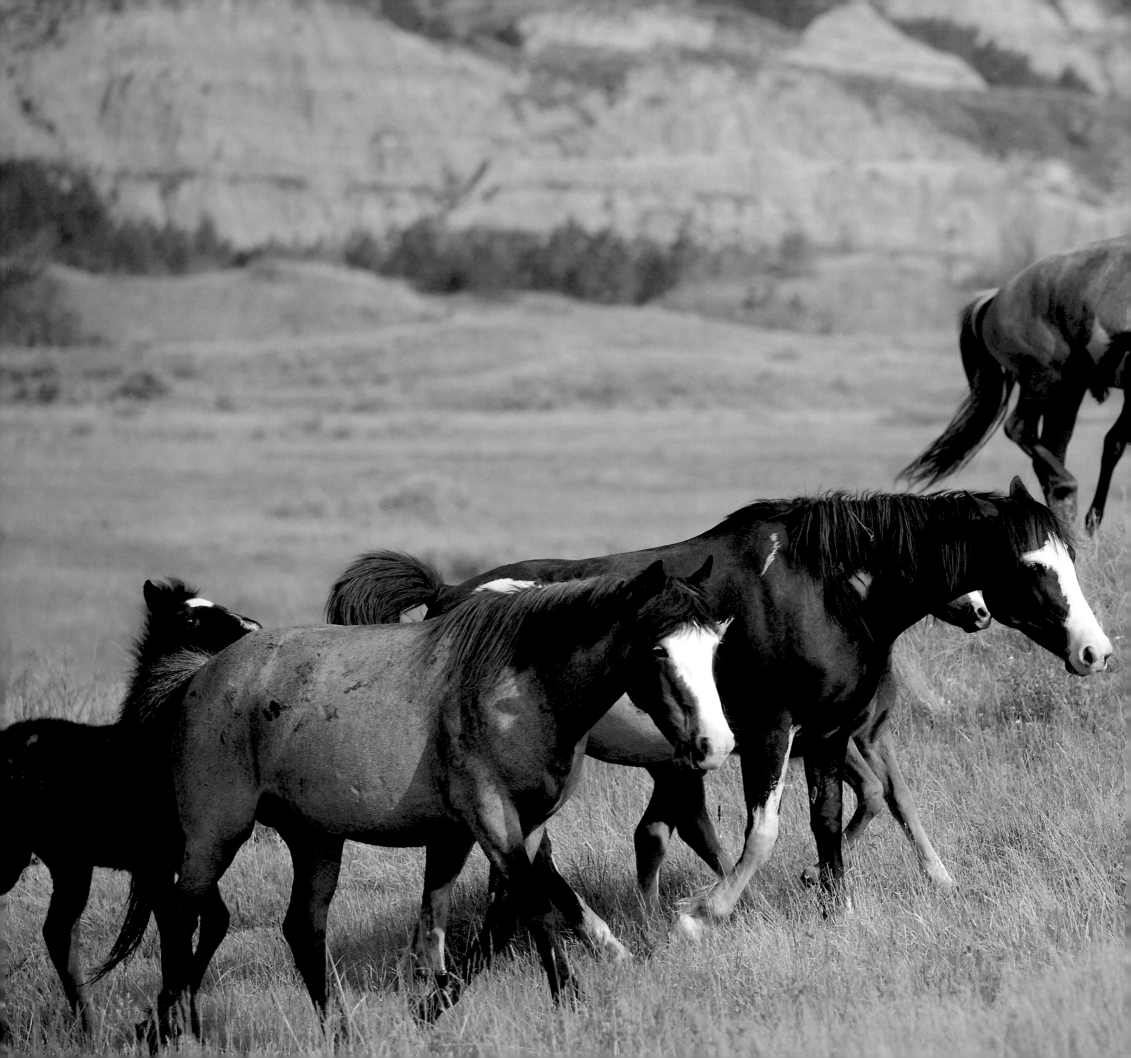

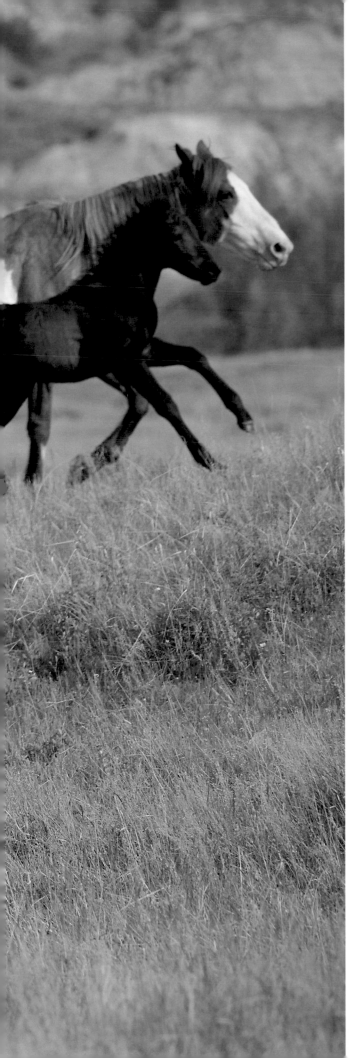

TO PROTECT WILD HORSES

As you can see from all the previous pages, I feel passionately about these animals and the beauty and freedom they represent. In so many ways, these wild horses have become an integral part of my family and, with all my heart, I want to see them properly protected. Indeed, a large part of my mission with this book is to inspire you and others to feel the same way and to act on their behalf.

I am not alone in this struggle. Here are some organizations that are doing admirable work on behalf of America's wild horses. I urge you to learn more about what they do. Working together, I believe we can lift our understanding and protect this cherished element of our American heritage.

- *Return to Freedom*. This is a national nonprofit organization dedicated to preserving the freedom, diversity and habitat of America's wild horses. They sponsor and manage a wild horse sanctuary that provides a safe haven to almost 400 wild horses. They are also a wonderful source of information, educational resources, and national networking opportunities. For more information, please visit their website, ReturntoFreedom.org.

- *Wild in North Dakota, Inc.* This is a nonprofit corporation that operates in support of the wild horse herds in Theodore Roosevelt National Park. They document the life of the herds on a yearly basis and help educate the public about the horses and their needs and interactions. They also offer guidance to individuals who may be interested in adopting a wild horse. To learn more, visit their Facebook page: facebook.com/dakotawildofficial.

- *The American Wild Horse Campaign*. This nonprofit organization was created in 2004 to oppose government policies that they say are designed to drive wild horses and burros from national parks and other public lands. They view wild horses just as I do: as "living symbols of the historic and pioneer spirit of the West." To learn more about their efforts to protect wild horses, please see their website: www.americanwildhorsecampaign.org.

I looked about me once again, and suddenly the dancing horses without number changed into animals of every kind and into all the fowls that are, and these fled back to the four quarters of the world from whence the horses came, and vanished.

– Black Elk
19th century Indian seer and healer

UNDERSTANDING WILD HORSE BEHAVIORS

BAND Members of a herd, and their social structure. Bands consist of 2-24 members.

Stallions: Usually there is one dominant stallion per band. Observing from behind, he protects his band from other stallions and breeds his mares.

Lead mare: The lead mare brings the band to grazing, water, and away from danger. She eats and drinks first, decides when and where the herd will move to next.

Mares: Female horses of breeding age. A mare can be bred back within 10 days of foaling.

Foals: A newborn horse up to one year of age. A filly is a female horse under four years of age. A colt is a young male horse under four years of age.

Yearlings and two-year olds: Young horses who have not reached sexual maturity and may still attempt to nurse.

Bachelors: Young stallions who have reached sexual maturity and are kicked out of their band, or older stallions who have lost their bands to younger stallions.

CLACKING When foals or young horses are feeling vulnerable, they will extend their neck, point their head forward, curl their lips and clack their teeth together letting the other horses know they are submissive.

CURLING Colts or stallions raise their heads and curl their upper lip to take in the scent of a mare or an otherwise unfamiliar smell.

EAR POSITION Whichever way the ears of a wild horse are pointed says a lot about their behavior.

Relaxed ears: When the ears loosely point forward, sideways, or backwards the horse is aware of its surroundings and is relaxing or resting.

Alert ears: If the ears are distinctly pricked forward and the head comes up, they are acutely alert and focusing on something from interesting to threatening.

Angry ears: When the ears are pointed backwards and pinned to the back of their heads it's an indication of displeasure which can be followed by a bite, kick, or a lunge.

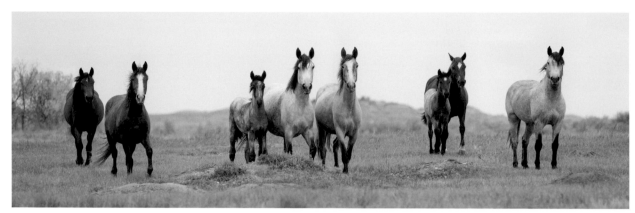

Members of a band: *(left)* two mares; *(center)* a foal, the lead mare, a mare; *(right)* a foal and a mare; *(far right)* the band stallion.

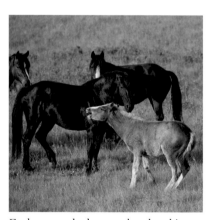

Foal approached wrong band and is clacking. The black stallion is pinning his ears expressing displeasure.

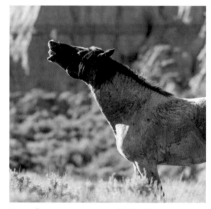

Breeding season is in full swing and a young stallion catches an unfamiliar scent. He curls his upper lip.

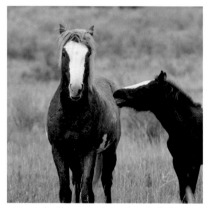

Young foal approaching his dad shows his submissiveness by clacking.

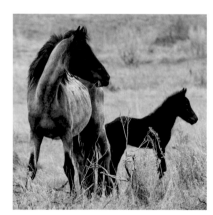

Ears pricked forward, mare and foal alert to potential danger.

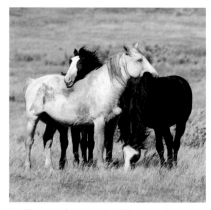

Stallion and mares huddle together with relaxed ear positions showing strong family ties.

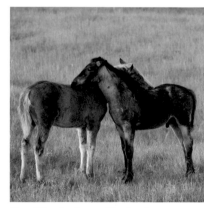

Best friends show affection by grooming one another.

GROOMING As soon as a foal is born, the grooming begins. Mares are constantly licking, scratching and rubbing their newborns. The mares pay particular attention to the foal's withers where the top of their shoulders and the base of their necks meet. It's a comforting time between mares and their foals. As foals mature, they come together and groom each other creating close bonds in the process and ridding each other of those summertime parasites. Grooming continues well into adulthood with best friends grooming each other.

MOODS & EXPRESSION The moods of wild horses can be read while understanding their ears, head carriage, tails, and posture.

Anxiety: When a grazing horse stops eating and suddenly raises its head with ears pricked forward, it is alert to danger. A wild horse instinctually knows to run when it is frightened. Alert ears, raised heads and tails indicate readiness to flee. The band takes their direction from the lead mare. If she feels it is necessary to run, they all follow. They may run away and circle back as a unified band to confront what they are seeing.

Breeding: The stallion's instinct to breed runs deeply. When excited over a mare, a stallion will arch his neck, prance, breath heavily, and hold his tail erect. A mare who is uninterested will lay her ears back, swish her tail, kick, and move away.

Battling: There are many levels of battling. Some are just showing off by rearing, prancing, and snorting. Some instances are an actual confrontation involving biting and kicking. Sometimes young stallions will practice battling with no intent to harm the other horse. Most battles end quickly unless a young stallion really is intending to take over an older stallion's band. Then the younger stallion may agitate and attack the older stallion over a period of time, wearing the older stallion down until he's given up.

RELAXING Horses are relaxing when they graze or stand contently. Ears are floppy and not really concentrating on anything. When sleeping or resting while standing, their head will droop, a hind foot may be bent and resting, and their eyes may be closed or half open.

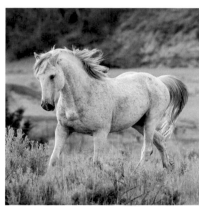
Head, neck, and tail raised, nostrils flared, stallion is moving toward a challenge.

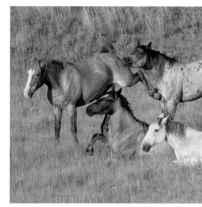
Red Roan is not happy with stallion's interest. Ears flat back, tail raised, and she strikes out.

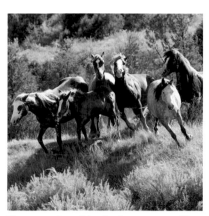
Ears are pinned back. An angry stallion *(right)* moves his herd along.

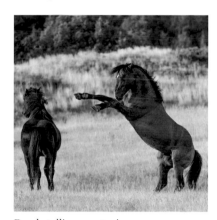
Band stallions posturing.

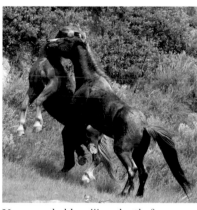
Young and old stallions battle for position.

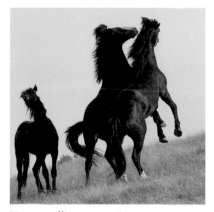
Young stallions posturing.

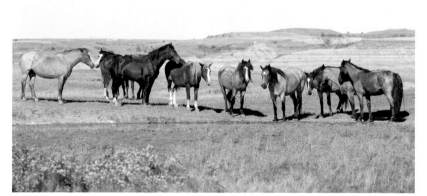
It is the afternoon, and all horses have a relaxed ear position. The stallion is in the very center and aware of my presence.

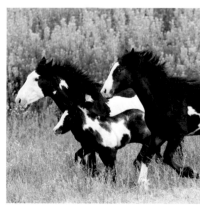
Relaxed gallop. Head and neck carriage is normal, ears relaxed.

149

SNAKING The dominant stallion moves his mares and foals along by lowering his head, his nose just above the ground, and waving his neck side to side. It is deemed an aggressive act whether the lead stallion is chasing off a challenger to his band or coaxing one of his uncooperative mares in the right direction.

STRETCHING Often when horses wake up from a nap they stretch.

TAIL POSITIONS are important. They can tell a lot about a horse's mood.

Relaxed: When the tail hangs loosely the horse is content.

Raised or "flagged": The tail is carried above the level of the back and indicates the horse is excited.

Clamped down: When their tails are pressed down, or even tucked between their hind legs, the horse is nervous or stressed.

Rapid swishing: Slow slapping of the tail is all about fly control. But when a horse moves its tail rapidly from side to side or up and down, the horse is irritated. It is sometimes referred to as "wringing" and may be followed by a kick or bite.

VOCALIZATIONS

Neighs and whinnies: Are used to announce the presence or greeting of a horse. When wild horses that are close to each other within a band become separated, prolonged whinnies are vocalized to reunite.

Nickers: A low pitched nicker is a loving greeting to friends within a band, and a mare nuzzling and nurturing a newborn foal.

Squeals: This sound indicates displeasure. It means "Keep off" or "Keep away, I don't like what you are doing."

Snorts: A snort is used to alarm the band of a potential threat, the louder the snort, the bigger the threat. A series of snorts can also mean a horse is anxious or skittish.

WILD HORSES AND HUMANS, PARALLELING BEHAVIORS Wild horses experience joy and elation, pain and suffering in all stages of their lives. Similar to what humans experience, family units can be complex. The same holds true for wild horses in their bands. They express themselves vocally and through body language much like we do.

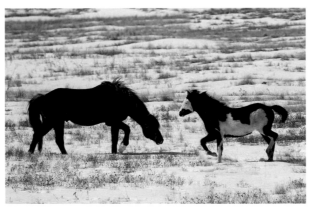

Band stallion on left commands this young foal's obedience by snaking.

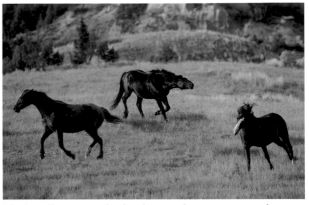

Black stallion moves his herd to another grazing area by snaking.

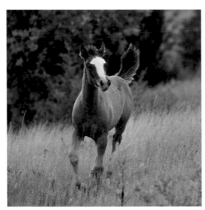

Foal's tail is up in excitement. He was napping and his band had moved on.

Napping foal wakes to join nearby herd. Head down, tail normal position, walking relaxed pace.

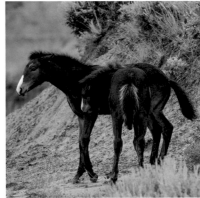

A young, submissive foal with tail clamped down pesters another young foal who shows displeasure with his ears back and flat.

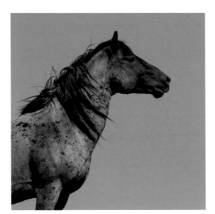

Band stallion neighs for one of his mares he thinks may be lost.

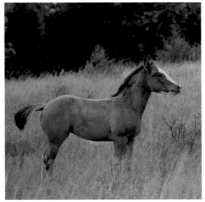

Lost young foal whinnies for his mother. He fell asleep and did not notice the band had moved on.

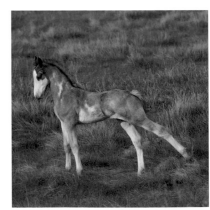

Just woke from a nap. A stretch feels good.

HORSES IDENTIFICATIONS

This index serves as an historical identification record of horses observed and photographed within Theodore Roosevelt National Park, North Dakota, and Return to Freedom Sanctuary, California. Dates listed are birth dates, unless a range appears, indicating a death. The names given are cited according to conventions established by Wild in North Dakota and Return to Freedom organizations. Refer to the indicated book page to see the full image.

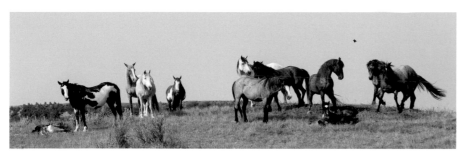

Dust Jacket (left to right): 2014 dam *Taylor*, 2019 colt *Alabaster* (sleeping), 2001 mare *Pale Lady*, 2005 mare *Spotted Blue*, 2000 dam *Strawberry*, 2007 *Angel*, 2004 *Winter* (light gray in back), 2010 mare *Cowgirl* (darker gray), 2001 band stallion *Thunder* (dark gray, standing behind 2019 filly *Addie* who is laying down), 2004 band stallion *Sidekick* moves 2005 mare *Mist* (farthest right) away from *Thunder*.

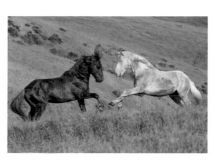

Page ii–iii Stallions *Galahad* and *Silver King* from the Silver King Herd Management Area in Nevada.

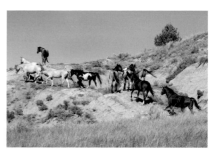

Page iv–v 2001 band stallion *Thunder* and his band. He is at the top of the butte, dark gray with a white star.

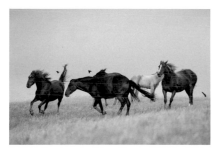

Page vi–vii Mares of 2010 band stallion *Half Moon* in 2018.

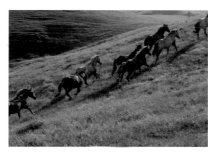

Page viii–ix Mixed band horses at Return to Freedom Wild Horse Sanctuary.

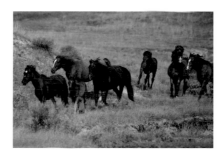

Page x–xi 2013 dam *Eagle*, 2019 filly *Agency*, 2005 mare *Ginger Spice*, 2006 mare *Raven*, 2018 filly *Athena*, 2006 mare *Ember's Girl*, and 2005 mare *Sundance*.

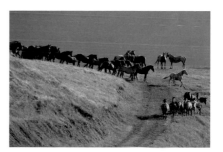

Page xii–xiii Mixed band horses and *Silver King* (the lone gray stallion) at Return to Freedom Wild Horse Sanctuary.

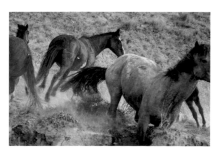

Page xiv–xv Mares of 2001 band stallion *Satellite* and 2004 band stallion *Sidekick* (front right).

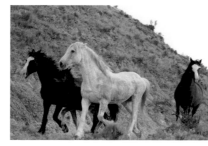

Page xvi–xvii 1998 dam *Lightening*, 2019 colt *Aimes*, 2001 band stallion *Satellite*, 2007 mare *Crow*, and 2016 dam *Minnie* with 2019 filly *Almanac*.

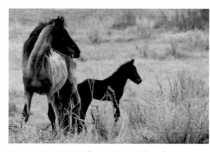

Page xix 2010 dam *Cowgirl* and 2016 colt *Rhode Island*.

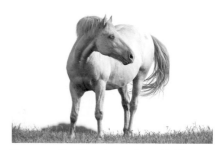

Page xx Stallion *Azura* from Cold Creek Herd in Nevada.

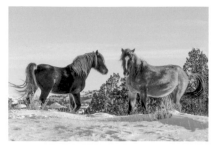

Page 6–7 2011 band stallion *Flax* and 2014 mare *Thunder Rose*.

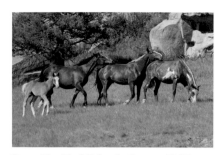

Page 8–9 2004 band stallion *Mystery* and 2010 band stallion *Ollie, Jr.*

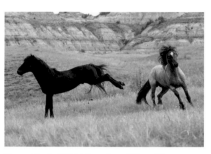

Page 10–11 2018 colt *Cagney*, 2007 dam *Firefly*, 2012 band stallion *Frontier*, and 2000–2019 mare *Lacey*.

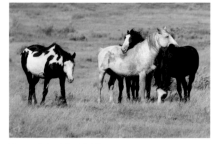

Page 12–13 2002–2019 mare *Sweetheart*, 2001 band stallion *Satellite*, 1998 mare *Lightening*, and 2007 mare *Crow*.

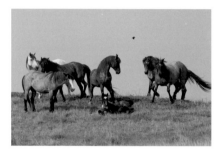

Page 15 *See* dust jacket identifications, page 151.

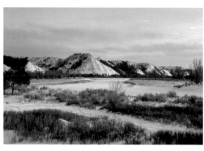

Page 18–19 WINTER: Not far from Jones Creek on the Little Missouri River in Theodore Roosevelt National Park.

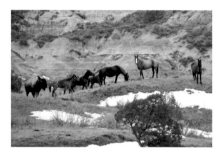

Page 20–21 Bison and 2011 band stallion *Wild Rye's* mares and foals; 2014 mare *Lorena* is the red roan.

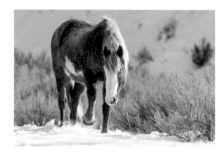

Page 23 Band stallion *Cloud* forages for food.

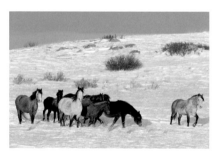

Page 24 2010 band stallion *Teton* (the gray standing far right by himself) with his band at sunset in freezing temperatures.

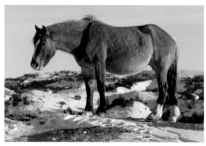

Page 25 2014 mare *Thunder Rose*, currently with 2011 band stallion *Flax*.

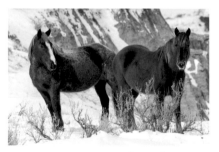

Page 26 2001 mare *Tanker* and 2014 mare *Eclipse*, currently with 2010 band stallion *Half Moon*.

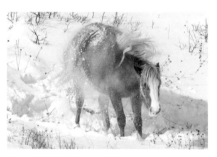

Page 27 2017 mare *Perty*, currently with 2001 band stallion *Redface*.

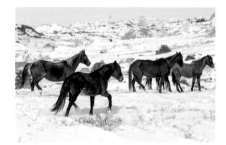

Page 28 2010 band stallion *Half Moon* (with black mane and tail) with band startled by bounding elk.

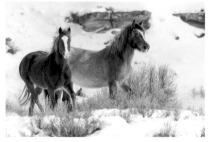

Page 29 2013 mare *Maggie Mae* and 2014 mare *Thunder Rose*, currently with 2011 band stallion *Flax*, startled by running deer.

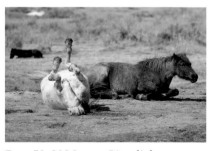

Page 30 2006 mare *River*, light gray, and 2005 mare *Mist*, dark gray, currently with 2004 band stallion *Sidekick*.

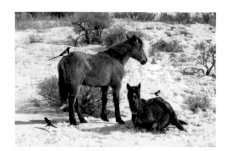

Page 31 2017 filly *Little Heart* and 2017 colt *Garryn* with black-billed magpies.

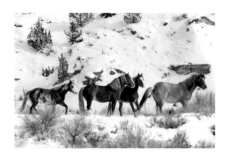

Page 32–33 2006 mare *Dolly*, 2011 band stallion *Flax*, 2013 mare *Maggie Mae*, and 2014 mare *Thunder Rose* spot some deer on the hillside.

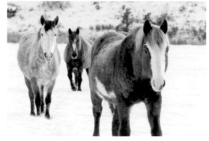

Page 34 2004 band stallion *Cloud*, 2010 mare *Whiskey*, and 2002 mare *Shale*.

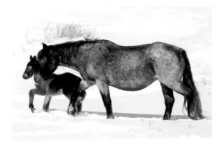

Page 35 1999 dam *Frosty* with 2019 filly *Aden*.

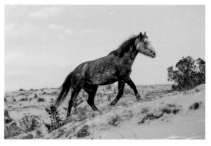

Page 36 2014 mare *Holly*, was with 2004 band stallion *Cloud*.

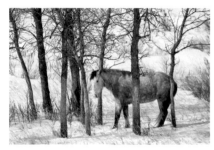

Page 37 2010 mare *Whiskey*, was with 2004 band stallion *Cloud*.

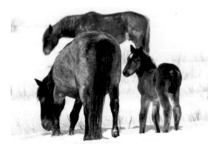

Page 38 2001 band stallion *Redface* in the back, with 1999 dam *Frosty* and 2019 filly *Aden*.

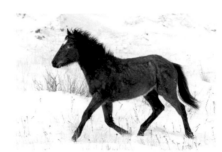

Page 39 2018 filly *Blue Moon*, was with 2010 band stallion *Half Moon*.

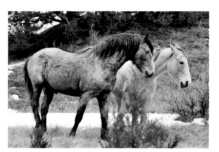

Page 40 2011 band stallion *Wild Rye* and 2004 mare *Little Gray*.

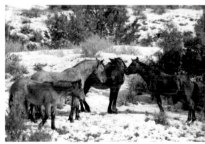

Page 41 2011 band stallion *Wild Rye* (light gray) flirts with 2014 mare *Paige* and foals.

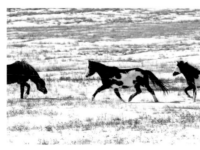

Page 42–43 2001 band stallion *Thunder*, 2014 mare *Taylor*, and 2017 filly *Black Magic*.

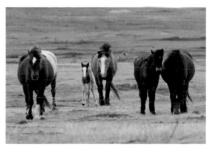

Page 44–45 2010 band stallion *Teton's* band on the move with newborn foal.

Page 48–49 SPRING: Little Missouri River from East River Road looking into Theodore Roosevelt National Park.

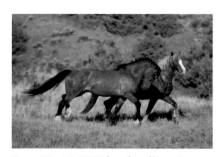

Page 50–51 2002 band stallion *Copper* posturing with 2011 band stallion *Flax*.

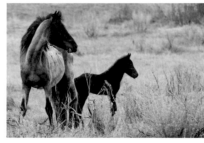

Page 52 2010 dam *Cowgirl* and 2016 colt *Rhode Island*.

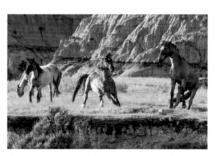

Page 54–55 2010 mare *Cowgirl*, 2001 band stallion *Thunder*, and 2004 band stallion *Sidekick*.

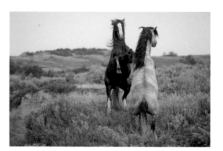

Page 56 2011 band stallion *Flax* posturing with 2010 band stallion *Arrowhead*.

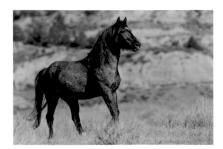 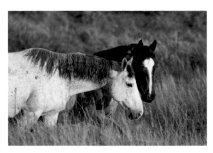 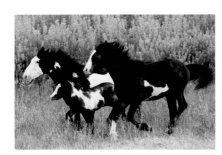 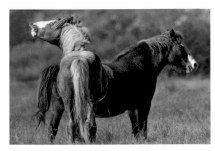

Page 57 2001 band stallion *Thunder* spotting bachelor stallions.

Page 58 2001 mare *Snip's Gray* and 2014 mare *Valentina* (dam *Snip's Gray*, sire *Sidekick*).

Page 59 2002 dam *Sweetheart*, 2016 colt *Wisconsin*, and 2015 colt *Rocky*.

Page 60 2004 stallion *Cloud* and 2001–2018 mare *Chubby*.

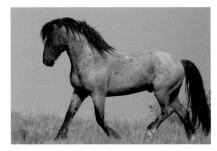 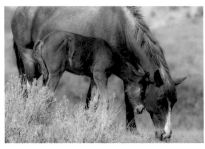 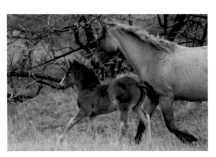 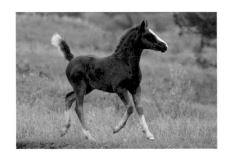

Page 61 2010 band stallion *Ollie, Jr.* off to battle.

Page 62 2007 dam *Nordie* and 2016 filly *Jersey*.

Page 63 2014 dam *Thunder Rose* with 2019 filly *Amargo* (sire *Flax*).

Page 64 2019 filly *Alkaline* (dam *Autumn*, sire *Ollie, Jr.*).

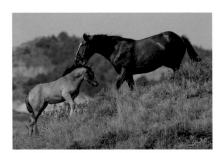 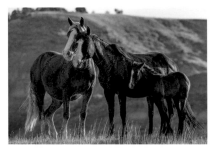 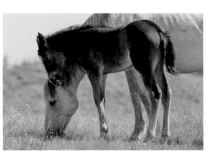 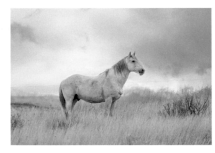

Page 65 2019 filly *Aggie* (dam *Faith*, sire *Silver*) is disciplined by 2013 mare *Democracy* who lost her colt 2019.

Page 66 2004 mare *Little Brother's Girl* and 2006 dam *Domino* with her 2019 filly *Antice* (sire *Arrowhead*).

Page 67 2006 dam *Betty Blue* with her 2019 colt *Amantes* (sire *Coal*).

Page 68 2001 band stallion *Satellite*.

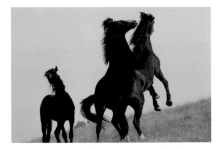 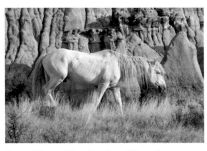 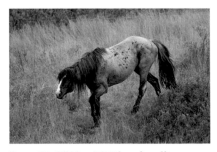 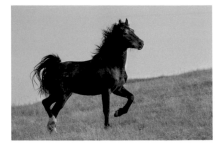

Page 69 2014 colt *Gunner*, 2014 colt *Maverick*, and 2014 colt *Remington*.

Page 70 2002 – 2018 stallion *Gray Ghost*.

Page 71 2002 – 2017 band stallion *Blaze*.

Page 72 2014 colt *Remington*.

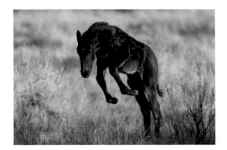

Page 73 2016 colt *Dakota*.

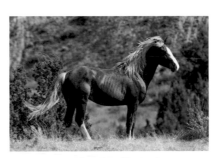

Page 74 2011 band stallion *Flax*.

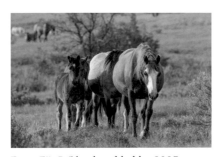

Page 75 *Redface* band led by 2003 mare *Pretty Girl*, with 1999 dam *Frosty* and 2019 filly *Aden* behind her.

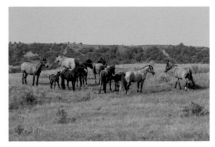

Page 76–77 Band of 2010 stallion *Arrowhead* (dapple gray with dark mane and tail), with stallion *Half Moon* on the far right.

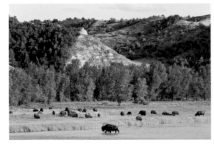

Page 80–81 SUMMER: Not far from Jones Creek on the Little Missouri River with bison in Theodore Roosevelt National Park.

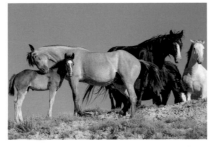

Page 82–83 2005 band stallion *Coal* (large dark brown horse with white blaze and pink nose) with his mares and foal.

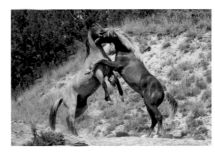

Page 85 2016 colts *Indy* and *Volt* playing

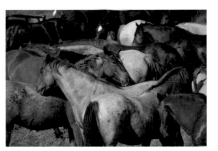

Page 86 1998 red roan herd from Hart Mountain National Antelope Refuge, Oregon.

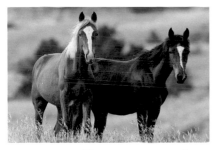

Page 87 2013 fillies *Maggie Mae* and *Democracy*.

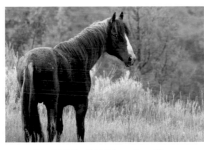

Page 88 2005 – 2018 band stallion *Clinker*.

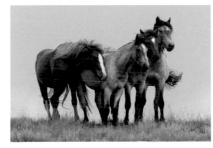

Page 89 Bachelor boys: 2011 *Flax*, 2011 *Wild Rye*, 2010 *Ollie, Jr.*, and 2010 *Teton*.

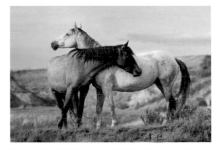

Page 90 2001 mare *Snip's Gray* and 2014 mare *Valentina*.

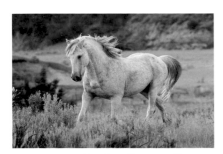

Page 91 2001 band stallion *Satellite*.

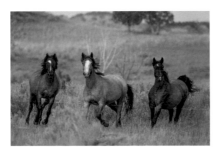

Page 92–93 2010 mare *Cassie*, 2017 filly *Aurora*, 2013 mare *Dawn*, all part of band led by 2004 stallion *Brutus*.

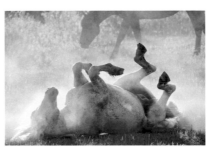

Page 94 2004 band stallion *Brutus* rolling.

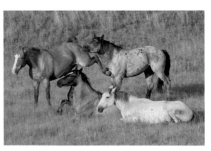

Page 95 2004 band stallion *Sidekick* kicked by 2006 mare *Escape;* 2014 mare *Valentina* and 2001 mare *Snip's Gray* are lying down.

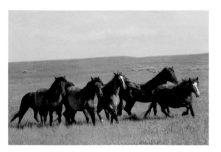

Page 96–97 (left to right) *Blue Velvet, Blue, Justice, Diamond, Remington,* and *Papoose;* the black in the back is *Domino.*

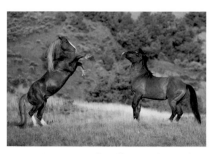

Page 98–99 Band stallions *Flax* and *Copper* posturing.

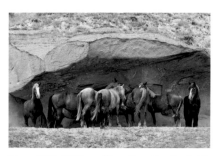

Page 100 2012 stallion *Frontier* (far left) and 2005–2018 band stallion *Clinker* (far right) keep an eye on each other.

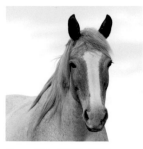

Page 101 2005–2014 mare *Sundance.*

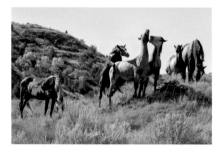

Page 102 *Clinker's* band after a drink and swim in nearby river.

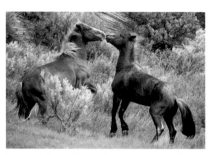

Page 103 2012 stallion *Frontier* and 2005–2018 stallion *Clinker.*

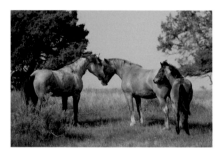

Page 104 2010 band stallion *Arrowhead,* flirting with 2006 mare from band stallion *Sidekick's* band, and 2018 colt *Lyle.*

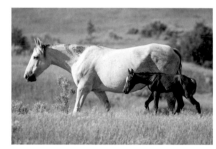

Page 105 2004 dam *Little Gray* with 24-hour-old 2018 colt *Jasper.*

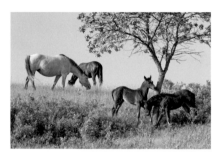

Page 106 Mares and foals of 2010 band stallion *Half Moon.*

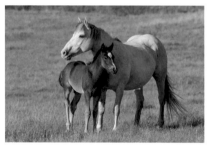

Page 107 2019 colt *Amantes* with 2006 dam *Betty Blue* (sire band stallion *Coal*).

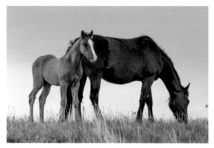

Page 108 2017 colt *Chance* with 2013 dam *Democracy.*

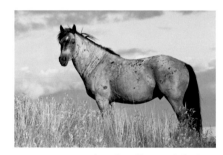

Page 109 2004 band stallion *Sidekick.*

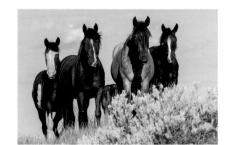

Page 110 Mares of 2004–2017 band stallion *Silver:* 2006 mare *Daisy,* 2011 mare *Esprit,* 2017 newborn foal, 2013 mare *Faith,* and 2016 filly *Charity.*

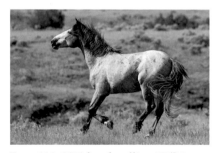

Page 111 2011 band stallion *Wild Rye.*

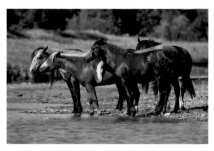

Page 112 Mares and fillies of 2005 former band stallion *George's Boy.*

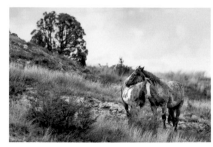

Page 113 1999–2019 band stallion *Wind Canyon* and 2014 mare *Paisley.*

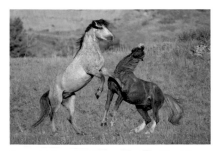

Page 114 Battle between band stallions *Arrowhead* and *Flax*.

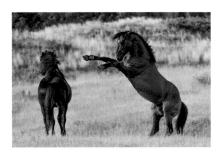

Page 115 2004 band stallion *Mystery* and 2002 band stallion *Copper*.

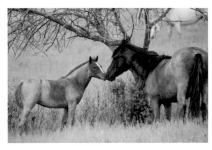

Page 116 2017 fillies *Nala* (red roan on left) and *Grace* (dark gray on right)

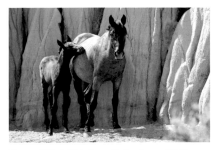

Page 117 2014 dam *Paige* from *Wild Rye's* band with 2017 colt *Garryn*.

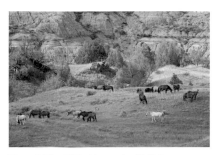

Page 118–119 Along the Talkington Trail, Theodore Roosevelt National Park, horses from the bands: 2001 *Redface*, 2001 *Satellite*, 2001 *Thunder,* and 2004 *Brutus*.

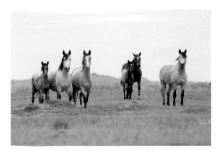

Page 122–123 AUTUMN: Little Missouri River from East River Drive.

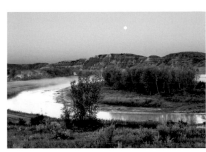

Page 124–125 2010 mare *Teepee,* 2014 mare *Shay,* 2016 colt *Traveler,* 2009 dam *Goblin,* 2014 mare *Boo,* 2016 filly *Crystal,* 2006 dame *Ruby,* and 2010 band stallion *Teton*.

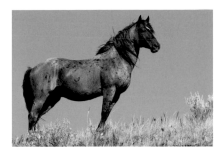

Page 126 2001 band stallion *Thunder*.

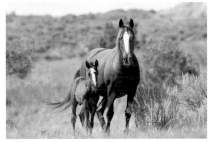

Page 128 2005 dam *Twister* and 2016 colt *Tornado*.

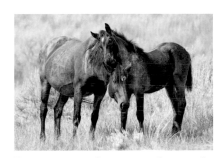

Page 129 2004 dam *Rosie* and 2016 colt *Sterling*.

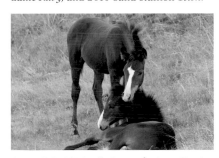

Page 130 2016 colt *Renegade* (standing) and 2016 filly *Half Pint* (lying down) sired by 2000 – 2018 band stallion *Cocoa*.

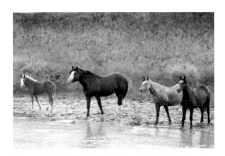

Page 131 2016 filly *Georgie,* 2005 band stallion *George's Boy,* 2010 mare *Whiskey,* and 2013 colt *Ranger*.

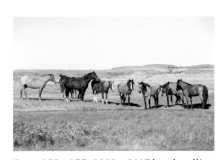

Page 132–133 2002 – 2017 band stallion *Blaze* (in center with large white blaze, pink nose, and ears forward) and his band.

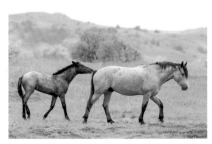

Page 134 2016 filly *Crystal* and 2010 band stallion *Teton*.

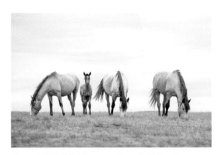

Page 135 2014 mare *Boo,* 2016 colt *Traveler,* 2009 dam *Goblin,* and 2010 band stallion *Teton*.

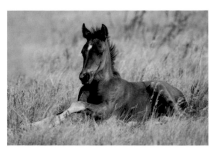

Page 136 2016 filly *Mystic Moon* (sire *Half Moon*).

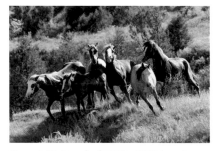

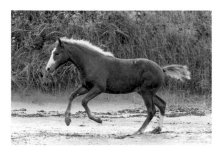

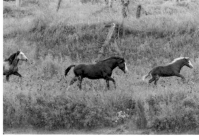

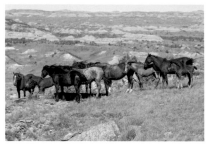

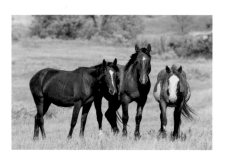

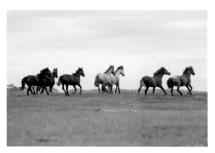

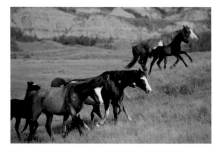

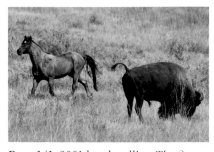

Page 137 2016 filly *Georgie* (sire *George's Boy*).

Page 138–139 2010 mare *Whiskey*, 2005 band stallion *George's Boy*, and 2016 filly *Georgie*.

Page 140 2013 mare *Democracy*, 2002 band stallion *Copper*, and 2000 mare *Strawberry*.

Page 141 2001 band stallion *Thunder* and a bison.

Page 142 Band of 2005–2018 band stallion *Clinker* (dark horse in the back far right) in 2016.

Page 143 Band of 2010 band stallion *Half Moon*.

Page 144–145 Band of 2010 band stallion *Teton*.

Page 146 Dams and foals of 2001 stallion *Thunder*: 2007 *Angel* with 2019 filly *Addie*, 2014 *Taylor* with 2019 colt *Alabaster*, and 2000 mare *Strawberry* with 2019 colt *Amite*.

ACKNOWLEDGMENTS

Over the years, there have been a number of people who have been integral in my growth as a photographer and inspirational throughout my career, which finally led to the creation of *The Wild Herd*.

I wish to acknowledge photographer Charles Bartholomew, who believed in my creativity and what I had to say. He encouraged me to focus on photography when I was a teenager and I have done that ever since.

I'm also grateful to photographer Phillip Lehans for his invaluable technical work and advice. The same holds true for Malin Wengdahl, an equine photographer who I have learned so much from.

Throughout my career as a photographer, I have been eternally grateful for my sons, my family, and for friends who have supported and encouraged me throughout the years including: Ellen Hughes, Amanda Conklin, Lynn Holley, and equestrian friends Sue Ellen O'Connor, Nancy Banfield, Paul Valliere.

Certainly, *The Wild Herd* would not have come to fruition without those who have immersed themselves in Theodore Roosevelt National Park and its wild horses.

It was the late, great photographer Pat Gerlach (1947-2018) who initially introduced me to the park during one of his wildlife photography workshops five years ago. Thanks to his trip, I fell in love with the wild horses, returning many times to photograph the bands.

My time spent in the field with Tiffany Craigo was instrumental in the creation of *The Wild Herd*. We hiked for many hours, tracking the bands of Theodore Roosevelt National Park. During our observations her keen eye helped in identifying the wild horses.

Eileen Norton was a wealth of information, not only identifying particular wild horses, but also explaining the different behaviors and personalities these amazing animals possess. Neda Demayo helped to deepen my understanding of the plight of all wild horses in America.

I'm also thankful for the knowledge and information provided by Doug Ellison about the town of Medora on the western fringe of North Dakota.

The production of *The Wild Herd* itself was a real group effort. Thank you to Jenna Bingham for helping to create the beautiful artwork on the vellum pages. I'm also very appreciative for the beautiful cover artwork created by C.R. Liles. Heartfelt appreciation to Paul Chutkow and Val de Grâce Books for fine tuning and elevating *The Wild Herd* to its most expressive form.

Lastly, I want to thank book designer Terri Wright for corralling all the moving parts. It was her support, vision, and hard work that made *The Wild Herd* a reality.

—Deb Kalas

PHOTOGRAPHY AND TEXT BY: Deborah Kalas

BOOK DESIGNED AND PRODUCED BY: Terri Wright, terriwright.com

COPY EDITING BY: Laura Horowitz
COVER ARTWORK: Hand drawn by C.R. Liles
HORSE DRAWINGS ON VELLUM PAGES: Created by Jenna Bingham

PRINTED AND BOUND BY: Crash Paper through Artron Art Printing (HK) Ltd., China.

CREDITS

p. 1. Photo by Tiffany Craigo.

p. 3. Thoreau, Henry David. *The Journal of Henry David Thoreau, 1837–1861*, entry for August 23, 1853. New York: NYRB, 2009.

p. 138. McCarthy, Cormac. *All the Pretty Horses*, p. 161. New York: Alfred A. Knopf, 1992.

p. 147. Neidhardt, John G. *Black Elk Speaks*, p. 16. Lincoln, Nebraska: University of Nebraska Press, 2014.

PRODUCTION DETAILS

TEXT PAPER: 157 gsm Moorim matte

ENDSHEETS: 120 gsm Pingri Bamboo Texture

CASE: JHT-0821 with foil stamp front & spine over 3mm grey board

JACKET: 157 gsm Chinese Oji gloss coated artpaper

VELLUM: 135 gsm tracing paper

A NOTE ON THE TYPE IN WHICH THIS BOOK IS SET

Cochin is a serif typeface. It was originally produced in 1912 by Georges Peignot for the Paris foundry G. Peignot et Fils (future Deberny & Peignot) and was based on the copperplate engravings of 18th century French artist Charles-Nicolas Cochin, from which the typeface also takes its name. The font has a small x-height with long ascenders and delicate design.